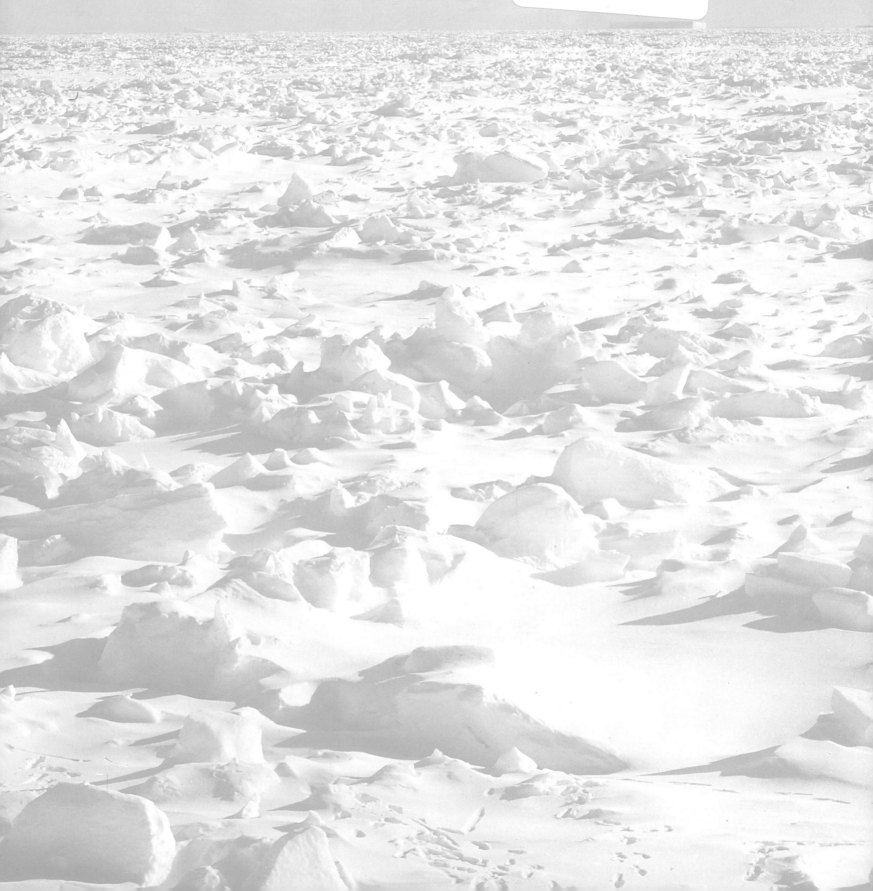

THE HEART *of the*
GREAT ALONE

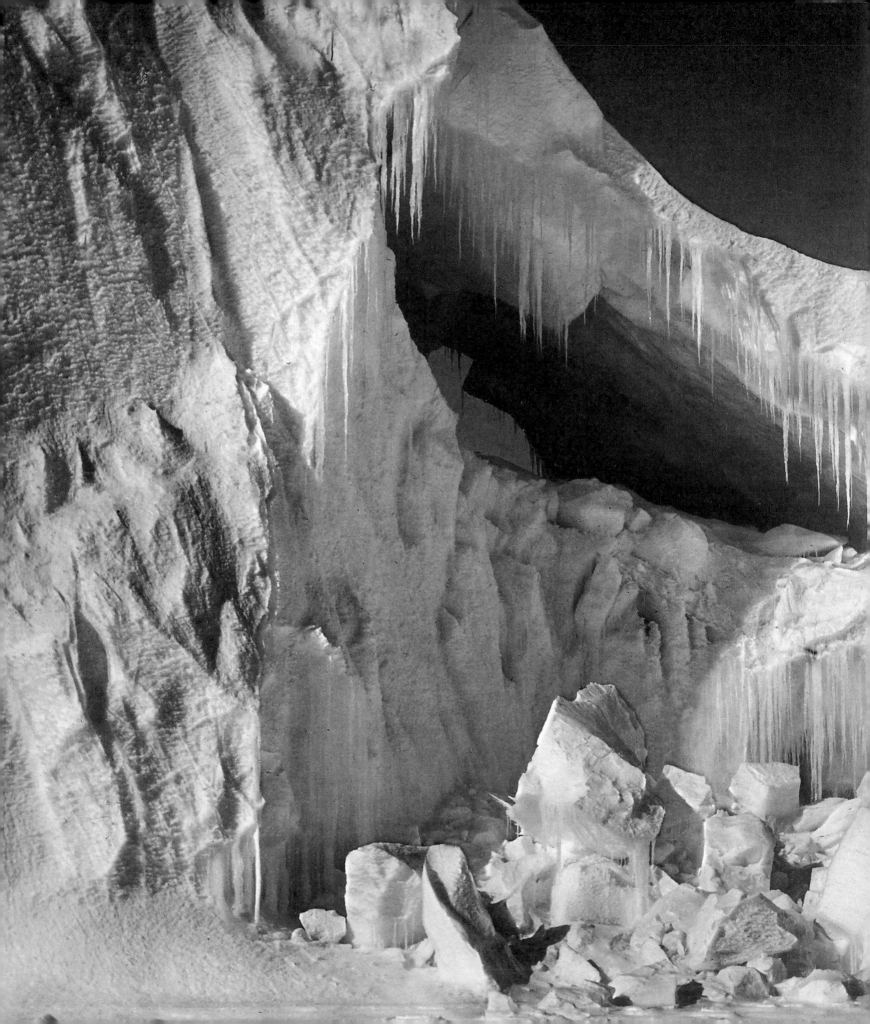

THE HEART *of the* GREAT ALONE

SCOTT, SHACKLETON, AND ANTARCTIC PHOTOGRAPHY

BLOOMSBURY

NEW YORK · BERLIN · LONDON

Published by Bloomsbury USA, New York

All papers used by Bloomsbury USA are natural, recyclable products made from wood grown in well-managed forests. The manufacturing processes conform to the environmental regulations of the country of origin.

Library of Congress Control Number: 2009929569

ISBN 978-1-60819-007-2

First published in the United Kingdom in 2009 by Royal Collection Enterprises Ltd
First U.S. edition 2009

10 9 8 7 6 5 4 3 2 1

Text by David Hempleman-Adams, Sophie Gordon, Emma Stuart and Alan Donnithorne © 2009 HM Queen Elizabeth II.
All works reproduced are Royal Collection © 2009 HM Queen Elizabeth II unless otherwise stated.
The Royal Collection photographs by Frank Hurley, Tryggve Gran, G. Hubert Wilkins and nos 92 and 97 are © reserved/Royal Collection.

Designed by Isobel Gillan
Editorial and project management by Alison Thomas
Production by Debbie Wayment
Printed in Italy by Studio Fasoli, Verona
Typeset in Granjon

The title of this book, *The Heart of the Great Alone*, is a quotation from Herbert Ponting's book, *The Great White South* (Ponting 1921, p. 189).

ILLUSTRATIONS

Pages 2–3: Herbert Ponting, **A weathered iceberg, 29 December 1911** (RCIN 2580032)
Pages 6–7: Frank Hurley, **Typical ice pack, Weddell Sea, December 1914** (RCIN 2580053)
Page 8: Herbert Ponting, **Evening in the ice pack, December 1912** (RCIN 2580004)

NOTE

Miles are quoted in nautical (geographical) miles, in keeping with the measurements that Scott used.
1 nautical mile = 1.15 statute miles (1.852 km)

ABBREVIATIONS

FAS	Fine Art Society, London
Journal	Queen Victoria's Journal, Royal Archives
RA	Royal Archives
RCIN	Royal Collection Inventory Number
SPRI	Scott Polar Research Institute

Printed on Symbol Tatami Ivory
Fedrigoni Cartiere SPA, Verona

Mixed Sources
Product group from well-managed forests and other controlled sources
www.fsc.org Cert no. SA-COC-002103
© 1996 Forest Stewardship Council
FSC

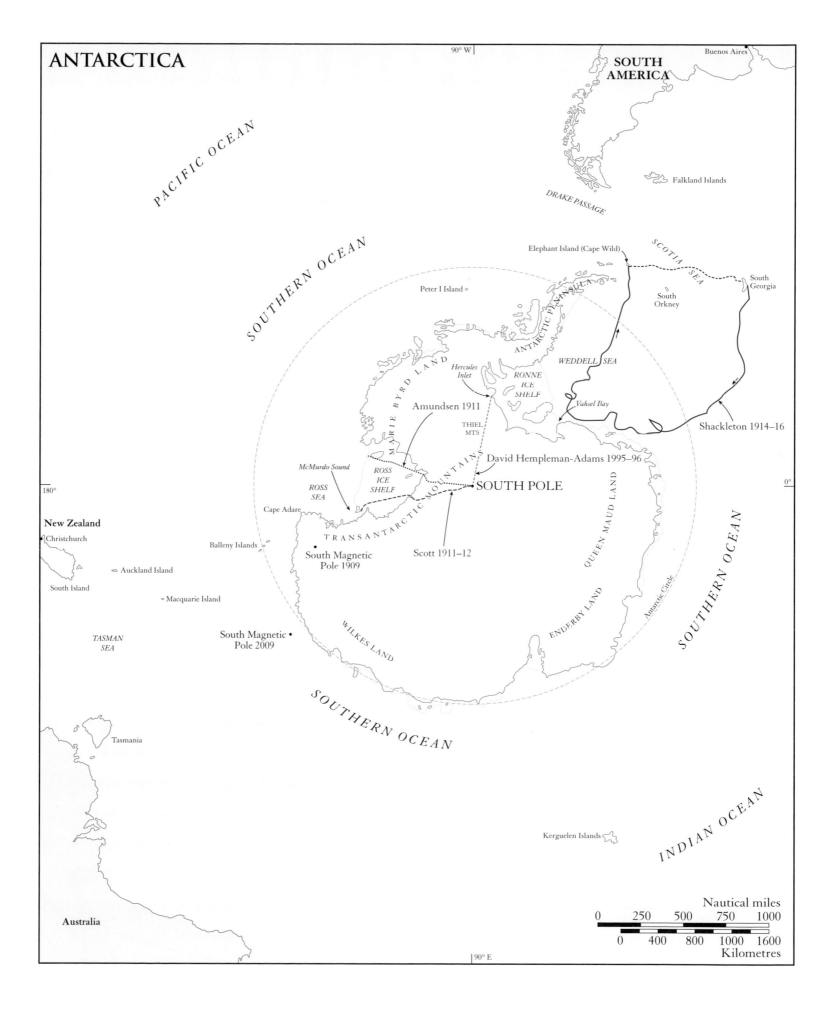

ANTARCTICA

PACIFIC OCEAN

SOUTH
AMERICA

Buenos Aires

Falkland Islands

DRAKE PASSAGE

SOUTHERN OCEAN

SCOTIA SEA

Elephant Island (Cape Wild)

South
Georgia

South
Orkney

Peter I Island

ANTARCTIC PENINSULA

WEDDELL SEA

Hercules
Inlet

RONNE
ICE
SHELF

MARIE BYRD LAND

Amundsen 1911

THIEL
MT S

Vahsel Bay

Shackleton 1914–16

David Hempleman-Adams 1995–96

McMurdo Sound

ROSS
ICE
SHELF

TRANSANTARCTIC MOUNTAINS

SOUTH POLE

QUEEN MAUD LAND

ROSS
SEA

0°

180°

Cape Adare

Scott 1911–12

New Zealand

Christchurch

Balleny Islands

South Magnetic
Pole 1909

TRANSANTARCTIC MOUNTAINS

Auckland Island

South Island

ENDERBY LAND

Antarctic Circle

SOUTHERN OCEAN

Macquarie Island

TASMAN
SEA

South Magnetic •
Pole 2009

WILKES LAND

SOUTHERN OCEAN

Tasmania

INDIAN OCEAN

Kerguelen Islands

Australia

Nautical miles

0 250 500 750 1000

0 400 800 1000 1600

Kilometres

90° W

90° E

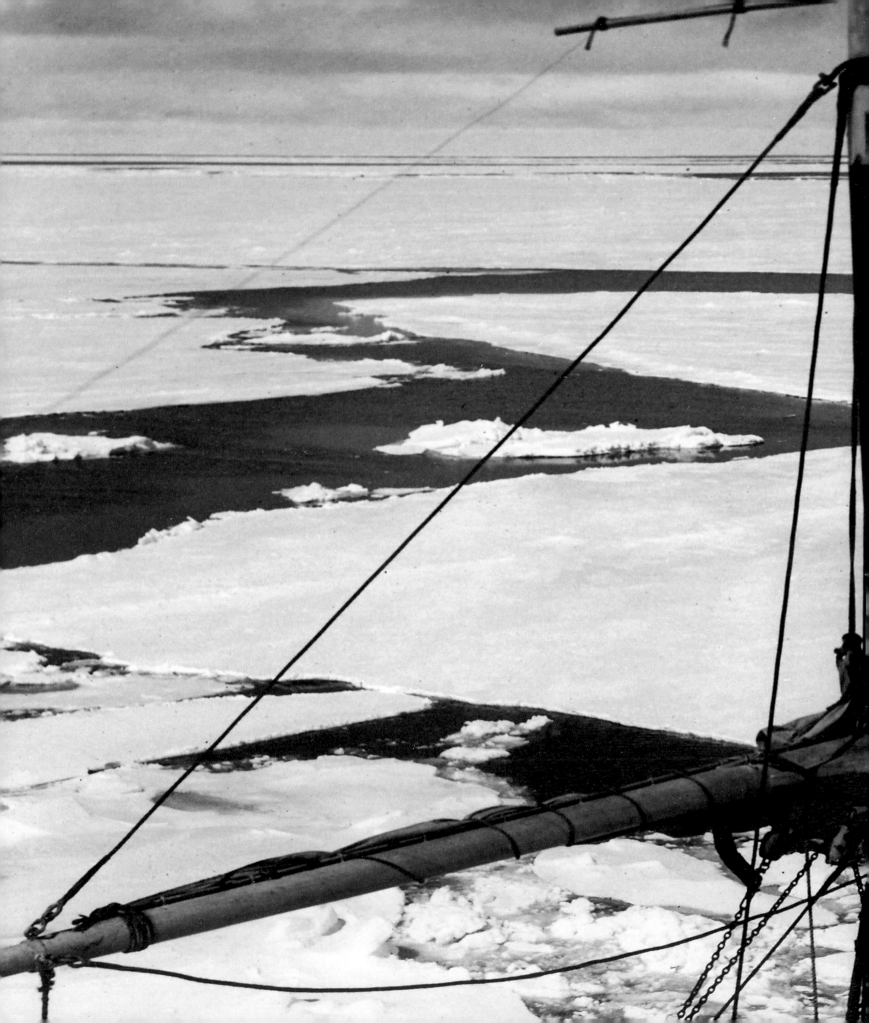

CONTENTS

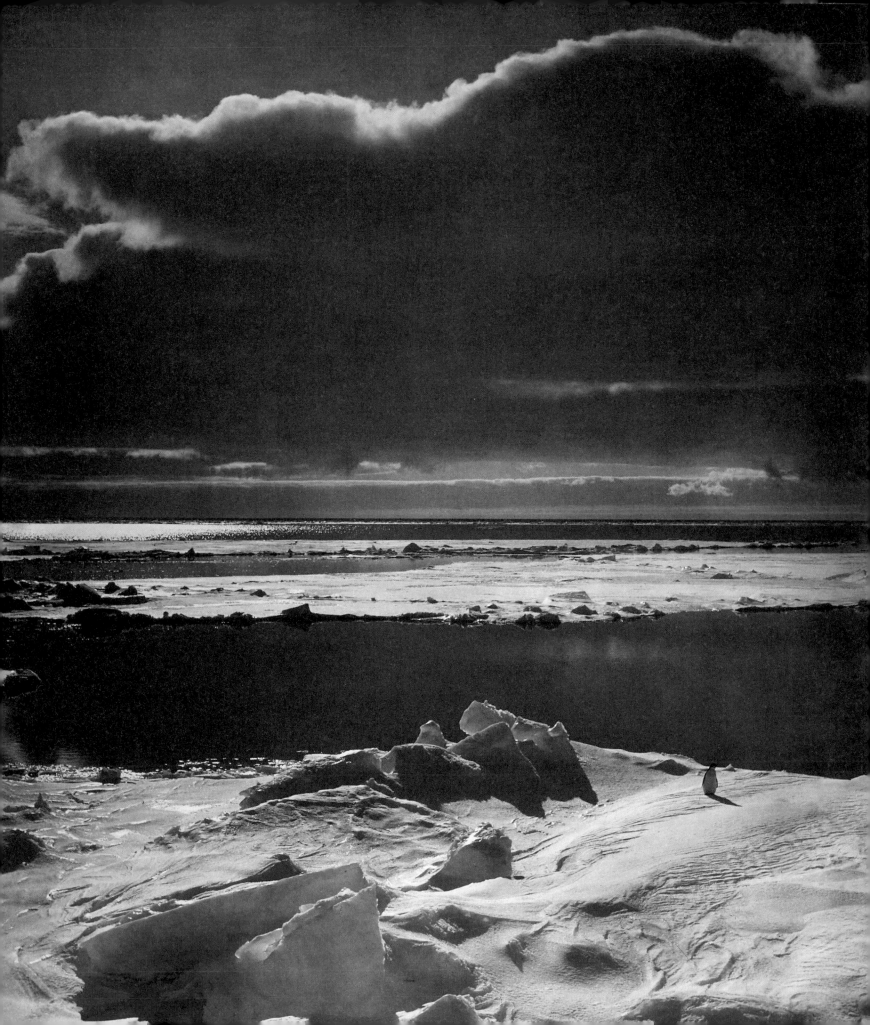

Years ago, I happened to be pottering about the Ballroom at Sandringham, when I came across a large Union flag tucked away in an alcove beside the fireplace. I noticed that there was a silver plate attached to the pole, so I pulled a chair to get high enough to read the inscription. It recorded that the flag had been given by Queen Alexandra to Ernest Shackleton to take with him on his 1914 Antarctic Expedition. As it had been given back, I realised that it must have accompanied the Expedition right through to Elephant Island before coming back to this country and back to the Queen.

Further investigation of the Ballroom revealed another Union flag in the opposite alcove, with a similar silver plate. This one recorded that it had been given to Captain Scott to take with him on his Antarctic Expedition in 1910. It had similarly been returned when the survivors got back to this country.

In 1956, I attended the Olympic Games in Melbourne, and returned in HMY *Britannia* via the South Pacific and the Grahamland Peninsula. I then transferred to the Falkland Islands Dependencies ship *John Biscoe*, to visit some of the FIDS Research Stations within the Antarctic Circle. As a consequence of that short cruise, I was invited to become an Honorary Member of the Antarctic Club. Then in 1958, I was invited to attend the Club's Annual Dinner, and it occurred to me that the members might like to see these two flags again. At the dinner, they were mounted behind the President's chair, so that they could be seen by all the members.

After dinner, an elderly man came up to me and said, 'The last time I saw that flag was on Elephant Island'! You can see both flags in this book.

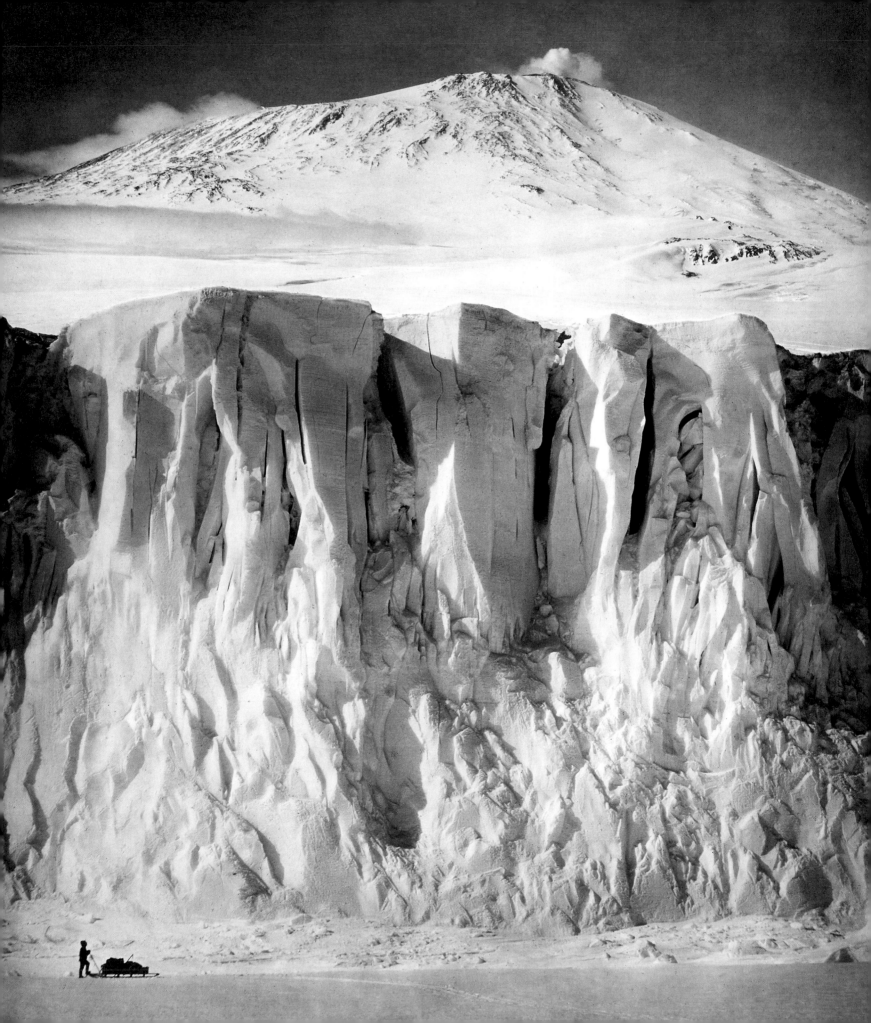

INTRODUCTION

David Hempleman-Adams

IN 1910 ROBERT FALCON SCOTT set off on his ill-fated Antarctic expedition aboard the *Terra Nova*. A few years later, in 1914, Ernest Shackleton embarked on his Transantarctic expedition in the *Endurance*. This publication celebrates their achievements through the official photographs taken by Herbert Ponting (with Scott) and Frank Hurley (with Shackleton). The book also includes some of Scott's and Shackleton's writings and archive material, which offer a unique insight into the minds of these extraordinary men.

The powerful images portray both the beauty and the utter desolation of Antarctica. They also convey the inner strength of the explorers as they struggled in extreme conditions to discover new land and reach their ultimate goal: the South Pole.

Today, adventurers endeavour to reach the South Pole more quickly and by a variety of means, but these exploits can never diminish the feats of Scott and Shackleton, who captured the public's imagination through their dynamic leadership and the dramatic stories of their expeditions. They did not have the advantages we enjoy today: satellite phones, GPS, planes and helicopters. They had no contact with the outside world or any hope of an imminent rescue. Modern day adventurers also have a psychological advantage: today we know it is possible to reach the South Pole.

Scott and Shackleton were pioneers at a new frontier and their achievements will always command respect and admiration. They also made significant scientific discoveries: they charted new territory and undertook important scientific research on wildlife and the environment. This historical data provides us with a context in which to study climate change – one of the most significant issues facing the world today. Polar scientists are able to build on research conducted by Scott and Shackleton more than a century ago.

I consider myself very privileged to follow in their footsteps and can only marvel at what both Scott and Shackleton achieved without the benefit of modern equipment and technology. Ultimately, this publication celebrates the spirit of these remarkable men and their teams.

(left) HERBERT PONTING (1870–1935) **The ramparts of Mount Erebus, 1911** (no. 18)

BRITISH HEROES

At a time of great international rivalry, Scott and Shackleton undertook on behalf of their country major expeditions that would part them from their families and loved ones for several years, with the knowledge that they might never return. Their reputations have fluctuated over the decades, but they were men of their time and circumstances. They certainly shared a passion for success. Both aimed to be the first to reach the South Pole, yet they approached their expeditions and dealt with their teams in very different ways.

At the end of the twentieth century Shackleton became a role model for modern leadership. His career in the Merchant Navy was not as hierarchical as Scott's had been in the Royal Navy. It may have been this experience that made Shackleton more approachable – what today we might call a team player. Men respected him for his generosity of spirit and his warm character. On expeditions he adopted a very hands-on role, undertaking menial jobs alongside his team.

In contrast, Scott was educated within the formal hierarchy of the Royal Navy and was used to commanding junior officers. He was confident and assured, although to some he appeared aloof and arrogant.

In January 1912 Scott pushed on to the South Pole, even though his supplies were low and his team was suffering in the freezing temperatures. At the end, the men would have experienced a slow, terrible death. When most people would have turned back, Scott persisted, utterly determined. I admire his bravery and like to believe that I would have done the same.

In 1909 Shackleton had the foresight to turn back when he realised he would run out of food and supplies for his team, thus avoiding almost certain disaster. Later, in 1915, when he lost the *Endurance*, he was accused of being naive for taking a ship so poorly suited to Antarctic conditions into the pack ice. Even in such circumstances, Shackleton continued to lead by example, sacrificing all of his prized possessions from the *Endurance* and proving that he was no different from the men in his team, fighting to survive.

This tale of survival, of reaching Elephant Island and bringing the entire team back to safety, is a magnificent one. Shackleton's journey from Elephant Island to South Georgia remains one of the most audacious sea voyages ever undertaken. That he then traversed South Georgia without a map or any climbing equipment makes it all the more remarkable. Today, even experienced mountaineers with the latest equipment find the climb extremely challenging.

One of my favourite paintings is the portrait of Ernest Shackleton by Reginald Eves *(left)*, painted in 1921 and on display in the National Portrait Gallery, London. He looks handsome and self-contained, and radiates an inner strength. I try to model myself on this free spirit, in terms of my leadership skills and concern for my fellow man, but I'm

REGINALD EVES
(1876–1941)
Ernest Shackleton, **1921**
Oil on canvas
610 × 508 mm
(24 × 20 in.)
National Portrait Gallery,
London

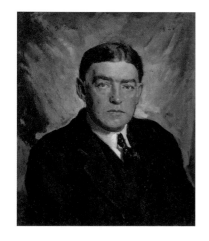

still learning. I also like to pay tribute to Scott when I'm in London, by visiting the bronze statue in Waterloo Place executed by his widow, Kathleen Scott. The statue *(right)*, which shows Scott in full polar gear, immediately transports me to Antarctica and my own experiences.

There will always be critics of Scott and Shackleton who will say, 'This is what they should have done ...' Hindsight is a wonderful thing. It is not until you have visited the Antarctic and sat in a tent feeling freezing cold, hungry and scared that you can even begin to understand what these men went through.

REACHING THE SOUTH POLE, 1996

As a young child growing up on a farm in the English countryside, I read about Scott and Shackleton and dreamt that one day I would explore the same distant lands. It was difficult to imagine a world so remote and unforgiving, but their heroic stories sparked my ambition.

At the age of 13 their writings became more real to me when I started on the Duke of Edinburgh's Award scheme; I began to undertake short expeditions and experience cold and hardship on a minor scale. When, as an adult, I embarked on polar expeditions, their achievements took on greater significance. I became obsessed with the Poles as a young man and was determined to set new records, as well as experiencing the beauty of the Arctic and Antarctic for myself. I was always driven by the desire to push myself to the limit, mentally and physically.

In 1995 I was ready for a fresh challenge and decided to attempt a solo South Pole trip, which had long been an ambition of mine. It was the first time I had been on a solo trip since reaching the North Magnetic Pole in 1984 and it was my first polar expedition since 1992. It was undeniably one of the toughest and most dangerous trips of my life. It took 60 days and I lost 42 lb (19 kg) during the 700-mile (1,130-km) trek from Hercules Inlet up to the South Pole.

I have always felt that it was important to keep a photographic record of my expeditions. I had only a small 35-mm camera in Antarctica and whenever I wanted to take a photograph I had to set it on a timer. My hands froze as I put the camera on the ice axe. At the end of the day I was very tired and all I really wanted to do was eat; taking photographs was not at the top of my agenda. I learnt how difficult it is to take photographs in sub-zero temperatures; for every successful photograph there were five failed attempts. However, when I return to England I'm always delighted that I persevered as the images remind me of the brutal beauty of the landscape.

The Thiel Mountains, about 45 miles (83 km) long, marked the halfway point of my expedition, so I always knew they would be a welcome sight. For 30 days, each step, each

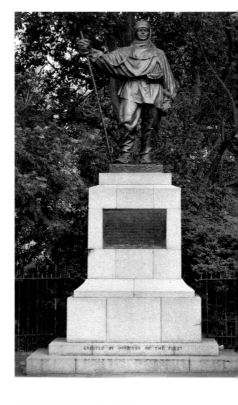

KATHLEEN SCOTT
(1878–1947)
Statue of Robert Falcon Scott, unveiled **1915**
Bronze on granite pedestal
Waterloo Place, London

(right) DAVID
HEMPLEMAN-ADAMS
(b.1956)
**David Hempleman-Adams
at the South Pole,
5 January 1996**

(above) DAVID
HEMPLEMAN-ADAMS
(b.1956)
**David Hempleman-Adams
en route to the South Pole,
2 December 1995**

hour was no different from the next. I negotiated crevasses and navigated by the sun. I ended up talking to the sledge and gave each ski its own name. It was only when I saw the Thiel Mountains and realised that I was halfway towards my goal that I knew I wasn't going crazy.

The photograph above was taken when I finally achieved my goal of becoming the first Briton to reach the South Pole solo and unsupported. When I was 13 miles (24 km) from the Pole I saw the first signs of the Amundsen-Scott South Pole Station: a black shadow emitting steam. I heard an aeroplane – the first sound I had detected in weeks. As I drew closer I kept standing on tiptoes, desperately trying to spot any buildings.

Scott and his team must have seen a little black spot on the horizon as they approached the South Pole, not knowing then that it was the remains of Amundsen's camp. Scott must have wondered if it was a rock or an animal, or maybe just the ice playing tricks. As I approached the South Pole, I thought about Scott and how he might have felt when he realised he had been beaten. His spirit must have been crushed as he advanced upon the abandoned camp, feeling that the arduous journey had been for nothing.

Every hour brought me slowly closer to my goal, and then, suddenly, the Pole Station was distinct. It was a wonderful feeling. Seeing it for the first time, in the distance, I just stood there and cried.

When I reached the South Pole I felt exhausted, but very proud to be British. I had fulfilled a lifelong ambition. I then had the luxury of being picked up by aeroplane.

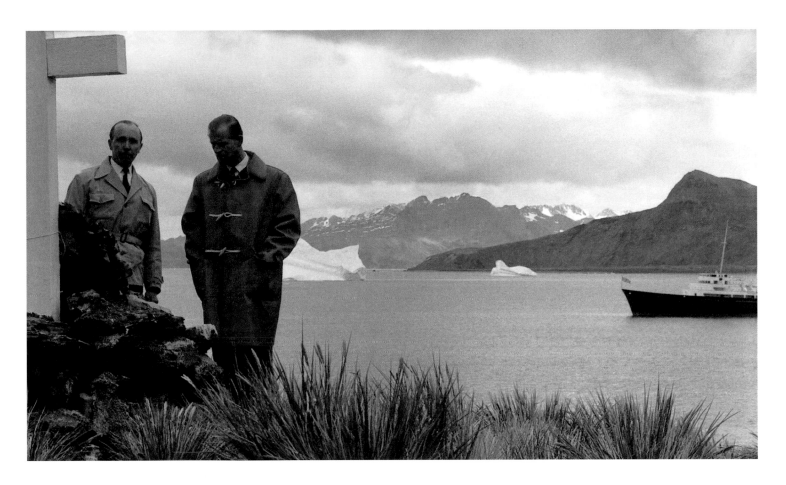

ROYAL PATRONAGE

During the 'heroic age' of Antarctic exploration, new discoveries were made in the name of the King, on behalf of the nation. The teams took flags presented by the King and Queen and planted them in the ice. The royal patron provided support and encouragement.

Continuing in this tradition, His Royal Highness The Duke of Edinburgh has been patron of many of my polar expeditions, from my first expedition to the North Pole in 1983. I meet The Duke before and after each trip. He always wants to know the objectives of the expedition and what makes each one different from those that have gone before. Following a successful trip, he is the first to write and extend his congratulations. When I reach the Pole I take out the Union Flag, and when I return I always feel immense pride in recounting my tales to The Duke of Edinburgh. With this support, I feel as if I am undertaking the expedition for my country and for Her Majesty The Queen.

The Duke of Edinburgh is one of the few members of the Royal Family to have crossed the Antarctic Circle. He has paid tribute to Shackleton at the memorial cross erected on South Georgia and has met some of the men who had first-hand memories of Scott and Shackleton.

The South Pole remains very special to me. It is a dangerous and beautiful wilderness. It can be incredibly lonely and brutal, but I yearn to go back. I hope to return one day with my three daughters, so that they can experience these remote parts of the Earth where brave men came and conquered.

MICHAEL PARKER
(1920–2001)
HRH The Duke of Edinburgh visiting Shackleton's memorial cross, with the Administrative Officer of South Georgia, January 1957
Collection of HRH The Duke of Edinburgh

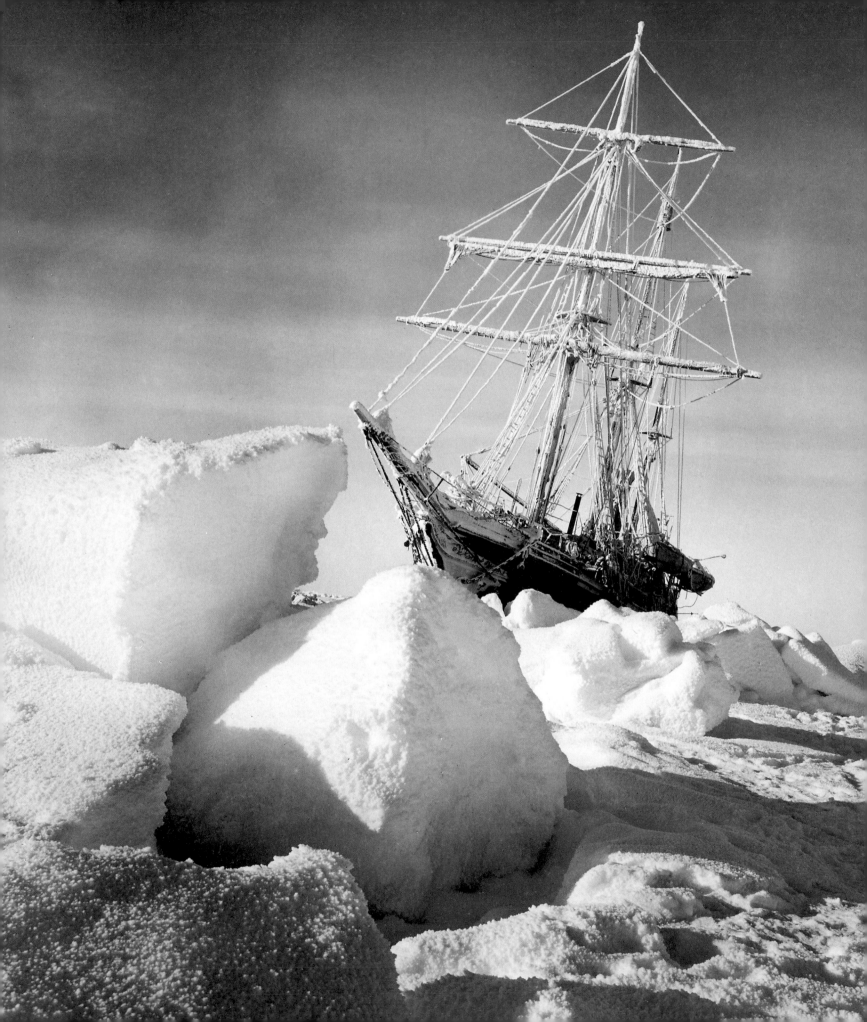

TO STRIVE, TO SEEK, TO FIND, AND NOT TO YIELD

Scott and Shackleton in the Antarctic

Emma Stuart

When King Alfred reigned in England the Vikings were navigating the ice-fields of the North; yet when Wellington fought the battle of Waterloo there was still an undiscovered continent in the South.[1]

ANTARCTICA IS A HIGH, cold, ice-covered desert; no man lives there easily. The summer season, when temperatures on the coast can hover around freezing point, lasts from about November to March. Winter's bite will bring average coastal temperatures of around –4 to –22 °F (–20 to –30 °C), and –40 to –94 °F (–40 to –70 °C) inland. At these temperatures sweat can freeze inside clothes and sleeping bags, breath can freeze on beards, and teeth can shatter. Unlike man, the indigenous life – including several species of penguin, whale and seal – is extremely well adapted to the cold. The first expeditions to sail to the Southern Continent did so in a narrow window of unfrozen seas, between December and February, generally departing from New Zealand or South America; and for those who overwintered on the continent, all contact with the outside world was lost until the ice permitted the return of their ship.

Early inland exploration concentrated principally on reaching the Poles (the geographical South Pole and the South Magnetic Pole). The geographical South Pole is generally defined as the southern point of the two points where the Earth's axis of rotation intersects its surface. Since the surface position of the South Pole sits on top of a moving ice sheet, at an altitude of about 9,300 feet (2,835m) above sea level, its marker shifts at a rate of about 33 feet (10m) every year. The South Magnetic Pole is a moving point on the Earth's surface where the geomagnetic field lines are directed vertically upwards. Its position is of great importance to navigation and shipping, and mapping its location was a useful hook on which to hang appeals for funding and other support.

(left) FRANK HURLEY (1885–1962) **The return of the sun after 92 days, 1915** (no. 56)

THE BRITISH NATIONAL ANTARCTIC EXPEDITION, *DISCOVERY*, 1901–1904

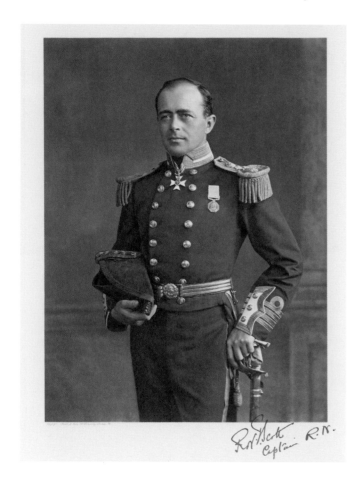

Robert Falcon Scott was born near Devonport, England, on 6 June 1868 and was destined for the Royal Navy, joining the training ship *Britannia* at the age of 13. He passed out in 1883 and served as a midshipman until 1887, when he passed his lieutenant's examination. Stationed that year in the West Indies, he caught the attention of Sir Clements Markham, Secretary and (from 1893) President of the Royal Geographical Society and *éminence grise* of South Polar exploration. Markham was adamant from his own past experience in the Arctic that only the vigour and clear-sightedness of youth from the Royal Navy would suffice in the south, and Midshipman Scott, winning a cutter race under Markham's approving eye, was a fine example.

From 1891 Scott undertook torpedo training aboard HMS *Vernon*, later qualifying as a torpedo lieutenant. Lacking both wealth and connections, Scott decided that his best route up the career ladder was to specialise in new naval technologies. This may also explain why, with 'no predilection for Polar exploration',[2] he applied in 1899 to command Markham's fledgling expedition.

In 1893 a landmark lecture by Sir John Murray to the Royal Geographical Society had called for the thorough and systematic exploration of the Southern Continent.[3] Extraordinarily little was known of the Antarctic: Captain Cook had first crossed the Antarctic Circle in the 1760s and 1770s, and had correctly postulated a large ice-covered continent; in 1841 Captain James Ross penetrated as far as what we now know as the Ross Sea; later sightings by whalers and explorers from other countries had sketched details of the shoreline, but much remained completely uncharted *(see map opposite)*. The contest between science and the naval ideal (supported by Markham) came to a head in 1899 over the appointment of a leader for the expedition. Scott, in London on leave, met Markham by chance, and learning of the proposed expedition, he applied to command it and was finally confirmed as leader in May 1900. With just over a year before his ship was to set sail, Scott managed to equip a full scientific exploratory expedition into unknown territory, assisted by the advice of Fridtjof Nansen, the famed Norwegian explorer.

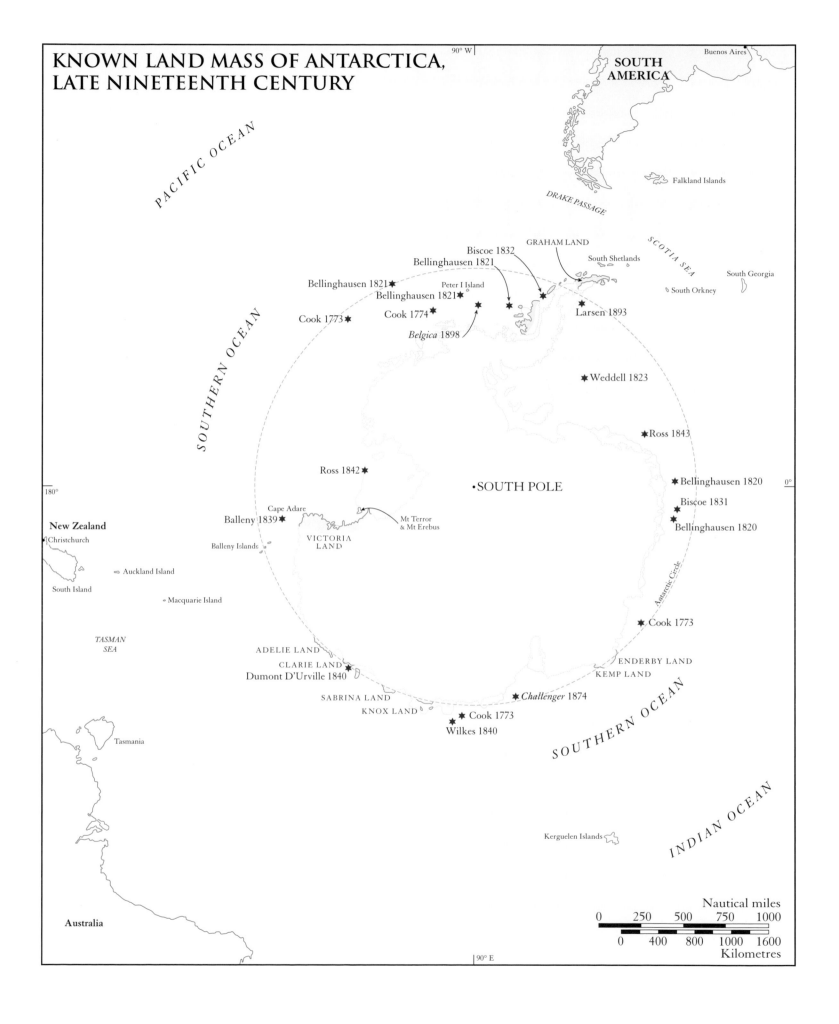

KNOWN LAND MASS OF ANTARCTICA, LATE NINETEENTH CENTURY

SOUTH AMERICA

Buenos Aires

PACIFIC OCEAN

Falkland Islands

DRAKE PASSAGE

SCOTIA SEA

South Georgia

SOUTHERN OCEAN

South Shetlands

GRAHAM LAND

Biscoe 1832

Bellinghausen 1821

Bellinghausen 1821

South Orkney

Peter I Island

Bellinghausen 1821

Cook 1774

Larsen 1893

Cook 1773

Belgica 1898

Weddell 1823

Ross 1843

Ross 1842

•SOUTH POLE

Bellinghausen 1820

180°

0°

Biscoe 1831

Cape Adare

Balleny 1839

Bellinghausen 1820

New Zealand

Mt Terror & Mt Erebus

Christchurch

VICTORIA LAND

Balleny Islands

Auckland Island

South Island

Antarctic Circle

Macquarie Island

Cook 1773

TASMAN SEA

ADELIE LAND

ENDERBY LAND

CLARIE LAND

KEMP LAND

Dumont D'Urville 1840

SABRINA LAND

Challenger 1874

KNOX LAND

Tasmania

Cook 1773

Wilkes 1840

SOUTHERN OCEAN

INDIAN OCEAN

Kerguelen Islands

Australia

Nautical miles				
0	250	500	750	1000

0	400	800	1000	1600

Kilometres

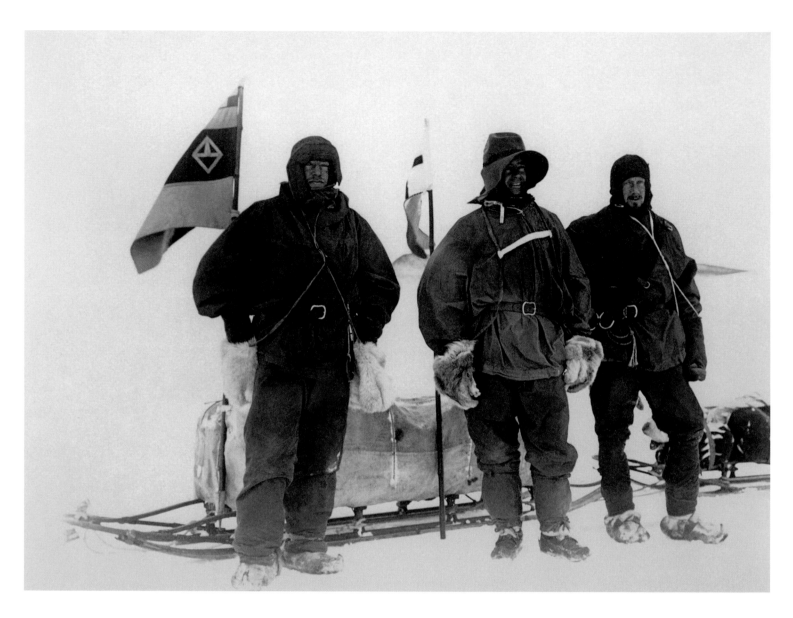

LOUIS BERNACCHI
(1876–1942)
**Shackleton, Scott and
Wilson ready for the
southern journey,
2 November 1902**
Scott Polar Research
Institute, Cambridge

Discovery set sail on 6 August 1901, after an inspection by King Edward VII and Queen Alexandra at Cowes and the award of the MVO (Member of the Royal Victorian Order) to Scott. Among the crew was Ernest Shackleton, then of the Merchant Navy, who signed on as junior officer, and the junior surgeon Edward Wilson, who would later go with Scott to the South Pole. *Discovery* docked at Winter Quarters in McMurdo Sound in February 1902 and was deliberately frozen in *(see map on p. 72)*. Early attempts at sledging were not entirely successful; Scott noted with dismay: 'The errors were patent; food, clothing, everything was wrong, the whole system was bad'.[4] Their inexperience at snow travel led to the death of Seaman Vince, who slipped off an ice cliff into the sea in a blizzard. Despite these early setbacks the ship's company settled into a comfortable winter routine, with regular concerts and lectures and a monthly newsletter, the *South Polar Times*; everyone had a specific job to do.

The 1902–3 sledging season saw Scott, Shackleton and Wilson set off south with five sledges and 19 dogs to explore the Great Ice Barrier, reaching their Furthest South at 82° 17' S.

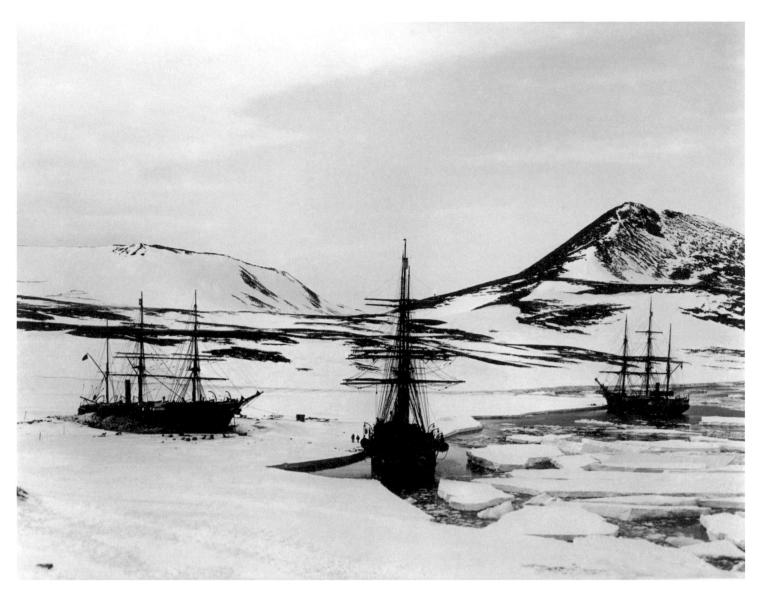

Travelling conditions were extremely difficult, and dogs and men began to starve on their wholly inadequate rations. With the demise of the dogs, scurvy (a degenerative disease caused by lack of vitamin C) struck the returning party, particularly Shackleton, who became so weak that he was unable to help pull the sledge and was eventually invalided home. But they had made the first extended journey in the interior of Antarctica and a survey of the mountains bordering the Barrier. *Discovery* was resupplied by the relief ship *Morning*, since she was still frozen in, and in a second season Scott and his men consolidated and improved on their earlier discoveries: Lieutenant Mulock surveyed and plotted the heights of some 200 peaks; the geologist Ferrar established the composition of the Royal Society Range; magnetic observations were carried out on the Barrier by the physicist Bernacchi; and Scott himself sledged up the Ferrar Glacier onto the Polar Plateau, with Seamen Evans and Lashly, and explored 200 miles (370 km) to the west. *Discovery* was eventually freed from the ice – with the help of the *Morning*, accompanied by *Terra Nova* – and left Antarctica in February 1904.

REGINALD SKELTON
(1872–1956)
Discovery, Morning and ***Terra Nova*** in winter quarters, January/ February 1904
Scott Polar Research Institute, Cambridge

THE BRITISH ANTARCTIC EXPEDITION, *NIMROD*, 1907–1909

Like Scott, Shackleton 'had no natural affinity for the polar regions',[5] but was ambitious and impatient to get on, partly for the sake of his fiancée, Emily Dorman. He was born in County Kildare, Ireland, and his early career was in the Merchant Navy. He was also a member of the Royal Geographical Society and a great lover of poetry. After a chance meeting with the son of Llewellyn Longstaff, the expedition's chief sponsor, he was appointed junior officer aboard *Discovery*. He had the knack of getting on with all hands, both officers and seamen, and made a particular friend of Wilson. This was probably what led Scott to take him on the southern journey when Wilson argued for a third man. The scurvy that invalided him home in 1903 caused him deep mortification, despite Scott's commendation that 'This gentleman has performed his work in a highly satisfactory manner but unfortunately his constitution has proved unequal to the rigours of a polar climate'.[6] Shackleton's future polar career was almost designed to prove to Scott, and himself, just how wrong that judgement had been.

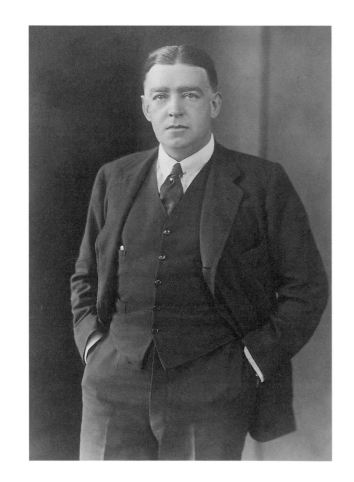

FRANK HURLEY
(1885–1962)
Ernest Shackleton, 1915
Silver bromide print
138 × 95 mm (5⅜ × 3¾ in.)
RCIN 2582406

On his return, Shackleton was pressed into service to help fit out *Terra Nova*, the government's relief ship, and he also made several public presentations on *Discovery*'s first season. He could not settle though: despite marriage, a stint as Secretary to the Royal Scottish Geographical Society, a spell in politics and some time in industry working for the Scots industrialist William Beardmore, he was formulating plans to return to the south, in the manifesto 'Plans for an Antarctic Expedition to proceed to the Ross Quadrant of the Antarctic with a view to reaching the Geographical South Pole and the South Magnetic Pole'.[7] Beardmore guaranteed a loan of £7,000 for him, and on 11 February 1907 Shackleton made his announcement at the Royal Geographical Society, unaware of undefined further plans by Scott. After a lengthy exchange of letters mediated by Wilson, Shackleton promised Scott, in writing, not to explore west of 170° W and to leave the Ross Sea area entirely alone, since Scott felt he had territorial priority – a position that would make it impossible for Shackleton to attain the South Magnetic Pole.

Shackleton consulted Nansen on equipment and transport – although he ignored Nansen's advice on dogs in favour of Manchurian ponies, which had proved a success in the Arctic – and purchased *Nimrod*, a small sealing ship. His crew was coming

together too, including old *Discovery* hands such as Frank Wild and Ernest Joyce, and others who would return to the Antarctic, including Alfred Cheetham, Raymond Priestley and George 'Putty' Marston, the expedition artist. Beardmore provided him with a car 'Designed to withstand extreme cold'[8] and a mechanic, Bernard Day, to go with it.

The expedition left England on 7 August 1907, after a visit to Cowes on 4 August to be inspected by the King and Queen.[9] On that occasion, King Edward VII gave Shackleton the MVO, and Queen Alexandra presented him with a Union Jack[10] to carry to the South Pole *(see p. 24)*.[11] In Australia Shackleton acquired not only the services of Professor T. Edgeworth David, world-renowned glaciologist and geologist, and of his student Douglas Mawson (who was to lead his own expedition in 1911), but also £5,000 from the Australian government (followed by £1,000 from New Zealand). Almost despite himself – for he had little personal interest in scientific results except insofar as they promoted the expedition – Shackleton had gathered about him some formidable scientific heavyweights.

Nimrod was towed to the Antarctic Circle to save fuel and reached the Barrier on 23 January 1908. Beset by icebergs and unable to find his intended landfall, Shackleton was forced to abandon his promise to Scott and made harbour in McMurdo Sound at Cape Royds, where the stores and ten ponies were landed and an expedition hut was built. Before winter set in, a team led by David made the first successful ascent of Mount Erebus, the active volcano behind the hut. The polar winter passed without trouble, the party generally in good spirits, despite their cramped quarters. Wild and Joyce produced the expedition newsletter, the *Aurora Australis*, the first book to be printed in Antarctica (no. 98); one of its chief features was a lengthy account of the ascent of Erebus.

Throughout August and September teams sledged provisions for a southern journey out to Hut Point. On 29 October 1908 the four-man Southern Party – Shackleton, Wild, Marshall and Adams – set out with the surviving four ponies, passing Scott's Furthest South in late November. On 3 December they discovered 'an open road to the south … a great glacier'[12] (later named the Beardmore after Shackleton's chief sponsor), their route through the Transantarctic Mountains. It took them over three weeks to ascend, losing their final pony Socks (and nearly Wild and his sledge) down a crevasse. By early January they were slowly freezing and starving to death, and on 9 January, at 88° 23' S, 97 miles (180 km) from the Pole, they planted Queen Alexandra's flag, photographed themselves at a new Furthest South record and turned back. It was one of the bravest decisions of Shackleton's career. 'If we'd gone on one more hour, we shouldn't have got back',[13] Adams admitted later. The journey home was a series of dashes to get to the next depot before their food or strength ran out, at one point sustained only by Marshall's Forced March tablets, a cocaine preparation. The cached pony meat they had so looked forward to gave them dysentery, yet they had to keep going. At last the four starving men stumbled into the Bluff Depot, left by Joyce, and were able to gorge themselves on eggs, cakes and

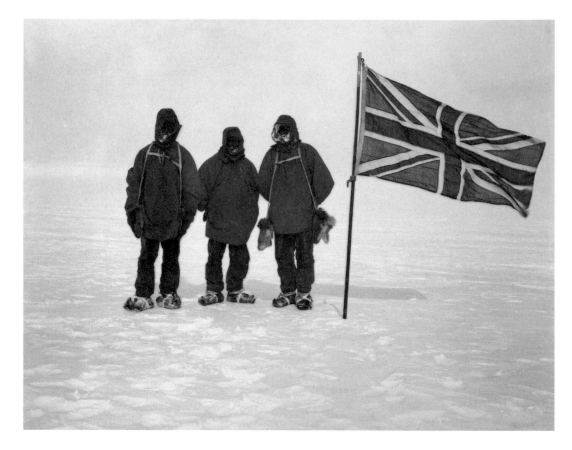

ERIC MARSHALL
(1879–1963)
Adams, Wild and Shackleton beside the Union Jack at Furthest South, 9 January 1909
Scott Polar Research Institute, Cambridge

The Union Jack of the British Antarctic Expedition 1907–9
845 × 1740 mm
(33¼ × 68½ in.)
RCIN 38033
This flag can be seen in the photograph on the right.

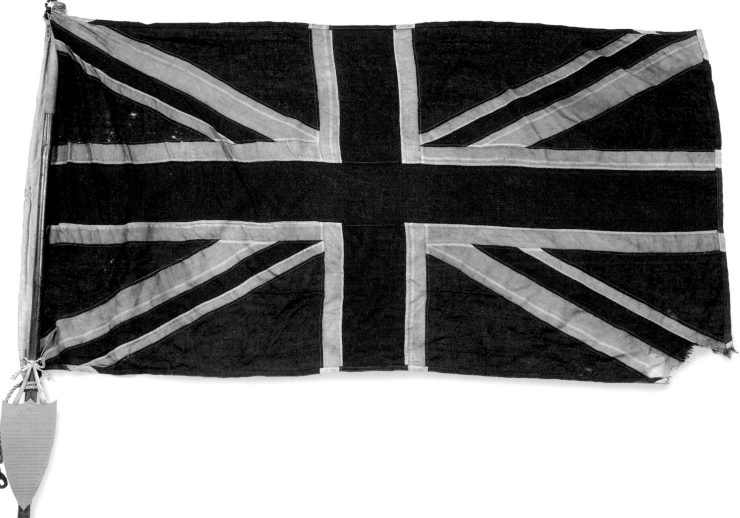

gingerbread, and were all back on the ship by 4 March. *Nimrod* finally left for New Zealand on 9 March.

The rest of the party had been far from idle. While Priestley, Brocklehurst and Armytage had explored the Ferrar Glacier to look for fossils, David, Mawson and Mackay set out in October to claim Victoria Land, first seen and named after Queen Victoria by Ross in January 1841, for the British Empire. They then continued towards the South Magnetic Pole, which they reached on 16 January 1909, despite reduced rations, difficult terrain and the effects of altitude. Their return journey was blighted by starvation, frostbite and exhaustion, and they nearly missed the ship, but were eventually picked up on 4 February.

Nimrod arrived in New Zealand to a tumultuous welcome. A telegram to the King (no. 100) announced the achievements of the expedition, and Shackleton delivered several public lectures, the proceeds of which he gave to local charities. The British nation was equally enthusiastic and Shackleton was showered with honours, including the Royal Geographical Society's gold medal, presented by the Prince of Wales.[14] On 10 July the King awarded Shackleton the CVO (Commander of the Royal Victorian Order) and he received a knighthood in the November Birthday Honours. In August the government voted him £20,000, which allowed him to settle many of the expedition's debts.

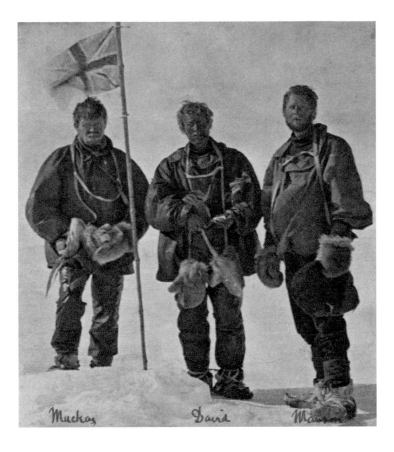

T. EDGEWORTH DAVID
(1858–1934)
Mackay, David and Mawson beside the Union Jack at the South Magnetic Pole, 16 January 1909
Scott Polar Research Institute, Cambridge

THE BRITISH ANTARCTIC EXPEDITION, *TERRA NOVA*, 1910–1913

Shackleton's near miss on the South Pole opened the way for Scott to make an appeal for funds for a further expedition in September 1909: 'The main object of this Expedition is to reach the South Pole, and to secure for The British Empire the honour of this achievement'.[15] Scott hoped for further major scientific work to be undertaken as well, and appointed as chief of the scientific staff his old friend Wilson, who wrote to his father: 'No one can say that it will only have been a Pole-hunt, though that is a *sine qua non*. We *must* get to the Pole; but we shall get more too … We want the Scientific work to make the bagging of the Pole merely an item in the results'.[16]

After the formal announcement of the project, Scott was involved in a whirlwind of preparation and fund-raising. He was fortunate to recruit the charismatic Lieutenant Edward Evans (1880–1957), former navigator on the relief ship *Morning*, who was willing to cede his own leadership ambitions in the south in exchange for the post of Scott's second in command, and who relished the challenge of fund-raising. There were several

significant private donations, including £500 from the Royal Geographical Society, school subscriptions for tents, ponies, sledges and dogs, and eventually, in early 1910, a government grant of £20,000. On 15 June the expedition set sail from Cardiff, having taken on a gift of coal. Scott remained behind to continue fund-raising, before joining the ship at Cape Town in August. Besides Wilson and Lieutenant Evans, Scott had secured other former colleagues, including Petty Officer Evans, Lashly and Crean. Wilson assembled a sizeable scientific staff, representing meteorology, geology, physics and zoology. The 'camera artist' Herbert Ponting was engaged (the first time an expedition had taken a professional photographer and film-maker) and there were four experts in Scott's chosen means of transport – skis, dogs, ponies and motor sledges. The Norwegian Tryggve Gran was a ski expert; the well-travelled and enigmatic Cecil Meares handled the dogs; Bernard Day was in charge of the motor sledges; and Captain Lawrence Oates ('Titus') was the laconic master of the ponies. He also contributed £1,000 to the expedition coffers. The other subscribing member of the expedition was Apsley Cherry-Garrard ('Cherry'), a friend of Wilson, who became his zoological assistant, despite his own short-sightedness. After the return of the expedition, Cherry wrote *The Worst Journey in the World* (1922). The final notable member of this motley band was Henry Bowers ('Birdie')

HERBERT PONTING
(1870–1935)
Lieutenant Evans and one of the sledging theodolites, October 1911
Scott Polar Research Institute, Cambridge

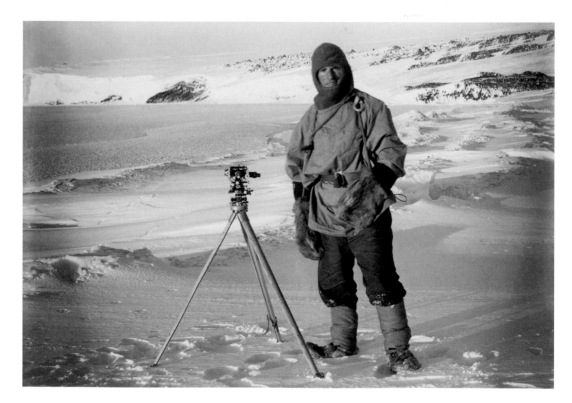

of the Royal Indian Marine Service and another of Markham's protégés, 'a fat little man with a perfectly immense nose and red bristly hair, unquenchable spirits and energy',[17] who became chief storekeeper. In all, the Shore Party numbered 33.

In mid-October 1910 *Terra Nova* reached Melbourne, where the crew found a telegram awaiting them: 'Beg leave to inform you Fram [Amundsen's ship] proceeding Antarctic. Amundsen'.[18] The Norwegian Roald Amundsen was a formidable opponent – a highly accomplished polar explorer, well acquainted with the techniques of the Inuit, the first man to sail the North-West Passage, a protégé of Nansen, and single-mindedly intent on the South Pole. He had originally intended to seek the North Pole, but turned his attention south after news of Frederick Cook's and Robert Peary's rival claims to the north in 1908–9. Crucially, he deliberately informed no one of his change of heart – certainly not his British rival. Scott, determined that this unwelcome news was not going to alter his plans, finally set out for Antarctica from New Zealand on 29 November 1910.

Despite atrocious weather, *Terra Nova* arrived at the Ross Sea on 31 December, and after attempting to set up their base at Cape Crozier, which would have given them direct access to the Barrier, the crew eventually made landfall at a point later named Cape Evans (after Scott's second in command) on 4 January 1911. Men and stores were landed and a palatial hut was built, measuring 50 × 25 feet (15 × 7.5m) and nearly 9 feet (2.7m) high. Meanwhile the ship dropped off a party (known as the Eastern Party) led by Victor Campbell on the Barrier, where they were to explore the coastline of King Edward VII Land (named by Scott in 1902) to the east of Cape Evans. On 25 January sledging parties left Cape Evans before the break-up of the sea ice, to lay supply depots at various points across the Barrier, up to 80° S at One Ton Depot. The weakness of the ponies led Scott to establish One Ton Depot at 79° 29' S, about 30 miles (55 km) short of its proposed site. Of the eight ponies taken on the depot journey, only two survived, four dying as their party crossed the broken sea ice (where they were beset by killer whales) and two others dying of exposure. A letter from Campbell also brought bad news – he had encountered Amundsen in the Bay of Whales with a huge party of dogs. Amundsen's camping position gave him direct access to the Barrier, he was nearly 60 miles (110 km) further south, and he would be able to start earlier in the season since dogs were better adapted to the cold than ponies. In what had already – and inevitably – become a race to the Pole, Scott was

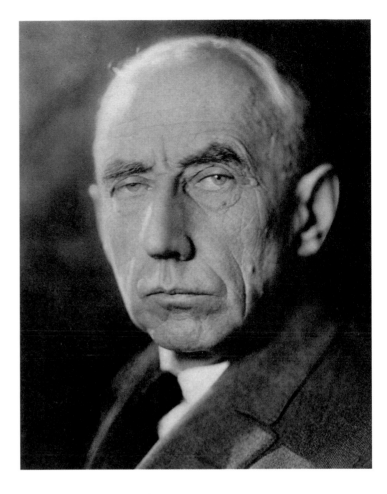

PHOTOGRAPHER UNKNOWN
Captain Roald Amundsen, c.1925
Scott Polar Research Institute, Cambridge

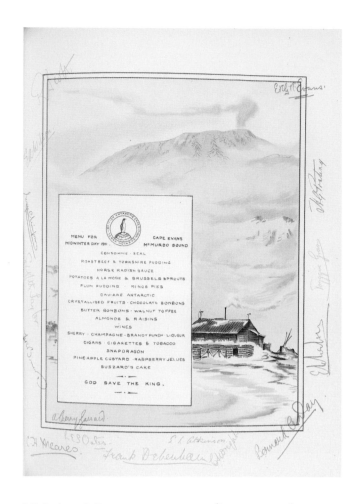

**Midwinter's Day menu,
22 June 1911, from
The South Polar Times,
Volume III**
RCIN 1102272 fol. 91

at a considerable disadvantage, although he did have the one clear advantage of a known route up to the Polar Plateau via the Beardmore Glacier. Amundsen would be crossing unknown ground.

As the winter darkness descended, the Shore Party settled into their routines of observations, experiments, exercise for man and beast, and preparation of kit for the next season's journey. Campbell and his party (now known as the Northern Party) had already been dropped off by *Terra Nova* to geologise at Cape Adare on the coast to the north-west of Cape Evans. There was the *South Polar Times* (edited by Cherry) to prepare, lectures and Ponting's ever-popular slide shows. Their diet contained plenty of fresh seal and penguin meat to ward off scurvy, with mutton from New Zealand on Sundays. In June there were two special occasions: Scott's birthday dinner on 6 June, when the hut was festooned with sledging flags (no. 33), and the traditional Antarctic 'Christmas' (Midwinter's Day on 22 June), celebrated with champagne, liqueurs, seal soup, roast beef and Yorkshire pudding, plum pudding and mince pies, and dainties such as chocolates, crystallised fruits and almonds *(see left)*. Scott made a speech and everyone received a present from a tree manufactured by Bowers.[19]

On 27 June 'the weirdest bird's-nesting expedition that has ever been'[20] set out (no. 29). Wilson, Cherry and Bowers manhauled to Cape Crozier in the dark and in temperatures down to –77.4 °F (–60.8 °C) to catch the Emperor penguins at a crucial stage in their egg-laying cycle. Wilson was convinced that the Emperor constituted a missing link between dinosaurs and birds, and wished to study their embryology. They were out for five weeks, frequently had to relay their loads, got so cold that their teeth shattered and their blisters froze, were buried in a snow drift, nearly lost their tent in a hurricane, and had to be cut out of their frozen garments when they returned to the hut. Ponting likened them to half-starved Russian prisoners of war, and 'Their looks haunted me for days'.[21] Fortunately they returned essentially undamaged, for, as Cherry knew, 'we were Southern Journey men'.[22] They had recovered three eggs and made useful experiments on proportions in the ratio of fats, proteins and carbohydrates.

Final preparations for the southern journey began after sun-return on 22 August 1911. Scott announced his plans – to deliver four men to the Pole, using motors, ponies and dogs – to general enthusiasm on 13 September. Lieutenant Evans led the motor party out on 24 October, but they lasted less than two weeks, forcing their drivers to start manhauling a mere 50 miles (92 km) from base. The Main Party set off on 1 November,

moving at a variety of paces. The dog teams, whose purpose was to drag supplies and support the other parties as far as One Ton Depot (though they were eventually taken as far as the Beardmore Glacier before turning for home), caught up with the pony parties on 7 November. Blizzards and soft-going hampered their progress, the ponies were shot one by one to feed the dog teams, and they first sighted the Transantarctic Mountains on 28 November. The heavy blizzards which confined them to their tents in early December were the final straw for the remaining exhausted ponies. They were shot at 'Shambles Camp' on 9 December, the meat was cached and the party began to manhaul. Scott noted gloomily that he was seven days behind Shackleton.

On 10 December they started climbing, and near the summit on 22 December the First Returning Party – Wright, Keohane, Cherry and Atkinson – turned back. Scott was gradually weeding out the weak points as he saw them, and on 3 January he dismissed the Last Returning Party – Lieutenant Evans, Lashly and Crean – but retained Bowers from Evans's team, an unexpected fifth man for the Pole. All travelling calculations, tent sizes, ration packs and so on had been based on a unit of four, not five. It would require additional care from Evans's party to take only three men's worth of rations and fuel from

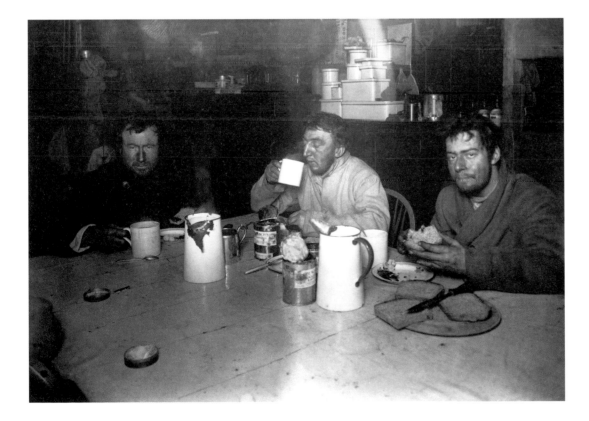

HERBERT PONTING
(1870–1935)
Wilson, Bowers and Cherry-Garrard on their return from the winter trip to Cape Crozier, August 1911
Scott Polar Research Institute, Cambridge

each depot; five men would be overcrowded in one tent; and (a fact Scott admitted that he had overlooked) cooking for five took longer than cooking for four. Still, a fifth man meant more muscle power; apart from himself and Wilson, Scott was taking Petty Officer Evans and Oates, among the tallest and most powerful men on the expedition, and Bowers was well known for his strength and all-round utility. Lieutenant Evans and his men turned back on 4 January 1912, hoping for a straightforward run. However, at the foot of the glacier Evans began to show the first signs of scurvy (he had been manhauling virtually the whole way) and by mid-February he had to be strapped to the sledge and dragged. Evans's total collapse on 18 February, 30 miles (55 km) from Hut Point, caused another rethink, and the two sailors, themselves exhausted and starving, decided that one of them must march for help. Crean accomplished the journey without shelter or much food, hours before a blizzard swept in that would have killed him, and brought Atkinson with the dog team back out to where Lashly was nursing Evans in the tent. The two seamen were later awarded the Albert Medal by King George V for their role in saving Evans's life.[23]

Meanwhile the Polar Party soldiered on, over an uneven and difficult surface, passing Shackleton's Furthest South on 9 January. On 16 January the worst happened – Bowers spotted a black flag fluttering in the distance (no. 95) and they found the remains of a camp and the paw prints of many dogs. Amundsen had forestalled them, reaching the Pole on 14 December 1911. Scott's team finally reached the Pole on 17 January and spent the following days verifying their position and taking measurements. They found 'Polheim' (the Norwegian tent and flag) and put up their Union Jack for the official photograph at their own computed Pole position (no. 36). There was not much time to waste – the season was drawing in and Scott's diary for 17 January read: 'there is that curious damp, cold feeling in the air which chills one to the bone … Great God! this is an awful place and terrible enough for us to have laboured to it without the reward of priority'.[24] Their return across the plateau was somewhat aided by a sail to catch the wind from the south, but they also had to contend with the worsening surfaces 'without a particle of slide or give'.[25] Petty Officer Evans's nose and fingers kept getting frostbitten, and Oates's feet, which he had recorded over a month ago as being cold, were on the verge of frostbite. There was also the insidious psychological effect of having been beaten to their goal. Their descent of the glacier took them into warmer weather and they discovered some highly significant fossils that indicated Antarctica's warmer past, but they were having difficulty finding their depots. By the time they reached the foot of the glacier, Evans was on the verge of breakdown and could no longer pull; on 17 February he collapsed completely and died several hours later, his death possibly caused by a brain haemorrhage after a fall into a crevasse, exacerbated by incipient scurvy or dehydration and the effects of altitude (no. 15). The persistent low temperatures made pulling difficult, and Oates's feet were continually being frostbitten. Evans's absence was 'a help to the commissariat',[26] but there was an alarming shortage of oil at the depots, probably

due to evaporation in the cold weather. By 10 March Scott considered that Oates had no chance of pulling through, given the state of his feet, and on 17 March Oates took his fate in his own hands and 'walked out', knowing that he was impeding his comrades' progress (no. 16). By then it was probably too late. Everyone was on the verge of serious frostbite, caused by what has since been shown to be a 'rogue' winter,[27] and on 18 March Scott's own right foot went. Their final march on 19 March got them to within 11 miles (20 km) of plentiful food and fuel at One Ton Depot (which they would have reached had it been positioned where it was originally intended), when they were forced to stop, pinned down by a blizzard. In his sleeping bag, Scott wrote: 'we are getting weaker, of course, and the end cannot be far. It seems a pity, but I do not think I can write more … For God's sake look after our people.'[28]

They were found, intact in their tent, eight months later.

The remaining members of the Shore Party spent a second winter at Cape Evans under Atkinson's command, knowing that their colleagues on the Barrier must be dead, and unsure of the fate of Campbell and his men, who had been geologising on the coast to the

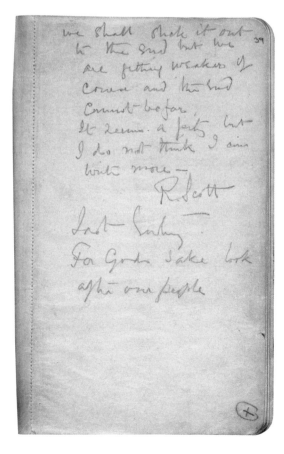

Captain Scott's diary, showing the final entry, 29 March 1912
The British Library, London

north of Cape Evans, and who were cut off from rescue by thick sea ice. As the sun returned the men debated whether to set off in search of those who might be alive, or those who must be dead. Virtually all were in favour of the latter, and on 29 October they set out to find Scott's remains. They spotted the roof of the tent just south of One Ton Depot on 12 November, and retrieved the men's diaries, letters and other personal items before collapsing the tent over them and building a cairn (no. 38). A more cheerful note was sounded as they returned to base – Campbell and his men had rescued themselves, and had returned safe and moderately well, despite having spent the winter in a snow cave in conditions of unimaginable squalor, subsisting on a diet of seal meat and determination.

Terra Nova returned quietly to New Zealand on 10 February 1913, and made its exclusive telegraph of the tragedy to Central News. Coming so soon after the release of Ponting's second film of the expedition, in which the Polar Party had appeared happy and unconcerned, the shock was all the greater. The news swept round the world, and official messages of sympathy were sent to King George V and to Parliament. Memorial services were held up and down the country, led by one at St Paul's attended by the King,[29] which expressed the profound sense of public mourning and national pride in the way in which Scott and his companions had met their deaths. A public appeal raised £75,000 (the equivalent of £4,500,000 today) to aid the bereaved and set up memorials, several based on the statue of Scott standing proud in his sledging gear, by his widow, Kathleen Scott. A bronze version of the statue stands in Waterloo Place, London *(see p. 13)*, and a white marble version in Christchurch, New Zealand. The remainder of the money went towards establishing the Scott Polar Research Institute at Cambridge. As the country descended into the First World War, Scott's example would be held up to the men in the trenches as an ideal of courage and good comradeship.

THE IMPERIAL TRANSANTARCTIC EXPEDITION, *ENDURANCE* AND *AURORA*, 1914–1917

The achievement of the Pole and Scott's death in 1912 galvanised Shackleton into half-formed plans for a crossing of Antarctica, and in the autumn of 1913 he issued a prospectus appealing to public sentiment: 'it is the last great Polar journey that can be made ... I feel it is up to the British nation to accomplish this, for we have been beaten at the conquest of the North Pole and beaten at the conquest of the South Pole.'[30] By 29 December he had the promise of £10,000 from the government and wrote to *The Times* that 'I can announce that an expedition will start next year with the object of crossing the South Polar continent from sea to sea'.[31] He planned to land at Vahsel Bay in the Weddell Sea and to cross via the Pole and down the Beardmore Glacier, picking up depots laid by another party starting from the Ross Sea. The Royal Geographical Society, despite severe misgivings, voted him £1,000;

public schools paid for the dog teams; and the lion's share of the costs was provided by three wealthy sponsors: Janet Stancomb-Wills, Dudley Docker and Sir James Caird. Shackleton also planned an extensive scientific programme, not only on the traverse itself, where he proposed constant meteorological, magnetic, geographical and geological observations, but also at base camp in the Weddell Sea, where a team of scientists would be left to explore the little-known surrounding area; meanwhile the Ross Sea Party would carry out further observations on the Beardmore Glacier. Five thousand applications flooded in. Frank Wild was to be second in command, Frank Worsley of the Royal Naval Reserve was given command of Shackleton's ship, *Endurance*, and Tom Crean and Alf Cheetham were made second and third officers respectively. In a series of idiosyncratic interviews, where men were asked if they could sing and were appointed because they looked funny or could make a suitable quip about wearing spectacles or losing a finger, Shackleton selected his scientific and medical staff. Their professional abilities he accepted from references; it was their cheerfulness and optimism that he sought to gauge in his interviews, and his gut feeling was seldom wrong. George Marston came as expedition artist and the Australian photographer Frank Hurley, who had been with Douglas Mawson's Australasian Antarctic Expedition in 1911, was engaged to take full charge of the expedition photography and film. The Ross Sea Party, in Mawson's old ship *Aurora*, included Aeneas Mackintosh, Frank Wild's brother Ernest, and Ernest Joyce. After Amundsen's undoubted success with dogs, Shackleton finally shed his prejudices and planned on taking '100 dogs with sledges, and two motor-sledges with aerial propellers',[32] which had been tested positively in Norway. On 16 July 1914 Queen Alexandra and her sister, the Dowager Empress of Russia, visited *Endurance* at Cowes,[33] and the Queen presented Shackleton with a Union Jack *(right)*, a replica of her own standard and two inscribed copies of the Bible. War was brewing and on 4 August Shackleton offered his ship and crew to the Admiralty, only to receive a terse telegram from Churchill, then First Lord, saying simply 'Proceed.'[34] On 5 August Shackleton was received by King George V[35] and given a second Union Jack to carry across the continent (no. 101). *Endurance* finally departed on 8 August for Buenos Aires, leaving Shackleton worrying about where his patriotic duty lay, but he finally followed on 27 September.

After acquiring more crew at Buenos Aires, including a new cook and a stowaway, Perce Blackborrow, on 26 October *Endurance* left for the whaling station at Grytviken, South Georgia, their last harbour before the ice. The ice report from the whaling stations was bad and the ship met ice less than three days out of South Georgia, on 5 December 1914, much sooner than they had expected. Thus began their battle with the pack, as they gradually worked their way south. Christmas was celebrated with a sumptuous feast of jugged hare, Christmas pudding, mince pies and other delicacies; and on 30 December they crossed the Antarctic Circle. A pause by a sizeable floe allowed them to water the

Union Jack presented to Shackleton by Queen Alexandra on 16 July 1914
Silk, with silver plaque
Furled 2472 × 146 mm
(97³⁄₈ × 5³⁄₄ in.)
RCIN 38034

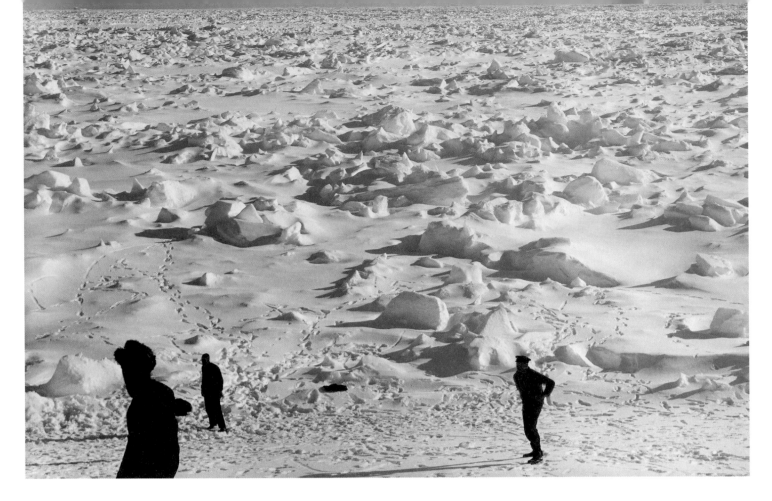

FRANK HURLEY
(1885–1962)
Looking south over the
frozen sea, lat. 74° 10' S,
long. 27° 10' W,
14 January, 1915 (detail)
Silver bromide print
153 × 205 mm (6 × 8¹/₈ in.)
RCIN 2580056

ship, exercise the dogs and have a game of football; and on 10 January 1915 they first sighted land. Shackleton decided to sail past Glacier Bay, a good landing spot but 100 miles (185 km) further north than his intended landfall. It would prove his only opportunity to land; the ship became trapped in the ice on 18 January, and by 27 January was stuck fast, at the mercy of the ice and current. Initially the ice carried them nearer their harbour and they reached their Furthest South on 22 February, a mere 25 miles (46 km) from their goal: 'It was more than tantalizing, it was maddening',[36] wrote Dr Macklin. Shackleton decided to let the ship become a winter station and everyone hunkered down to wait out the winter.

The team destined for the crossing – Shackleton, Wild, Crean, Hurley, Marston and Macklin – began training their dog teams (no. 66) and all were involved in preparing equipment, discussing plans and participating in the expedition. 'Dogloos' (instead of igloos) were built on the ice (no. 54), electric light was set up by Hurley and a line strung round the ship to guide the men home in the dark. On 15 June they held a dog derby and the traditional Midwinter's Day feast was on 22 June, followed by rowdy cross-dressing entertainment. July saw a turn for the worse as the pack ice became increasingly disturbed; this continued until 18 October, when pressure forced the ship over at an angle, and on 24 October she began to leak. The men prepared to abandon and on 27 October the pressure finally staved in the sides: 'the ice mill is in motion again … Immense slabs are rafted, balance a moment, then topple down and are over-ridden by a chaos of crunched fragments … The line of pressure now assaults the ship and she is heaved to the crest of the ridge like a toy';[37] she finally sank on 21 November.

In the second half of October Dump Camp had been established on the ice near the ship, and new Burberry suits and underclothes were issued. As much as possible was retrieved from the ship and preparations were made for a trek across the ice to Paulet Island, where they would find shelter and stores. Personal gear was limited to 2 lb (less than 1 kg) per man, and Shackleton threw away the remaining Bible given to him by the Queen, removing merely the inscribed page and some verses from the book of Job. They set off on 30 October and by 1 November, having discovered that travelling was too strenuous for dogs and men, they set up Ocean Camp on a large solid bit of floe and settled down to wait. More provisions were recovered from the ship and Dump Camp; there was a daily seal and penguin hunt; a stove and galley were built for the cook (since food played a vital role in keeping up morale); and a lookout post with a mast was established, from which they flew the King's flag (no. 78). McNish the carpenter strengthened their three small boats and they were named after the three principal benefactors of the expedition. On 23 December they recommenced their march to Paulet Island, but their progress was slow and frustrating and led to the one major crisis of discipline, when McNish refused an order from Worsley. Shackleton defused the crisis before it spread, but never forgave McNish for his attack on the good spirit of the party, and despite McNish's later outstanding work reinforcing the *James Caird* for the voyage to South Georgia, and his good conduct on the boat journeys, he was one of the few sailors whom Shackleton did not recommend for a Polar Medal.

They eventually camped on about 29 or 30 December on another old solid floe, which they named Patience Camp, and all settled down for another long spell of waiting and drifting. Most of the dog teams were shot in mid-January, since food supplies were running low and Shackleton was now putting his faith in boats, not sledges, to rescue them. They drifted on Patience Camp for another three and a half months, beset by mild weather, strong winds and blizzards, which melted the ice surface and soaked all their belongings. Food supplies were also dwindling and it must have been with profound relief that Shackleton finally ordered them to take to the boats on 9 April. Their drift had carried them past Paulet Island and they were now heading towards Clarence, Elephant and Deception Islands. Beyond them lay the South Atlantic. The current carried them southeast, away from their goal, and the men were visibly flagging in the cold, soaking conditions. Shackleton therefore decided to head direct for Elephant Island, their nearest refuge, and they finally made landfall on 15 April, soaked, frozen, demented and racked with thirst (no. 79). On 17 April they moved again, to a beach where they would be safe from stormy high water and where they could camp. Shackleton was already contemplating his next move – a desperate voyage in an open boat to South Georgia, to get help.

On 24 April he set off in a reinforced and covered-over *James Caird*, with Worsley, Crean, McCarthy, Vincent and McNish, to make the 800-mile (1,480-km) journey. The

FRANK HURLEY
(1885–1962)
**Inaccessible mountain,
Cape Wild, which blocked
communications from the
spit to the mainland of the
island, 1916**
Silver bromide print
203 × 124 mm (8 × 4⁷/₈ in.)
RCIN 2580114

men left behind were under the command of Wild, who had orders to try for Deception Island in the spring if no relief came, where there would be stores, shelter and possibly whalers. The men made themselves shelter to survive the wait, first digging snow holes, and when these melted, upending the two remaining boats on top of rock walls and covering them with tent material (nos 82, 83). The chinks in the walls were stuffed with snow, pebbles lined the floor and two minute windows provided light. The whole measured 10 × 18 feet (3 × 5.4m), and was barely 5 feet (1.5m) high; 22 men survived here for four months. Wild doled out luxuries at suitable intervals, the doctors performed amputations, and the favourite topic of conversation was derived from Marston's penny cookbook: 'From this he would read out one recipe each night … This would be discussed very seriously, and alterations and improvements suggested'.[38] And thus they waited …

Shackleton's party took 17 days to reach South Georgia, an incredible feat of navigation by Worsley, and of endurance by six men already at their limits. Ice began to settle on the boat and threatened to sink them; they were continually lashed by huge waves and were nearly undone by a monster wave that Shackleton originally mistook for a clearing of the sky: 'I realized that what I had seen was not a rift in the clouds but the white crest of an enormous wave … It was a mighty upheaval of the ocean, a thing quite apart from the big white-capped seas that had been our tireless enemies for many days.'[39] They survived by good fortune and frantic bailing, but everything was now soaked and their drinking water contaminated with salt. At last, on 10 May, they landed. After four days' recuperation in a cave, served by a small stream and fed by baby albatrosses, they moved camp further up the bay where there was more shelter and food for those who would remain, while Shackleton attempted to cross South Georgia to the whaling stations and rescue. This was uncharted territory, dominated by forbidding mountains and riven with glaciers, and they had no mountaineering equipment beyond nails in the soles of their boots, the carpenter's adze and a 50-foot (15m) coil of rope. Shackleton, Worsley and Crean set off on 19 May, climbed 3,000 feet (900m) to the top of uninhabited Possession Bay, and made their way along a glacier to a ridge that barred their way. After two failed attempts to find a way over and down, they succumbed to desperate measures and tobogganed down a slope on their coil of rope. The gamble paid off and, after many more hours of trudging and false turns, on the morning of 20 May they got within sight of Husvik Harbour, adjacent to Stromness Bay, which they had last seen 18 months earlier. 'In memories we were rich. We had "suffered, starved, and triumphed, grovelled down yet grasped at glory, grown bigger in the bigness of the whole." We had seen God in his splendours, heard the text that Nature renders. We had reached the naked soul of man.'[40] At 7am they heard the sound of the whaling station's whistle. There were more obstacles ahead, but at 1.30pm they watched ships entering Stromness Bay and saw men moving around the whaling sheds. Their arrival at Stromness has been much described – three filthy scarecrows in tattered

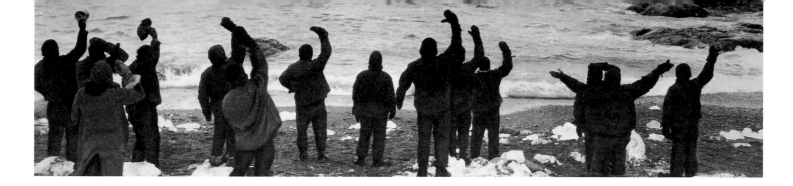

Burberrys; it is hardly surprising that small boys ran from them. The sight of the three men reputedly made the hard-bitten station manager weep, but he rapidly produced food, shelter, baths and clean clothes. The following day Worsley set off to pick up the three seamen on the other side of the island, while Shackleton began to ponder how to rescue his men on Elephant Island and to make contact again with the outside world. Several attempts to reach them, first in a whaler wintering in Husvik, then in ships lent by the Uruguayan and Chilean governments, failed because of the ice conditions. Shackleton also appealed to the Admiralty, but became impatient as they dragged their feet. He made one more attempt at the end of August in the steamer *Yelcho* and finally reached Elephant Island on 30 August (nos 86, 87). All hands were rescued, not a life lost and Shackleton wrote to his wife in typically robust language: 'I have done it. damn [*sic*] the Admiralty'.[41]

The rescue mission, however, was not quite over: Shackleton had the Ross Sea Party to consider. Under Aeneas Mackintosh, the party had reached McMurdo Sound in *Aurora* on 16 January 1915 and began laying depots, but they were stranded without their supplies when the ship was blown out to sea in a gale. Despite scavenged stores and improvised equipment, six men somehow managed to establish Shackleton's depots all the way to the foot of the Beardmore Glacier. Three men, including Mackintosh, went down with scurvy, one eventually dying; the other two were nursed back to health, only to drown crossing unstable sea ice in an impatient bid to reach Cape Evans. The remainder of the shore party was eventually rescued by *Aurora*, with Shackleton on board, in January 1917.

FRANK HURLEY
(1885–1962)
Sir Ernest Shackleton arriving at Elephant Island to take off the marooned men, 30 August 1916 (*detail*)
(Original nitrate film shows the departure of the *James Caird*, 24 April 1916)
Silver bromide print
147 × 205 mm
(5³/₄ × 8¹/₈ in.)
RCIN 2580123 (no. 87)

NOTES

The title for this section is taken from Scott's memorial cross in the Antarctic (Scott 1913, vol. II, p. 398).

1 Cherry-Garrard 1922, p. xvii.
2 Scott 1905, vol. I, p. 32.
3 Crane 2005, p. 75; Savours 1992, pp. 3–4.
4 Scott 1905, vol. I, p. 273.
5 Mill 1923, p. 57.
6 Scott, quoted in Crane 2005, pp. 241–2.
7 Fisher and Fisher 1957, p. 101.
8 Riffenburgh 2004, p. 122.
9 RA GV/PRIV/GVD/1907: 4 August.
10 The common name for the Union Flag.
11 Shackleton 1909, vol. I, p. 35.
12 Ibid., p. 308.
13 Riffenburgh 2004, p. 231; Fisher and Fisher 1957, p. 218.
14 RA GV/PRIV/GVD/1909: 28 June.
15 Scott, quoted in Crane 2005, p. 397.
16 Wilson, quoted in Seaver 1933, p. 182.
17 Debenham Back 1992, p. 125.
18 Van der Merwe *et al*. 2000, p. 60.
19 Scott 1913, vol. I, pp. 324–9.
20 Cherry-Garrard 1922, p. 234.
21 Ponting 1921, p. 154.
22 Cherry-Garrard 1922, p. 250.
23 RA GV/PRIV/GVD/1913: 26 July.
24 Scott 1913, vol. I, p. 544.
25 Bowers, quoted in Solomon 2001, p. 223.
26 Scott 1913, vol. I, p. 575.
27 Solomon 2001, pp. 287–306, especially pp. 293–4.
28 Scott 1913, vol. I, p. 595.
29 RA GV/PRIV/GVD/1913: 14 February.
30 Alexander 1998, p. 9.
31 Shackleton, quoted in Fisher and Fisher 1957, p. 298.
32 Shackleton 1919, p. x.
33 RA VIC/MAIN/QAD/1914: 16 July.
34 Shackleton 1919, p. xiv.
35 RA GV/PRIV/GVD/1914: 5 August.
36 Macklin, quoted in Fisher and Fisher 1957, p. 340.
37 Hurley 1925, pp. 186–7.
38 Shackleton 1919, p. 236.
39 Ibid., p. 174.
40 Ibid., p. 205.
41 Fisher and Fisher 1957, p. 395.

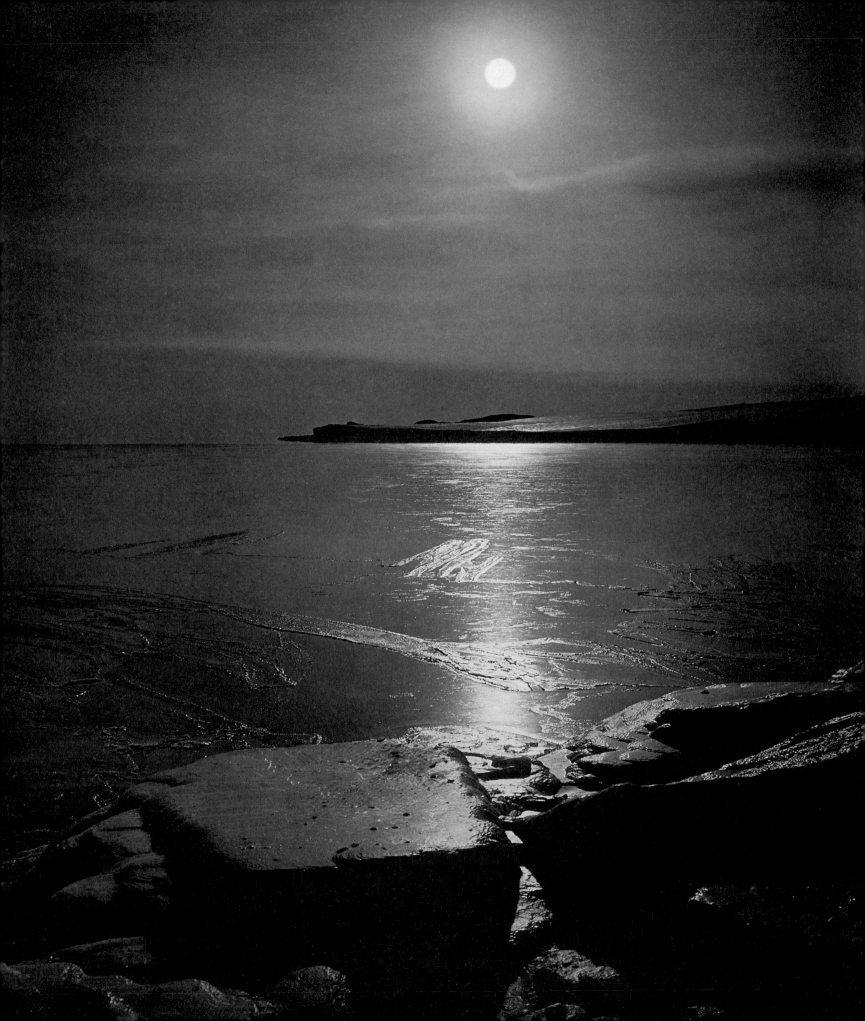

AT THE ENDS OF THE EARTH
Polar images and royal collecting
Sophie Gordon

Here in these pictures is beauty linked to tragedy –
one of the great tragedies – and the beauty is inconceivable for
it is endless and runs to eternity.[1]

EARLY IN THE REIGN of Queen Victoria, Sir John Franklin, an experienced Arctic explorer, set out in command of an expedition to navigate a North-West Passage, a route that was intended to facilitate trade between Europe and Asia, via Canada. Franklin's expedition headed out on 19 May 1845 towards the Canadian Arctic, with expectations of successfully navigating the final stretches of the North-West Passage. The two ships and their crews, totalling 129 men, did not return. In 1848, prompted by Franklin's widow, the Admiralty sent out the first of many expeditions to uncover the fate of the lost crew. Between 1848 and 1859 as many as 20 search expeditions were dispatched, with a further 16 expeditions arriving to give support and supplies to the search ships.[2] Although by 1854 it had been accepted that Franklin and his men had perished, it was not until Francis McClintock's search expedition in HMS *Fox* (1857–9) that it was confirmed that most, if not all, of the ship's company had died.

Franklin became a public hero, with the newspapers and other publications describing his death as a brave sacrifice and an example to all Englishmen, foreshadowing the fate of Scott in 1912. Many of the search expeditions that followed Franklin's route had artists or photographers on board, which led to the publication of illustrated accounts of their journeys. The images brought the tales to life and led to the commanders of the search expeditions – including Francis McClintock, Edward Inglefield and Edward Belcher – becoming well-known figures in their own right. Franklin had carried daguerreotype equipment on board, but the equipment and the results were not recovered with the other items retrieved by later explorers. Prior to their departure, Franklin and some of the officers were photographed on board the ships HMS *Erebus* and HMS *Terror*. The

(left) HERBERT PONTING (1870–1935) **The freezing of the sea, April 1911** (no. 30)

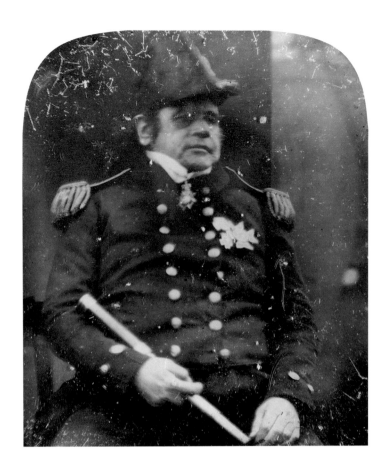

RICHARD BEARD
(1801–85) attrib.
Sir John Franklin, 1845
Daguerreotype
76 × 63 mm
(3 × 2½ in.)
Scott Polar Research
Institute, Cambridge

(opposite)
LIEUTENANT WILLIAM
J. BROWNE
**The Bivouac, Cape
Seppings, Leopold Island,
May 1848**
1850
Lithograph
242 × 170 mm
(9½ × 6¾ in.)
RCIN 750930.d

daguerreotypes became the basis of engraved portraits which were subsequently published in the newspapers.[3] Photography, the new technology which had been announced to the public in 1839, had been seized upon immediately as an efficient and accurate method of recording scientific and geographical discoveries, and fortunately it coincided with a new era in British exploration.

Many of the written accounts and the associated images are to be found in the Royal Collection, evidence that Queen Victoria and Prince Albert and their successors were not immune to the intense excitement and interest that polar exploration generated. While these items demonstrate that there has been royal interest in this area since the 1840s, the images also show that the visual documentation of the polar regions generally followed existing aesthetic conventions, moving between the sublime and the picturesque, although occasionally the impressive icescapes inspired a more unusual vision. This was particularly the case with photography.

SIR JAMES CLARK ROSS (1800–1862)

One outcome of the numerous expeditions setting out in search of Franklin was the accurate documentation of thousands of miles of previously unsurveyed territory. The records that the expeditions brought back incorporated new scientific information, although the images that were produced were mediated by the hand of the artist and the aesthetics of the day. One early set of colour lithographs, based on sketches by Lieutenant William J. Browne, contains ten views from the voyage of HMS *Enterprise* and HMS *Investigator* under the command of Captain James Clark Ross in 1848–9.[4] The lithographs, published with descriptive text in 1850, documented the first search for Franklin and were among the first sets of polar images that were available to the public. Most of the scenes, printed on a surprisingly small scale given the nature of the subject matter, are standard picturesque compositions, yet there is also an attempt to convey the immensity of the landscape by contrasting the smallness of man against his surroundings in at least two of the views. Emphasising the vastness of the cliff face against the small group of men at its base, who appear ant-like in comparison, the artist is attempting to convey to the viewer the overwhelming sense of awe when faced with such a landscape (*right*). This became something of a motif in the visual representation of the polar regions,

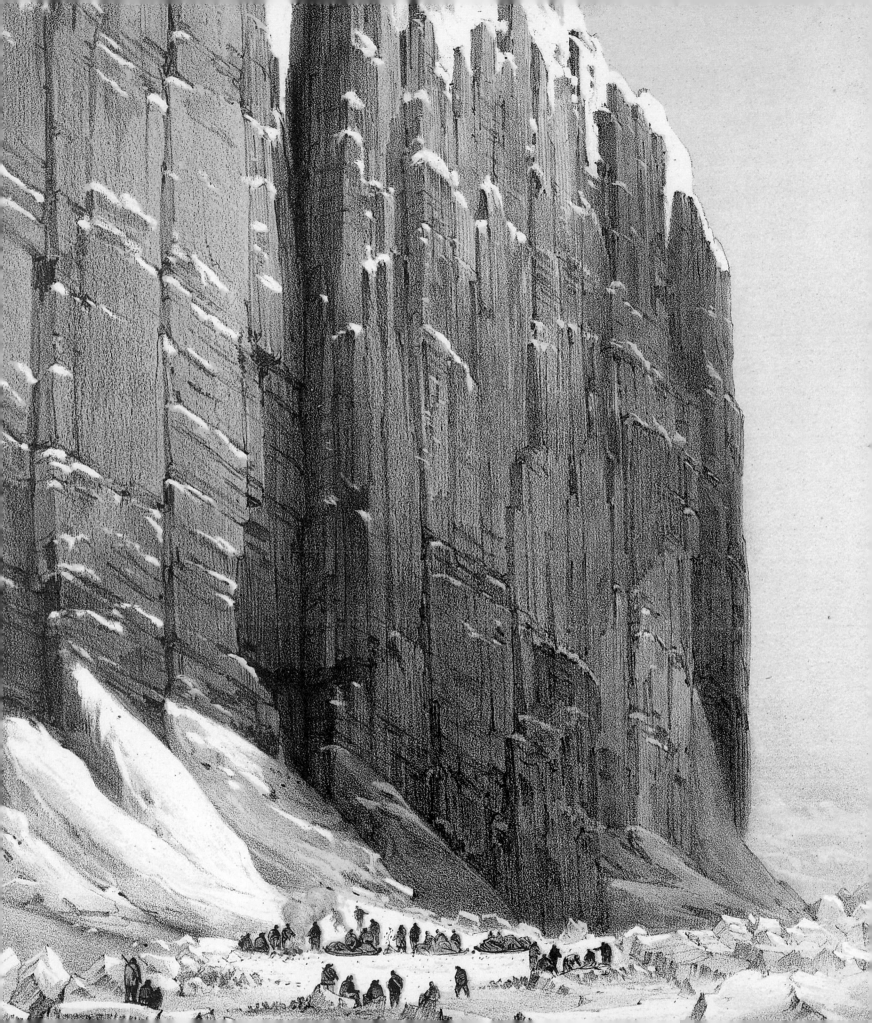

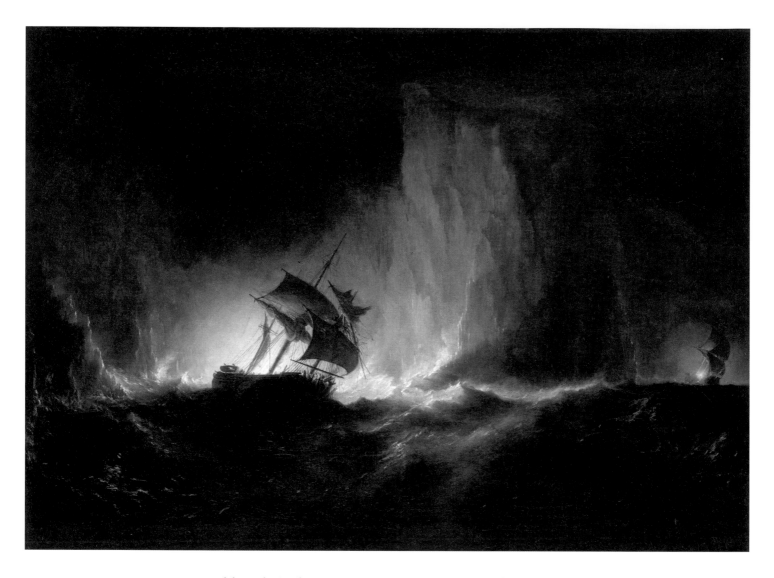

RICHARD BRYDGES
BEECHEY (1808–95)
**HMS *Erebus* passing
through the chain of
bergs, 1842**
c.1847
Oil on canvas
788 × 1118 mm
(31 × 44 in.)
National Maritime
Museum, London

although it draws on an existing practice of depicting the mountain ranges of the Himalayas and the Alps in a similar way – for example, in the work of some of the early nineteenth-century Romantic painters such as Caspar David Friedrich.[5]

Prior to his final Arctic expedition, Ross also made a journey to the Antarctic in 1839–43, discovering the immense ice shelf now known as the Ross Ice Shelf, and the two volcanoes which were named Mounts Erebus and Terror, after the ships under his command *(see map on p. 19)*. This voyage inspired several artists to produce works that are in the tradition of the sublime, including John Edward Davis, who was on board *Terror*, and later the painter and explorer Admiral Richard Brydges Beechey, who painted a highly dramatic Antarctic scene (inspired by Ross's account), depicting *Erebus* and *Terror* caught in the middle of a violent storm after they had collided and damaged each other.[6] It is probable that the expedition carried photographic equipment, as Dr Joseph Hooker, on board the *Erebus* as assistant surgeon, remarked in 1846 during a lecture at the Royal Institution of South Wales: 'I believe no instruments, however newly invented, was [*sic*] omitted, even down to an apparatus for daguerreotyping and talbotyping'.[7] No photographic images from Ross's Antarctic voyage have so far been identified.

There was great public interest in Ross's endeavours and the resulting images helped to sustain enthusiasm and support for polar exploration, but following the loss of the Franklin expedition, efforts were to be directed almost entirely towards the Arctic throughout the rest of the nineteenth century.

CONTINUING THE SEARCH FOR FRANKLIN

Several of the expeditions in search of Franklin carried cameras, although the operators were not professional photographers, but rather working members of the crew who also had the skill and knowledge to take photographs. In 1852 HMS *Resolute* sailed under the command of Edward Belcher, with Dr William Domville on board. Domville's surviving photographs represent some of the earliest polar photographs in existence. Unfortunately the *Resolute* became stuck in ice and was subsequently abandoned by Belcher, who was court-martialled (but acquitted) on arriving home. In 1855 the ship was rescued by an American whaler and taken to New London, Connecticut, where she was refitted and eventually handed back to Britain in a grand diplomatic gesture. On 16 December 1856, after the *Resolute* had been returned to Britain, Queen Victoria went on board to receive the ship formally from its commander Captain Hartstein.[8] The Queen was presented with a photograph of the ship, now in one of Prince Albert's photograph albums, as well as a signed portrait of the captain.

In 1854, while the fate of Belcher's expedition remained unknown, a support expedition was sent out to provide him with assistance under the leadership of Edward Augustus Inglefield (1820–94), in command of the ships HMS *Phoenix* and HMS *Talbot*. In addition to Inglefield's skills as a naval commander, he was a talented artist. In November 1853 Queen Victoria had seen some of his Arctic views from an earlier expedition. She wrote in her Journal: 'After luncheon we saw Capt: Inglefield's very fine & interesting paintings of his ineffectual voyage in search of Franklin, but which led to the discovery of the Western Passage. Quite awful are the situations depicted in the ice'.[9]

MEADE BROTHERS
The Arctic ship *Resolute*, New York, 1857
Salted paper print
146 × 192 mm
(5³/₄ × 7¹/₂ in.)
RCIN 2932765

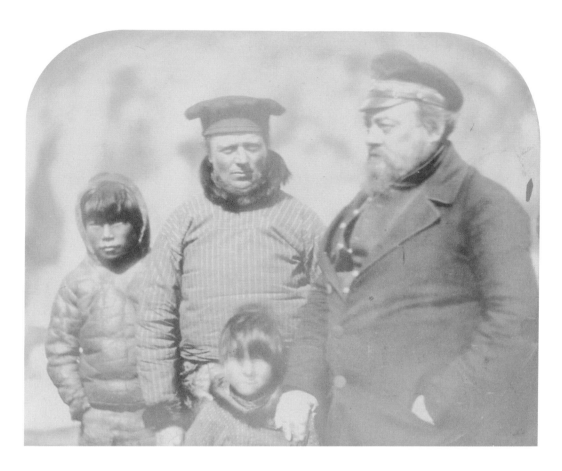

EDWARD AUGUSTUS
INGLEFIELD (1820–94)
**Governor of Fiskenæsset,
Lieutenant Governor and
Esquimaux boys, 1854**
Albumen print
157 × 194 mm
(6¹/₈ × 7⁵/₈ in.)
RCIN 1124489, p. 7

Following his return to Britain, Inglefield presented Queen Victoria with an album of 30 photographs taken in northern Greenland in 1854.[10] The photographs can be divided into two groups: portraits and topographical views. Unlike Antarctica, the Arctic regions are inhabited, and early photographers, including Inglefield, frequently asked the local Inuit population to sit as subjects for the camera. Inglefield produced a number of fairly unadventurous views documenting his surroundings: he made views of the small village that had been constructed by the Danish settlers, and some of the ships in the harbour. He also produced a startling, almost abstract composition, by filling the frame of the camera almost entirely with the rock and ice that he would have encountered around the bay *(opposite)*. It is the most photographic of his compositions, as he moves away from the existing aesthetics of the time into a vision of the landscape that emerged entirely from the camera. It is disorientating and, while it could be read as a scientific study of the rock face, it is also a graphic composition intended to have an impact on the viewer.

This striking approach to snow and ice is seen in the work of other photographers during the 1850s and 1860s, such as Adolphe Braun and the Bisson Frères in the Alps, and Samuel Bourne in the Indian Himalayas. While they continued to produce standard compositions that followed a conventional picturesque approach, the photographers also sought out compositions that were distinctly photographic, by concentrating the lens on singular motifs and distinct features within the landscape. This approach was to have a strong influence on future photographers visiting the polar regions, well into the twentieth century.

Queen Victoria and Prince Albert were evidently keen to acquire other photographs connected with the continuing search expeditions; their names headed the list of

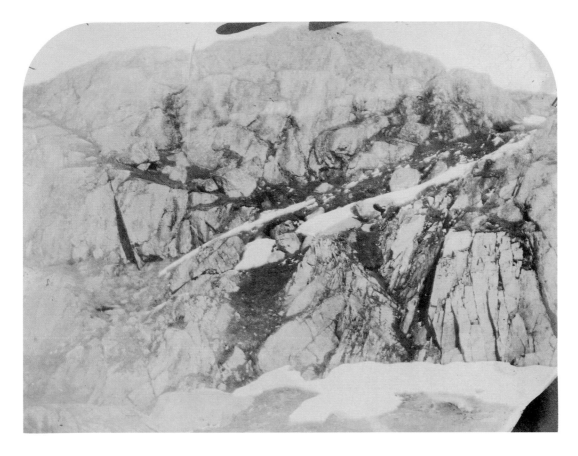

EDWARD AUGUSTUS
INGLEFIELD (1820–94)
Rock scenery, 1854
Albumen print
157 × 202 mm
(6¹/₈ × 8 in.)
RCIN 1124489, p. 23

subscribers for a set of stereographic images published in 1859.[11] Between 1857 and 1859 the HMS *Fox* expedition, under the command of Francis McClintock (1819–1907), discovered a large number of objects, including notebooks and cooking utensils from Franklin's ships, as well as evidence of skeletons. This confirmed the fate of the crew. McClintock brought these relics back to Britain, and a boxed set of 15 stereographic views by Lieutenant John P. Cheyne (1826–1902) was produced with an accompanying booklet containing explanatory notes. The writer of the text adopted a tone of deep reverence towards Franklin: 'The name of Franklin must, for ages to come, be revered by every Englishman … Has he not died only to spring up afresh and enduringly in the united hearts of all his countrymen, where his name will ever be a talisman of enterprise, courage and glory!'[12] Cheyne's photographs documented box after box of the Franklin relics. The images, supported by such ripe text, portrayed a powerful story of heroism and sacrifice on behalf of England. The role that photography could play in reinforcing such stories because of its apparent truthfulness was evident.

FURTHEST NORTH: THE BRITISH ARCTIC EXPEDITION

Inglefield had reached Furthest North in 1854, but this record was swiftly passed by the American explorer Elisha Kent Kane during his 1853–5 expedition. Kane had sailed with daguerreotype equipment on board, but no daguerreotypes from this journey appear to have survived. On board with Kane was the doctor Isaac Israel Hayes, who participated in several Arctic expeditions and produced a number of photographs. Hayes also took

PHOTOGRAPHER
UNKNOWN
Francis McClintock, 1860s
Albumen *carte de visite*
89 × 54 mm (3¹/₂ × 2¹/₈ in.)
RCIN 2911408

WILLIAM BRADFORD
(1823–92)
**The *Panther* in
Melville Bay, 1869**
1873
Oil on canvas
460 × 761 mm
(18⅛ × 30 in.)
RCIN 401327

part in the privately financed expedition of the *Panther* in 1869, under the leadership of the American artist and explorer William Bradford (1823–92).

When he chartered the steamer *Panther*, Bradford had already made several voyages to the Arctic regions, primarily to find inspirational subject matter for his paintings. He had asked two photographers to accompany him: George Critcherson and John Dunmore, from the studio of J.W. Black in Boston. Both had accompanied Bradford on previous journeys. According to Bradford, the expedition was 'made solely for the purposes of art',[13] as he hoped he would be able to use many of the photographs as the basis for future paintings. He eventually produced a series of fine paintings of Arctic landscapes. A selection of the photographs was published in a lavish volume, with text by Bradford describing the voyage. It was published in 1873 as *The Arctic Regions, illustrated with photographs taken on an Art Expedition to Greenland*. A copy was ordered for the Royal Library, and Bradford took the opportunity to present Queen Victoria with a painting at the same time. The artist wrote in 1873 that he had 'completed the picture which was to accompany the work, and which is

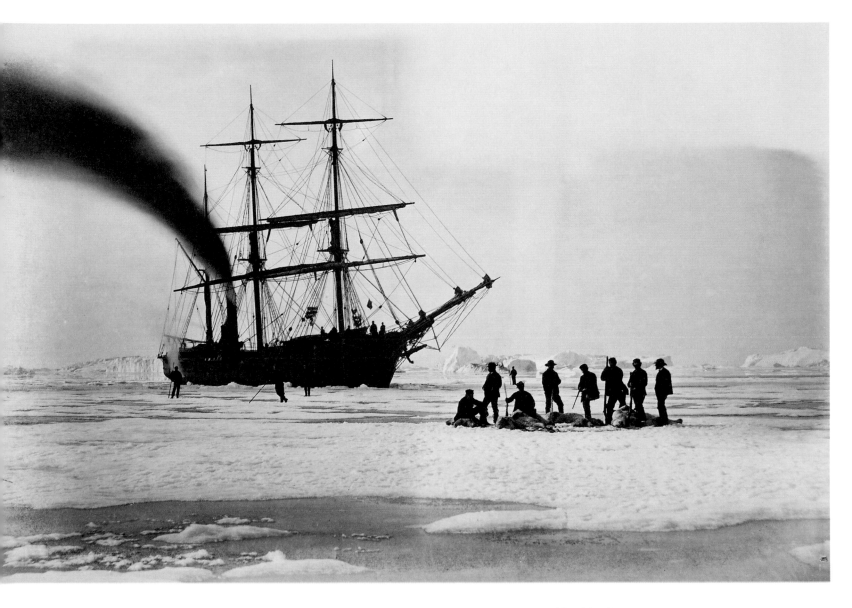

included in the subscription price of the Arctic Regions illustrated, which Mr Bradford had the honor of receiving an order for the Royal Library at Windsor'.[14] The painting shows the *Panther* stuck in ice, in danger of being completely crushed – something that was to become familiar to many expeditions, to both north and south.

The photographs are among the most successful ever taken in the Arctic region. They document the expedition, showing the ship, the men, the tasks they undertook and the wildlife and landscape they encountered on the journey. These were the images that Bradford used later for his own paintings. The photographers have also produced images that concentrate on the unusual qualities of the landscape, capturing the shapes and abstract forms of the icebergs and glaciers.

It is also possible to divide into documentary work and graphic art the photographs produced on one of the most important nineteenth-century Arctic expeditions: the British Arctic Expedition under the command of Captain George Nares in 1875–6.[15] The expedition set out to reach the North Pole; although ultimately unsuccessful, it did reach a Furthest

CRITCHERSON
AND DUNMORE
**Hunting in steam in
Melville Bay, 1869**
Albumen print
270 × 384 mm
(10⁵⁄₈ × 15¹⁄₈ in.)
Plate 83 in Bradford,
The Arctic Regions, 1873
RCIN 1070274

CRITCHERSON
AND DUNMORE
**The front of the glacier,
1869**
Albumen print
400 × 313 mm
(15³/₄ × 12³/₈ in.)
Plate 40 in Bradford,
The Arctic Regions, 1873
RCIN 1070274

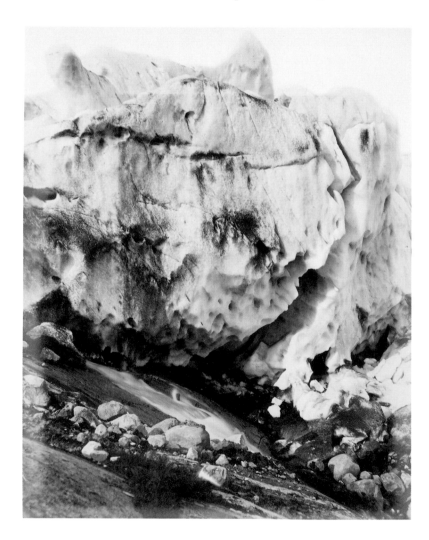

North of 83° 20' 26" N, which was not to be surpassed for another 20 years. Queen Victoria followed the progress of the expedition and made several mentions of its achievements in her Journal. Following the return of the crew, she wrote: 'They found impenetrable ice to the north of the Pole, but have been 30 miles further, than any of the other explorers'.[16] A few days later, Princess Beatrice read out an account of the expedition to her mother: 'She read to me after tea out of the printed papers a very interesting account of the Arctic Expedition. They suffered terribly. For 13 days the temperature was 50 below zero [–46 °C], & once 110 [–79 °C] which is almost incredible'.[17]

Captain Nares was later invited to Windsor, where he and his colleague Captain Stephenson met Queen Victoria. He told the Queen about their experiences sledging on ice with dogs, stating that it 'required great strength & youth & the progress was so slow'.[18] The Queen was evidently moved by his tales, as she remarked: '[Nares] said that any other Expedition (of which I hope there will be none) would profit by their mistakes'.[19] A few days after this meeting, Nares was knighted at Buckingham Palace.

The Queen was presented with a set of photographs from the expedition which provide a narrative of the journey as the team pushed on as far north as they could manage. Two photographers accompanied Nares: Thomas Mitchell, paymaster on HMS *Discovery*, and George White, assistant engineer on HMS *Alert*. Some of the views show the team with dogs and sledges trekking through the ice; others illustrate the empty, desolate landscape, particularly those taken as they approached their Furthest North. Mitchell took a number of views at 82° 40' N, showing the empty, untouched terrain *(opposite)*.[20]

On their return to England in late October 1876, the British Arctic Expedition had made contact with an expedition under the command of Allen Young (1827–1915) on board his steamer *Pandora*. Young, who had been on board the *Fox* with McClintock in 1859, had made several journeys north and was now searching for Nares to provide assistance.[21] It was not until his return

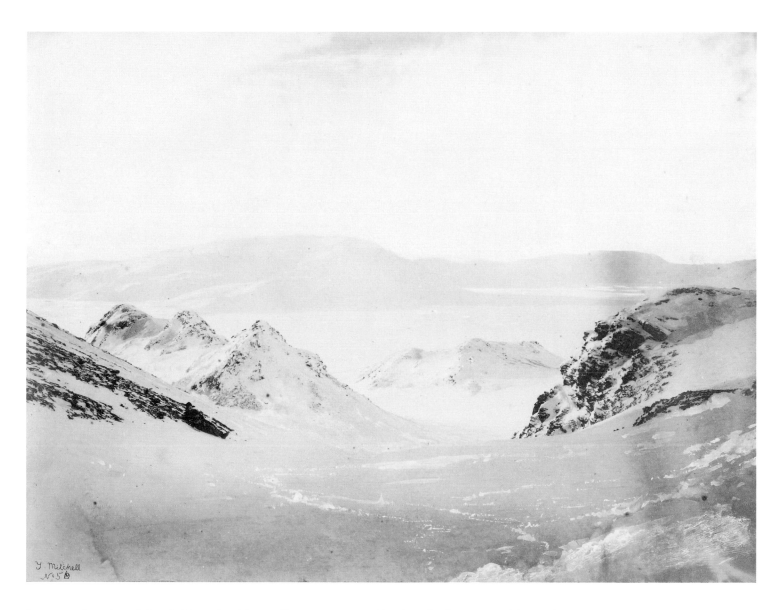

journey that he sighted Nares's ships off Cape Farewell, already homeward-bound. Young had a professional photographer on board, W.J.A. Grant, who later wrote about the difficulties of photographing in such cold climates: 'At sea it was terrible, and very hard to work in, for … the motion was very great, and it required more skill than I had to develop dry plates and prepare wet again. When working among the ice, one was repeatedly knocked off one's legs, while in the midst of developing, by the ship's frequent changes and collisions while forcing her way through the floes.'[22]

THOMAS MITCHELL
**'Westwood Ho' Valley,
82° 40' N, 1876**
Albumen print
160 × 210 mm
(6³⁄₈ × 8¹⁄₄ in.)
RCIN 2580223

Young was a close friend to the royal family, particularly the Prince of Wales (later King Edward VII), who had taken a great interest in the bestowal of Young's knighthood in 1877. Young took the Prince's sons sailing in his yacht off Cowes in 1885, and he was to be a guest at Balmoral in 1909, when Sir Ernest Shackleton visited the King in the wake of the *Nimrod* expedition.[23]

THE GREAT WHITE SOUTH

Towards the end of the nineteenth century, the potential of unexplored Antarctica began to attract the attention of scientists, whalers and the Royal Navy. National pride was at stake as other countries began to investigate the region to assess its commercial potential, while vying with each other to be the first to make new geographical discoveries and territorial claims. This coincided with the Admiralty deliberately increasing the size of the Navy to keep it twice the size of the next largest fleet, amid growing nationalistic fervour. Exhibitions such as the Royal Naval Exhibition of 1891 promoted to the public a sense of British naval superiority, focusing particularly on British expeditions in the Arctic – a 'Franklin Gallery' included a sledging tableau, surrounded by portraits of Arctic explorers.[24] Britain's success in building an empire, based on its naval strength, led to an assumption that Britain should also be the first to conquer the Antarctic.

An early Antarctic expedition with purely scientific aims, under the command of George Nares on board HMS *Challenger* in 1872–4, had used photography to keep records of the scientific work. They also produced the earliest photographs of icebergs in the Antarctic region. Other expeditions had photographers on board, although none was a professional photographer. The Dundee Whaling Expedition of 1892–3 travelled with two amateur photographers: the surgeon Dr Charles Donald and William Speirs Bruce, who was later to lead the Scottish National Antarctic Expedition (1902–4). The photographs they produced are probably the first taken of the Antarctic continent.[25] Early photographs of the region were also taken during the Belgian Antarctic Expedition (1897–9), under Adrien de Gerlache on board the *Belgica*.

The *Belgica* expedition was the first to overwinter in Antarctica. This was unintentional, and the men, poorly prepared, suffered badly both mentally and physically. The crew was drawn from several nationalities and included

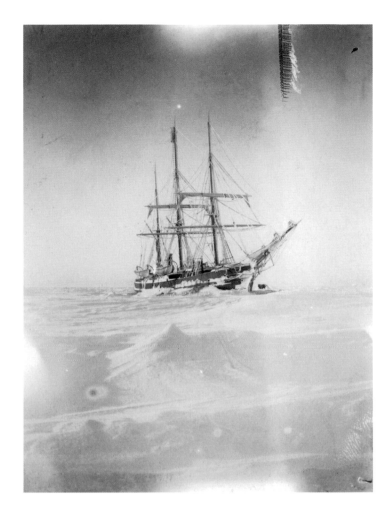

Frederick Cook, who somewhat contentiously later claimed to be the first man to reach the North Pole in April 1908, and Roald Amundsen, on his first Antarctic expedition. Amundsen was to be the first man to navigate the North-West Passage successfully, in 1903 (inspired as a boy by reading about Franklin), and to lead the first team to reach the South Pole, on 14 December 1911. Cook was responsible for many of the photographs to emerge from the *Belgica* voyage. They are nearly all documentary, although some fine images of the ship stuck in ice were produced. Amundsen incorporated images of the *Belgica* on his lecture tours, in which he also showed photographs his team took at the South Pole in 1911.[26]

It was probably Sir Clements Markham, the principal mover in organising a nationally funded Antarctic expedition, who was responsible for ensuring that photography was taken seriously as part of the next major British expedition. By the turn of the century, developments in photographic technology meant that almost anyone could own a camera and create their own pictures. On expeditions it was quite usual for several members of the crew to have a camera. Most men, however, were on board to undertake specific roles, and their time for taking photographs was limited. Markham, supported by Scott, understood that having someone who was specifically tasked with taking photographs in order to document the expedition was essential. Both men realised that strong images were vital for fund-raising: rights to the images could be sold and could also keep enthusiasm alive for further voyages by showing the public the heroic achievements gained in the face of such harsh terrain.

ERNEST SHACKLETON
(1874–1922)
Captain Scott on skis,
***Discovery* behind,**
5 January 1902
Scott Polar Research
Institute, Cambridge

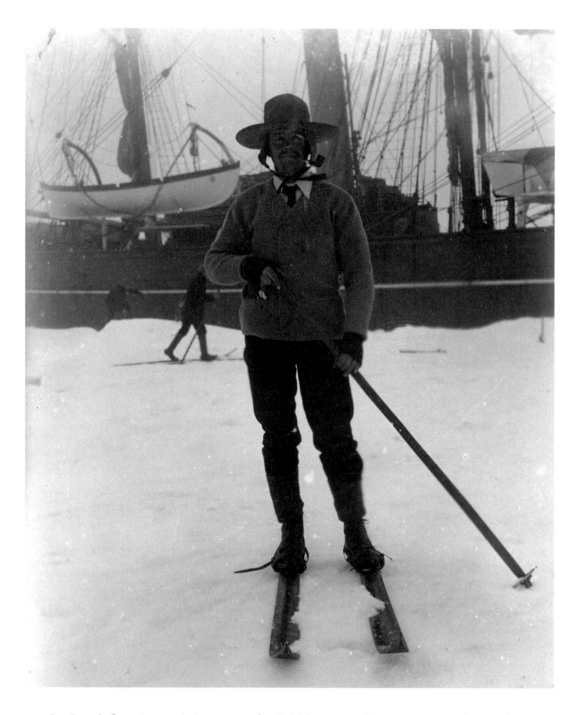

(opposite)
REGINALD SKELTON
(1872–1956)
Emperor penguin and chick,
18 October 1902 *(detail)*
Photogravure
149 × 101 mm (5⁷⁄₈ × 4 in.)
Plate LVI in *Album of
Photographs and Sketches with
a Portfolio of Panoramic Views*,
London, 1908
RCIN 1090464

On Scott's first Antarctic journey – the British National Antarctic Expedition of 1901–4 on board *Discovery* – at least eight men were carrying cameras. Chief engineer Reginald Skelton was the principal photographer, and he fitted out the ship with various pieces of photographic equipment; but images by Shackleton, Royds, Ford, Armitage, Wilson, Ferrar and Bernacchi have also survived.[27] Following the return of the expedition, an exhibition of Skelton's photographs, alongside Dr Wilson's paintings, was held at the Bruton Galleries in London.[28] The exhibition opened on 4 November 1904 and at least 10,000 people came to see the images.[29] Alongside the pictures there was a selection of objects used by members of the expedition, including a tent, a kayak, snowshoes, sleeping bags made of reindeer skin and a Union Jack presented to *Discovery* by the officers on board.

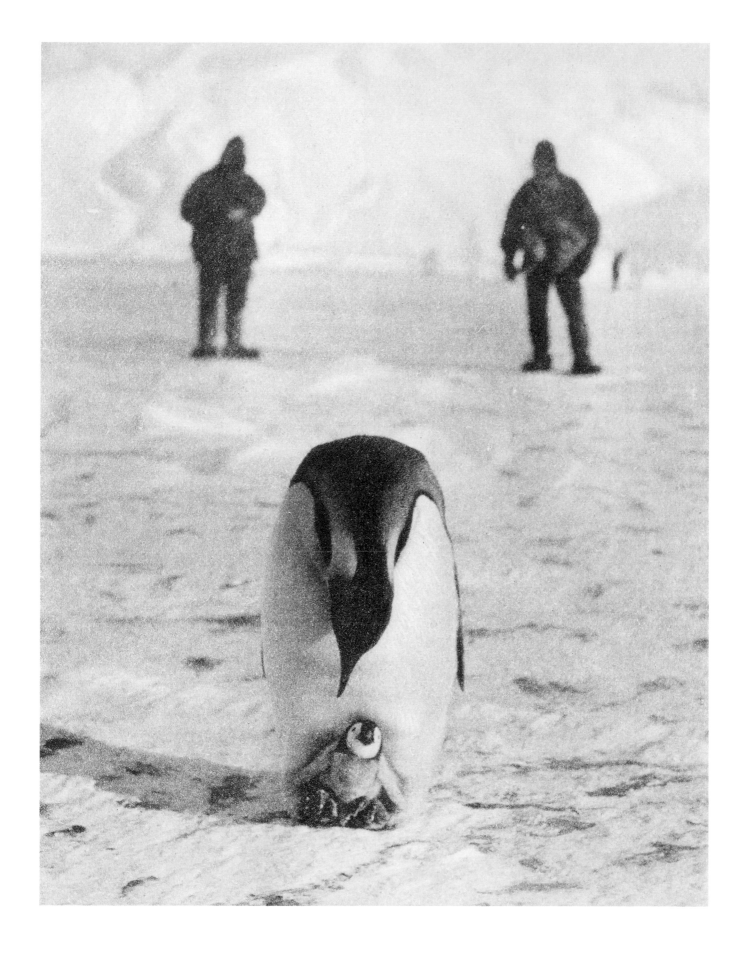

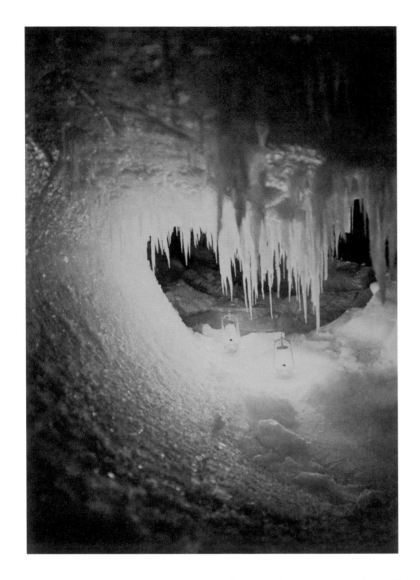

ERNEST SHACKLETON
(1874–1922)
**Ice cavern photographed
by the light of hurricane
lamps, 1907–9**
Scott Polar Research
Institute, Cambridge

Skelton's photographs were described in the exhibition catalogue as being 'of great scientific value'.[30] They were almost entirely documentary in nature: there was no attempt to create a unique vision of the landscape or to convey anything of the emotional aspect of exploring Antarctica. Skelton produced many snowscapes, showing the untouched landscape empty of human figures, as well as several studies of Emperor penguins, believed to be the first photographs of this species. The Bruton Galleries catalogue also pointed out one of the disadvantages of photographic images of the Antarctic: they were unable to record the colours of 'the solar phenomena which were observed and the wondrous combinations of colour effects in spring and autumn.'[31]

A large selection of the photographs was published as part of the 11-volume official report of the expedition's scientific findings. The final volume, *Album of Photographs and Sketches with a Portfolio of Panoramic Views*, published in 1908, was dedicated solely to the photographs.[32] Unfortunately the photographs are reproduced on a small scale which fails to do justice to the subject matter.

King Edward VII had followed the progress of the *Discovery* expedition, and on 28 September 1904 Scott was invited to Balmoral to lecture about his experiences and show slides of Skelton's work to a group that included the King and Queen, the Prince and Princess of Wales, the Duke and Duchess of Connaught and the Prime Minister. The Prince of Wales (later King George V) wrote about the event in his diary: 'Cap^t. Scott who has just returned in the "Discovery" from the Anartic [*sic*] Expedition, gave us an excellent lecture in the ball room & told us some interesting details of his three years [*sic*] adventures in the ice. They certainly went through great hardships & only lost one man.'[33] Scott later wrote to his mother that the King had asked so many questions that they were talking for three-quarters of an hour longer than had been scheduled. Scott was awarded the CVO during the visit, and the following day he was taken grouse shooting with the royal party, to be followed by deer stalking the next day. He then returned to London and embarked on a hectic national lecture tour, which began in London on 7 November and ended in Birmingham on 16 December, giving daily lectures with only Sundays off.[34]

For the British Antarctic Expedition on board *Nimrod* in 1907–9, Shackleton ensured there was a wealth of photographic equipment, including a stereoscopic camera and a cinematographic camera. In addition, there were at least nine hand-held cameras among the team.[35] Eric Marshall was responsible for many of the now iconic images that represent the successes of the journey south, and substantial work was produced by the assistant geologist Philip Brocklehurst and chief scientist T. Edgeworth David *(see pp. 24 and 25)*. Some of the most interesting landscapes were taken by Shackleton himself. His few surviving photographs demonstrate an eye for unusual ice formations arranged into striking and poetic compositions.

HERBERT PONTING AND THE *TERRA NOVA* EXPEDITION

So far, none of the expeditions had taken a photographer who would look at the landscape first and foremost with the eye of an artist. When Scott put together the team for his next assault on the Pole, however, he decided that it was essential to include an accomplished photographer who would not have any duty other than that of producing photographs and film. Herbert Ponting (1870–1935), who was in 1909 already a well-known and successful travel photographer, had met Cecil Meares on board a steamer bound for Shanghai in 1905. Ponting had been photographing the Russo-Japanese War, attached to the Japanese troops. Meares and Ponting travelled together in Burma and India for six months, and during this period they discussed polar exploration. At the same time, Ponting was reading *The Voyage of the 'Discovery'* (1905) by Scott (no. 89). Once news of Scott's plans for a second expedition began circulating, Meares offered his services and later introduced Scott to the photographer. The first meeting took place in the autumn of 1909 and Ponting was immediately engaged to accompany Scott to Antarctica, the first official photographer to participate in a polar expedition. Scott wrote in his journal that 'we shall have a cinematograph and photographic record which will be absolutely new in expeditionary work.'[36]

Ponting was given a more-or-less free hand by Scott in photographic matters. He took two film cameras (an adapted Newman-Sinclair and a J.A. Prestwich camera) and several still cameras, of which the most frequently used was a model specially adapted by Ponting, taking 7 × 5 inch (178 × 127 mm) glass plate negatives. Ponting also took a large number of photographs using 5 × 4 inch (127 × 102 mm) negatives.[37] On board *Terra Nova* on its journey south from New Zealand, Ponting fitted out a darkroom and began working immediately, photographing the first icebergs encountered on 7 December 1910, as well as scenes on board ship. He was generally very happy with his role, but occasionally Scott did not allow him to photograph when the needs of the expedition were overriding. For example, when they finally reached the Ross Ice Barrier, a feature about

which Scott had spoken to Ponting with great enthusiasm, Ponting did not have time to take the photographs he wanted because Scott wished to press on, given that they were already behind schedule. Ponting wrote that he watched disappearing 'one of the most remarkable features of the earth, to see which ... I had come over more than a third of the circumference of the globe.'[38]

Once the expedition reached Ross Island, they established a headquarters at the newly named Cape Evans. Ponting, who did not want to waste any time, was excused from unloading the ship, somewhat to the annoyance of other crew members. Scott, however, continued to give Ponting the freedom to pursue his work as he wished. Ponting soon set up a darkroom in the hut and began working in earnest. The day following their arrival, he set out to photograph some icebergs he had spotted about a mile away. He saw a group of killer whales nearby and tried to photograph them, but they immediately turned on him, crashing through the ice in an attempt to catch him in their jaws. Ponting had to jump from floe to floe in order to escape the whales. Scott had been watching, helpless to assist, and later wrote of the whales in his diary: 'it was possible to see their tawny head markings, their small glistening eyes, and their terrible array of teeth – by far the largest and most terrifying in the world.'[39] Ponting had a lucky escape.

Ponting spent the Antarctic summer photographing as much as possible; during the winter months he developed his negatives, printed some contact prints and gave lectures to the men, showing slides of his work from Japan as well as examples of his current Antarctic work. Between December 1910 and March 1912 (when he left Antarctica as planned), Ponting produced around 2,000 glass plate negatives, photographing the landscape, the Shore Party and the wildlife, including seals, gulls and penguins.[40] He also taught photography to other members of the team, including Debenham, Wright, Gran, Taylor, Scott and Bowers. It was clearly impractical and inappropriate for a professional photographer to be part of the final Polar Party, but Ponting's tuition ensured that the critical period of the expedition, including the journey to the Pole, would be documented photographically. Scott wrote: 'My incursion into photography has brought me in close touch with him and I realise what a very good fellow he is; no pains are too great for him to take to help and instruct others, whilst his enthusiasm for his own work is unlimited.'[41]

Ponting wrote of the difficulties of photographing in such cold temperatures and working in cramped conditions. He learnt that cameras had to be left outside, otherwise they would become covered in condensation when brought into a hut that was so much warmer than the outside. The negative plates, which were stored outdoors along with unrequired chemical stocks, had to be brought inside gradually, in order to avoid cracking in sudden temperature changes. The biggest pitfall, however, was frostbite, as it was almost impossible to manage the equipment without having to use bare fingers at some point. Ponting wrote that he often felt 'burnt' when he touched the metal, adding: 'On another

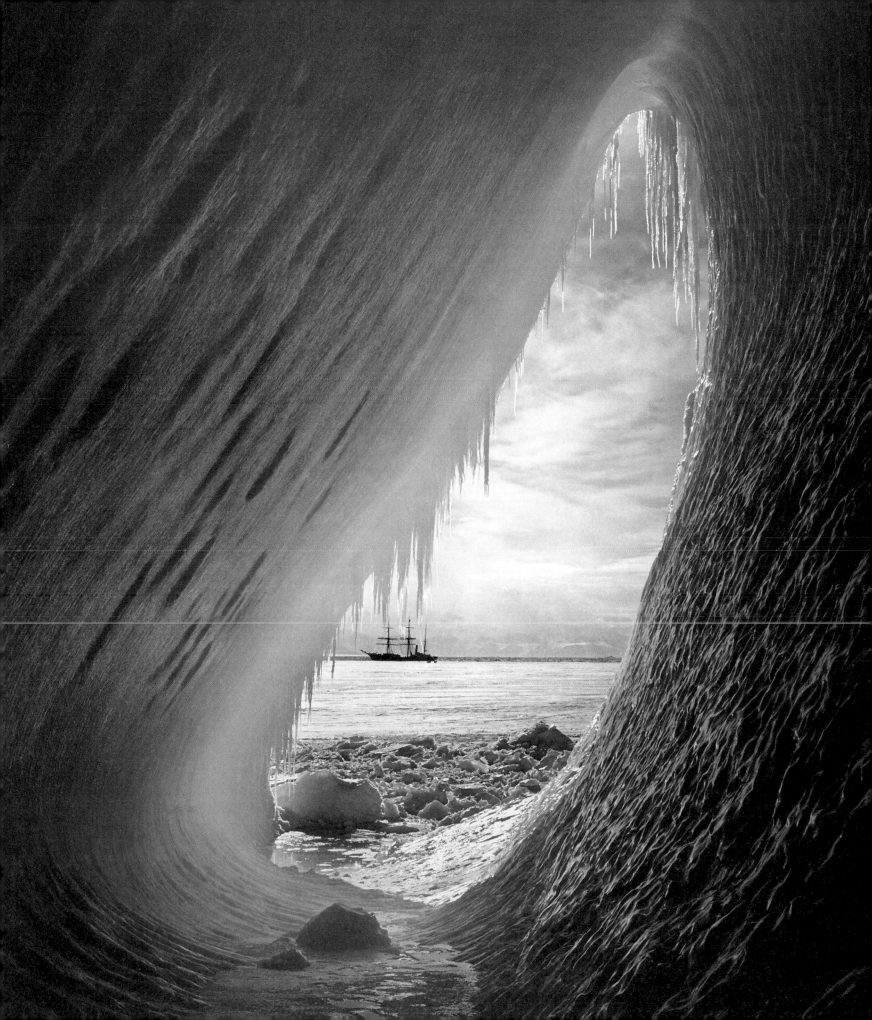

occasion, my tongue came into contact with a metal part of one of my cameras, whilst moistening my lips as I was focussing. It froze fast instantaneously; and to release myself I had to jerk it away, leaving the skin of the end of my tongue sticking to my camera.'[42]

Back in London, Ponting began to prepare his photographs and film footage.[43] He was, like the rest of the world, completely unaware of the death of Scott and his Polar Party until February 1913, when he received a telegram while on holiday in Switzerland. The headlines in Britain on 11 February 1913 read: 'Scott killed at the South Pole. British Antarctic Disaster. Found dead just 10 miles from Safety.'[44] The effect that this news had on Ponting, both emotionally and practically, was immense.

Although Scott had given Ponting a free hand with the photography, they had failed to establish a proper agreement over the use of the photographs. Ponting believed that he had control of the images, even though the copyright belonged to the expedition for two years. Unfortunately his belief was based on an unwritten gentleman's agreement, and Scott's death meant that Ponting lost control of his work as others began making deals to sell the rights to his photographs. Ponting, however, devastated by Scott's death, felt an obligation to lecture and display his work as widely as possible to perpetuate the memory of Scott and the men who had died. The photographs were successfully distributed around the world, leading some surviving members of the expedition to believe that Ponting had made a fortune. The opposite proved to be the case, and by the time of his death, in February 1935, Ponting's estate was worth only £815 8s 5d.[45]

The most important public exhibition of Ponting's photographs opened in December 1913 at the Fine Art Society (FAS) in London *(see Appendix 1)*. At the same time, an exhibition of Dr Wilson's drawings was opening at the Alpine Club.[46] Ponting's exhibition contained 145 photographs (two of which were stills from the film footage), alongside four photographs taken by Bowers and Wilson at the South Pole in January 1912, and one view by Tryggve Gran of the cairn constructed by the search party over the bodies of Scott, Wilson and Bowers in November 1912.[47]

The catalogue text indicates that the pictures could be printed up in four different sizes, the largest being 29 inches (737 mm) in height, the smallest 15 inches (381 mm). There was a suggested optimum size for each image, although it was possible to order larger prints if desired, but not smaller ones. Different processes were used, including carbon prints and toned and untoned silver bromide prints. The work was credited to Ponting by the use of a blindstamp in the lower right corner of the image. There was also the option to acquire the work framed; if so, there would be an FAS label on the backboard, giving the title and the catalogue number of the print.[48]

The exhibition also toured in order to maximise potential sales. During this period the financial profits went to defray the costs of the expedition, rather than to Ponting. On 12 May 1914 Ponting presented his Antarctic lecture at Buckingham Palace to the King

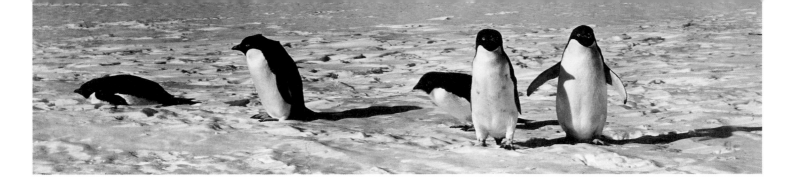

and Queen, with several hundred guests, including the King and Queen of Denmark.[49] The film footage was shown, and the photographs now in the Royal Collection were probably presented on this occasion or shortly afterwards. The set of photographs acquired by King George V contains many of the most popular and striking images reproduced as carbon prints, some with a blindstamp in the corner, which may indicate that these prints were part of the stock prepared for the FAS. The majority of the images have no blindstamp, however, which suggests that they were printed especially for the portfolio destined for the King.[50]

The royal photographs, with only one or two exceptions, are printed at the largest possible size. The colour of the carbon prints varies from black to strong blues and grey-greens, and on one occasion orange-dyed paper is used as the basis for a black carbon print (no. 2).[51] Colour is an important element within Ponting's work that has been frequently overlooked when it has been reproduced. Both Scott and Ponting remarked on the colours of the ice in Antarctica. In particular they responded to the 'ice grotto' which was the location of what is now one of Ponting's most iconic images (no. 20). Scott wrote of the sky: 'it looked a royal purple, whether by contrast with the blue of the cavern or whether from optical illusion I do not know. Through the larger entrance could be seen, also partly through icicles, the ship, the Western Mountains, and a lilac sky.'[52] Ponting continued:

> From outside, the interior appeared quite white and colourless, but once inside, it was a lovely symphony of blue and green. I made many photographs in this remarkable place – than which I secured none more beautiful the entire time I was in the South. By almost incredible good luck the entrance to the cavern framed a fine view of the *Terra Nova* lying at the icefoot, a mile away.[53]

The King had been moved by Ponting's presentation at the Palace. Ponting recorded that the King expressed a hope that 'it might be possible for every British boy to see the pictures – as the story of the Scott Expedition could not be known too widely among the youth of the nation, for it would help to promote the spirit of adventure that had made the Empire.'[54] After the successful publication of his *Great White South* (no. 91) in 1921, Ponting devoted much of the rest of his life to ensuring that the photographs and the film were seen as widely as possible. He had been profoundly affected by his Antarctic experience and subsequently undertook very little new work. Film extracts were shown to British troops during the First World War in order to encourage selfless devotion to the nation, with the story of Oates's sacrifice receiving special attention.[55] The photographs were also widely circulated around the world as postcards. The FAS issued a series, selling sets of seven cards containing six pictures and one message card printed with a moving extract from Scott's journal.[56]

HERBERT PONTING
(1870–1935)
**Mount Erebus,
13 January 1911** *(detail)*
Carbon print
580 × 731 mm
(22⁷/₈ × 28³/₄ in.)
RCIN 2580030

Today Ponting's photographs are inextricably linked with the memory of the men who died, and they have done much to sustain the story of Scott. Their power comes from the unique combination of 'personal, historic, artistic and scientific' values that they possess.[57] Ponting, aware that he had a duty to record the expedition, did so conscientiously, producing many portraits of the men at work, as well as more formal character studies, such as the portrait of Scott writing his journal in the hut (no. 32). In addition, he produced a large number of outstanding wildlife studies, ranging from close-ups of comical Adélie penguins to Weddell seals basking in the sunlight. It is, however, the landscapes that capture and convey Ponting's own emotional response to his surroundings. Views such as *Midnight in the Antarctic Summer* (no. 23) are composed within a conventional, picturesque aesthetic which conveys a reassuring peacefulness and familiarity, without any hint of the danger that exists in the region. Ponting also moves beyond the picturesque, towards the sublime, combining this with strong graphic qualities which he would have learnt through the experience of publishing his images in magazines and newspapers. In *The ramparts of Mount Erebus* (no. 18), for example, Ponting captures the immensity of the physical landscape, simultaneously suggesting the scale of the challenge faced by the expedition by contrasting the enormous ice cliff with the tiny human figure and sledge at the lower left corner. At the very top of the image, the volcano Mount Erebus looms over the entire composition, as well as over the viewer.

FRANK HURLEY AND THE IMPERIAL TRANSANTARCTIC EXPEDITION, 1914–1917

Ponting's artistic achievement in Antarctica has never been surpassed by any subsequent photographer. A few years afterwards, however, the Australian photographer Frank Hurley (1885–1962) produced a series of photographs recording Shackleton's ill-fated expedition in the Weddell Sea which came extremely close.

Hurley had begun his photographic career in 1905, with his first published picture, a seascape, appearing in a magazine in June. A few years later he became a partner in a picture-postcard business, subsequently known as Cave and Hurley. In 1910, when Douglas Mawson required an official photographer to accompany the Australasian Antarctic Expedition of 1911–14, Hurley talked his way into the position on a short train journey with Mawson. He took a very active role within the expedition, in particular undertaking a lengthy trip to the South Magnetic Pole in November 1912. He returned to Australia in March 1913, preparing his work and compiling a film of the expedition, *Home of the Blizzard*, which was first shown as *Life in the Antarctic* in July 1913. Hurley's photographic work was dramatic as well as documentary, and was displayed in London at an exhibition held at the FAS in 1915.

FRANK HURLEY
(1885–1962)
**Young King penguin
in first-year plumage,
South Georgia
1914** *(detail)*
Silver bromide print
152 × 204 mm
(6 × 8 in.)
RCIN 2580046 (no. 49)

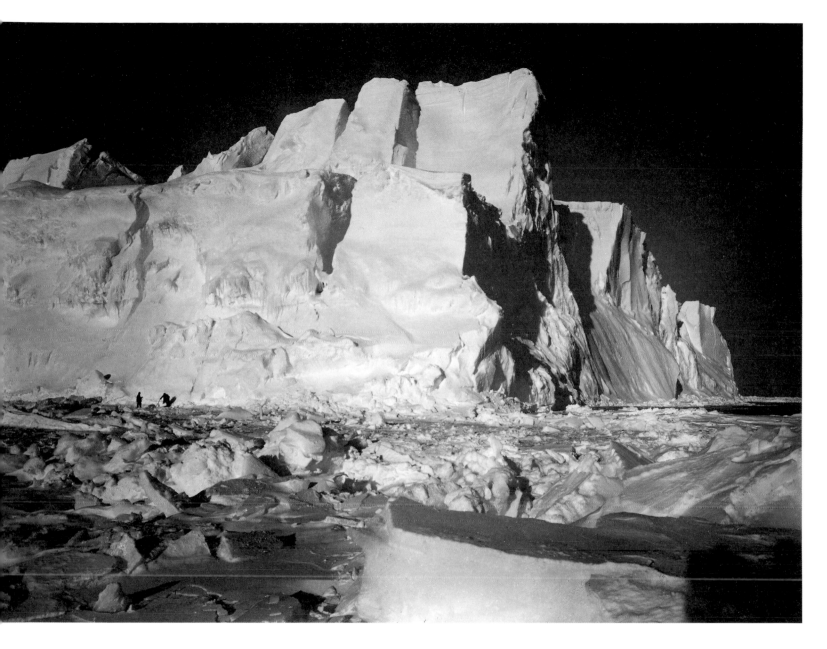

According to Hurley's later account, it was the success of *Home of the Blizzard* that led Shackleton, at the express desire of his sponsors, to ask Hurley to accompany him on the planned expedition, known as the Imperial Transantarctic Expedition, or the Weddell Sea Party Expedition. Shackleton planned to make the first crossing of the continent on foot and it was intended that Hurley would accompany the group making the crossing, as photographic evidence of the trip would be necessary. However, the expedition was marooned on the ice after *Endurance* was crushed, and the team subsequently ended up spending four and a half months on Elephant Island, waiting, while Shackleton and five men made an epic journey to South Georgia in the *James Caird* in search of rescue.

Hurley joined the *Endurance* in Buenos Aires on 12 October 1914. He threw himself into his work, photographing life on board from all angles, including climbing the rigging to obtain the best viewpoints. Once the ship became stuck fast in the ice, Hurley

FRANK HURLEY
(1885–1962)
**The Bastion Berg,
11 March 1915**
Silver bromide print
153 × 205 mm
(6 × 8¹/₈ in.)
RCIN 2580067

photographed the activities of the crew and the dogs as they occupied themselves, waiting to see what would happen. When the ship began to disintegrate in October 1915, Hurley spent almost three days out on the ice, intent on not missing the final moments of the vessel.

Initially Hurley salvaged most of his plates and equipment from the wreck of the *Endurance*. On 2 November 1915 he went on board, into the icy water, and pulled out the film canisters and negatives. In *Argonauts of the South*, his account of the expedition, Hurley wrote:

> We hacked our way through the splintered timbers and, after vainly fishing in the ice-laden waters with boathooks, I made up my mind to dive in after them. It was mighty cold work groping about in the mushy ice in semi-darkness of the ship's bowels, but I was rewarded in the end and passed out the three precious tins.[58]

About a week later, Hurley had the heart-wrenching task of selecting, with Shackleton, 120 plates to keep and smashing the remaining 400 plates.[59] This was necessary to reduce the weight of the equipment that the men would have to carry. A great deal of money had been advanced to the expedition against the rights to the films, and it was recognised by Shackleton and Hurley that they were valuable assets. This is nowhere more evident than when the crew were later faced with an overladen boat, and had the choice of discarding food or the photographic plates. The food was thrown overboard and the plates were saved.[60]

Hurley also lost his camera equipment – all except a small pocket camera and three rolls of unused film, which he used to take photographs on Elephant Island. These images are noticeably different from those taken with glass plate negatives: the images from film are grainy and they lack clarity and definition. This is somehow in keeping with the physical conditions that the men were enduring while stuck on Elephant Island, as it is suggestive of the difficult and dirty environment in which they had to survive.

After the expedition, Hurley arrived in London on 11 November 1916 and his work began to appear in publications, although the first photograph had been published in the *Daily Mirror* on 10 July 1916, as Shackleton had taken some of Hurley's photographs with him when he set off in the *James Caird*. Hurley later returned to South Georgia, arriving on 25 March 1917, where he spent a month filming additional material for his motion picture. The film was eventually released as *In the Grip of the Polar Pack Ice*. Hurley took more photographs too, of wildlife and the scenery in particular. The enormous success of the film enabled Shackleton to pay off many of the expedition's debts.

In 1917 Hurley joined the Australian Imperial Force, with the rank of captain; he was posted to Flanders where, as the army's official photographer, he saw action at Passchendaele during the summer. In December 1917 he joined the Palestine campaign,

but returned to London in May 1918 for an exhibition of his work at the Grafton Galleries. He resigned from the army on 11 July 1918 and returned to Australia.[61] His career continued to flourish and work took Hurley on further expeditions, to New Guinea, to the Antarctic again (with Mawson), and as a war photographer in the Middle East during the Second World War.

Like Ponting, Hurley printed his work in a large exhibition format, as both silver prints and carbon prints, but he also created a number of albums for friends, members of the expedition and sponsors. Hurley compiled these albums using relatively small prints, usually gelatin silver prints, each approximately 6 × 8 inches (152 × 203 mm), in window mounts, with handwritten captions in black ink on the page. A number of what may be termed 'de-luxe' albums were created in order to be presented to particularly important

FRANK HURLEY
(1885–1962)
The first hot food after five days in the boats, 15 April 1916
Silver bromide print
128 × 203 mm
(5 × 8 in.)
RCIN 2580106

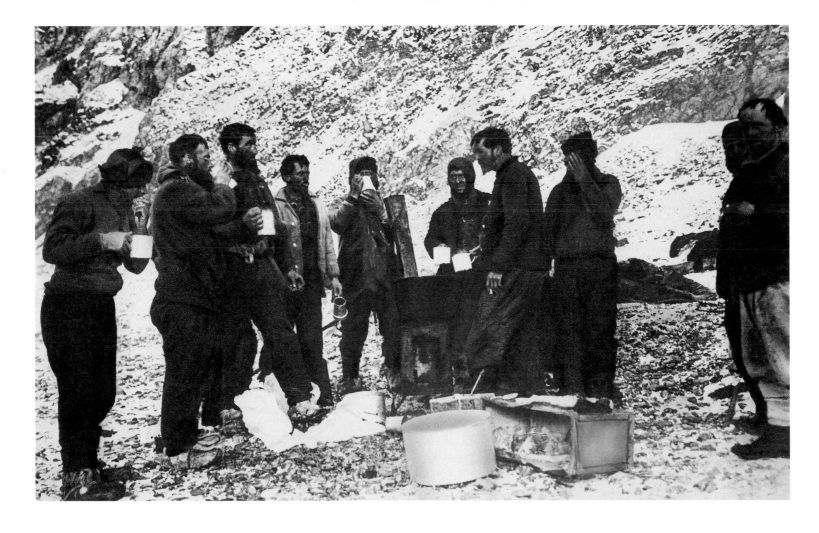

individuals, such as Janet Stancomb-Wills, one of Shackleton's key sponsors.[62] The album presented to King George V is one of these 'de-luxe' albums, with a title page and list of the officers of the expedition preceding the photographs. Unlike the Stancomb-Wills album, there is no inscription or date in the King's album, but it is most probable that Shackleton gave the album to the King either during his audience at Buckingham Palace on 30 May 1917, or when he visited Sandringham on 10 October the same year to give a lecture to the Royal Family on his experiences.[63]

AFTER PONTING AND HURLEY

King George V continued to take an interest in Shackleton's career, meeting him on two further occasions: receiving Shackleton at Buckingham Palace on 19 December 1918, on his return from his war work in Murmansk, and again at Buckingham Palace on 23 July 1921, shortly before Shackleton was to embark on his final expedition on board *Quest*. The purpose of the expedition, known as the Shackleton-Rowett Antarctic Expedition (1921–2) after the principal sponsor, was to explore and chart oceanic and subantarctic islands.

The King presented Shackleton with a Union Jack before *Quest* left London on 18 September 1921. The ship reached South Georgia on 4 January 1922 and Shackleton went ashore to meet various people. On his return to *Quest* he made an unusual and poetic entry in his diary: 'In the darkening twilight I saw a lone star hover gem-like above the bay.' It was his last entry, as at 3.30am on 5 January he suffered a heart attack and died. He was buried on 5 March in the cemetery at the old whaling station of Grytviken. A memorial cross was erected at King Edward Point, just outside the station.

An album of photographs by G. Hubert Wilkins (1888–1958), documenting the *Quest* expedition, is in the Royal Collection (no. 104). The photographs are documentary in nature, beginning with the ship leaving London, and covering the journey to South Georgia and Shackleton's burial. The album also contains a large number of wildlife and natural history views. Wilkins had joined the expedition in order to conduct ornithological research, which is reflected in the subject matter of many of the images. Previously Wilkins had been appointed second lieutenant in the Australian Imperial Force (AIF), and had worked with Hurley as an official photographer on the Western Front in 1918. He was employed specifically to record accurately the work of the AIF, which contrasted with Hurley's much more subjective wartime photography. When Hurley resigned from his post, Wilkins was promoted to captain.[64] In 1928 Wilkins was to be the first person to fly over Antarctica (although he did not fly over the South Pole).

Many years later, on 12 January 1957, His Royal Highness The Duke of Edinburgh visited South Georgia on board the Royal Yacht *Britannia* as part of a four-month voyage which circumnavigated the globe. The Duke was accompanied on the 'Antarctic leg' of the

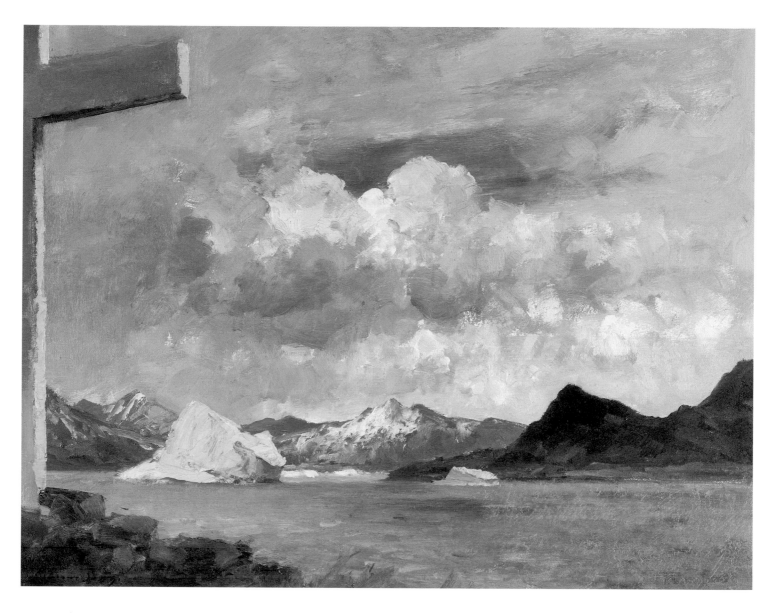

journey by Sir Raymond Priestley, a veteran of both the *Nimrod* and *Terra Nova* expeditions. The Duke visited Shackleton's grave as well as the memorial cross, and photographs were taken to mark the occasion *(see p. 15)*. The artist Edward Seago (1910–74) was also on board *Britannia* with the royal party, and he went on to produce a series of paintings on Antarctic subjects, the first professional painter to do so. Seago's response to the landscape of Antarctica recalls that of Ponting, as both were intensely moved by the variety of forms and colours. Seago recalled: 'The colour was tremendous. It was full of rich blues and greens and the cavities, particularly in the icebergs … weren't dark. They glowed with the most rich luminous blues and greens which were tremendously exciting to paint.'[65]

The Duke of Edinburgh's visit in 1957 represents a continued royal interest in the polar regions in the second half of the twentieth century, but it also looks back to the 'heroic age' of Scott and Shackleton. It is fitting that the 100th anniversaries of those extraordinary expeditions are marked by bringing together this rich collection of rare and often unique material.

EDWARD SEAGO
(1910–74)
Shackleton's cross, Grytviken Bay, South Georgia, 1957
Oil on board
500 × 650 mm
(19¾ × 25⅝ in.)
Collection of HRH The Duke of Edinburgh
RCIN 403126

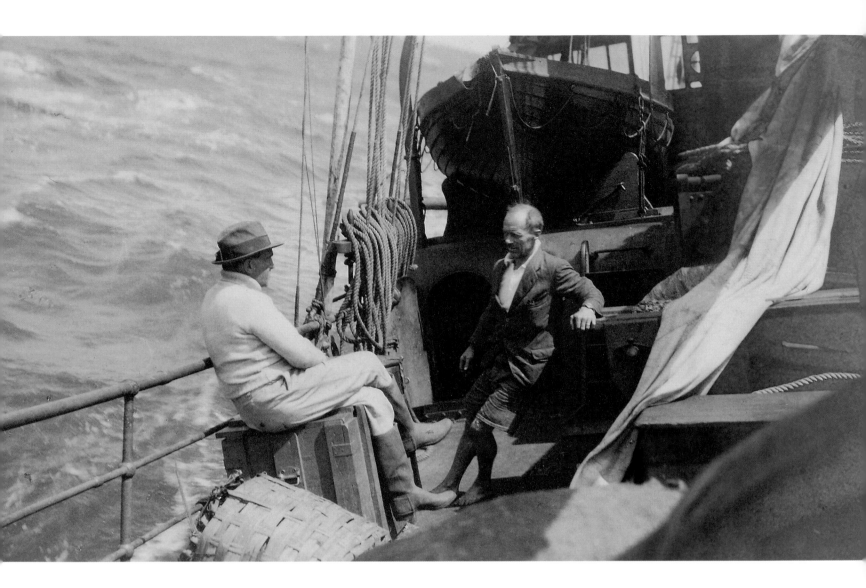

NOTES

1 Cherry-Garrard 1935, p. 391.

2 Ross 2002, p. 65.

3 A set of 12 daguerreotypes survives in the Scott Polar Research
 Institute, University of Cambridge, and others may be found in the
 National Maritime Museum, London.

4 Browne 1850 (RCIN 750930).

5 Friedrich painted an Arctic scene, *The Sea of Ice* (1823–4, Kunsthalle,
 Hamburg), also known as *The Wreck of Hope*, which includes a ship
 from an early Arctic expedition completely crushed by the ice.

6 Some drawings by Davis were published in Ross 1847. Admiral
 Beechey (1808–95) was the son of the portrait painter Sir William
 Beechey (1753–1839).

7 Hooker 1846.

8 The *Resolute* was broken up in 1879 and the wood was used to make a
 desk, known today as the Resolute desk. The desk was presented to the
 US President and has been used by most presidents in the Oval Office at
 the White House. The ship's bell was presented in 1965 to US President
 Lyndon Johnson by the British Prime Minister Harold Wilson.

9 Journal, RA VIC/MAIN/QVJ/1853: 9 November.

10 RCIN 1124489. The National Maritime Museum holds a collection of
 20 glass negatives by Inglefield; however, Queen Victoria's album
 contains at least 15 photographs not represented in that collection. Each
 photograph is laid down on the page, with the photographer's initials
 below the print. The majority of the photographs bear captions in pencil.
 Four of the photographs have been overpainted by an unknown hand.

11 Subscription list accompanying a set of the photographs, titled 'Relics of
 Sir John Franklin's Expedition' (Scott Polar Research Institute,
 P97/173). In addition, the Royal Library contains a copy of the
 published account of the expedition, (McClintock 1859), presented by
 Lady Franklin to Queen Victoria (RCIN 1024361).

12 From the 24-page booklet accompanying Anon. 1859.

13 Bradford 1873, p. vii.

14 RA PPTO/PP/QV/MAIN/1874/16919.

15 Nares had previously been the captain of HMS *Challenger*, which sailed
 south in 1872 and crossed the Antarctic Circle, undertaking important
 scientific research. Nares was recalled from *Challenger* in late 1874 in
 order to undertake the British Arctic Expedition.

16 Journal, RA VIC/MAIN/QVJ/1876: 29 October.

17 Ibid.: 2 November.

18 Ibid.: 1 December.

19 Ibid.

G. HUBERT WILKINS (1888–1958)
**The last photograph of
Sir Ernest Shackleton, here talking
to Commander Wild, 1921**
Silver bromide print
80 × 133 mm (3$\frac{1}{8}$ × 5$\frac{1}{4}$ in.)
RCIN 2582420

20 A number of the photographs were also published in Nares 1878 (RCIN 1132765 and 1132766).

21 Young had originally set out to navigate the North-West Passage, but he was asked by the Admiralty to change course in order to make contact with the British Arctic Expedition.

22 Quoted in Mörzer Bruyns 2003, p. 125.

23 Photographs show Sir Allen Young at Balmoral during a shooting party held at the same time as Shackleton's visit, although the two men do not appear in any photographs together (*Balmoral Snapshots 1868–1933*, RCIN 2140000–2140159).

24 Queen Victoria and the Prince and Princess of Wales visited the exhibition twice, on 7 and 21 May 1891. See Lewis-Jones 2005.

25 Piggott 2000, p. 15.

26 See Cook 1900, Huntford 1987 and Christie's, London, sale cat., 27 September 2006, p. 278.

27 Photographs were also taken by John Donald Morrison, who was on board the *Morning*, the relief ship sent out to find *Discovery*, between December 1903 and February 1904.

28 The catalogue included advertisements placed by companies who had supplied goods to the expedition, notably Winsor and Newton Ltd, 'manufacturers of finest Artists Oil & Watercolours & Materials', which would have been used by Dr Wilson. *'Discovery' Antarctic Exhibition*, 1904.

29 Huxley 1977, p. 141.

30 *'Discovery' Antarctic Exhibition* 1904, p. 22.

31 Ibid.

32 National Antarctic Expedition (1901–4) 1908 (RCIN 1090464).

33 RA GV/PRIV/GVD/1904: 28 September.

34 Leaflet, 'Captain Scott's Lecture Tour', National Art Library, London (200.B.28 (1–31)).

35 Riffenburgh 2004, p. 184. See Christie's, London, sale cat., 25 September 2008 (lot 139), for a rare set of stereoscopic photographs from the expedition.

36 Scott 1913, vol. I, p. 418.

37 Three albums of contact prints from these negatives survive in a private collection in London, with a corresponding list of titles and dates in Ponting's own hand.

38 Ponting 1921, p. 55.

39 Scott 1913, vol. I, p. 95.

40 The negatives are in the Scott Polar Research Institute, University of Cambridge.

41 Scott 1913, vol. I, pp. 417–18. After Ponting's departure in March 1912, Debenham took on the duties of main photographer, including developing the photographic film found in the tent with the bodies of Scott, Wilson and Bowers in November 1912. (George) Murray Levick acted as photographer for the Northern Party.

42 Ponting 1921, p. 171.

43 The first film, *With Captain Scott to the South Pole*, covered only the period December 1910 to February 1911, and premiered on 19 October 1911. The film went through different versions before being released in its final version in 1933 as *90° South: With Scott to the Antarctic*.

44 *London Herald*, Tuesday, 11 February 1913.

45 Christie 2004.

46 On 25 June 1911 Wilson and Scott had discussed plans for an exhibition of Ponting's work after they returned to Britain. Wilson 1972, p. 136.

47 Fine Art Society 1913.

48 After Ponting regained the copyright of his photographs, unmounted prints were often issued with ink stamps on the reverse, reading: 'Photograph by Herbert G. Ponting, British Antarctic Expedition, 1910' and 'Herbert G. Ponting copyright'. Beneath the image, the title and 'Scott's Last Expedition' would be written in pencil by a studio hand, and Ponting would add his signature. The collection of Queen Elizabeth The Queen Mother contains six Ponting photographs with these markings, the printing dating to *c*.1925/6 (RCIN 2306097–2306102). At a later date, Ponting appears to have stopped signing his work, with the studio adding his name instead.

49 Ponting 1921, p. 297; RA GV/PRIV/GVD/1914: 12 May.

50 The blindstamp appears to be two separate stamps and is used only on certain carbon prints. It reads: 'H.G. Ponting' and 'copyright'.

51 Close examination of this print (RCIN 2580021) under a microscope has confirmed it is dyed paper that provides the orange colour.

52 Scott 1913, vol. I, p. 98.

53 Ponting 1921, p. 67.

54 Ibid., p. 297.

55 Arnold 1969, p. 83.

56 Wharton 1998, pp. 173 9.

57 Fine Art Society 1913, p. 6.

58 Hurley 1925, pp. 196–7. The expedition artist, George Marston, also lost most of his work in the wreck.

59 Prints had already been made from some of the destroyed negatives, preserved in an album now known as the *Green Album* (Scott Polar Research Institute, University of Cambridge). The surviving negatives are at the Royal Geographical Society, London.

60 Although most of the plates saved were glass plate negatives which were used later for producing black and white prints, Hurley had also made a small number of images using the Paget process, an early colour process which was marketed for a short time from *c*.1913 into the 1920s. While it was a relatively straightforward process, using a black and white negative sandwiched against a colour screen during the exposure, the resulting colours were considered pale and inaccurate when compared with other colour processes of the time. The State Library of New South Wales, Australia, holds 32 examples.

61 Newton 2001, p. 51.

62 To date, six de luxe albums have been identified. See Christie's, London, sale cat., 27 September 2006 (lot 225), and Piggott 2000, p. 129.

63 RA GV/PRIV/GVD/1917: 30 May and 10 October.

64 Swan 1990.

65 Quoted in Dowdeswell and Lane 2006, p. 3.

THE PHOTOGRAPHS

David Hempleman-Adams

Sophie Gordon

Emma Stuart

The titles are adapted from those included in the photograph albums. The dates given refer to the date when the negative was exposed in the camera; the prints were made at a later date, following the departure of the photographers from the Antarctic.

Unless otherwise stated, the photographs are taken from the King's Albums, described in further detail in Appendix 4.

THE BRITISH ANTARCTIC EXPEDITION
1910–1913

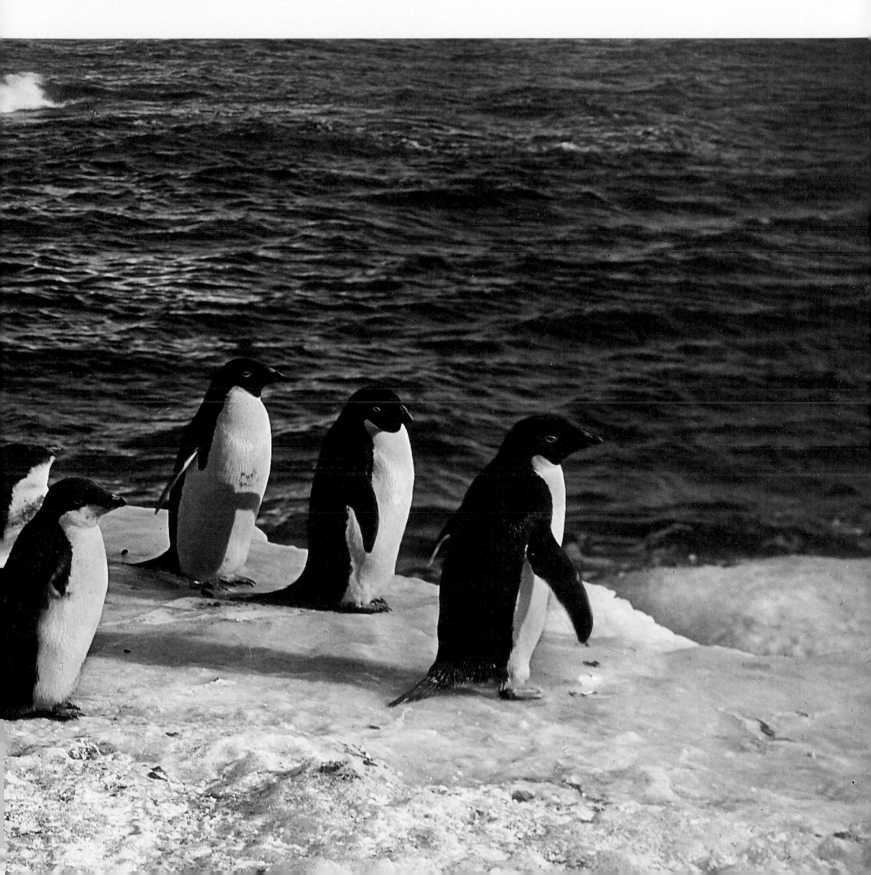

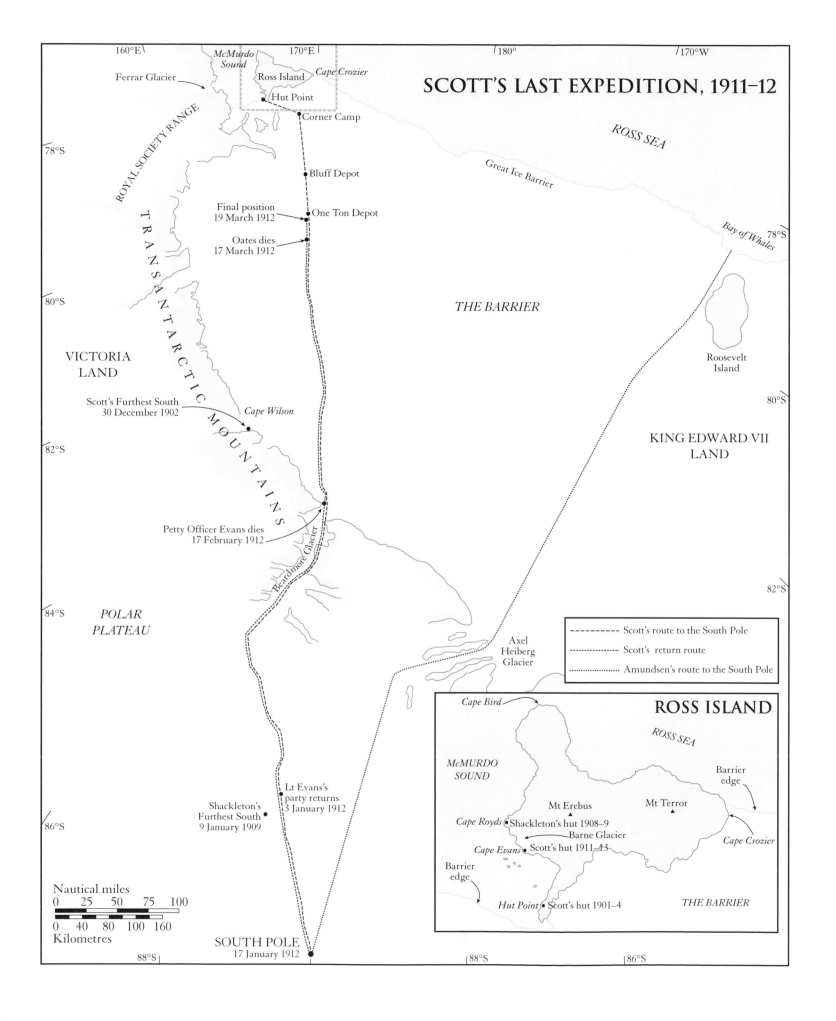

SCOTT'S LAST EXPEDITION, 1911–12

160°E
170°E
180°
170°W

McMurdo Sound

Ferrar Glacier

Ross Island
Cape Crozier

Hut Point

Corner Camp

ROSS SEA

Great Ice Barrier

78°S

ROYAL SOCIETY RANGE

Bluff Depot

Final position
19 March 1912
One Ton Depot

Oates dies
17 March 1912

Bay of Whales

78°S

TRANSANTARCTIC MOUNTAINS

80°S

THE BARRIER

80°S

VICTORIA
LAND

Roosevelt
Island

Scott's Furthest South
30 December 1902

Cape Wilson

80°S

KING EDWARD VII
LAND

82°S

82°S

Petty Officer Evans dies
17 February 1912

Beardmore Glacier

82°S

84°S

*POLAR
PLATEAU*

Axel
Heiberg
Glacier

— — — Scott's route to the South Pole

· · · · · Scott's return route

· · · · · Amundsen's route to the South Pole

ROSS ISLAND

Cape Bird

ROSS SEA

86°S

Lt Evans's
party returns
3 January 1912

Shackleton's
Furthest South
9 January 1909

*McMURDO
SOUND*

Mt Erebus

Mt Terror

Barrier
edge

Cape Royds • Shackleton's hut 1908–9

Barne Glacier

Cape Crozier

Cape Evans • Scott's hut 1911–13

Nautical miles

0 25 50 75 100

0 40 80 100 160

Kilometres

Barrier
edge

Hut Point • Scott's hut 1901–4

THE BARRIER

SOUTH POLE
17 January 1912

88°S

88°S

86°S

1. Herbert Ponting, with cinematographic camera, 1911

This portrait shows Ponting in the Antarctic with his J.A. Prestwich cinematographic camera. Ponting had no experience of filming motion pictures before he went to the Antarctic, but he learnt quickly and by the end of February 1911, while he was still in Antarctica, the first batch of film was ready to be sent home to be premiered in London on 19 October 1911. Ponting was always present to record the activities of the Shore Party, which inspired Cecil Meares to compose a song about the photographer, whose nickname was 'Ponko' *(see below)*.

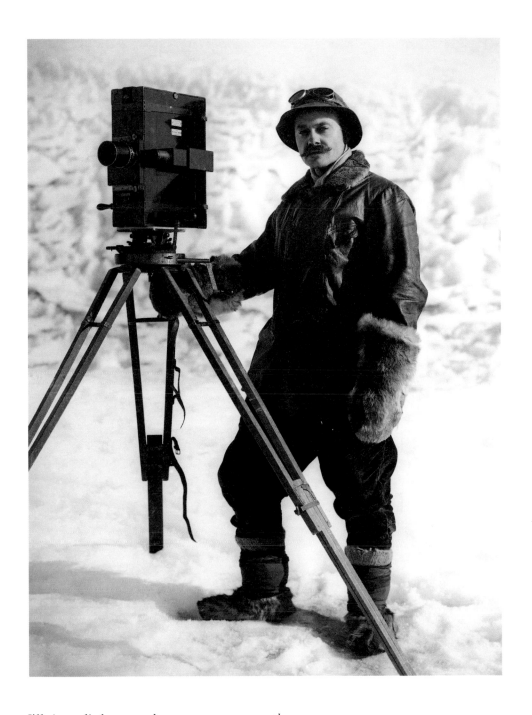

I'll sing a little song, about one among our throng,
Whose skill in making pictures is not wanting.
He takes pictures while you wait, 'prices strictly moderate';
I refer, of course, to our Professor Ponting.

Then pont, Ponko, pont, and long may Ponko pont;
With his finger on the trigger of the 'gadget'.
For whenever he's around, we're sure to hear the sound
Of his high-speed cinematographic ratchet.

(*South Polar Times*, 3 October 1911)

2. **Cirrus clouds over the Barne Glacier, 19 December 1911**

Ponting produced a number of studies of clouds over the Barne Glacier during the summer of December 1911 to January 1912. The effects of the sun through the different cloud types would have produced startling colour combinations, and Ponting suggests this through his decision to print onto orange paper. A blue version of this photograph was also produced. The FAS exhibition catalogue described the scene: 'The streamers were red and vivid as flames, whilst the sky behind them was deep azure blue' (FAS 1913, no. 112).

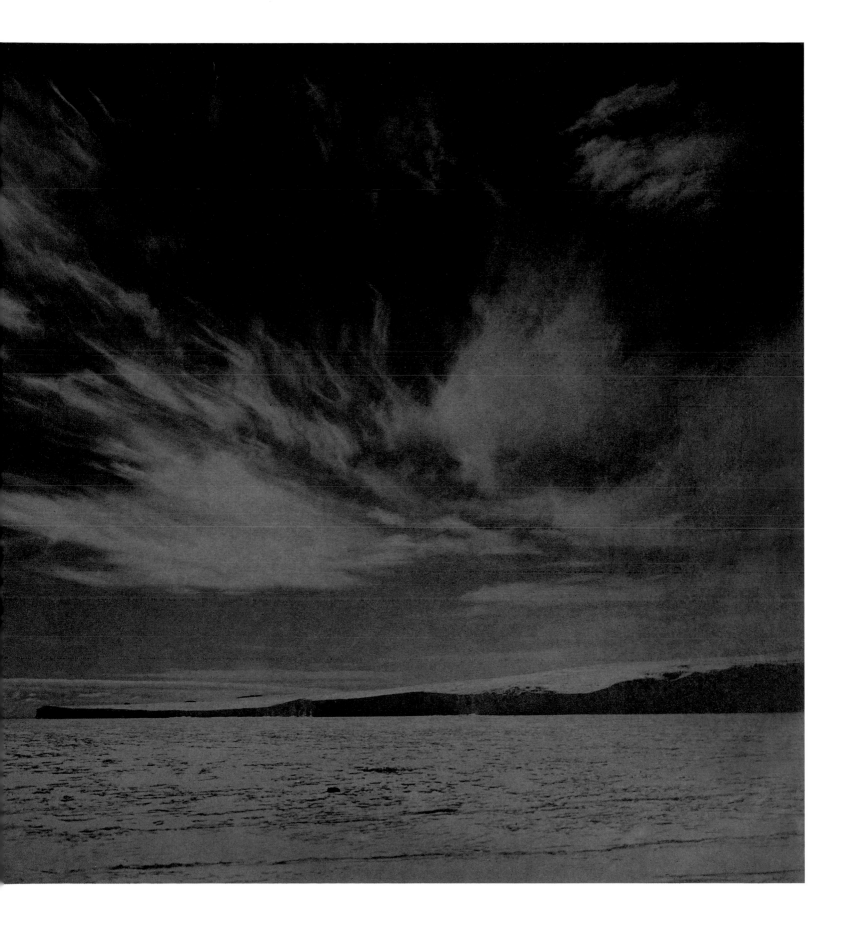

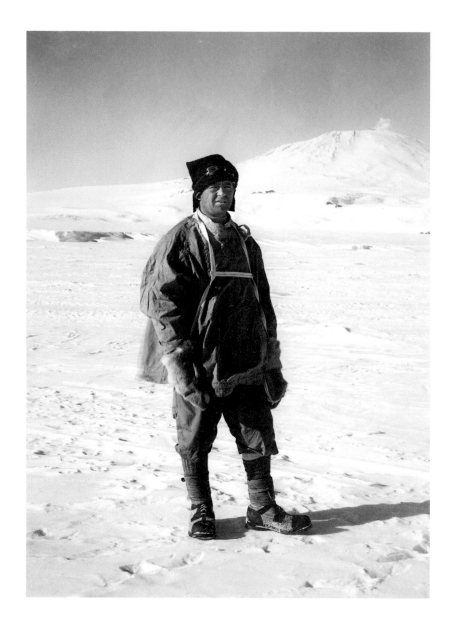

(right)

4. **The hut at Cape Evans, 26 March 1911**

It is still possible to visit Scott's hut at Cape Evans on Ross Island. Even though there is water in the bay, which shows it is still summer, this image portrays the utter desolation and isolation of the place. When the ship departed the men were left to fend for themselves. The stores are piled high close to the hut. If you look at the size of the hut which was to be their home during the winter, it looks minuscule. Of course, it was set up high to avoid the sea. This is a dramatic night shot which makes you shiver just looking at it. *DHA*

3. **Captain Scott, RN, CVO, February 1911**

This photograph of Captain Scott portrays the man in his element, with Mount Erebus in the background. The fact that he has placed his snow goggles on his hat so we can see his face shows a little vanity. I've rarely taken goggles off during an expedition. If you look carefully you can see that he is wearing fur gloves with attached cord, leather boots, gaiters and thick socks. This was taken at the start of the expedition and the expression on his face is posed; he appears healthy, confident and assured of the future. *DHA*

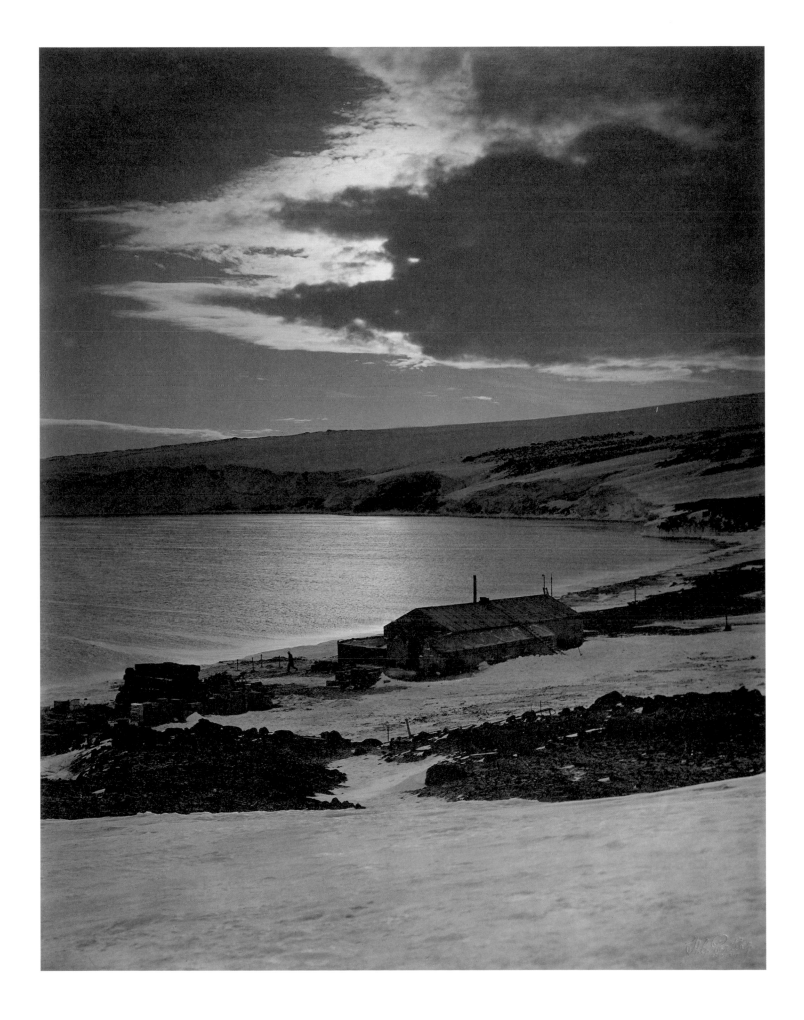

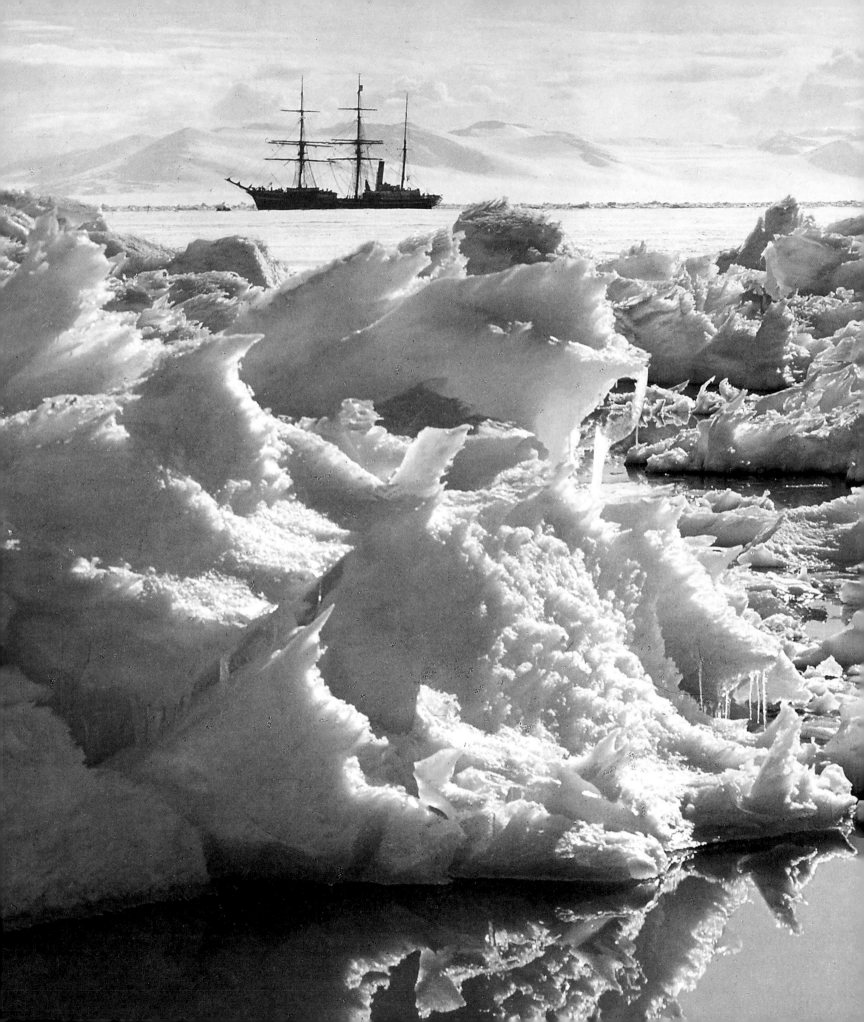

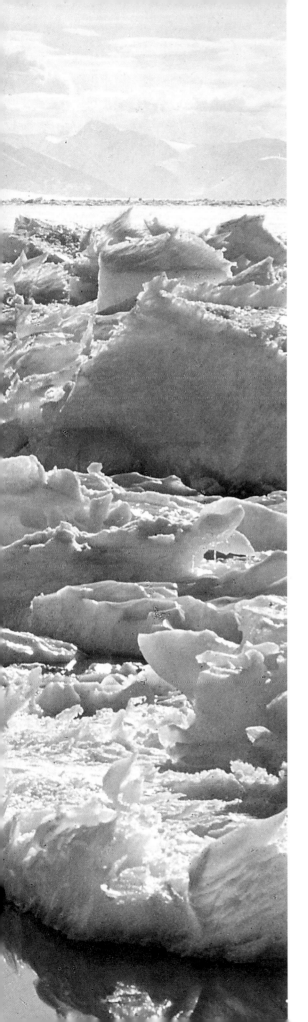

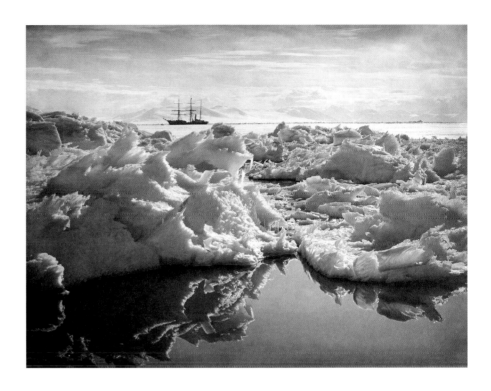

5. The *Terra Nova* in McMurdo Sound, 7 January 1911

This view of the *Terra Nova*, one of Ponting's best-known photographs, was taken while he was standing on unstable ice floes, a few days after the ship had reached landfall in the Antarctic. The description in the FAS exhibition catalogue is fulsome: 'This study, made on a dead-calm day, shows a berg in the last stage of decay, from the action of the sun and sea. In this condition the ice frequently assumes the most beautiful shapes imaginable, which, seen reflected in the surface of the sea, sometimes form a scene of extraordinary beauty. Owing to the treacherous nature of such ice, it is exceedingly dangerous to approach' (FAS 1913, no. 25).

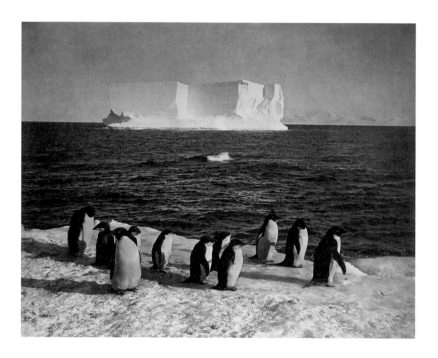

6. Tabular iceberg off Cape Royds, 13 February 1911

(right)
7. **The Castle Berg, with dog sledge, 17 September 1911**

Ponting returned several times to photograph the Castle Berg, even setting up flashlights on one occasion in June 1911, the middle of the Antarctic winter, to photograph it. 'This was the most beautiful iceberg seen by the Expedition. It was frozen into the ice about a mile from the hut and provided Mr Ponting with material for many fine studies. In shape it resembled a medieval castle, hence the name given to it. It was about 100 feet high, and was a good example of the picturesque shapes into which overturned icebergs are sometimes worn by the erosive action of the wind and water' (FAS 1913, no. 71).

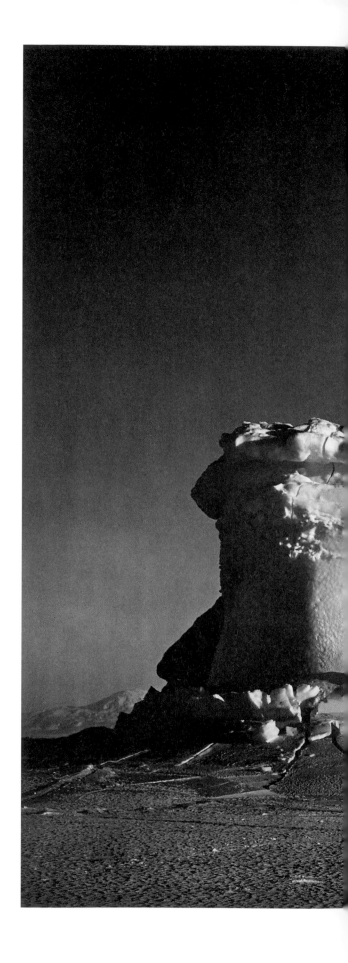

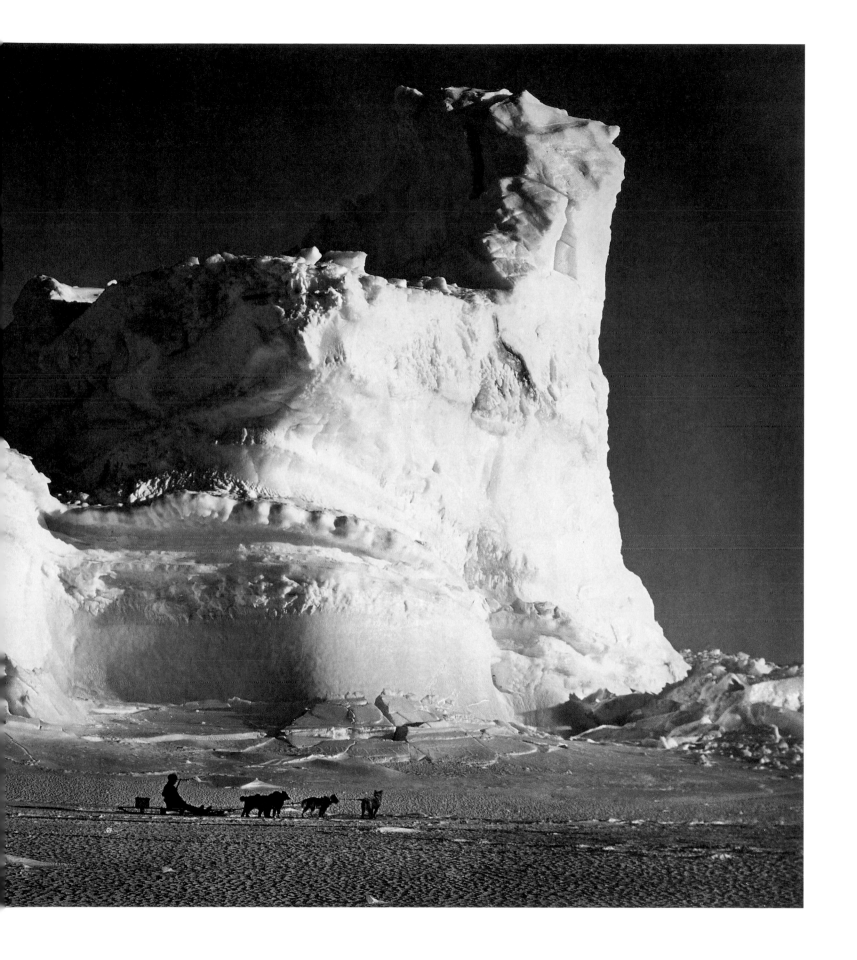

(right)
9. **Osman, 'our best sledge dog', 1911**

Osman, who had been a gift to the expedition from Richmond School in Yorkshire, quickly established himself as the leader of the pack. He had suffered greatly during the stormy journey from New Zealand to Antarctica, arousing Scott's sympathy, but he was soon back on form. Most of the dogs that accompanied Scott to the Antarctic survived (they did not accompany Scott to the South Pole), and Osman was taken to New Zealand by Dimitri Gerof, the dog handler, where he lived out a happy retirement.

8. **Vida, 1911**

Scott described the unusual relationship that he struck up with the bad-tempered husky Vida. 'He became a bad wreck with his poor coat at Hut Point, and in this condition I used to massage him; at first the operation was mistrusted and only continued to the accompaniment of much growling, but later he evidently grew to like the warming effect and sidled up to me whenever I came out of the hut, although still with some suspicion … He is a strange beast – I imagine so unused to kindness that it took him time to appreciate it' (Scott 1913, vol. I, pp. 275–6).

10. **Captain Lawrence Oates and Siberian ponies on board *Terra Nova*, 1910**

Photographs brought in money for an expedition, as well as possible fame and fortune for the photographer. One of the aims was to document every trivial aspect of an expedition. When they were in Antarctica, they used all sorts of transport: huskies, Siberian ponies, tractors (the forerunner of snowmobiles). This photograph shows Oates with four Siberian ponies and two huskies curled up on the ground. Ponting was more of an artist than Hurley and you can see that Oates is posing for the camera with the ponies. Scott's attitude towards his animals differed greatly from Amundsen's: Roald Amundsen used animals for one purpose only – to get him to the Pole – even if they had to be killed and fed to each other. *DHA*

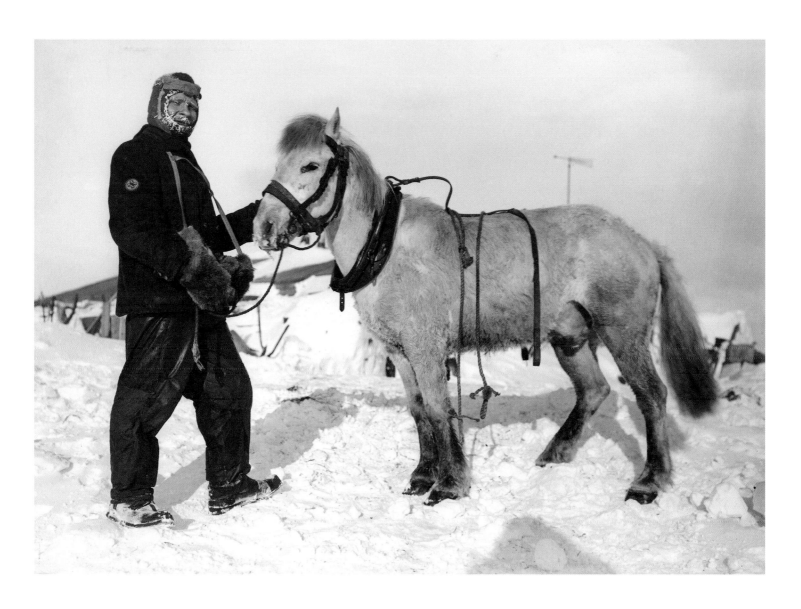

11. **Petty Officer Evans and Snatcher the pony, October 1911**
Toned silver bromide print, on board, 336 × 454 mm (13¼ × 17⅞ in.)
Blindstamp, *H.G. Ponting*; FAS gallery label on verso, with caption and
The British Antarctic Expedition 1910–1913 catalogue number, 'No. 128'
RCIN 501038

Introducing the ponies to the extreme conditions of the Antarctic brought all sorts
of difficulties. Snow blindness was a particular problem, and various solutions were
proposed, including dying the ponies' forelocks and making sun bonnets. The
ponies also found it hard to walk through the snow, and they would sometimes
sink in up to their bellies. This was a serious issue, as it would slow down the
progress of any march. In an attempt to solve this, Evans began trialling snowshoes
on his pony Snatcher, although both the form of the shoe and the method of its
attachment proved to be problematic.

This photograph is not from the album obtained by King George V, but was
acquired framed, either by gift or purchase, directly from the Fine Art Society.

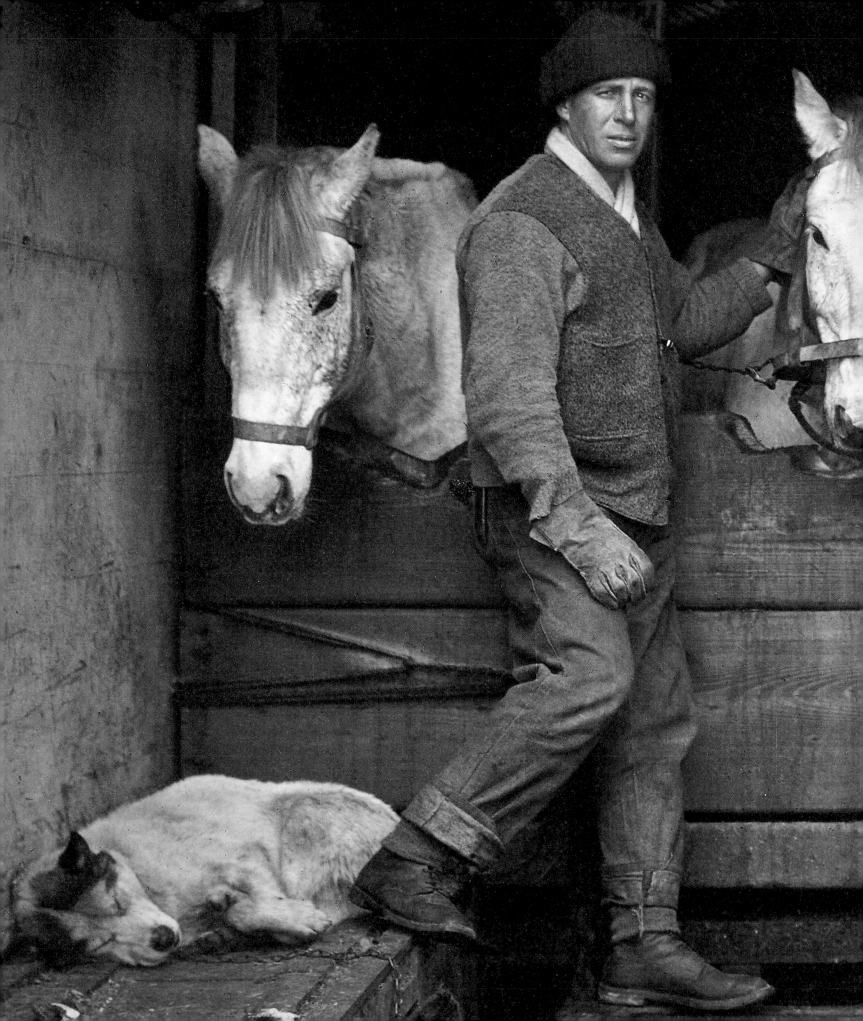

12. The Shore Party, January 1911

This is a great photograph as it shows all the men posing next to the hut. This was the Shore Party, who stayed throughout the winter. In the front row some of them are sitting on sledges. Tom Crean *(bottom right)* is smoking a clay pipe and grinning broadly, unlike the others, who look rather serious as they pose for the photographer. They are all wearing hats and thick woollies. It is interesting that only Scott *(standing, centre)* is wearing his outer parka, as if ready for action. He's purposefully looking away from the camera with an expression that suggests he is contemplating the huge task ahead. A strange relationship existed between the photographer and the team. Everyone realised the importance of keeping a record, but these photographs often took a long time to set up in freezing temperatures. The men's patience would have been tested to the limits. *DHA*

(See p. 226 for the names of those pictured here.)

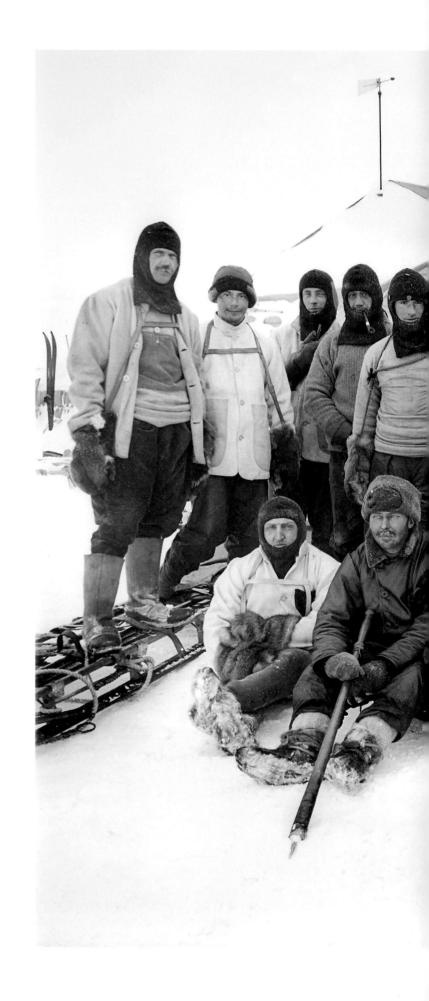

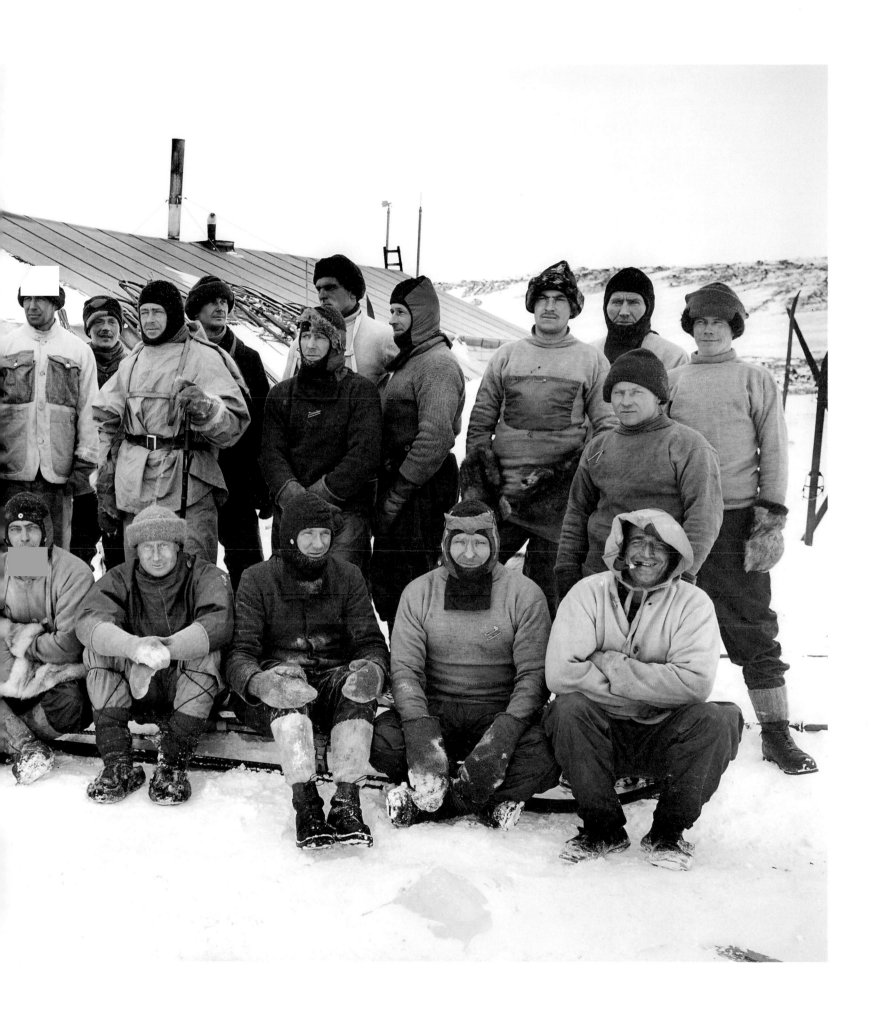

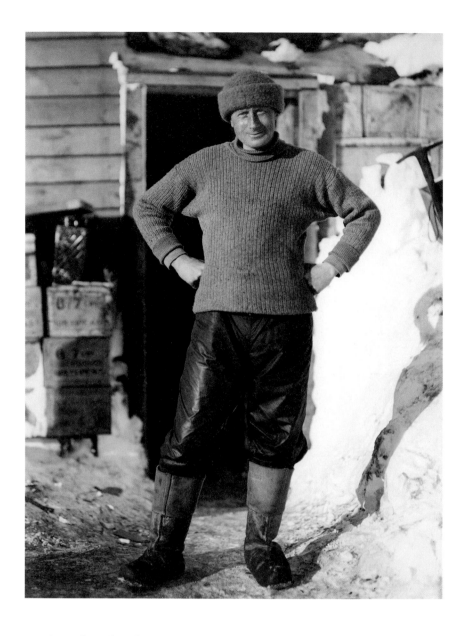

(right)
14. **Lieutenant Henry Bowers, 11 October 1911**

Lieutenant Henry Bowers (1883–1912), known as 'Birdie' because of his protuberant nose, was considered one of the most indomitable characters on the expedition, for whom cold, fatigue and discomfort did not exist. He was the surprise 'fifth man' in the Polar Party (all previous calculations being based on four men), but his sterling qualities persuaded Scott to include him. In a last letter to Bowers's mother, Scott dwelt on these qualities: 'As the troubles have thickened his dauntless spirit ever shone brighter and he has remained cheerful, hopeful, and indomitable to the end. The ways of Providence are inscrutable, but there must be some reason why such a young, vigorous and promising life is taken' (Scott 1913, vol. I, p. 598).

13. **Dr Edward Wilson, October 1911**

The set of four portraits of the Polar Party (Wilson, Bowers, Oates and Evans) that Ponting took in about October 1911, shortly before their departure, and one of Scott taken several months earlier (no. 3), were the only individual portraits included in the presentation album to King George V. They were presented as a set of five in the FAS exhibition catalogue, sold at 1 guinea each, or 4 guineas for the set in a portfolio.

Dr Edward Wilson (1872–1912), or Uncle Bill, had first been south on the *Discovery* expedition and was one of the three men to achieve Furthest South in 1903. He became one of Scott's closest friends and was made chief of the scientific staff on the *Terra Nova* expedition. It was inevitable that Scott should appoint him to the Polar Party, needing his emotional support as much as his practical abilities. As they lay dying, Scott wrote to Wilson's wife Oriana: 'His eyes have a comfortable blue look of hope and his mind is peaceful with the satisfaction of his faith in regarding himself as part of the great scheme of the Almighty' (Scott 1913, vol. I, p. 597).

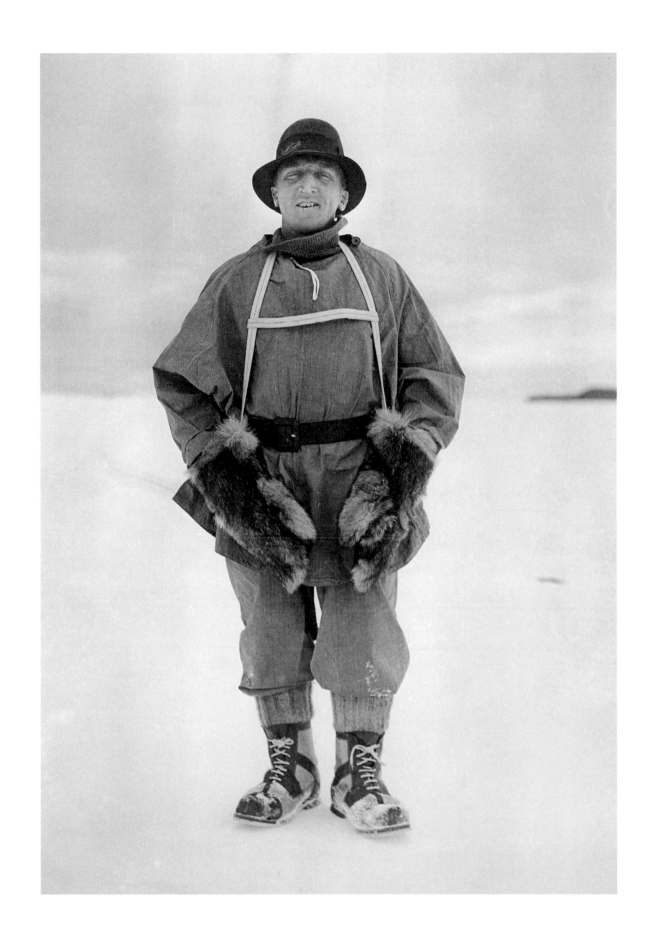

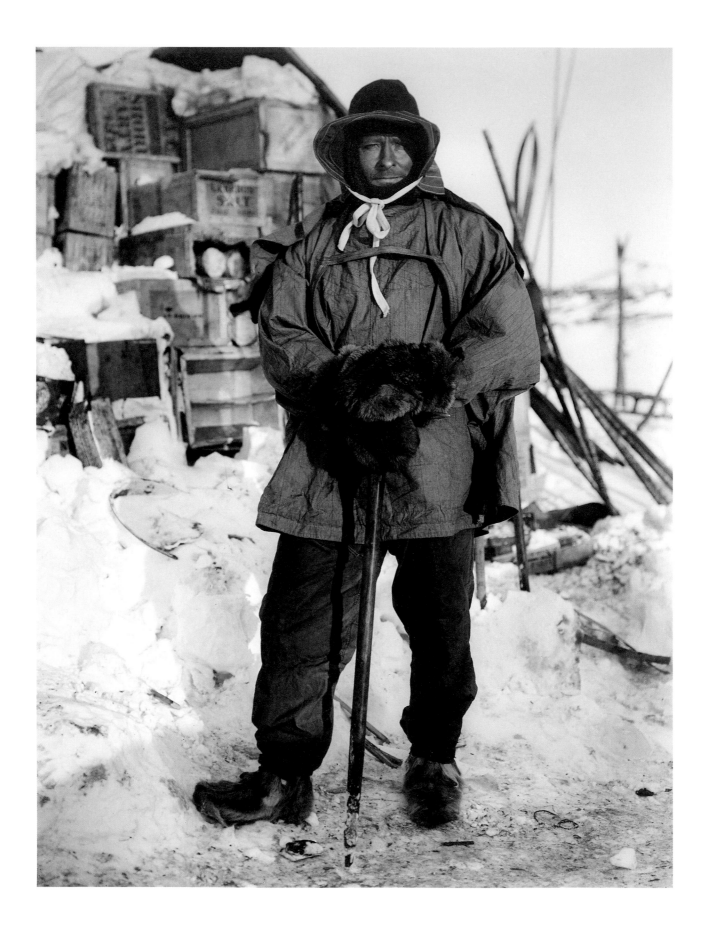

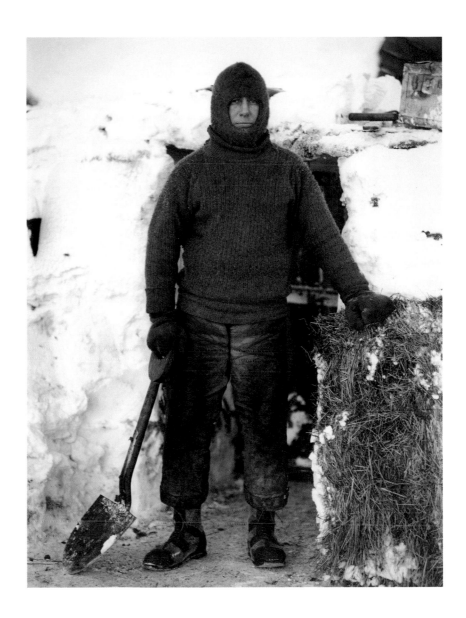

(left)

15. **Petty Officer Edgar Evans,
November 1911**

Petty Officer Edgar Evans (1876–1912),
known as 'Taff' (being a Welshman), was an
Antarctic veteran from Scott's *Discovery*
expedition. He was immensely strong and
resourceful, and was probably Scott's most
trusted member on the lower decks and
indispensable as a companion in the Polar
Party. His decline on the return march was
thus all the more appalling. On 17 February
Scott wrote of Evans's demise: 'A very terrible
day … [I was] shocked at his appearance; he
was on his knees with clothing disarranged,
hands uncovered and frostbitten, and a wild
look in his eyes … When we returned [with
the sledge] he was practically unconscious,
and when we got him into the tent quite
comatose. He died quietly at 12.30 A.M.'
(Scott 1913, vol. I, pp. 572–3).

16. **Captain Lawrence Oates, October–November 1911**

Captain Lawrence Oates (1880–1912), known as 'Titus' or 'Soldier',
was described by his companions as a lovable old pessimist, or an
exceptionally polite stable hand, so unassuming was he, but his expertise
with the ponies was crucial to the success of the expedition. He developed
severe frostbite on the return march from the Pole, and on 17 March he
chose to abandon his comrades rather than delay their march. Scott
wrote: 'Oates' last thoughts were of his Mother … He did not – would
not – give up hope to the very end … He slept through the night before
last, hoping not to wake; but he woke in the morning – yesterday. It was
blowing a blizzard. He said, "I am just going outside and may be some
time"' (Scott 1913, vol. I, p. 592).

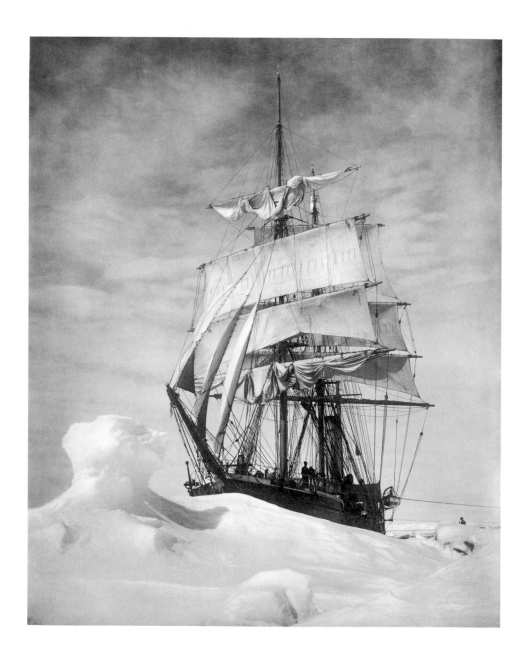

(right)
18. **The ramparts of Mount Erebus, 1911**

17. **The *Terra Nova* icebound in the pack, 13 December 1910**

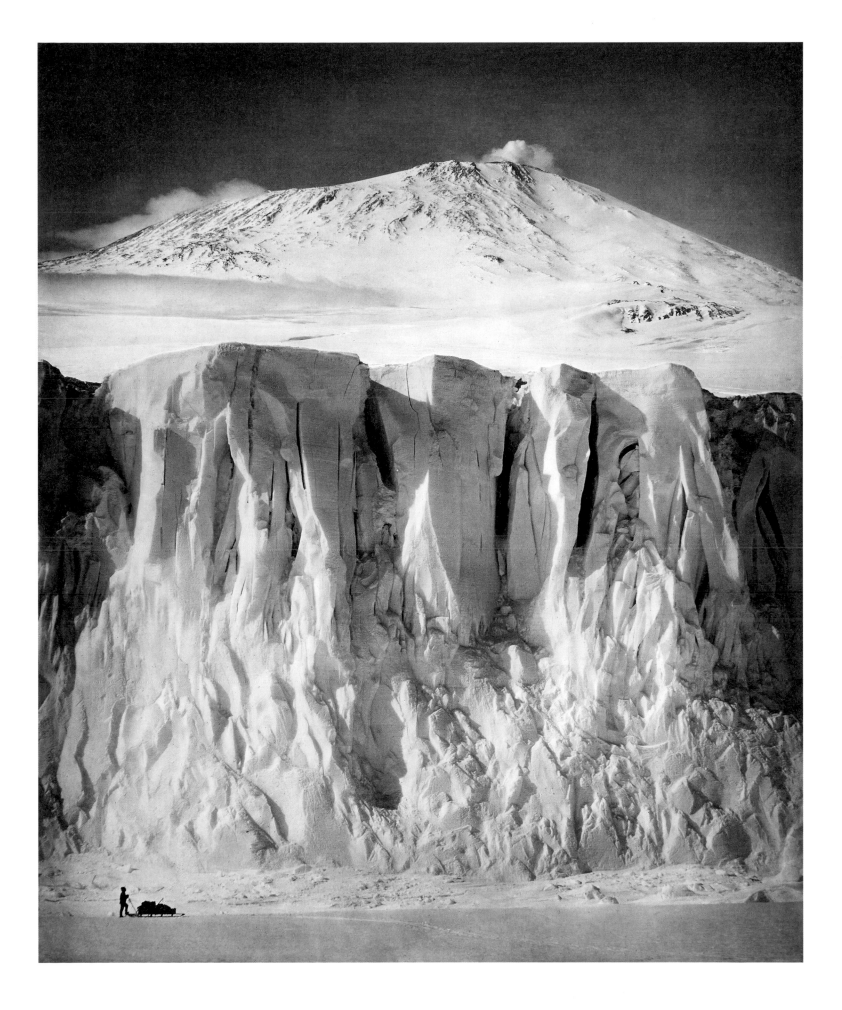

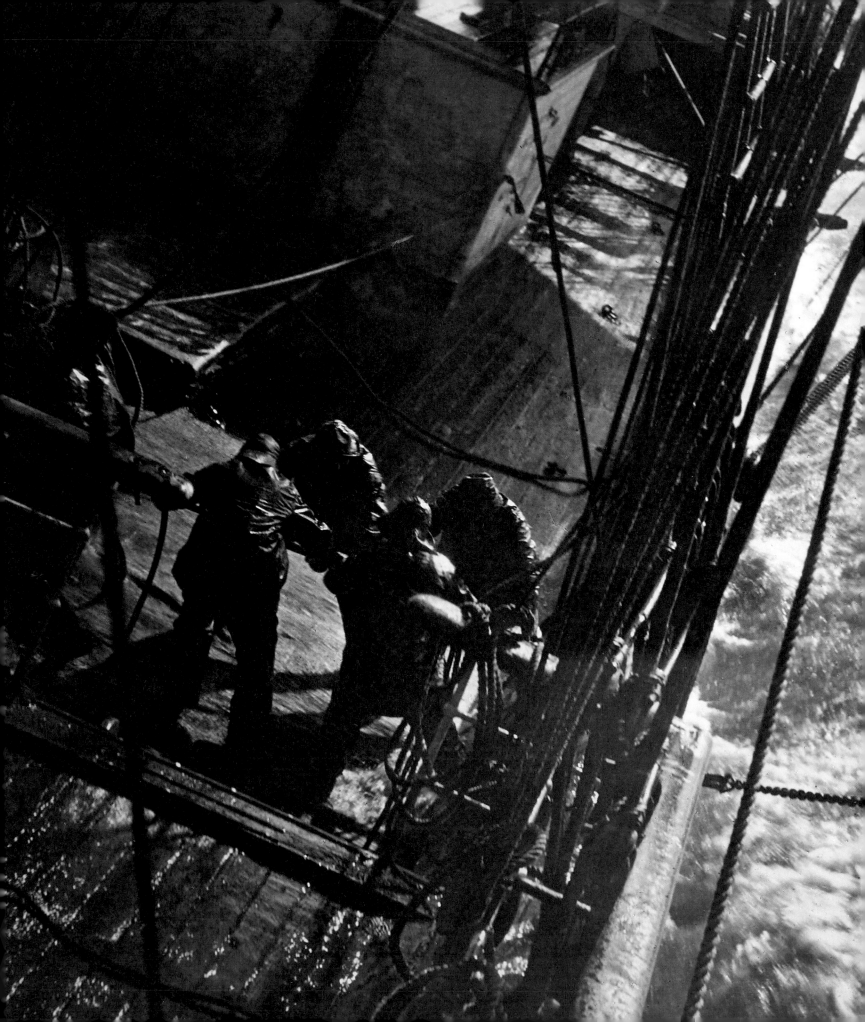

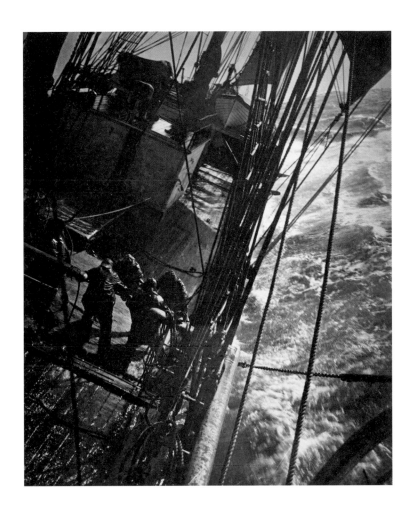

19. **The *Terra Nova* in a gale, March 1912**

Just to get to and from Antarctica was a major expedition in itself. These wooden ships went down through the Southern Ocean, transporting dogs and ponies through the Roaring Forties. This was a major undertaking and they often encountered severe storms. The photograph shows the *Terra Nova* in a gale. The ship is on its side, punching its way into a wave. It dramatically depicts the men working on the deck when they could so easily have been swept to their deaths. Ponting would have been risking his own life to take this photograph from the rigging in order to capture the men, cold and wet, in this dangerous situation. *DHA*

This photograph is sometimes dated to 1910, from the time of the outward journey to Antarctica. In the FAS exhibition catalogue, for example, it is listed in a section titled 'On the Way South'. It is more likely, however, that it was taken on the homeward journey to New Zealand in 1912 (Riffenburgh and Cruwys 2004, p. 76).

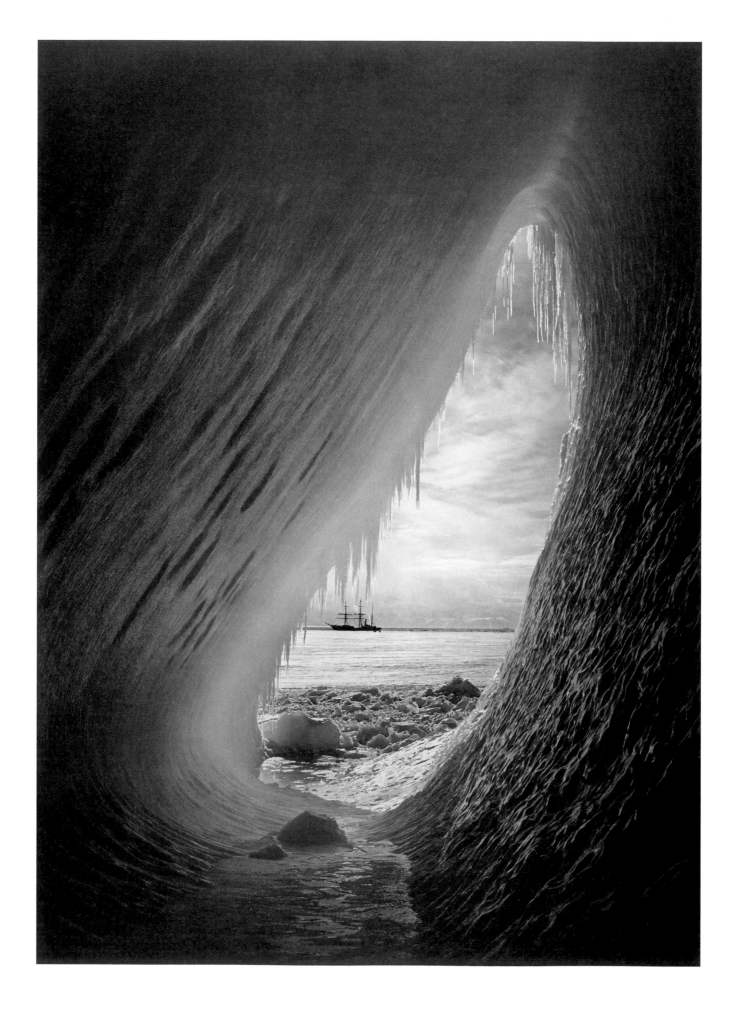

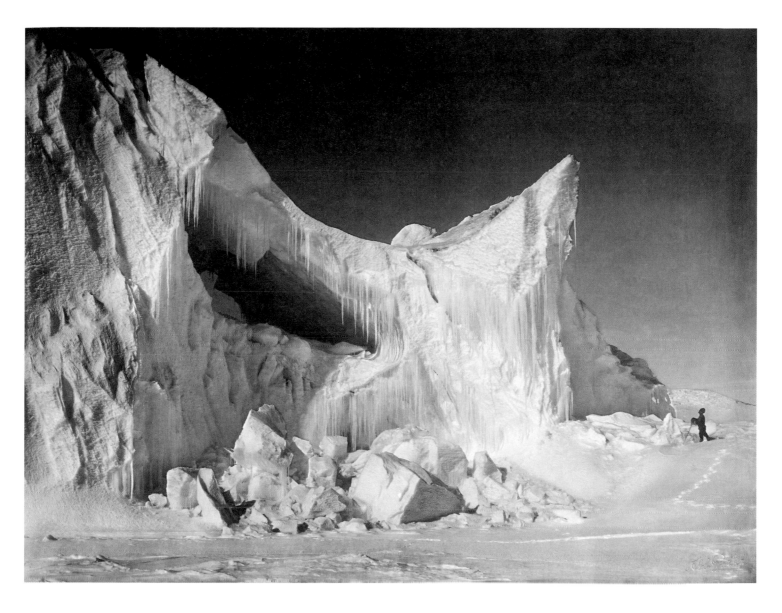

(left)

20. **Grotto in an iceberg, 5 January 1911**

This iconic photograph shows Ponting at his best. It is one of the best photographs from any polar expedition. The ship is in the bay and the picture is taken from the inside of an ice grotto. The photograph is beautifully composed, opening in the shape of a wave curling around a surfer. However, it doesn't capture the beauty of the blues and the light. The first time I saw this image I thought it was stunning. It is as significant an image as Neil Armstrong standing on the moon for the first time. *DHA*

21. **A weathered iceberg, 29 December 1911**

The subject is the same iceberg as seen in no. 20, photographed almost one year later, when the ice cavern has melted in the summer sun and shifted sideways. Ponting returned several times to this ice grotto during 1911, photographing both the interior and the exterior, with human figures and without.

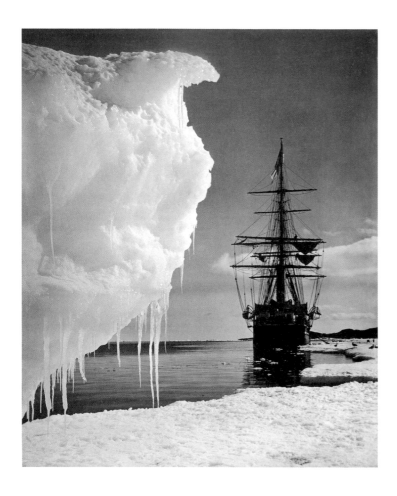

22. The *Terra Nova* at the ice foot, Cape Evans, 16 January 1911

This photograph was taken in midsummer. It was critical that the ship got as close to the hut as possible and that the team unloaded the stores before there was a storm or any adverse weather. It would have been very important that the ship then departed on time so it wouldn't get stuck in the pack ice on its return. This photograph shows wildlife (birds) along the edge, which you wouldn't have seen in the winter, and the open water. There is a remarkable stillness about this image which I love. It would have been relatively warm and at this time of year Ponting would have been able to use the time to take picturesque photographs. The gentle curve of the icicles mirrors the shape of the ship. *DHA*

(right)
23. Midnight in the Antarctic summer, 30 January 1911

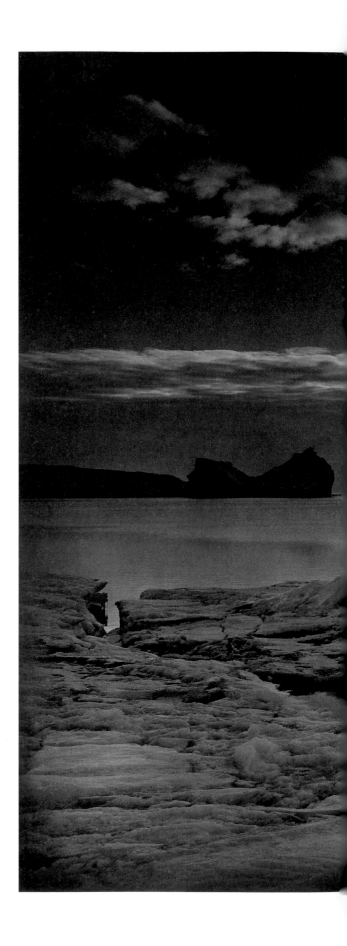

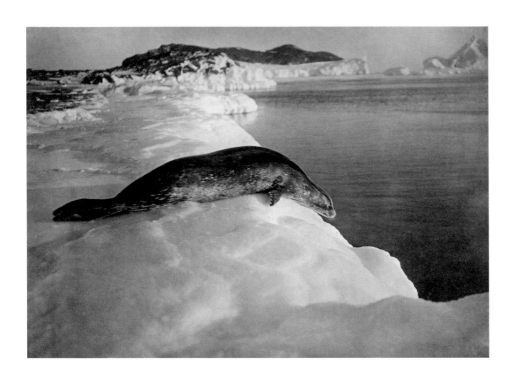

24. Weddell seal about to dive, Cape Evans, 15 March 1911

The Weddell seal, like the Weddell Sea, is named after the navigator Sir James Weddell (1787–1834), who undertook several expeditions in the Antarctic regions, hunting for whales and the seals that now carry his name. The Weddell seal can reach depths of over 2,000 feet (600m) during a dive and can stay underwater for up to an hour, during which time it will swim underneath the ice, searching for places to break through and create breathing holes for when it needs to surface.

(right)
25. Weddell seal on the beach at Cape Evans, November 1911 – March 1912

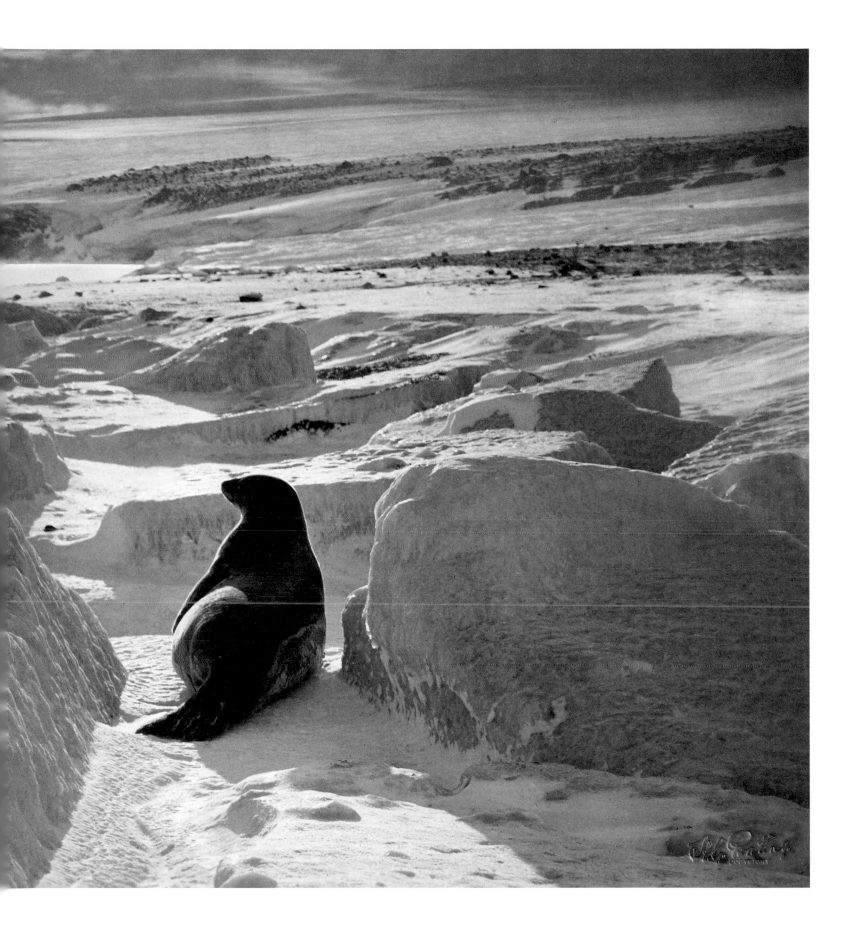

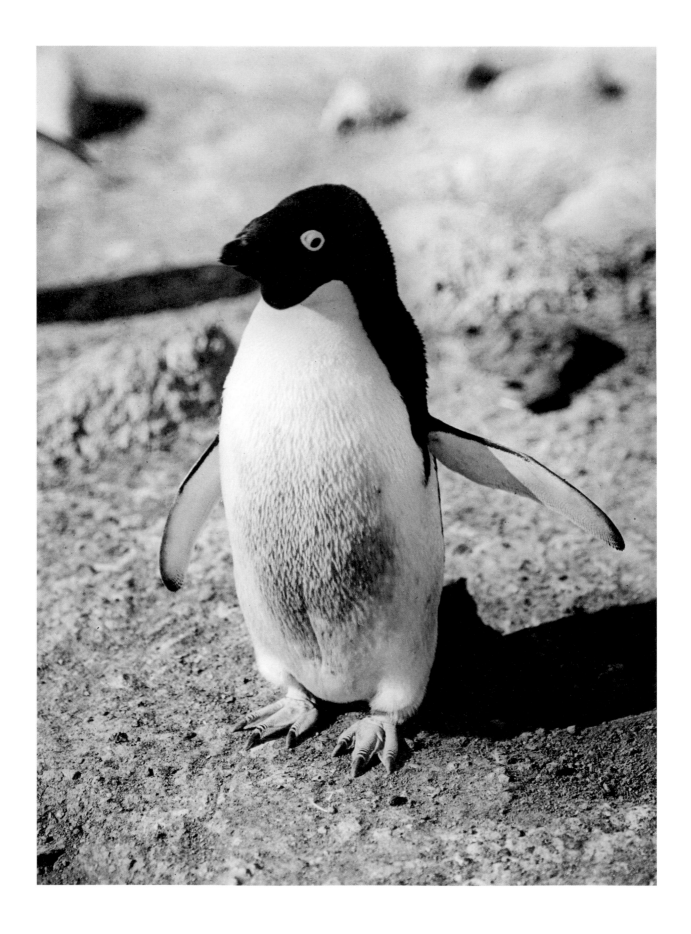

(left)

26. **The 'Glad Eye', November 1911 – March 1912**

The image of the 'Glad Eye penguin' (an Adélie penguin) was used to advertise Ponting's lectures in Britain following his return home. It became a popular image and was reproduced as a postcard by the FAS in 1913, along with its partner, the 'Stony Stare' *(right)*.

27. **The 'Stony Stare', November 1911 – March 1912**

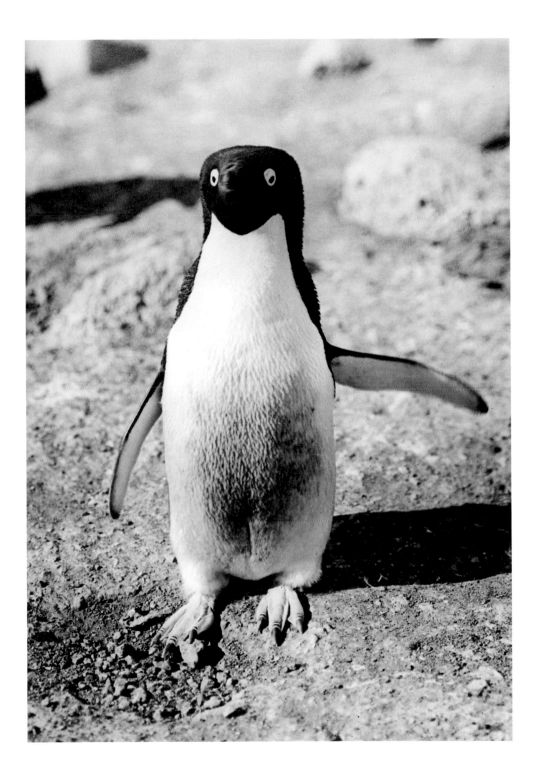

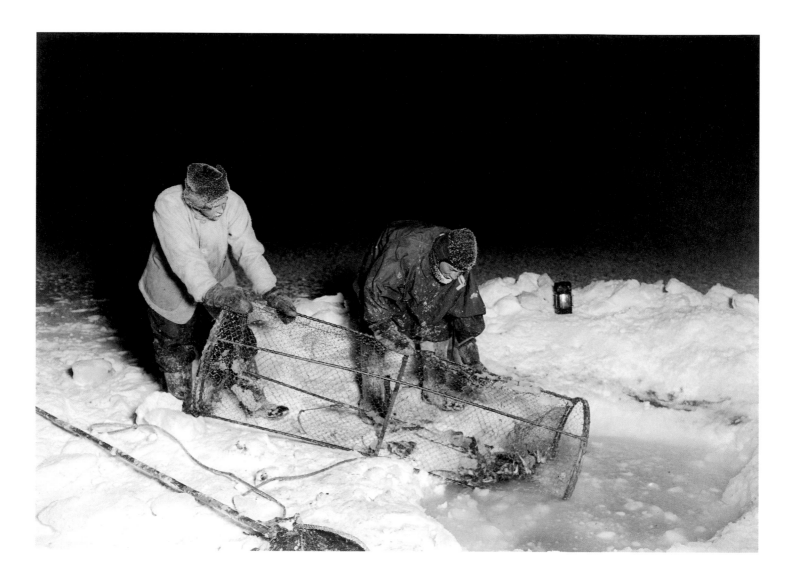

28. **Dr Atkinson and Clissold hauling up the fish trap, forty degrees below zero [−40 °F/−40 °C], 28 May 1911**

There is no other photograph that instantly tells me how brutally cold it must have been in midwinter. The men's hands would have frozen beneath their gloves as they created an opening in the ice and pulled up a fish trap in the name of science. Ice crystals are clearly visible on their clothes. *DHA*

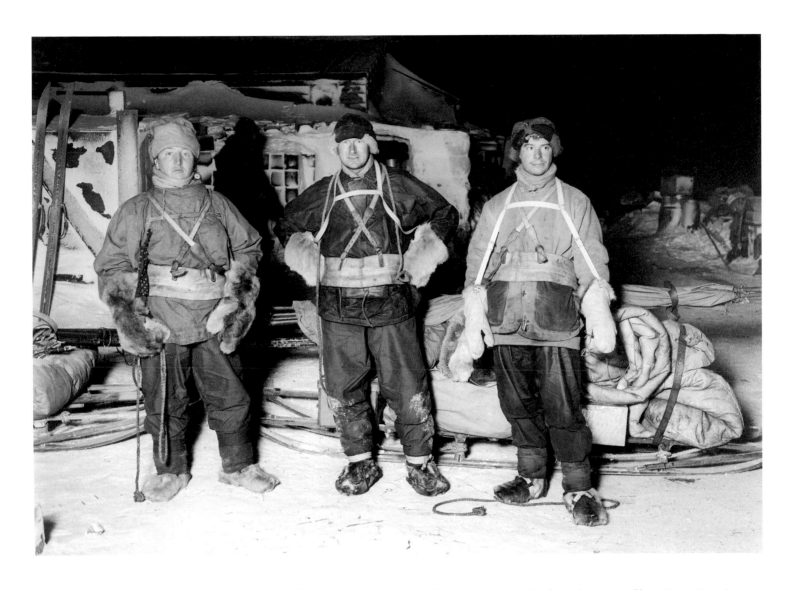

29. The winter journey to Cape Crozier, June 1911

From left to right: Bowers, Wilson and Cherry-Garrard

This photograph shows the intrepid trio before they set off to Cape Crozier in midwinter in search of Emperor penguin eggs. The trip was conceived by Dr Wilson and he was accompanied by Bowers and Cherry-Garrard. 'Cherry' afterwards described this as 'the worst journey in the world', which became the title of his book. The conditions the men endured were appalling. This photograph is particularly striking as we know what they went through shortly after it was taken. The men are ready for action, covered up in their layers of clothing, only revealing their faces. They appear apprehensive, the sledges behind them ready to go. They succeeded in returning with three eggs, which Cherry-Garrard took to the Natural History Museum in South Kensington in 1913. Despite the dreadful journey, the museum worker was too busy to acknowledge what they had gone through to get the eggs. Cherry described the moment: 'The Chief Custodian takes them into custody without a word of thanks' (Cherry-Garrard 1922, vol. 1, p. 299). *DHA*

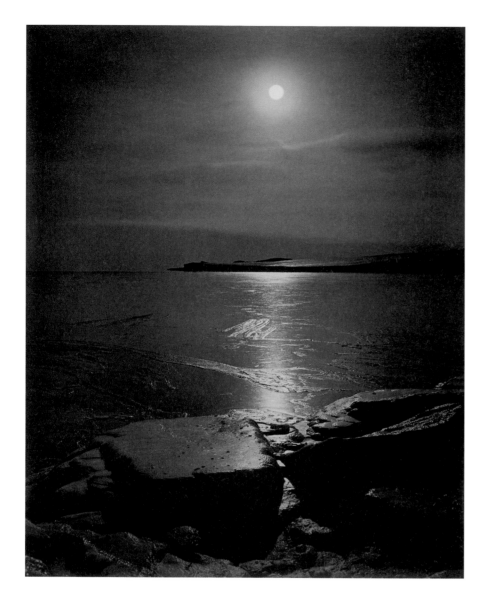

(right)
31. **End of the Barne Glacier, 1911**

30. **The freezing of the sea, April 1911**

The hut would have been completed by the beginning of winter, the dogs
would be in their kennels and the ponies stabled. Carpenters and craftsmen
would have worked on the hut in preparation for the oncoming winter
months. When the sea froze for the first time the team would have realised
that there was no going home. In this photograph you can see the ice forming
on the sea; it is a magical moment and very atmospheric. The light from the
sun going down reflects off the ice and Ponting manages to include the big
boulders on the shore. *DHA*

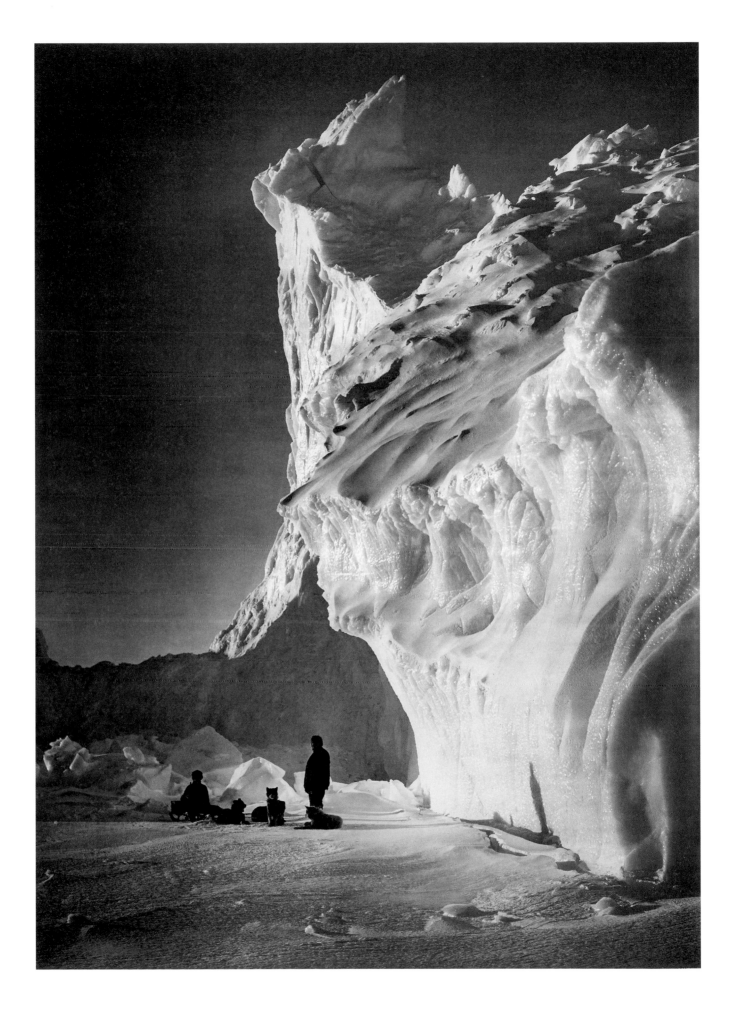

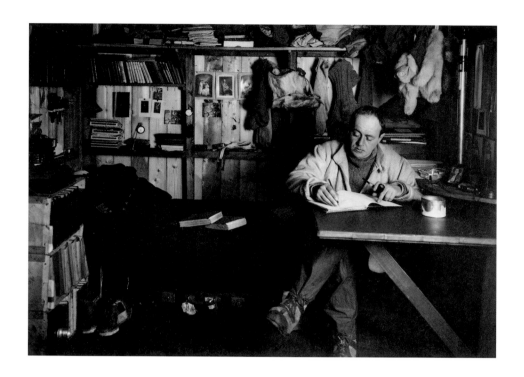

32. **Captain Scott writing his diary, 7 October 1911**

This is probably the best-known image of Scott in the Antarctic. It was taken
about three weeks before he embarked on his journey to the South Pole. Scott
is sitting at his desk, pipe in hand, writing his diary conscientiously. He is
casually dressed in his jumper, jacket and indoor boots. To his left is a small
photograph of his wife, Kathleen. Scott made his living quarters as homely as
possible; his bunk is surrounded by shelves of books and diaries. Underneath
his bed we can see his suitcase. The carpenters made sure Scott had a place to
put all his personal belongings: there is a rack of pipes, clothes are hanging up
to dry and photographs are displayed. Scott appears to be a man in his prime,
at ease in his small, carefully carved-out den in the Antarctic. Scott's prized
home is sectioned off from his team, who slept in bunk beds in one room. *DHA*

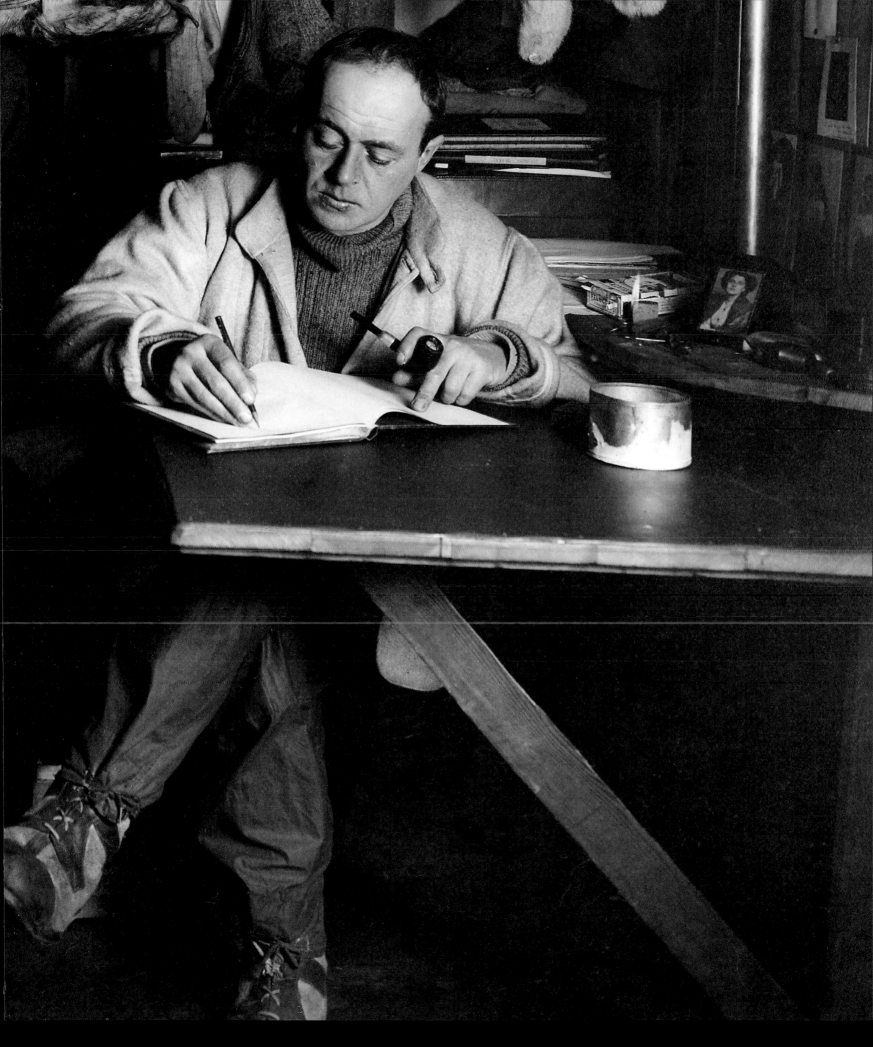

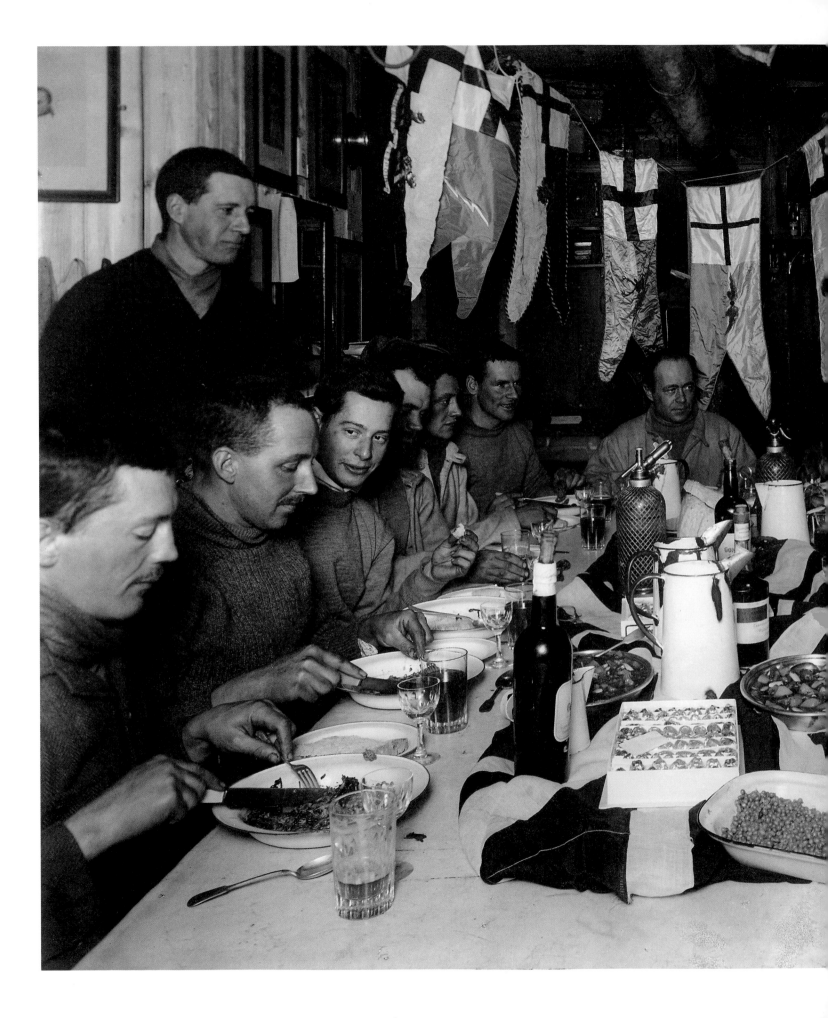

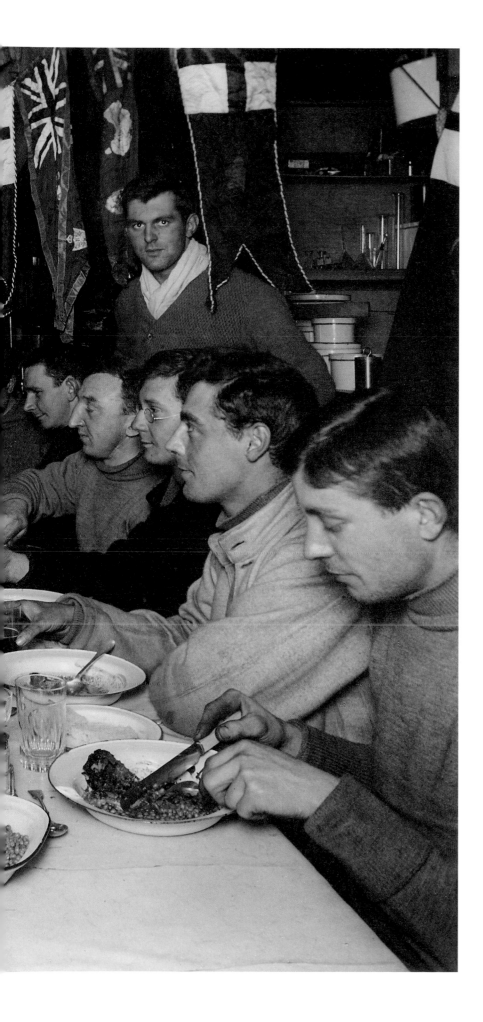

33. Captain Scott's last birthday dinner (aged 43), 6 June 1911

This photograph of the officers' table for Scott's birthday dinner is revealing in several ways. It shows that they ate very well and that on this special occasion they took great care with the presentation of the meal. They transported the best food that was available to them, which included potatoes, beans and even relative luxuries such as chocolates and wine. The serving dishes and spoons are good quality and they even have wine glasses and salt and pepper holders. Scott's position at the head of the table shows immediately who is the leader. There is a strong patriotic atmosphere: a Union Jack is laid out on the centre of the table and behind Scott we see the sledge flags belonging to the team. Photographic portraits of the King and Queen are visible on the wall. It is important to note that this is a highly controlled photograph. Only one man is looking at the camera. The rest are eating with knives and forks with their best table manners. An officer and a gentleman would never let his table manners slip, even in the middle of Antarctica in midwinter! *DHA*

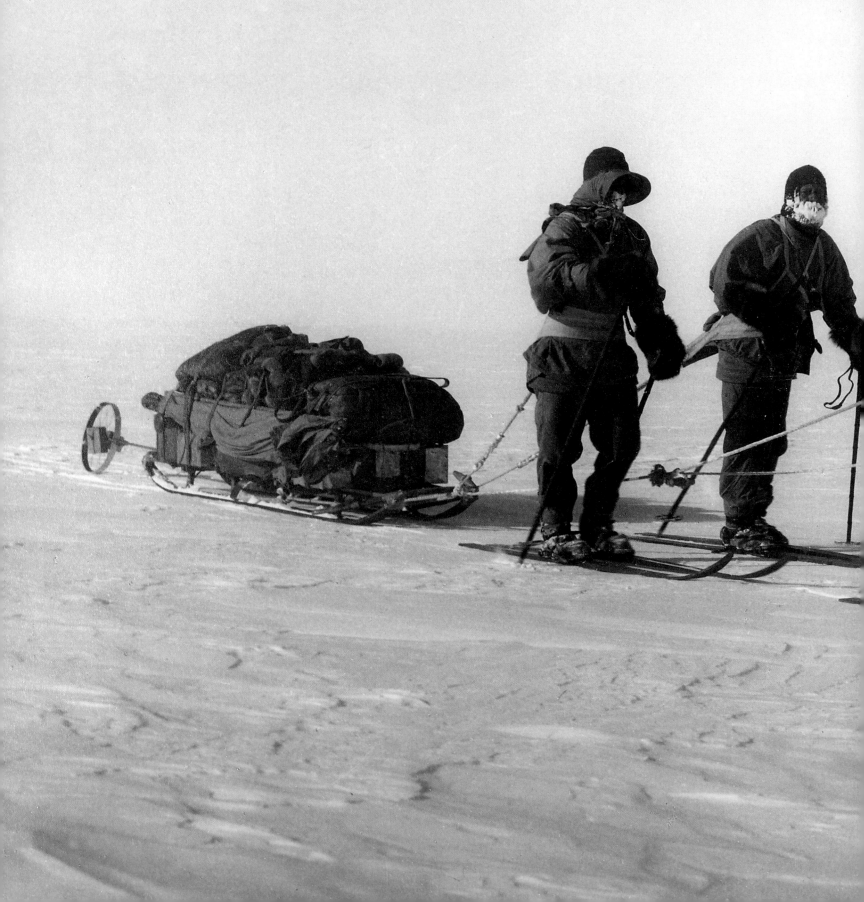

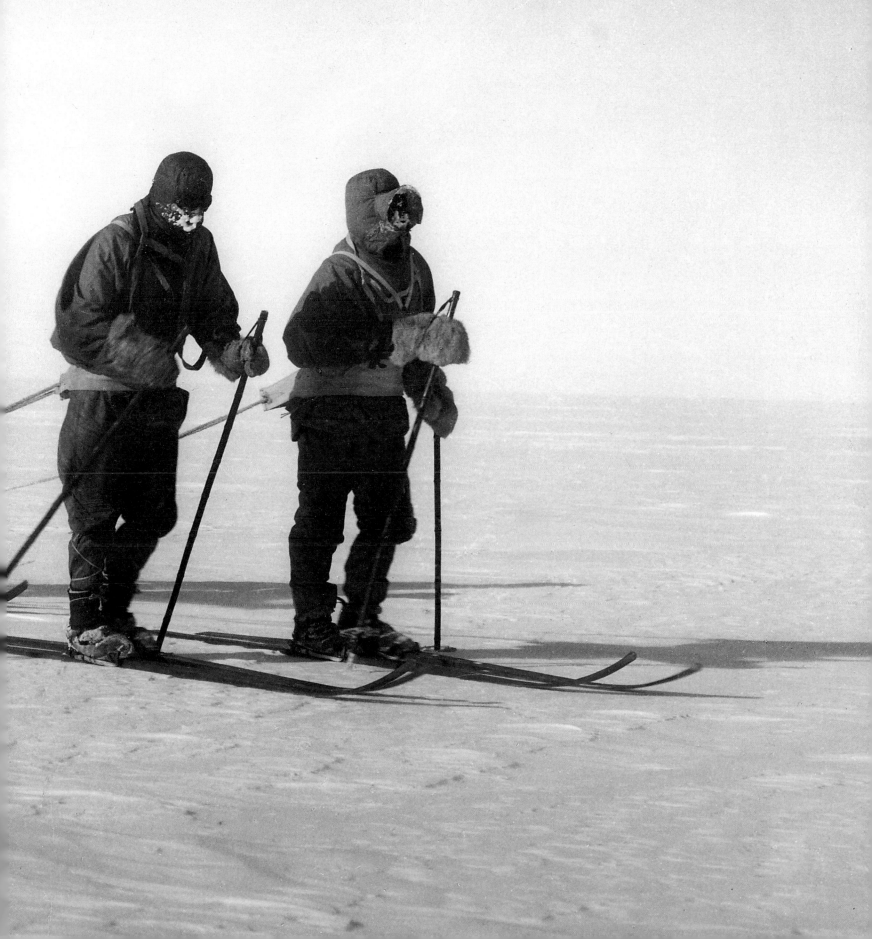

AT THE SOUTH POLE, JANUARY 1912

Ponting gave photography lessons to several members of the Shore Party, including Scott, Wilson and Bowers. It was important that when Scott's team reached the South Pole they could photograph their achievements. As none of the Polar Party survived the journey back from the Pole, the photographs by Bowers and Wilson provided valuable proof that they had obtained their goal. Amundsen's tent, with the Norwegian flag, can be seen in their photographs (no. 35), indicating that Scott reached the same position as Amundsen. The negatives were found in the tent in November 1912, with the bodies of Scott, Wilson and Bowers, and were developed at Cape Evans by Frank Debenham. Ponting later made prints for exhibition and sale through the FAS in London.

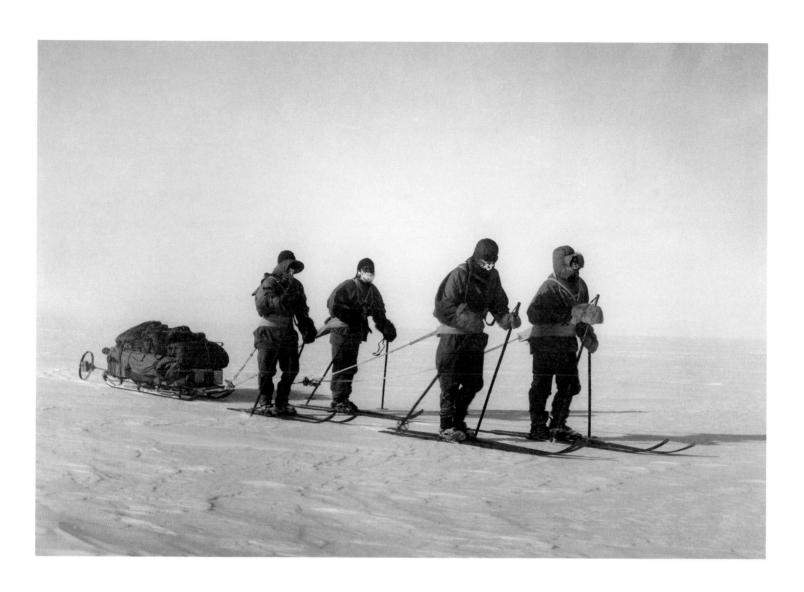

34. HENRY BOWERS
**The Polar Party and their sledge,
4–17 January 1912**

*From left to right: Evans, Oates,
Wilson and Scott*

This is an interesting photograph, showing the four men walking in pairs, pulling a huge sledge of provisions. The sledging party is on the plateau, moving in line with the sastrugi (wave-like ridges of snow formed by the wind). There is a wheel at the back of the sledge which acted as a counter and gave the distance travelled. This sledge was very difficult to manhaul, but to try to manhaul on skis in pairs with little or no experience would have been gruesome. You all have to be in synch, but there is always one man who pulls too hard or wants to stop to adjust his glasses or his harness. On several occasions I've tried pulling a sledge in a pair and it is incredibly difficult; it is the quickest form of frustration and annoyance man has ever invented. *DHA*

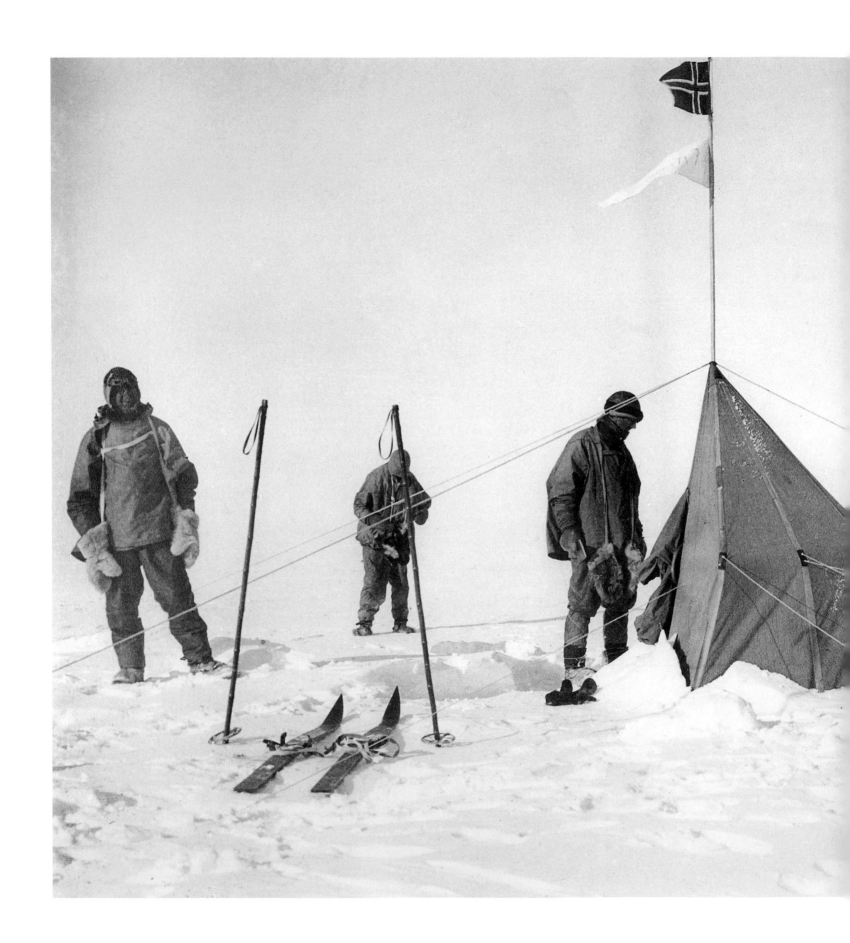

35. HENRY BOWERS
 Forestalled. Amundsen's tent at the South Pole, 18 January 1912

From left to right: Scott, Oates, Wilson and Evans

This is Scott's team arriving at Roald Amundsen's tent at the South Pole. It must have been soul-destroying for Scott and his men when they saw the tent flying the Norwegian flag and realised that the gruelling race was over. Amundsen was clever, marking out an area with flag markers to distinguish exactly where the South Pole was. Nowadays we have GPS, but then he would have had only a rudimentary sextant. In his tent, Amundsen left a note to Scott, asking him to return a message addressed to the King of Norway. This is not a photograph any of these men would have wanted to have been taken. The four men appear divided; one stares forlornly into Amundsen's tent while the others slouch. They must have felt shattered and heartbroken that they had been defeated in the race to reach the South Pole. *DHA*

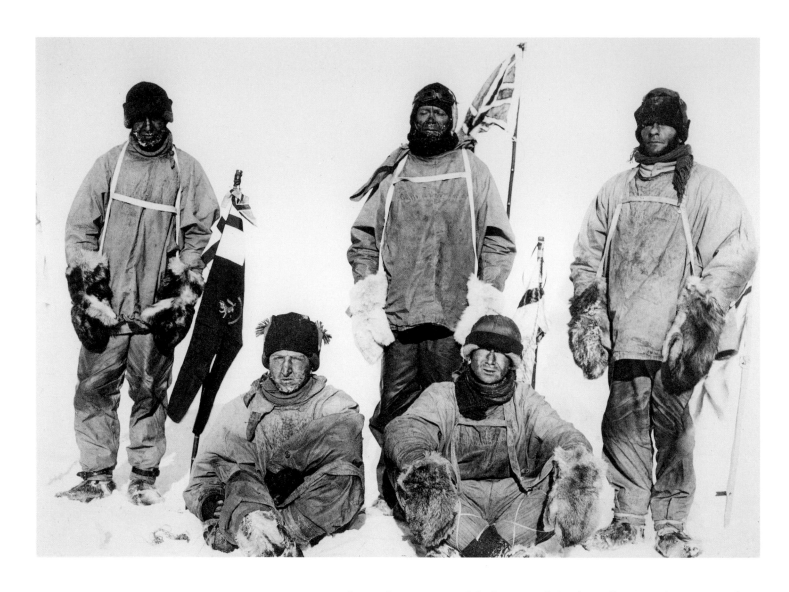

36. HENRY BOWERS
At the South Pole,
18 January 1912

From left to right: Oates, Bowers,
Scott, Wilson and Evans

For me, this is the most painful photograph in the collection. One can easily cry over its significance. You can tell by looking at the expression on each man's face that they were defeated: all were suffering from malnutrition, scurvy and frostbite. The three at the back can barely stand. It must have required courage to take this photograph. Bowers *(bottom left)* pulled the cord with his right hand to take the picture. They did their best to pose with their sledge flags and Union Jack.

If they had been the first to reach the South Pole this would have been an altogether different image: they would have smiled for the camera and I'm convinced they would have reached home safely. This soul-destroying moment was when they died. I have no doubt in my mind that if they had been first to the Pole they would have found the strength to survive. *DHA*

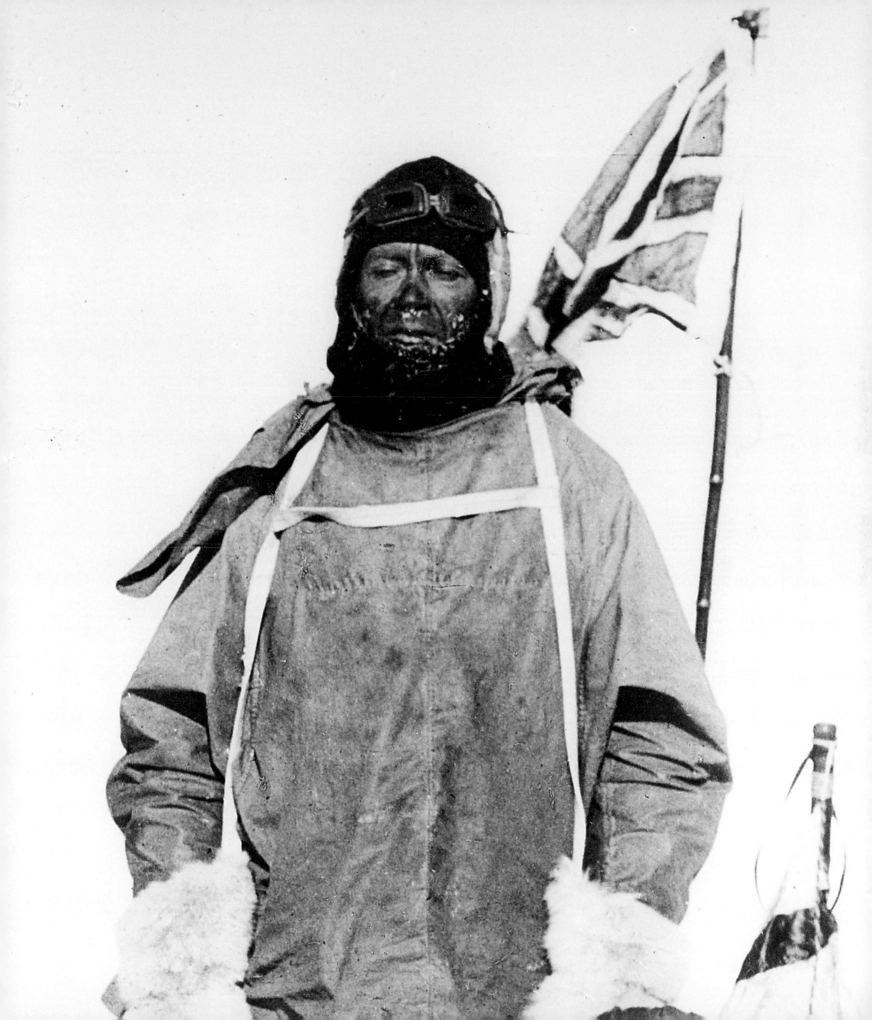

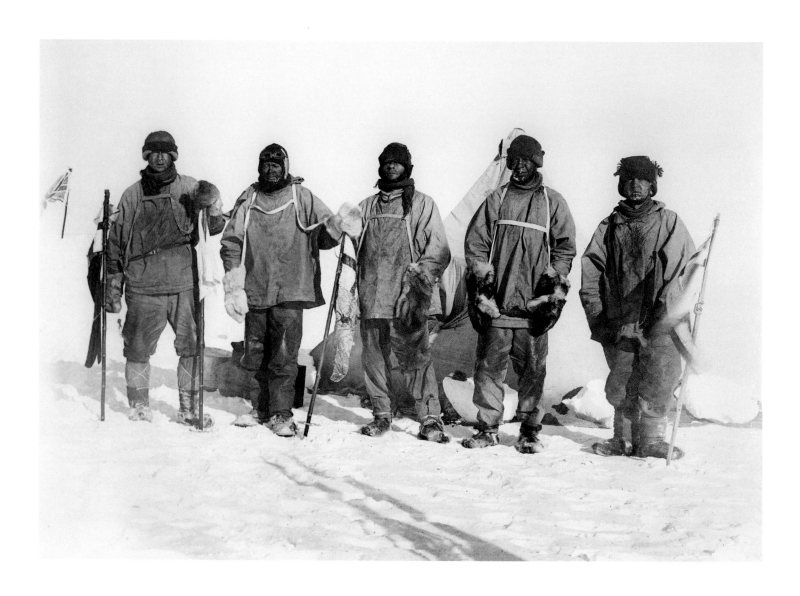

37. EDWARD WILSON
 The camp at the South Pole, 18 January 1912

'The Union Jack is flying on a cairn at the left of the picture.
Dr Wilson is seen pulling the string which operates the camera'
(FAS 1913, no. 'D').

From left to right: Wilson, Scott, Evans, Oates and Bowers

(right)

38. TRYGGVE GRAN
 **The grave on the Great Ice Barrier,
 12–13 November 1912**

Under Atkinson's command, a party set out on 29 October
1912 to discover the fate of the five missing men. The tent
was found on 12 November, and after retrieving the diaries,
letters, photographic negatives and flags, the cairn, seen here,
was constructed.
 'Over the bodies of Captain Scott, Dr Wilson and
Lieutenant Bowers, the search party spread the folds of the
outer tent, then built over all a cairn of ice, surmounted by a
simple cross. Beside the grave a smaller cairn was built, on
which they placed, upright, the sledge of their dead comrades'
(FAS 1913, no. 'E').

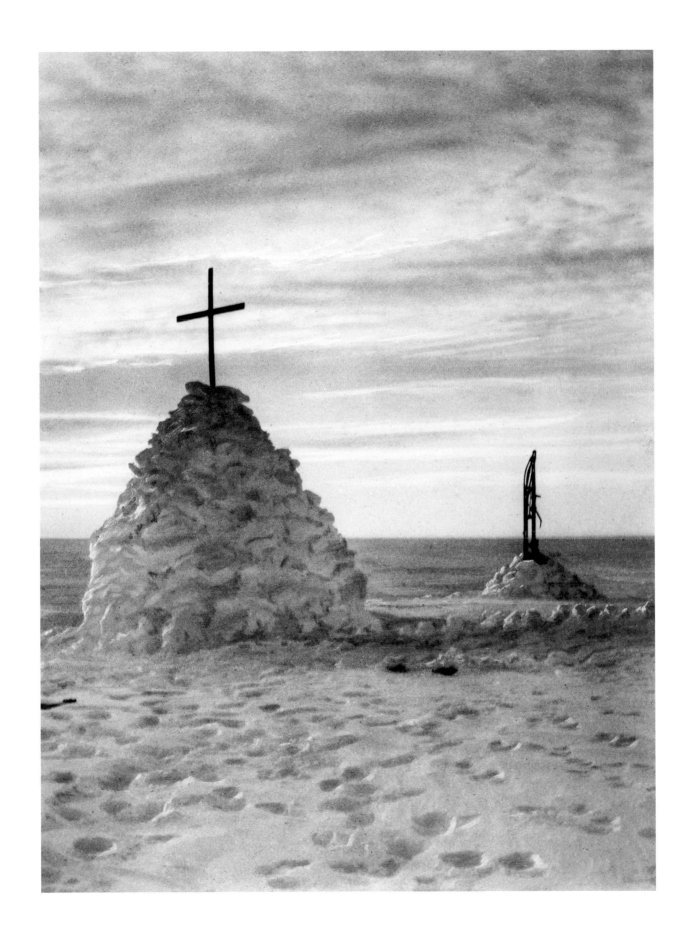

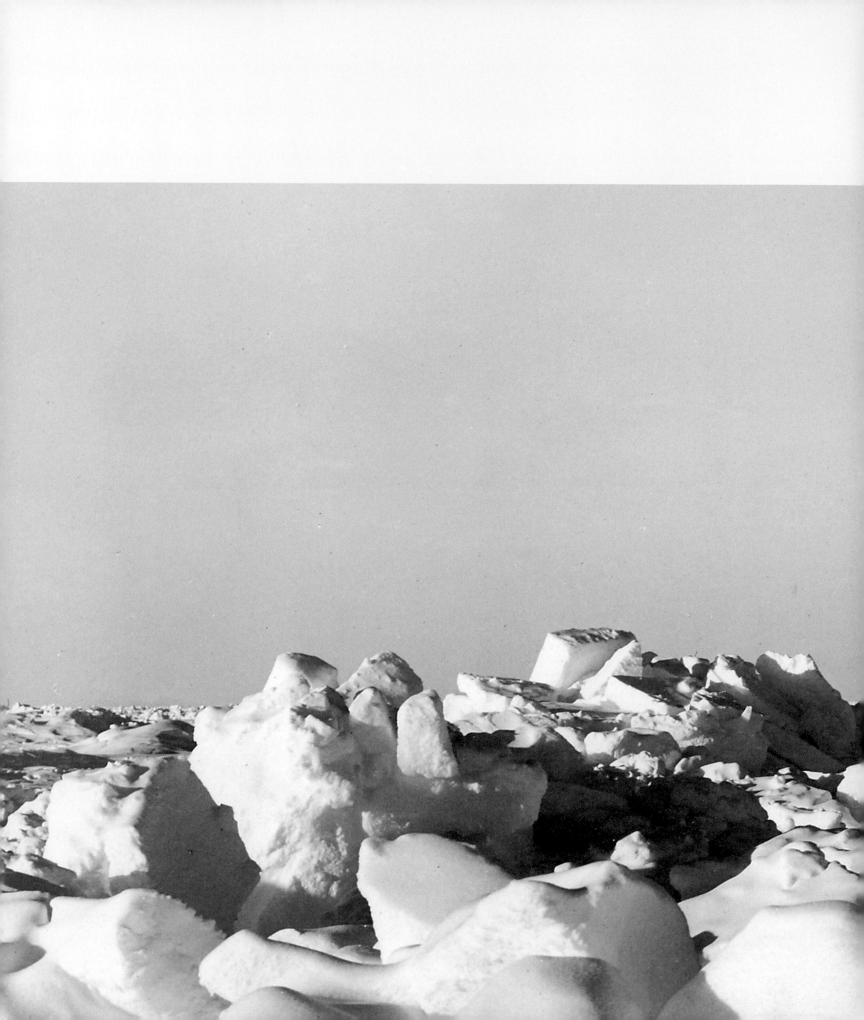

THE IMPERIAL TRANSANTARCTIC EXPEDITION
1914–1917

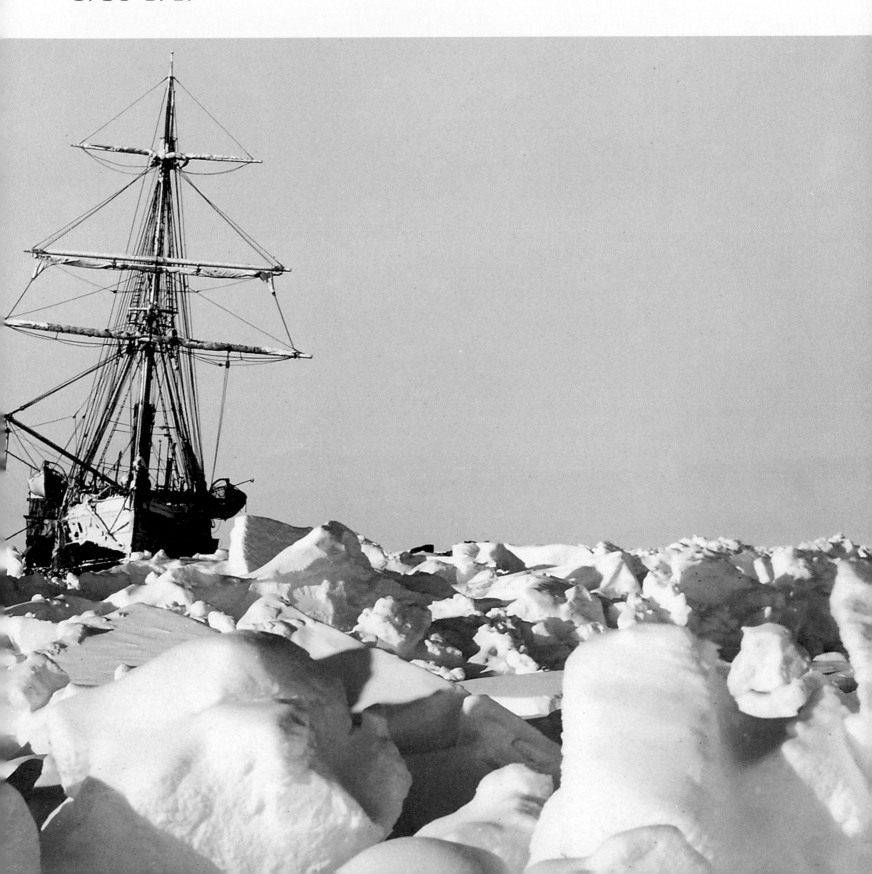

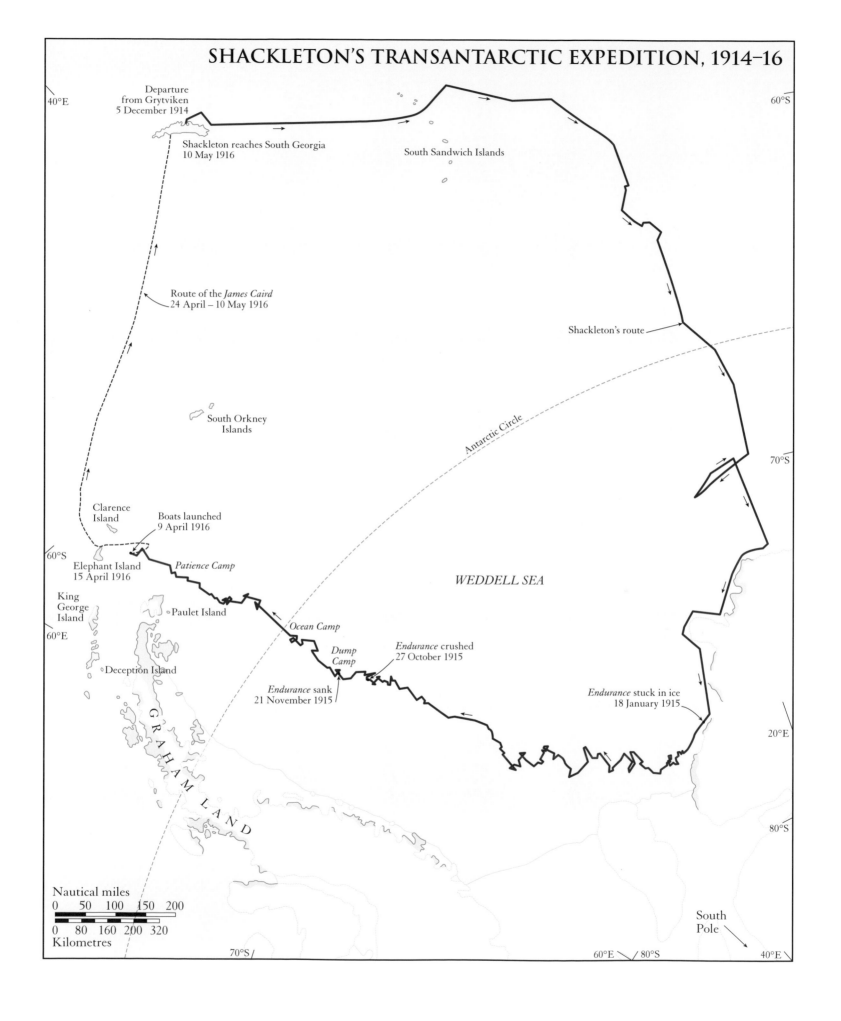

SHACKLETON'S TRANSANTARCTIC EXPEDITION, 1914–16

Departure
from Grytviken
5 December 1914

Shackleton reaches South Georgia
10 May 1916

South Sandwich Islands

Route of the *James Caird*
24 April – 10 May 1916

Shackleton's route

Antarctic Circle

60°S

70°S

South Orkney
Islands

Clarence
Island

Boats launched
9 April 1916

60°S

Elephant Island
15 April 1916

Patience Camp

King
George
Island

Paulet Island

60°E

Ocean Camp

WEDDELL SEA

Deception Island

*Dump
Camp*

Endurance crushed
27 October 1915

Endurance sank
21 November 1915

Endurance stuck in ice
18 January 1915

20°E

G R A H A M L A N D

80°S

Nautical miles

0 50 100 150 200

0 80 160 200 320

Kilometres

South
Pole

70°S /

60°E / 80°S

40°E

**39. Frank Hurley and Sir Ernest Shackleton at Patience Camp,
December 1915 – January 1916**

This portrait of Hurley with Shackleton shows the two men sitting either side of a
stove, which may have been made or adapted by Hurley. Hurley is skinning an animal,
while Shackleton gazes thoughtfully at the camera. Hurley and Shackleton had met for
the first time in October 1914, in Buenos Aires, after Hurley had sailed from Australia
to join the *Endurance*.

40. Glacier, Moraine Fjord, South Georgia, 24 November 1914

Circumstances forced Hurley to be a more adventurous photographer than Ponting. This photograph of a glacier moraine summarises the raw wilderness of South Georgia. Shackleton went to South Georgia before the Imperial Transantarctic Expedition and discovered one of the most inhospitable regions in the world, featuring glaciers and unclimbed mountains. After Shackleton's extraordinary journey from Elephant Island to South Georgia in the *James Caird* in May 1916, he then landed on the opposite side of the island from the whaling station and had to cross this mountainous region. Shackleton had no mountaineering experience, maps or equipment, yet he successfully traversed the island with his two companions to get to safety. *DHA*

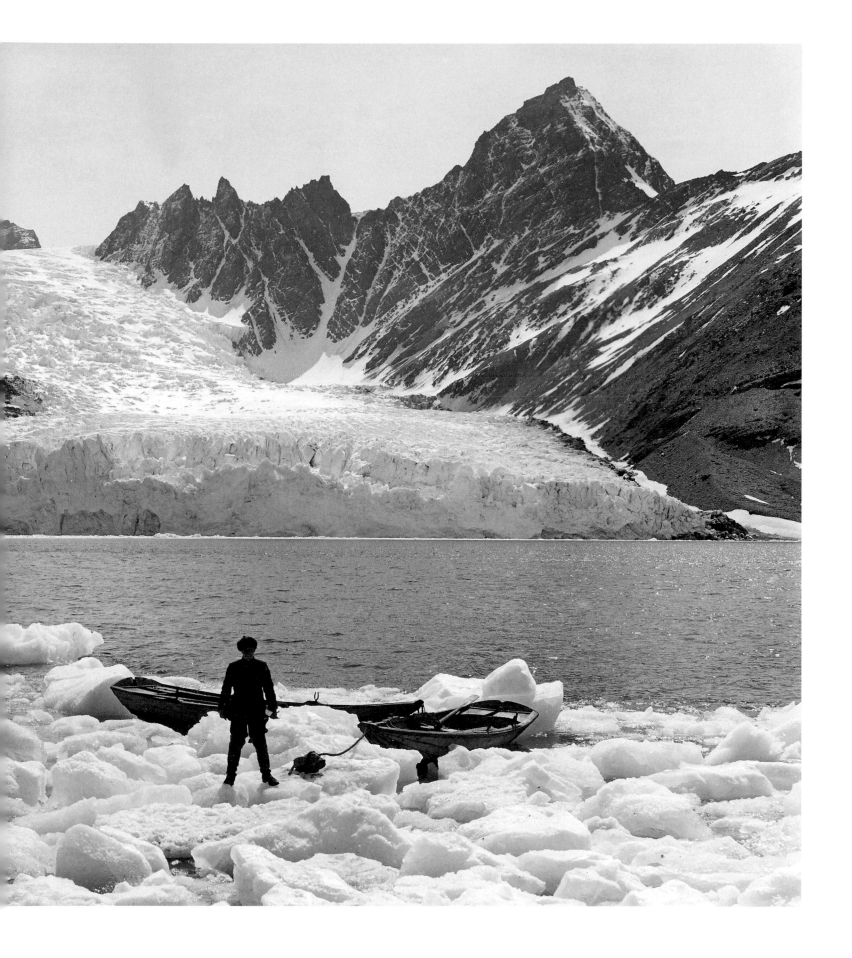

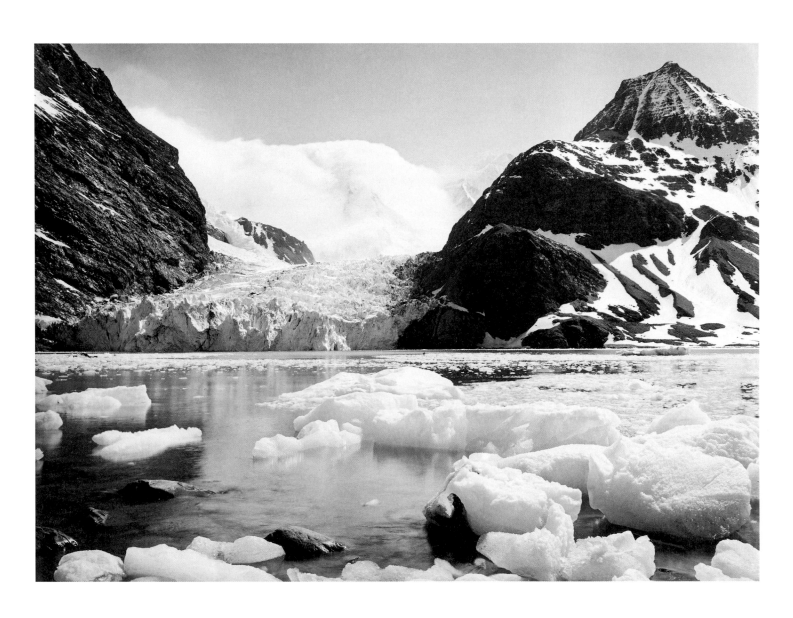

41. Head of Moraine Fjord, South Georgia, 24 November 1914

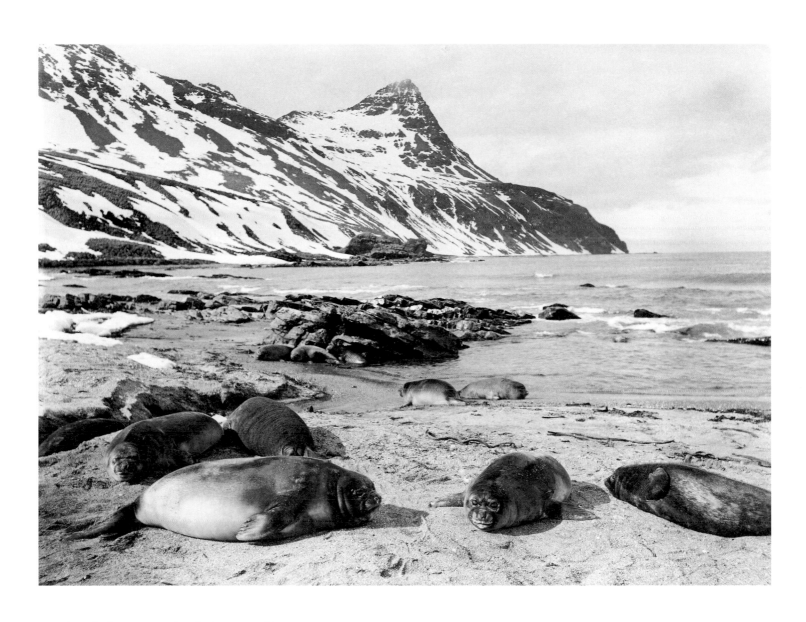

42. Sea elephant pups, South Georgia, 1914

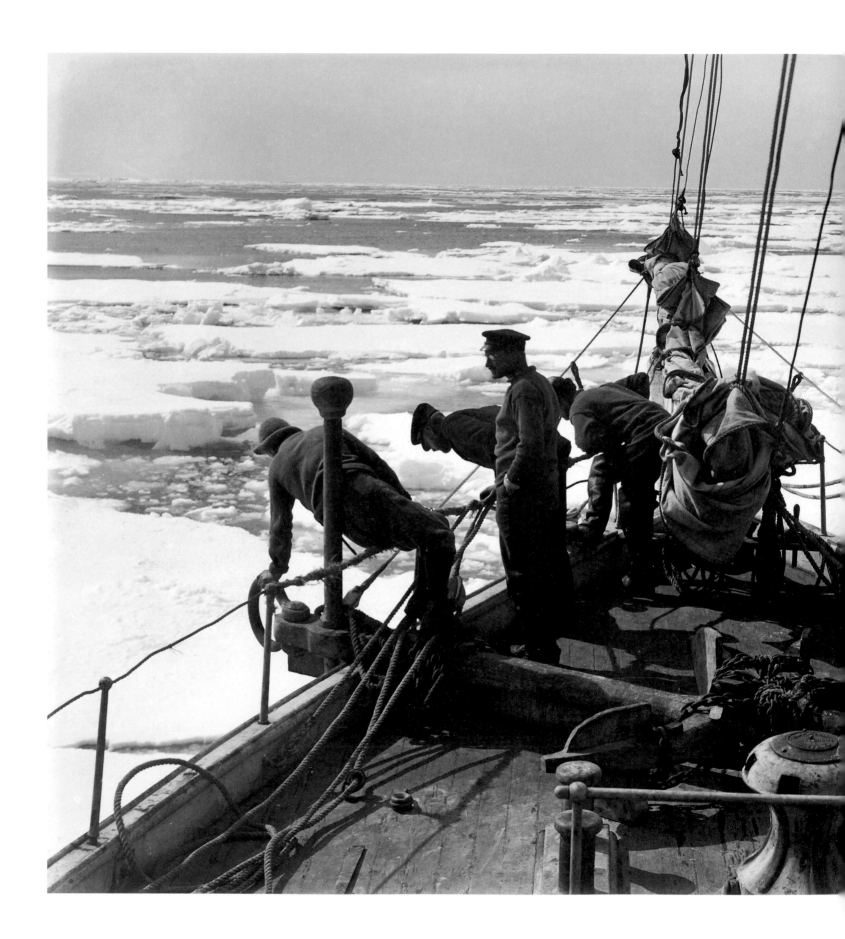

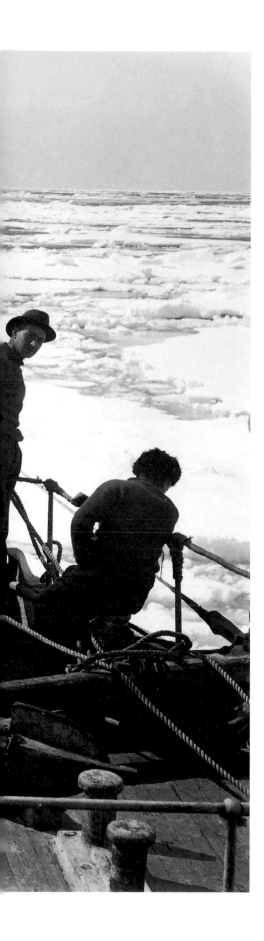

(left)

43. **Entering the pack ice, Weddell Sea, lat. 57° 59' S, long. 22° 39' W, 9 December 1914**

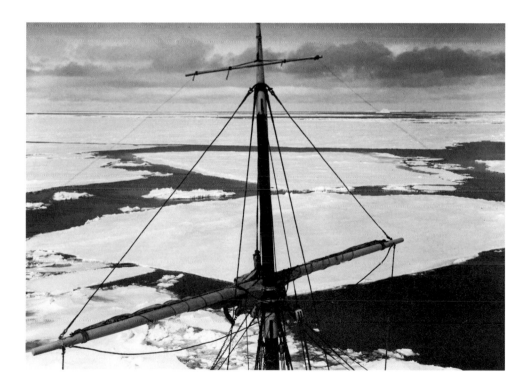

44. **Typical pack ice, Weddell Sea, lat. 62° 50' S, long. 17° 21' W, December 1914**

'Pack-ice might be described as a gigantic and interminable jigsaw-puzzle devised by nature. The parts of the puzzle in loose pack have floated slightly apart and become disarranged; at numerous places they have pressed together again; as the pack gets closer the congested areas grow larger and the parts are jammed harder till finally it becomes "close pack", when the whole of the jigsaw-puzzle becomes jammed to such an extent that with care and labour it can be traversed in every direction on foot' (Shackleton 1919, p. 11).

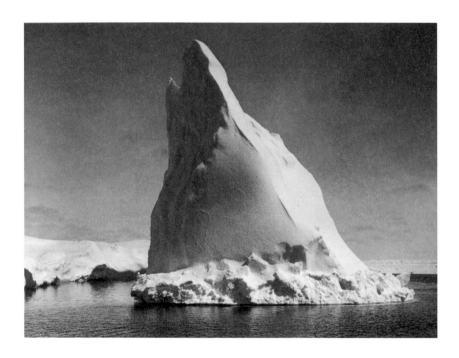

45. A pinnacled glacier berg, observed in lat. 62° 41' S, long. 17° 32' W, January 1915

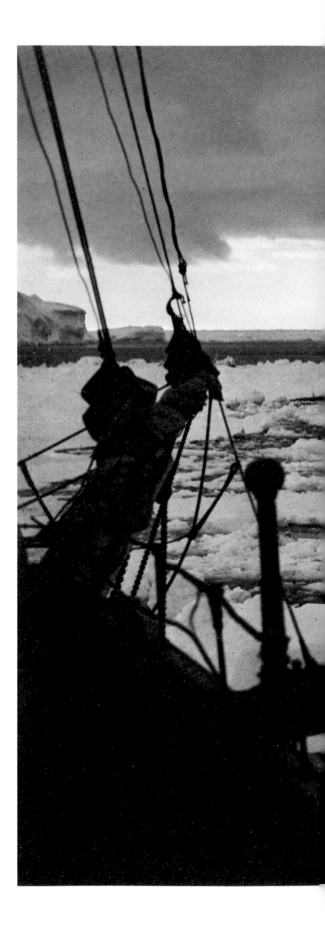

(right)
46. **Dawn of 1915, 1 January 1915**

'At midnight, as I was sitting in the "tub" [the crow's nest], I heard a clamorous noise down on the deck, with ringing of bells, and realized that it was the New Year' (Worsley, quoted in Shackleton 1919, p. 17).

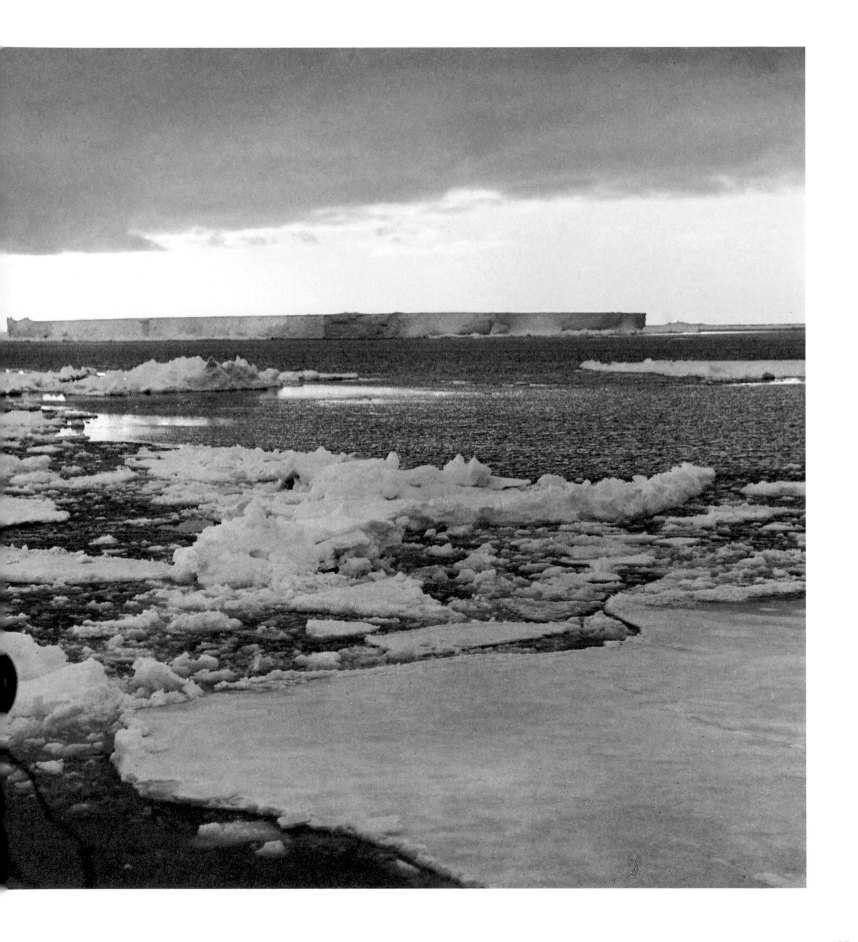

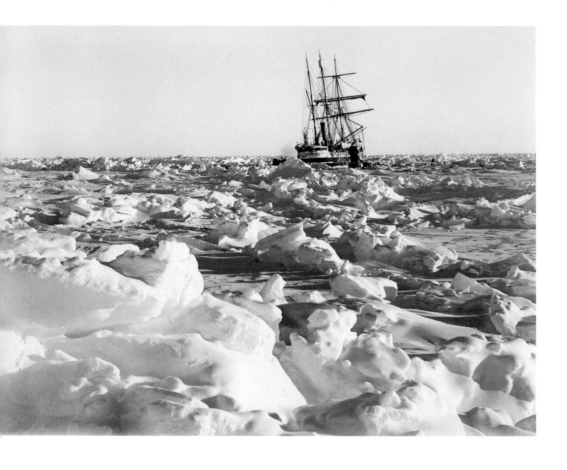

(right)
48. **The *Endurance* laying to awaiting the opening up of the pack, 1 January 1915**

'The first day of the New Year … was cloudy, with a gentle northerly breeze and occasional snow-squalls. The condition of the pack improved in the evening, and after 8 p.m. we forged ahead rapidly through brittle young ice, easily broken by the ship' (Shackleton 1919, p. 19).

47. **The surroundings of the ship at the end of winter, 1915**

This is the *Endurance* at the end of the winter. The ship is locked in, with nowhere to go except with the drift of the ice. The power of the ice is simply extraordinary. The photographer has captured the ship with the lumps of ice in the foreground, highlighting the part the ice played in the ship's voyage. Hurley proved his commitment to his job as he would have had to trudge through that ice in the freezing temperatures in order to photograph the ship from a distance. Seeing the ship in such a wilderness reinforces for me the brave journey these men undertook. *DHA*

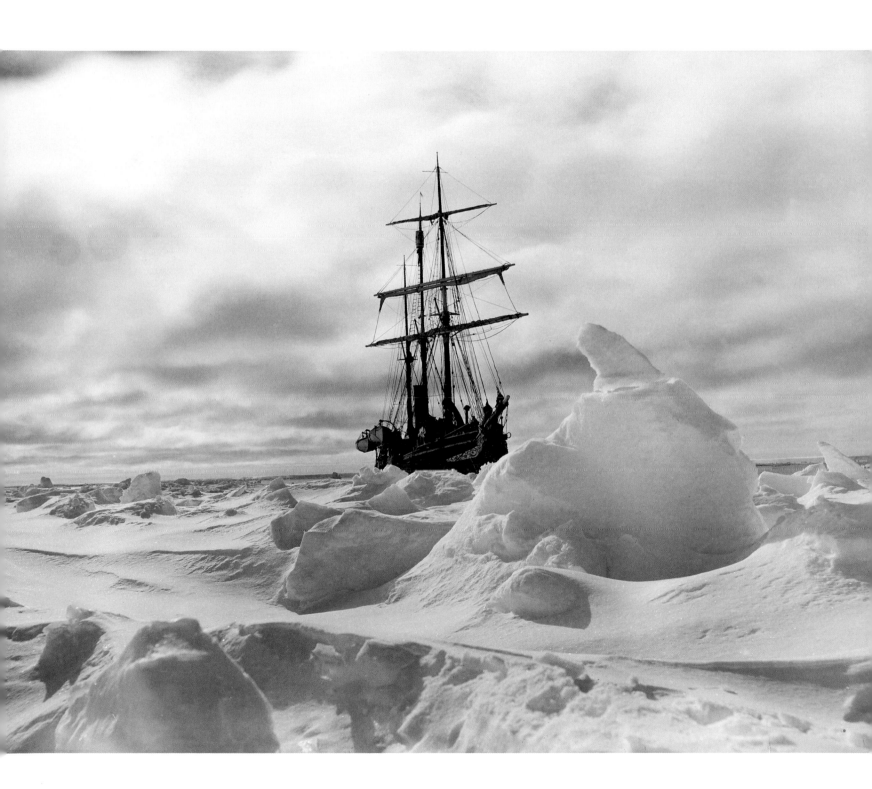

49. **Young King penguin in first-year plumage, South Georgia, 1914**

(right)
50. **Young Emperor penguins, 1915**

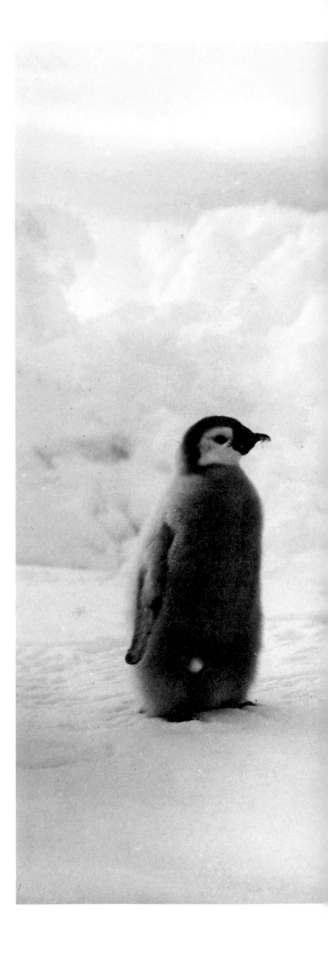

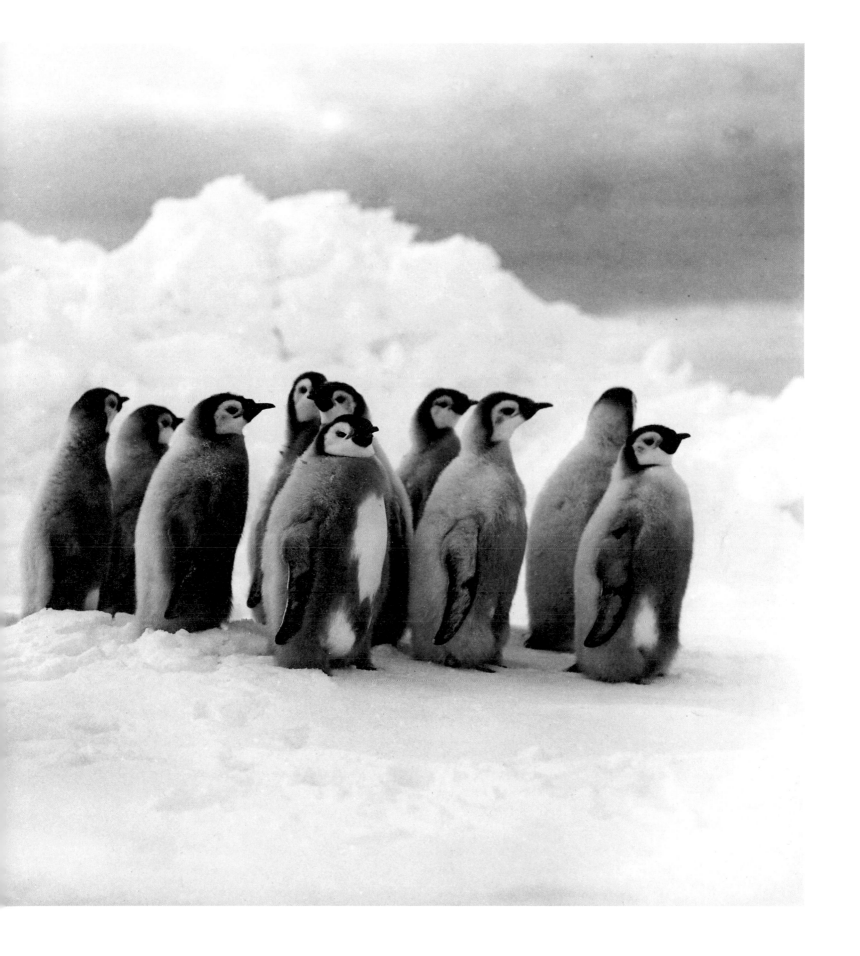

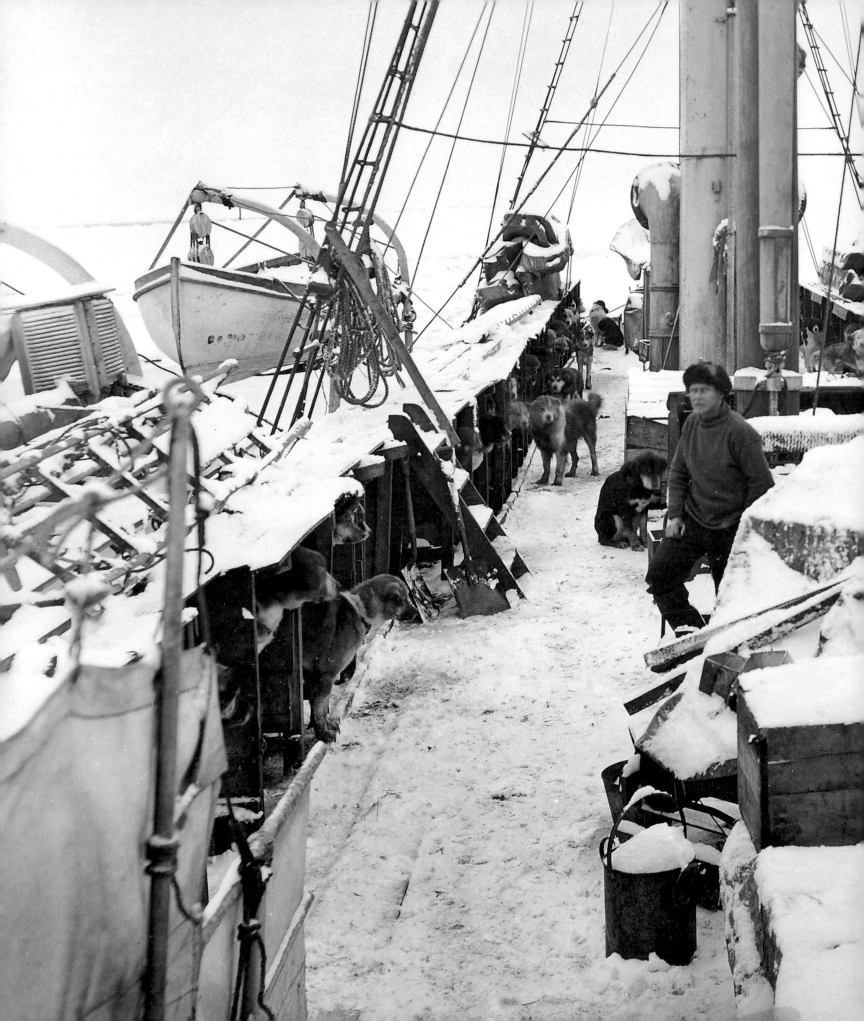

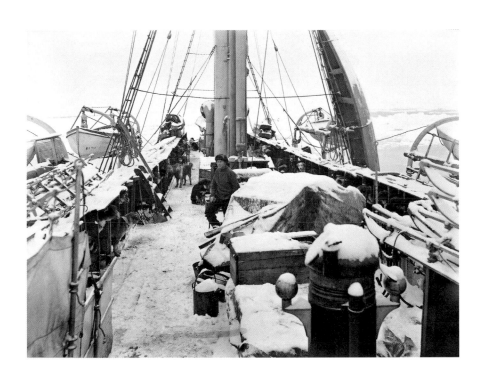

51. Deck of *Endurance* on the way south, 1915

52. **The departing sun, 1915**

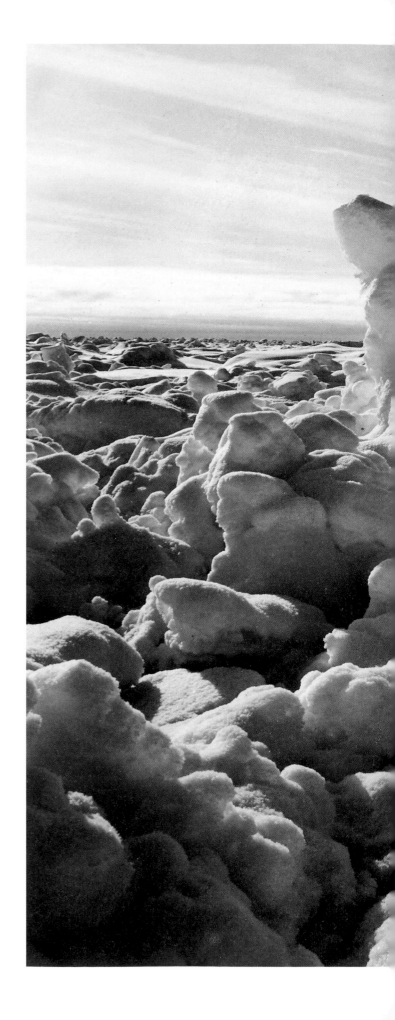

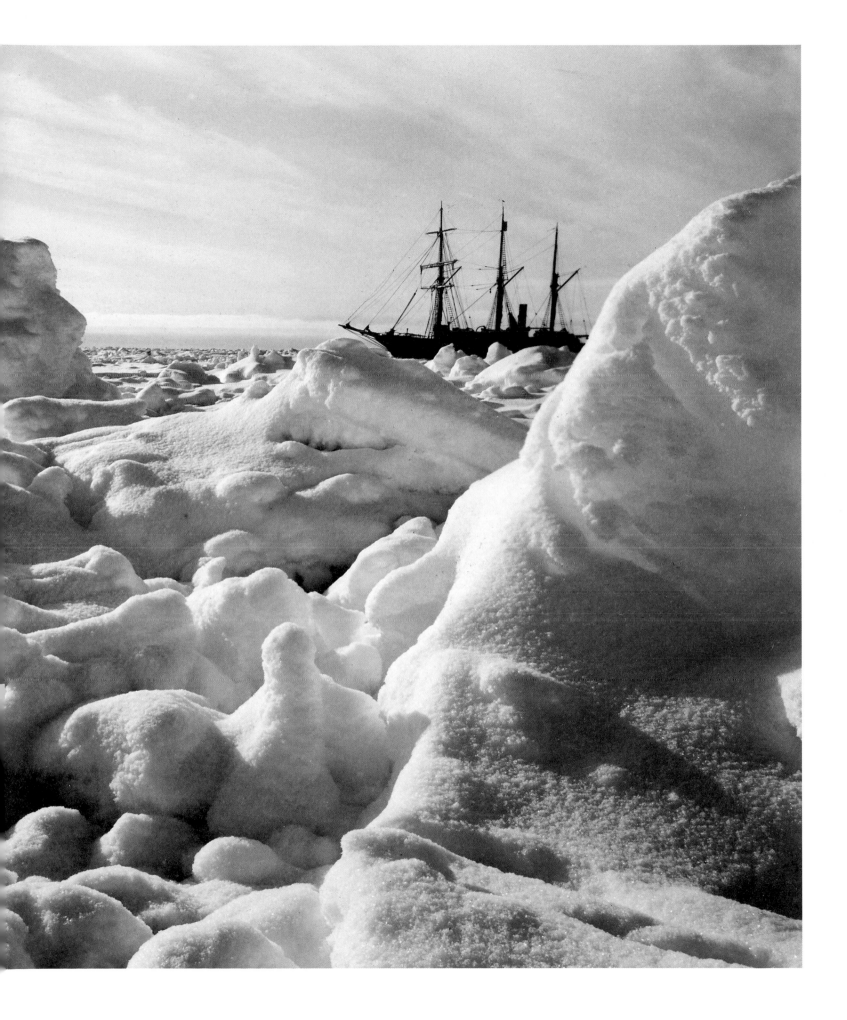

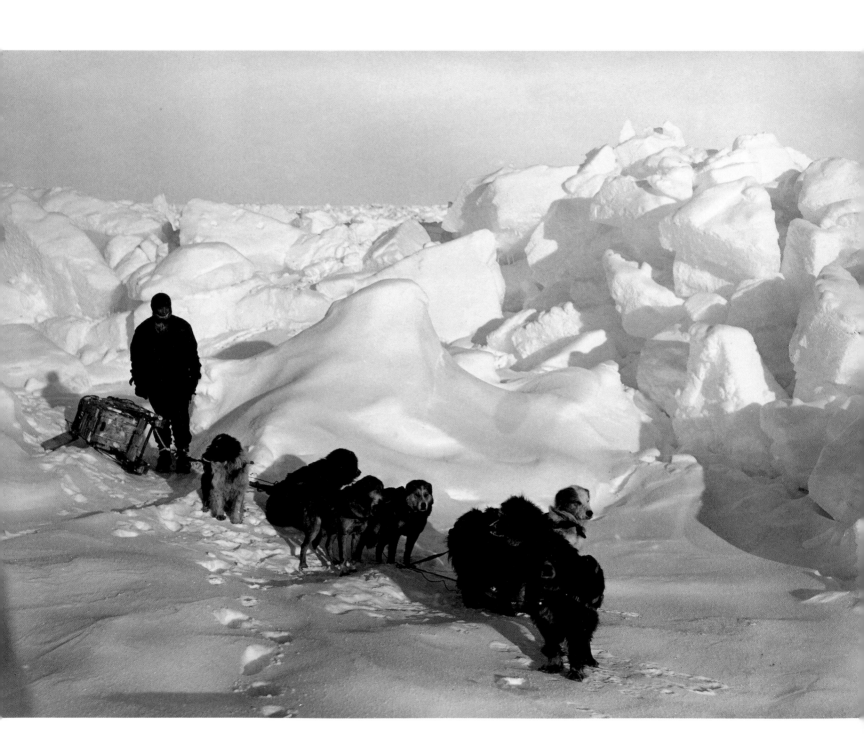

(left)

53. Hurley with his team, August–September 1915

'My dog-team greatly widened my field of operations. With a comrade on my sledge, I would scout the pack-ice far and wide, in quest of subjects for the camera. These trips were not without a certain risk, for frequently the ice would open up between us and the ship, and then we would be compelled to await a closing up, or to ferry ourselves across on a loose floe' (Hurley 1925, p. 172).

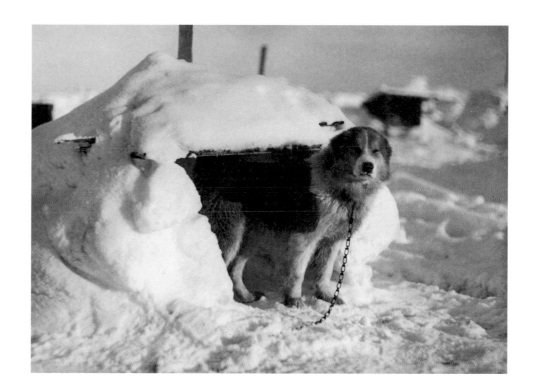

54. Samson at the entrance of his dogloo, February–March 1915

Samson was one of the many dogs that Shackleton took south with him, paid for by subscription from public schools in England and Scotland. Other photographs of Samson, the second heaviest dog by Shackleton's reckoning, show him almost swamping Hussey, one of the smallest men present. The men detailed to be part of the crossing party were instructed to train their own dog teams for the journey, and in April 1915 the dogs were moved from the ship to new homes on the ice known as dogloos. Hurley took advantage of his own team to search for more distant and varied photographic vantage points. By mid-June the dogs were at their peak and a dog derby was held, with bets laid in chocolate and cigarettes.

None of the dogs survived the drift on the ice floes; Shackleton regretfully had to order the deaths of all but two teams shortly after establishing Patience Camp, owing to the lack of stores and the need to feed the men before all else. The remainder were shot on 2 April 1916, shortly before the party took to the boats to make the voyage to Elephant Island.

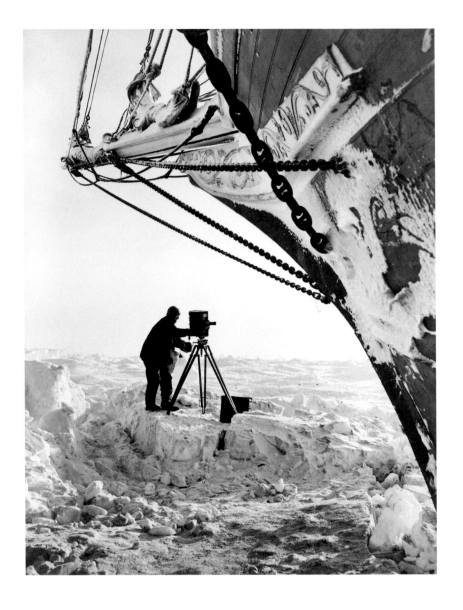

(right)
56. **The return of the sun after 92 days, 1915**

This is the *Endurance* stuck in the ice. You can see the frost from the winter months in the rigging. The men would have known the winter was over when they saw a slither of blue on the horizon. Day by day it would have become brighter and then, just below the horizon, they would have seen the most beautiful sight of the orange tinge of the sun returning after so many weeks. Seeing the sun for the first time after 92 days would have given the men a huge psychological boost, as they would have known that from then on life was going to get brighter and warmer. *DHA*

55. **Frank Hurley with cinematograph next to the *Endurance*, 1 September 1915**

This self-portrait of Hurley at work is a wonderful shot: the photographer with his camera, ship in the foreground, ice all around. This image shows the viewer how big the equipment was and how heavy it must have been. The box on the ice beside the camera would have added to the weight that Hurley had to carry around in pursuit of his art. Hurley was not only a superb photographer, he was an adventurer too; he was one of the men and he got stuck in helping the rest of the team. *DHA*

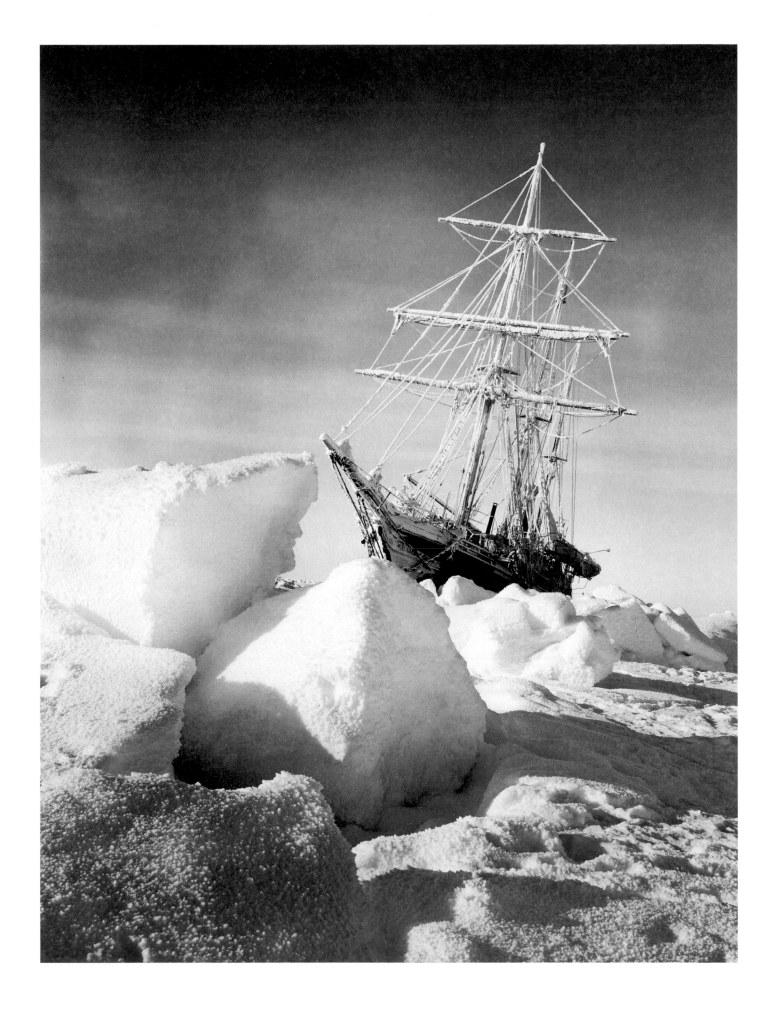

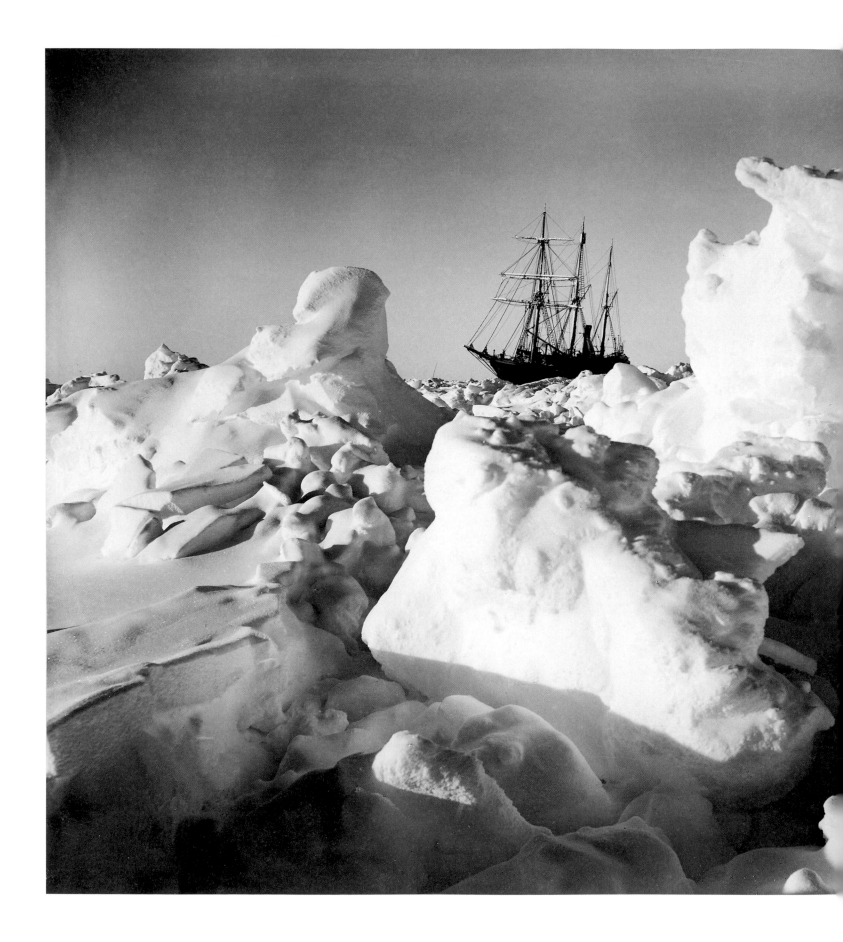

(left)

57. **Huge blocks weighing upwards of 50 tons were thrown about in indescribable confusion, September–October 1915**

58. **Worsley standing next to a working pressure ridge showing an immense block of over 100 tons being rafted, August 1915**

'The effects of the pressure around us were awe-inspiring. Mighty blocks of ice, gripped between meeting floes, rose slowly till they jumped like cherry-stones squeezed between thumb and finger. The pressure of millions of tons of moving ice was crushing and smashing inexorably' (Shackleton 1919, p. 58).

59. **Wild and Shackleton between two pressure ridges, spring 1915**

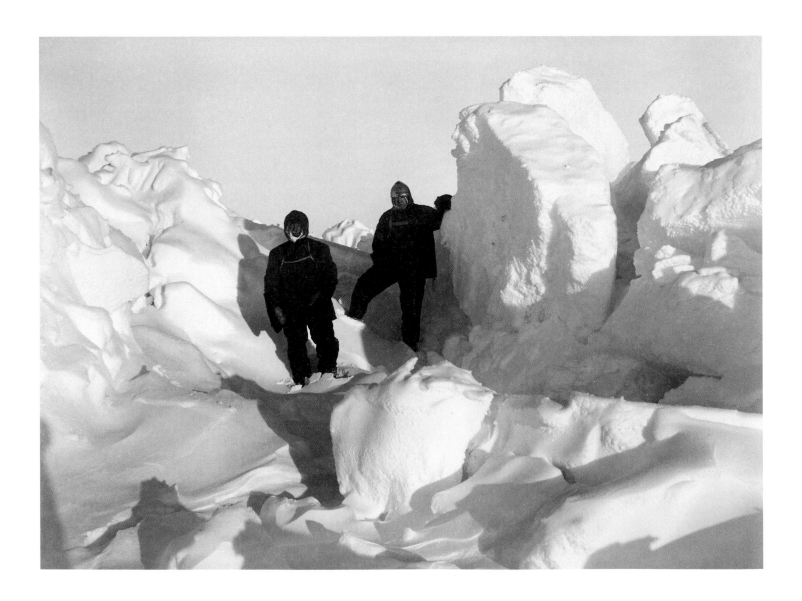

60. **Dawn after winter, August 1915**

'The approach of the returning sun was indicated by beautiful sunrise glows on the horizon in the early days of July … the northern sky, low to the horizon, was tinted with gold' (Shackleton 1919, pp. 53–4).

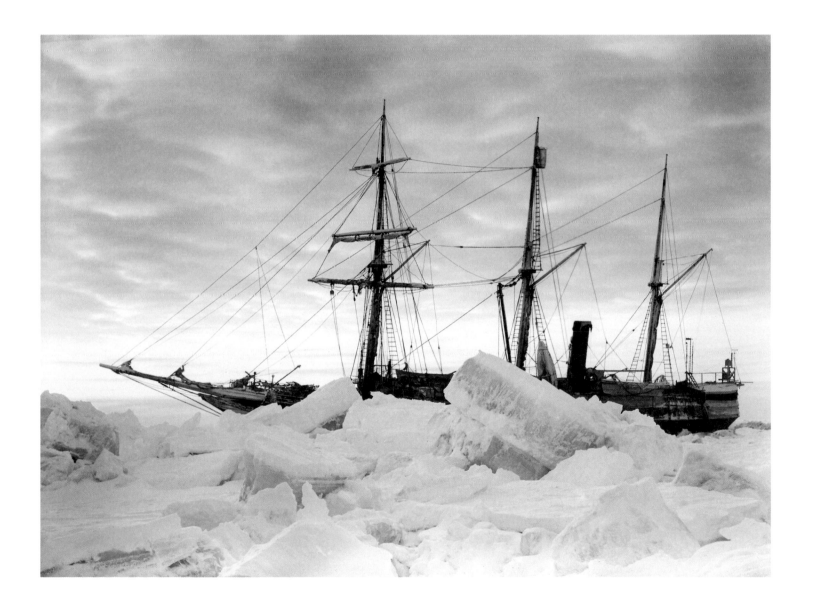

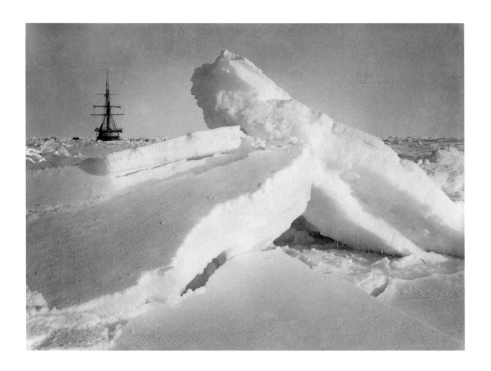

61. **The incipient stage of a pressure ridge, September 1915**

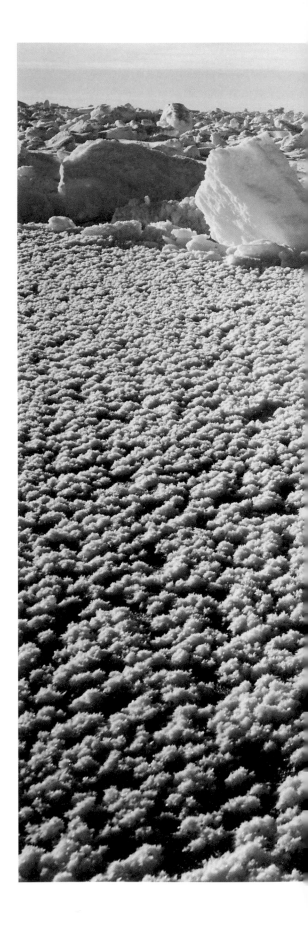

(right)

62. **Ice flowers, spring 1915**

The ice flowers in this photograph are mesmerising. Here Hurley captured the ice flowers close-up, with the distant image of the ship in the background. In between are some ice boulders and then flat ice. The sea ice is made up of pans of ice, varying in thickness from multi-year ice, which would be very dense, to frozen leads (open water), instantly frozen in the low temperatures. Ice flowers show newly frozen sea ice which resembles small, bunched-up flowers. I first saw ice flowers in 1983; I was transfixed by the sight and enjoyed pulling a sledge over them. *DHA*

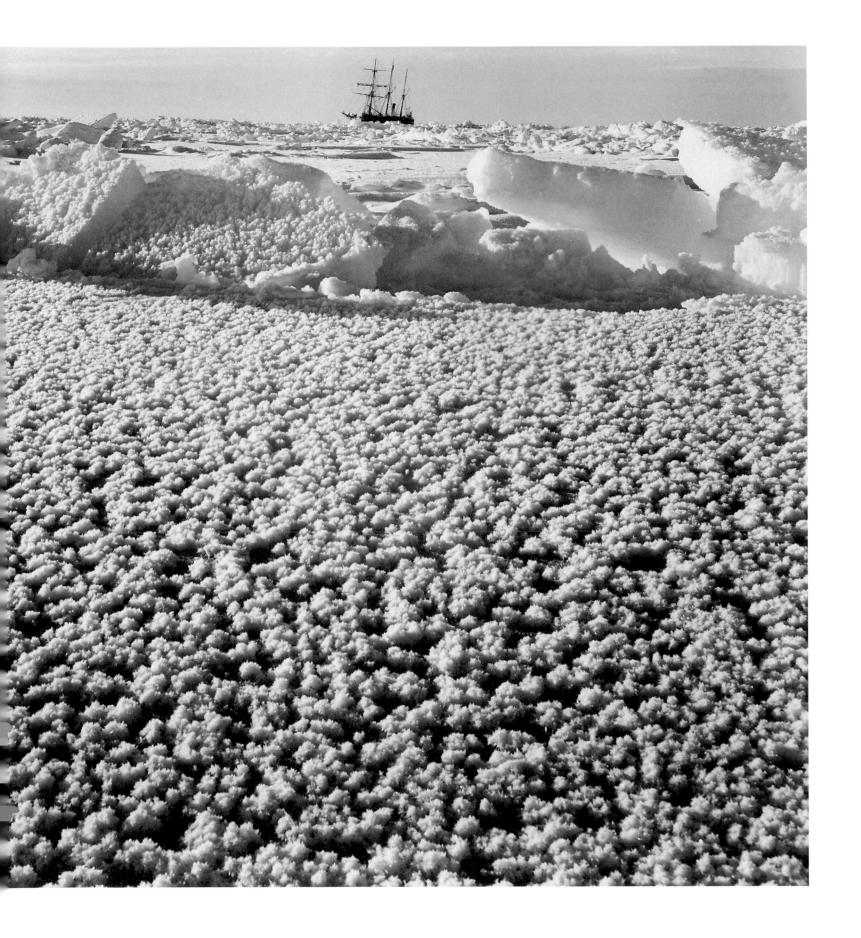

LIFE ON BOARD

After *Endurance* became a winter station in late February 1915, Shackleton ceased the usual ship routine of watches and organised a rota of nightwatchmen, who would look after the dogs and observe any ice movement. This was often an opportunity for gossip round the stove, for doing washing or for a quiet game of chess. The ship became a floating shore station, the dogs were housed on the ice, and a winter of scientific observations, checking of stores and dog team training got under way, lightened by games of football and concerts in the 'Ritz' (the main hold of the ship, which became the living accommodation). The clarity of the Antarctic darkness enabled James and Worsley to 'take occultations' – that is, to observe the local time at which the Moon obscured certain stars, and then compare that with the recorded times in the Nautical Almanac.

63. **The nightwatchman spins a yarn, 1915**

This is one of my favourite photographs because it symbolises comradeship. The men have huddled round the fire and appear relaxed and content. The light of the fire is reflected on their faces and one of the men is smoking a pipe. There is a sense that the fire has brought them together. Their eyes are drawn to the light, and the warmth must have given a great deal of comfort in the frozen wilderness. It is a simple but effective image. *DHA*

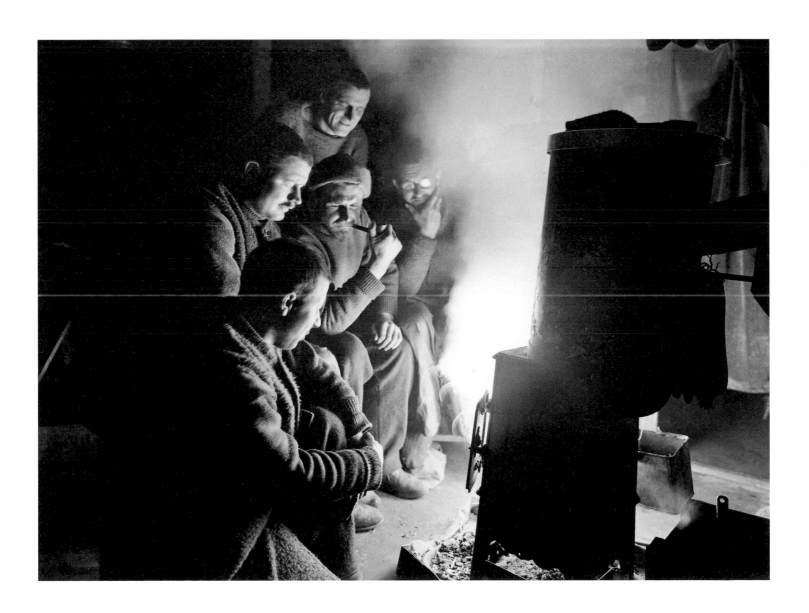

64. Frank Hurley and Leonard Hussey on night watch, midwinter 1915

(right)
65. Taking occultations, June 1915

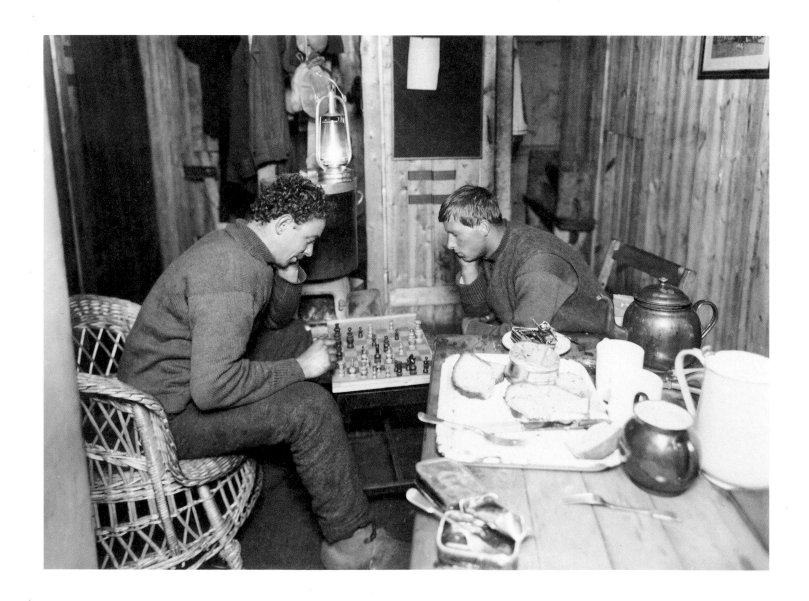

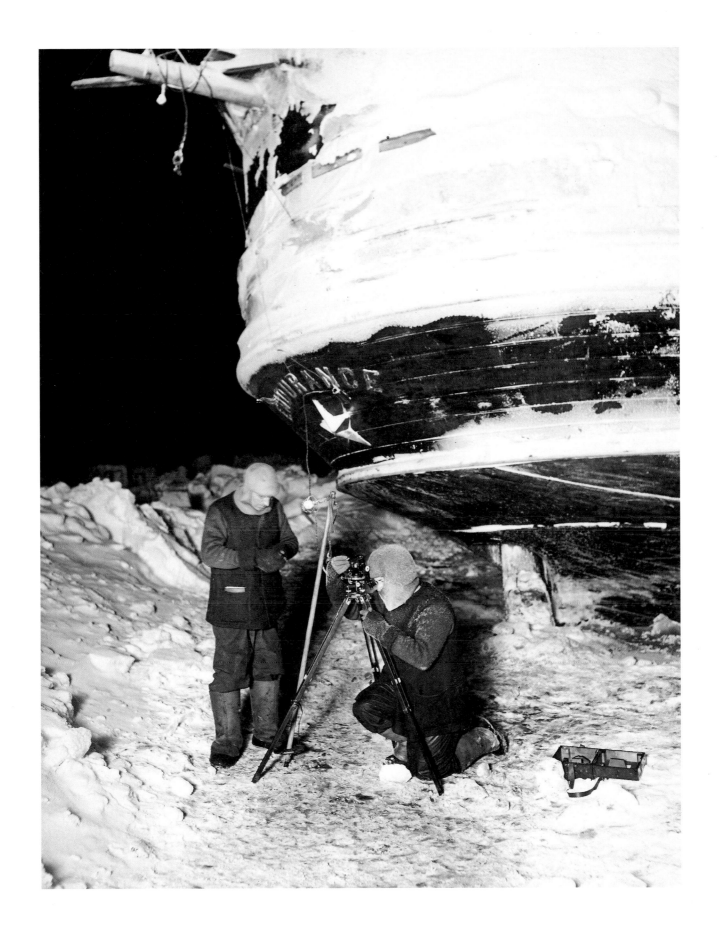

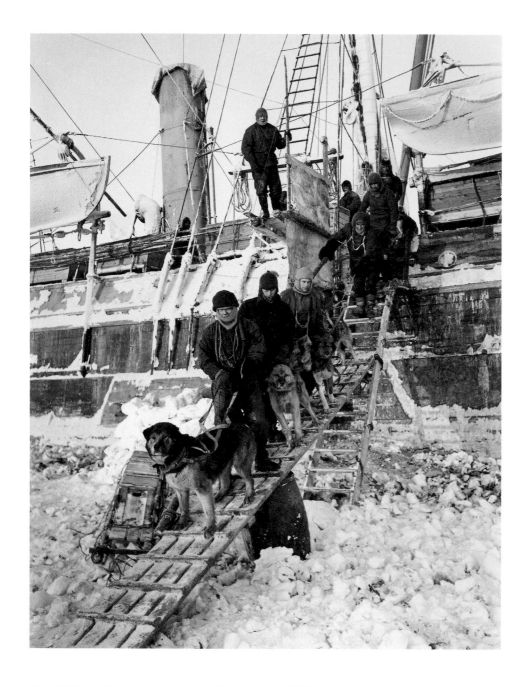

66. Taking the dogs out for exercise, August 1915

I love this photograph. These dogs are amazingly powerful and the handlers have one each. What the image does not reveal is the complete chaos that taking this photograph would have caused. The gangway would have been slippery, the dogs would have been barking and the men would have been holding on for dear life. Taking the dogs out for exercise would have been a daily trial. It looks serene, but it would have been extremely challenging. *DHA*

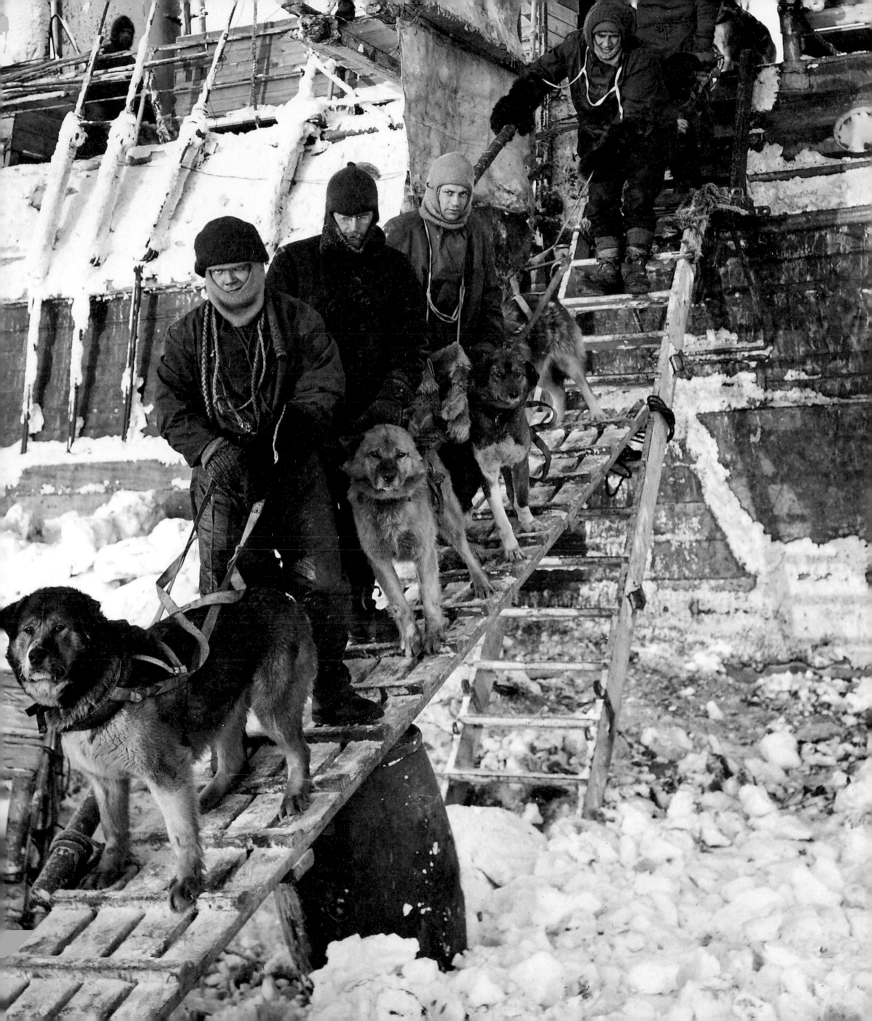

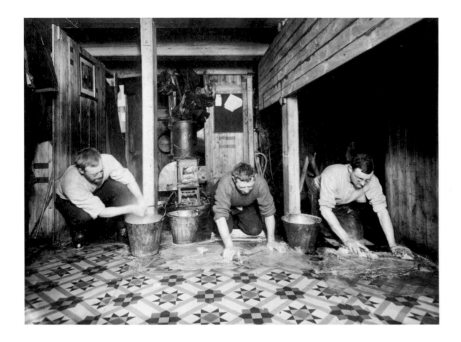

67. **The bi-weekly ablutions of the 'Ritz', undertaken by Wordie, Cheetham and Macklin, 1915**

(right)
68. **In the 'Ritz', the workroom of the ship, midwinter 1915**

After the ship had come to a halt in the ice in early 1915, Shackleton decreed that it stand down from ship's regulations and become a floating winter station. All the stores and cargo were removed from the main hold and the space was turned into living accommodation, jocularly called the 'Ritz'. The various cubicles developed fanciful names, such as 'The Anchorage', 'The Poison Cupboard', 'Auld Reekie' and 'The Billabong'. Despite these living cubicles, there was space for the mess table, and it became a communal living space. In mid-May there was a communal madness, as Hurley put it, for all to have their heads shaved, and on Midwinter's Day, 22 June, the traditional Antarctic high jinks took place, including risqué cross-dressing and satirical speeches and poems.

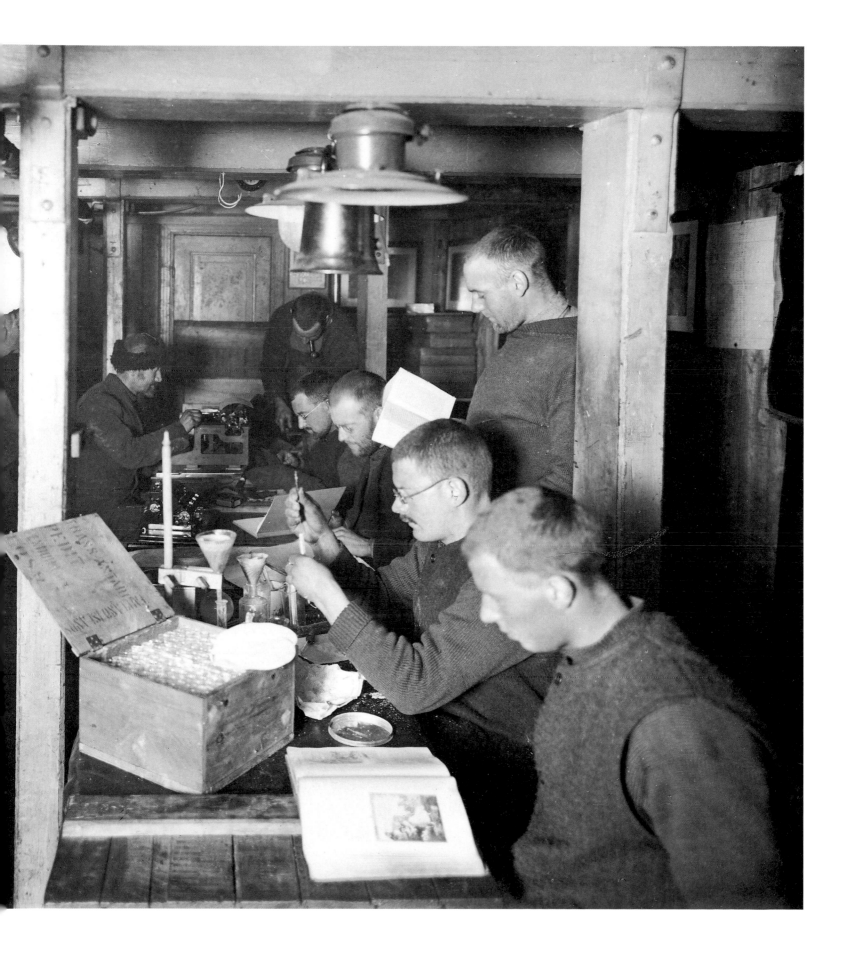

DEATH OF THE *ENDURANCE*

Hurley's dramatic sequence of shots of the sinking of *Endurance* took her from precariously balancing on the ice on 18 October 1915 (nos 73, 74), a recognisable ship, to the near-death shot, with a team of dogs phlegmatically observing the wreck (no. 75), after 'the twisting, grinding floes' had done their work. Shackleton had anticipated such a disaster, and men, stores and dogs were ready when the order came to abandon ship on 26 October. Dump Camp was established on the ice floes next to the ship, followed soon after by a longer-lasting base, on a large ice floe at Ocean Camp, once it had been established that attempting to travel across the ice was futile. Ocean Camp was to be their home for the next two months. The dying ship was fully salvaged and non-essential items were discarded, including all of Hurley's photographic equipment (apart from a small pocket camera and three rolls of film). A galley was built for the cook, and a lookout platform erected, complete with a flagpole from which to fly King George V's Union Jack (no. 101).

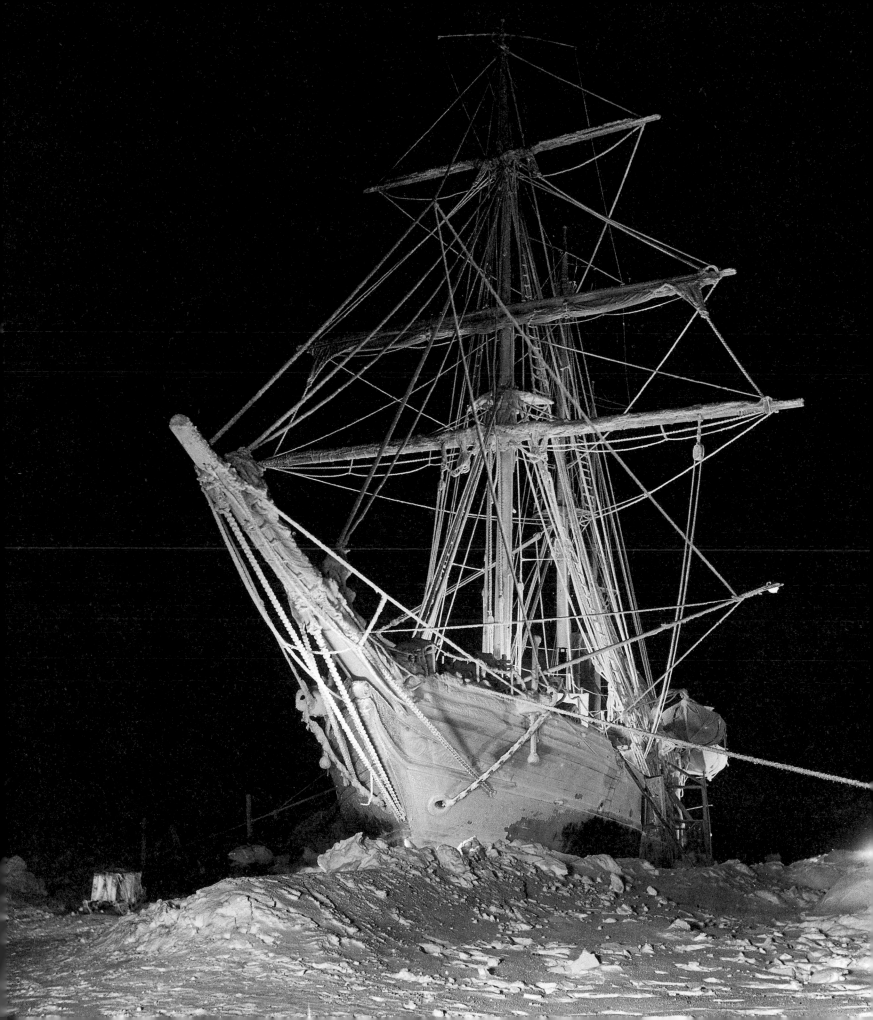

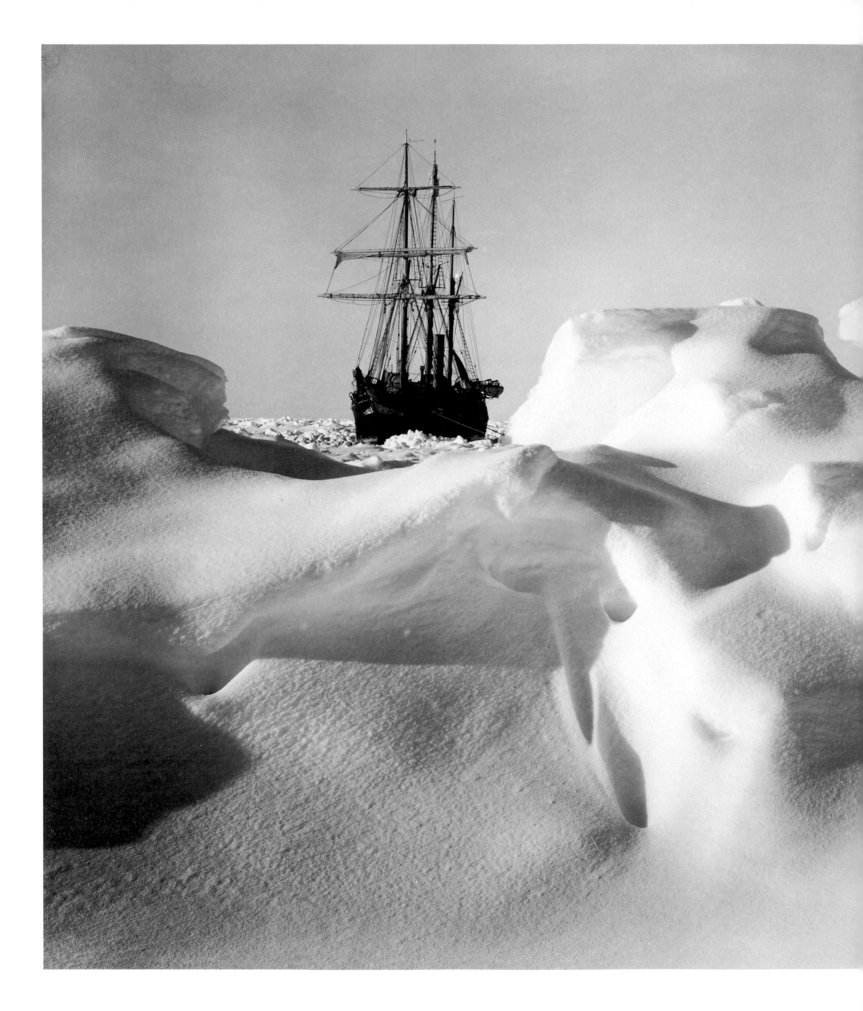

69. **Wind-sculptured hummocks, 1915**

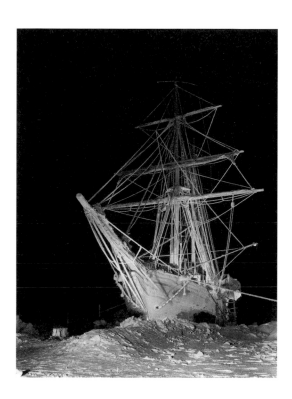

70. **The *Endurance* in the garb of winter, June 1915**

'Volumes of dense frost vapours condensed on the rigging; line and spar, stowed sails, braces, anchor chains, glittered with countless tiny ice-crystals which flashed like diamonds. But perhaps never did the ship look quite so beautiful as when the bright moonlight etched her in inky silhouette, or transformed her into a vessel from fairy-land. During the winter months, when we lost the sun for ninety days and everything was encased in ice, I took a series of flashlight pictures with the temperature at seventy degrees below freezing point [–38 °F/–39 °C]' (Hurley 1925, pp. 158–9).

This image has been reproduced many times, yet it never fails to startle. It shows the ship coated in ice. It is both a haunting and an artistic shot, almost too incredible to be real. Today, one might question whether an extra layer of ice had been added for dramatic effect. In creating this remarkable photograph, Hurley would have gone out in the freezing cold in complete darkness, carrying his heavy equipment to take a shot of the ghostly ship. He would have used powerful flashlights in order to create this striking image, which demonstrates the sheer professionalism of the man. *DHA*

71. **During midwinter, 1915**

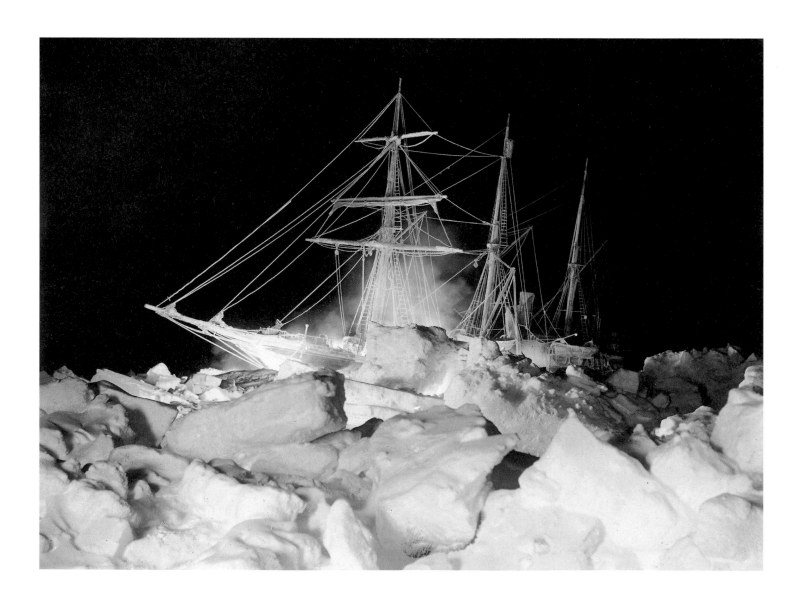

72. The ship was the nucleus of a pressure wave, September–October 1915

'The roar of the pressure grew louder, and I could see that the area of disturbance was rapidly approaching the ship. Stupendous forces were at work and the fields of firm ice around the *Endurance* were being diminished steadily … The ship sustained terrific pressure on the port side forward, the heaviest shocks being under the fore-rigging. It was the worst squeeze we had experienced' (Shackleton 1919, p. 65).

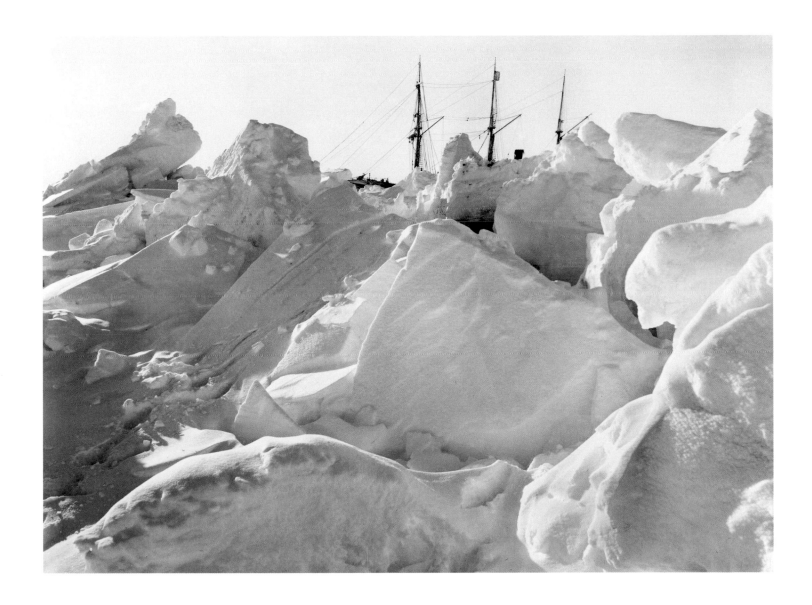

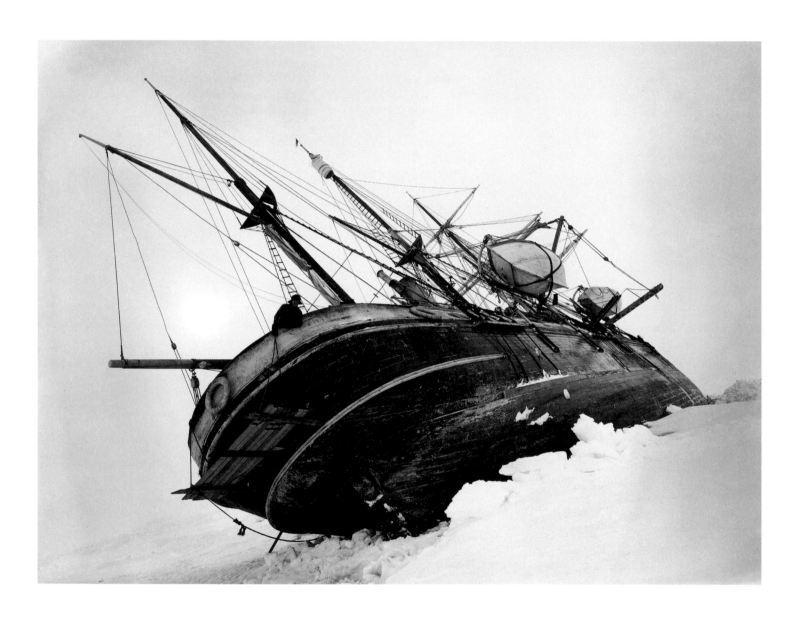

73. The *Endurance* forced out of the ice by the coming together of the floes, 18 October 1915

(right)

74. The ship was forced into this position 15 seconds after the floes came together, 18 October 1915

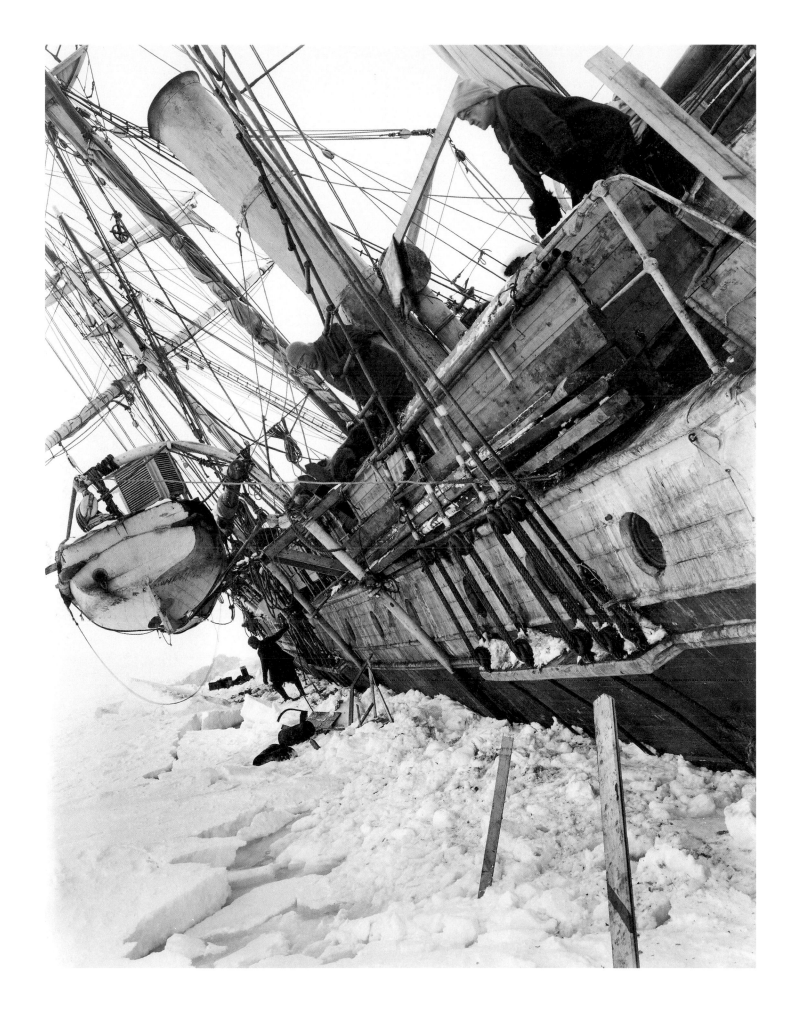

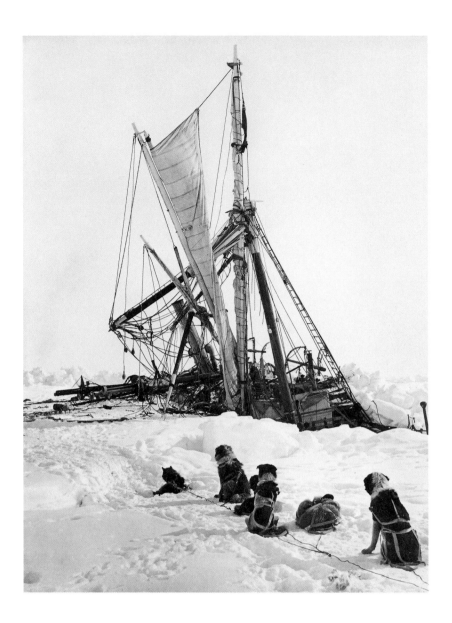

75. The *Endurance* crushed between the floes, 25 October 1915

This image of the wreck must have been heart-wrenching for Shackleton, in a similar way to the sight of Amundsen's tent for Scott. At this point the ship was destroyed and it was a question of pure survival to get home. The ship is a ghost of its former self, broken and crushed by the ice. The dogs, defeated, forlornly face their lost home. There are no men in the photograph. One can only imagine the expressions on their faces as they contemplated how they would reach home. *DHA*

(right)
76. **Wild observes the wreck, 8 November 1915**

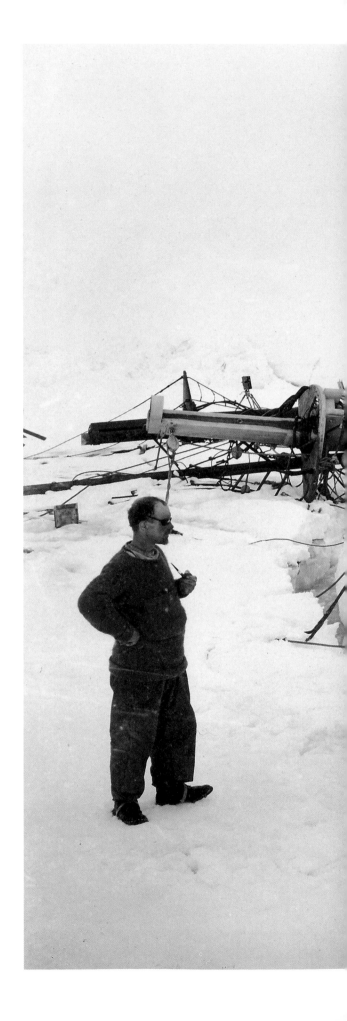

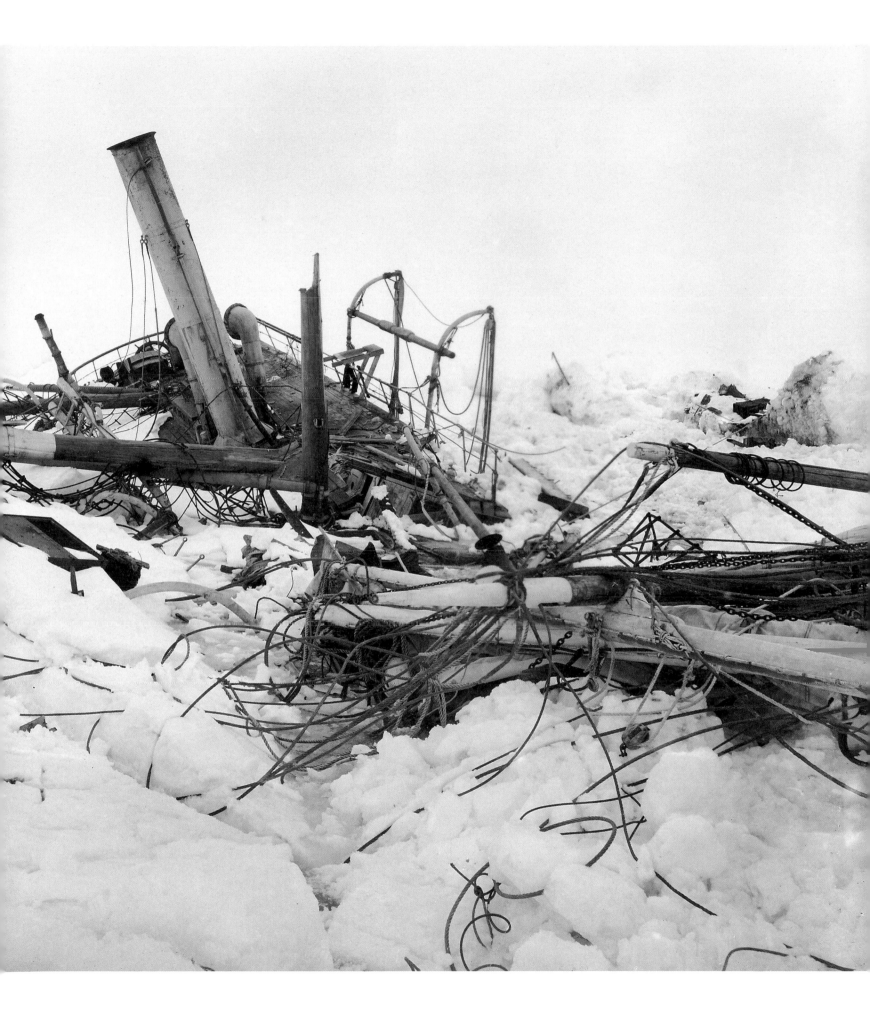

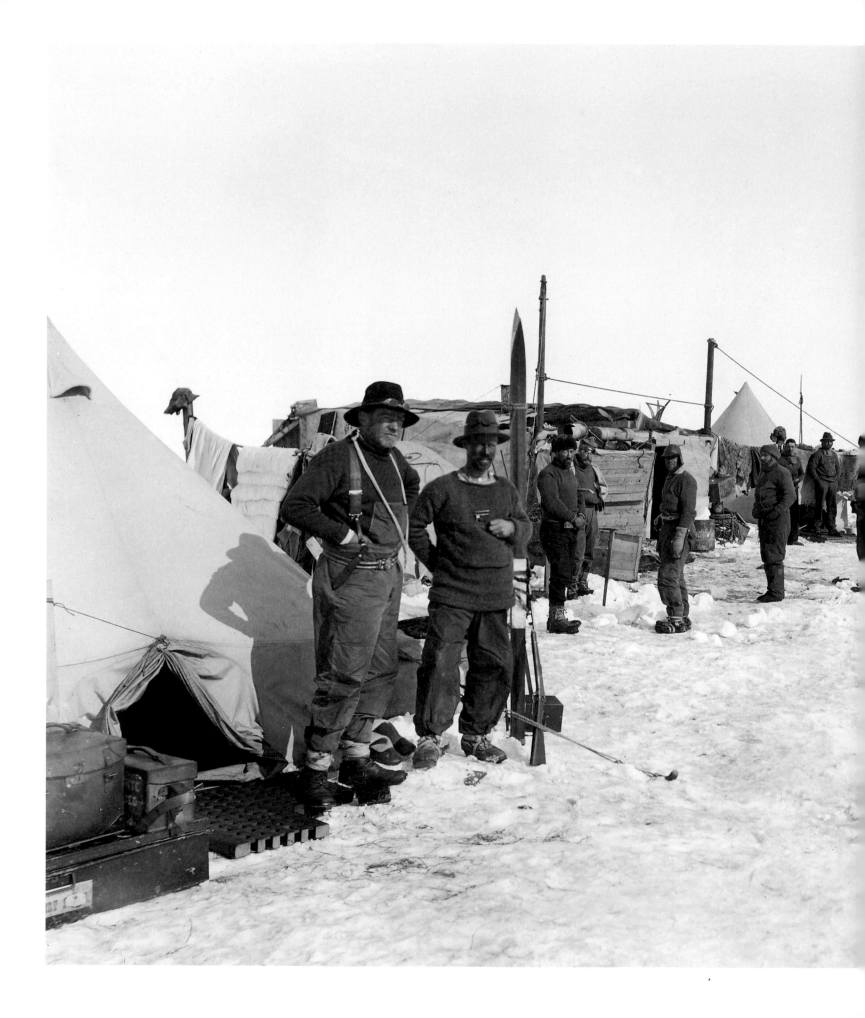

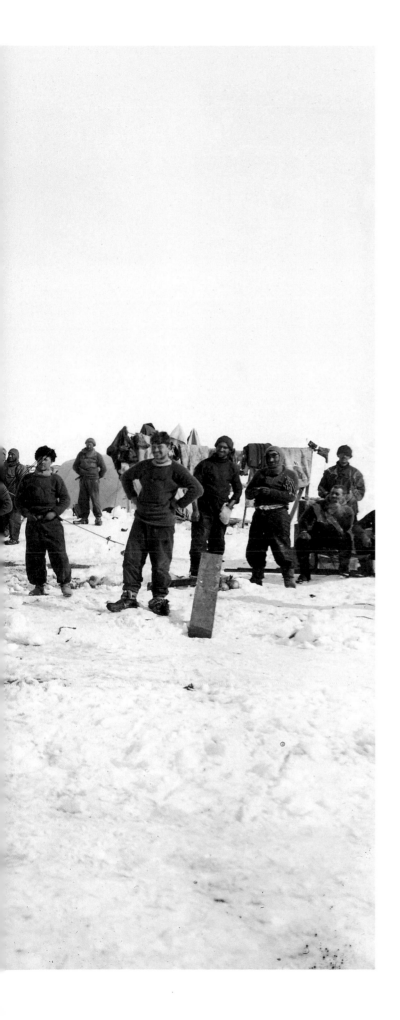

77. The party at Ocean Camp on the drifting sea ice:
 Sir Ernest Shackleton and Frank Wild on the left,
 30 October 1915

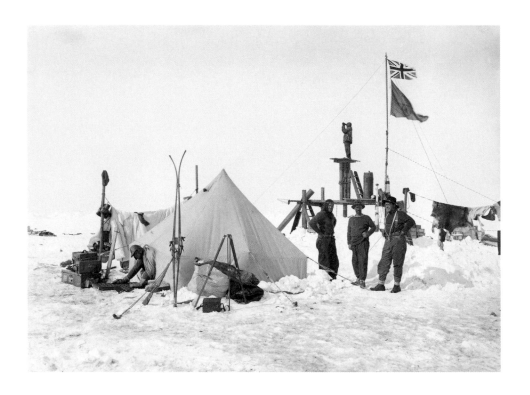

78. The lookout platform at Ocean Camp, November 1915

The photograph shows the Union Jack presented to Shackleton
by King George V on 5 August 1914 (no. 101).

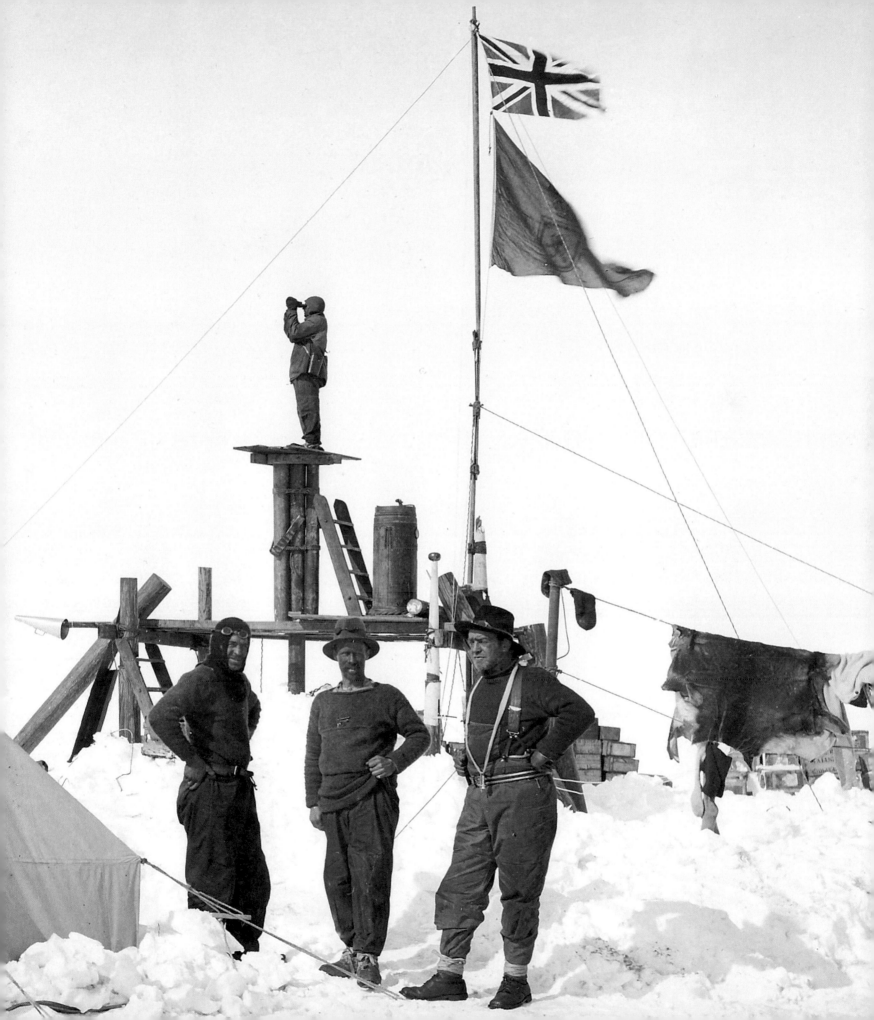

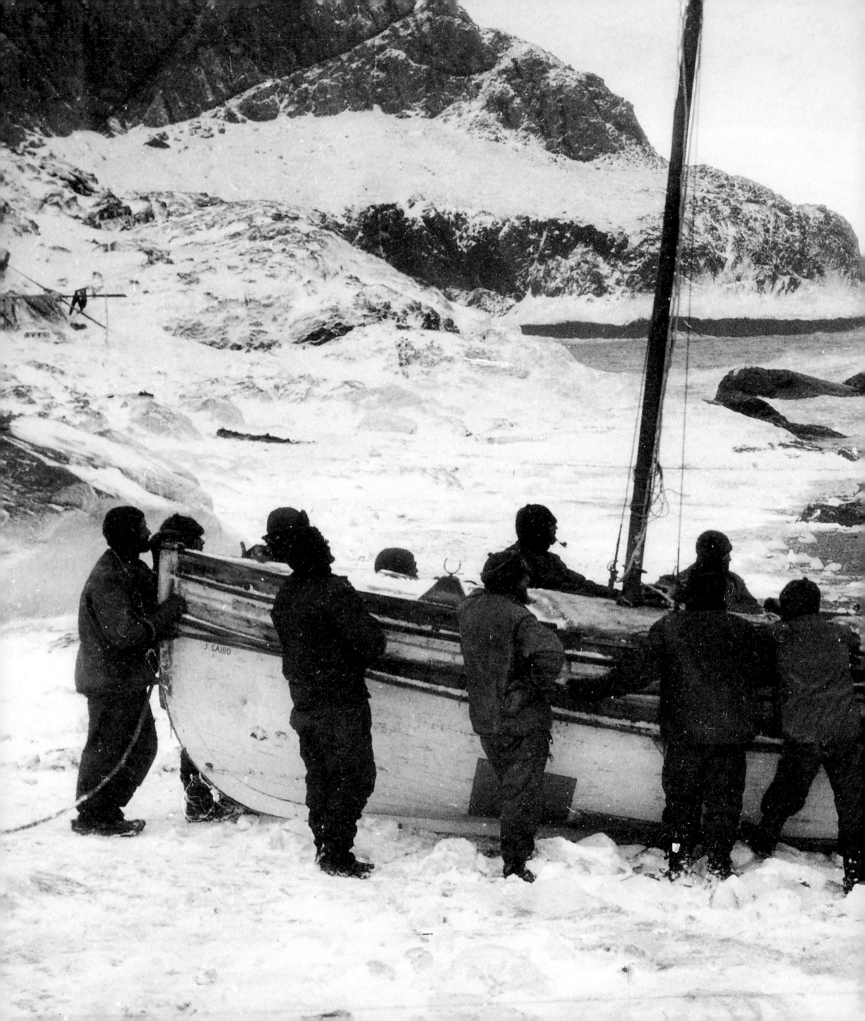

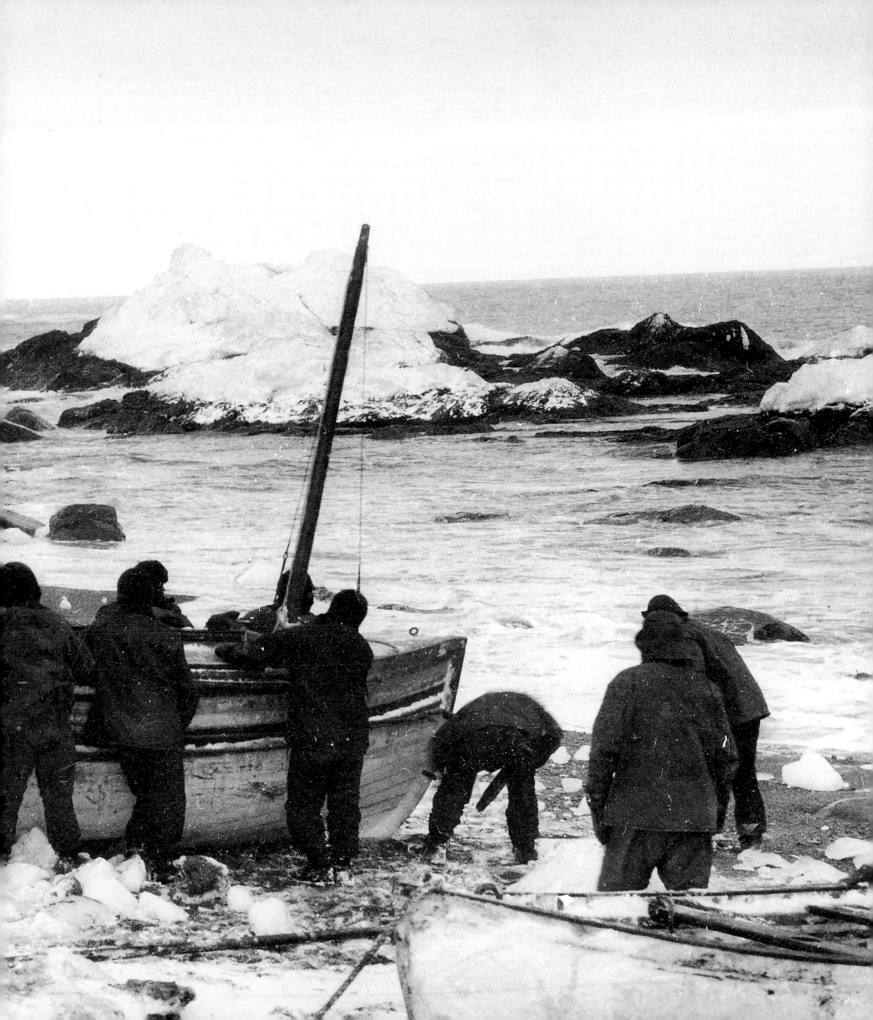

ELEPHANT ISLAND, APRIL–AUGUST 1916

After the ecstatic landing at Cape Valentine on 15 April 1916, Shackleton's men found that their safe haven lay below the high-water mark. The boats were relaunched and the party moved along the coast to the point later named Cape Wild, where a savage blizzard tore their tents to shreds. It was crucial, however, to provide shelter for the party who would remain while Shackleton made his desperate voyage to South Georgia, so the men started to dig snow caves in a neighbouring glacier (no. 83). Unfortunately, meltwater soon made these uninhabitable. Wild then had the idea of building a hut out of the two remaining boats, upturned on low stone walls covered with tent cloth. The diet of penguin and seal was sustaining but primitive, and the chief topic of conversation in the hut was usually food, derived from Marston's penny cookbook. The hut, though infinitely more solid than their tents, was black with blubber smoke, and the shingle floor would 'scarcely bear examination by strong light without causing even us to shudder and express our disapprobation at its state' (Shackleton 1919, p. 229). It sheltered them, however, until 30 August 1916, when Shackleton returned aboard the Chilean ship *Yelcho* to relieve them.

79. **The exhausted party on the beach at Cape Valentine, Elephant Island, 15 April 1916**

This image was taken by Hurley with his little pocket camera on 15 April 1916, capturing the crew's first experience of land since leaving South Georgia in December 1914, and their first hot drink since leaving the ice floes. They had just endured six days in open boats without adequate food, water or shelter, and Elephant Island – though one of the starkest, most rugged and inhospitable islands in the South Atlantic – was a godsend. Shackleton recorded the men's reactions: 'Some of the men were reeling about the beach as if they had found an unlimited supply of alcoholic liquor on the desolate shore. They were laughing uproariously, picking up stones and letting handfuls of pebbles trickle through their fingers like misers gloating over hoarded gold' (Shackleton 1919, p. 143).

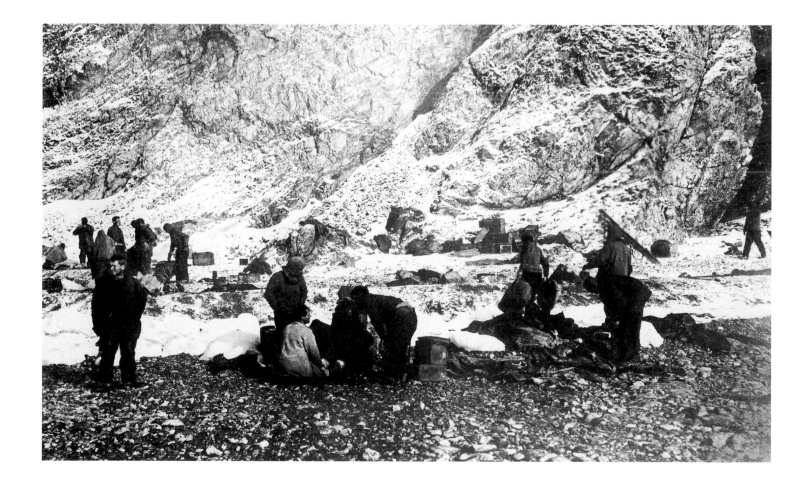

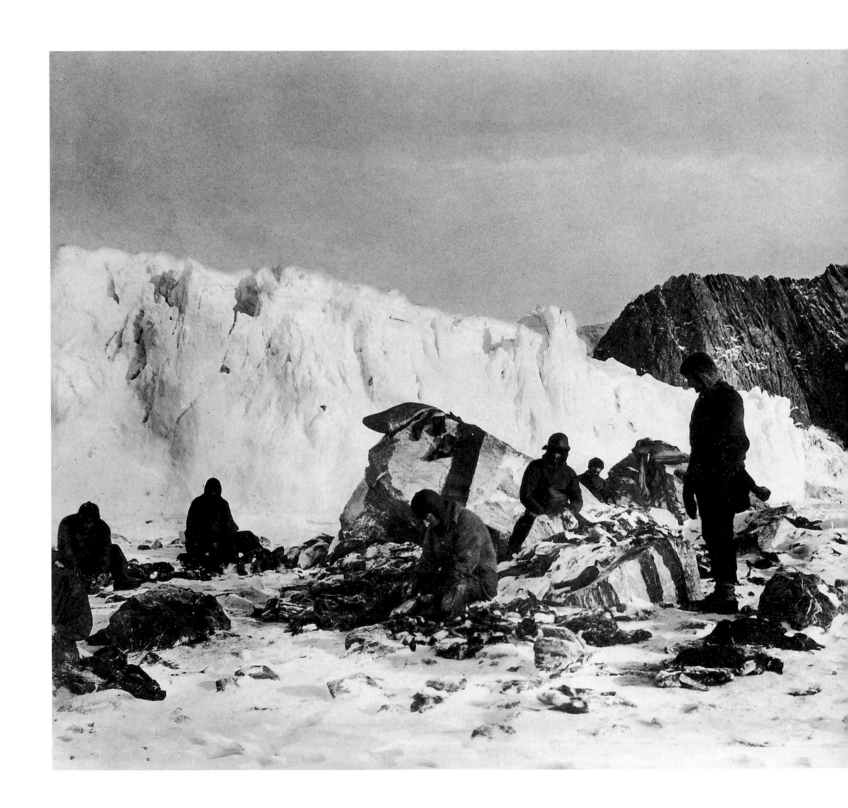

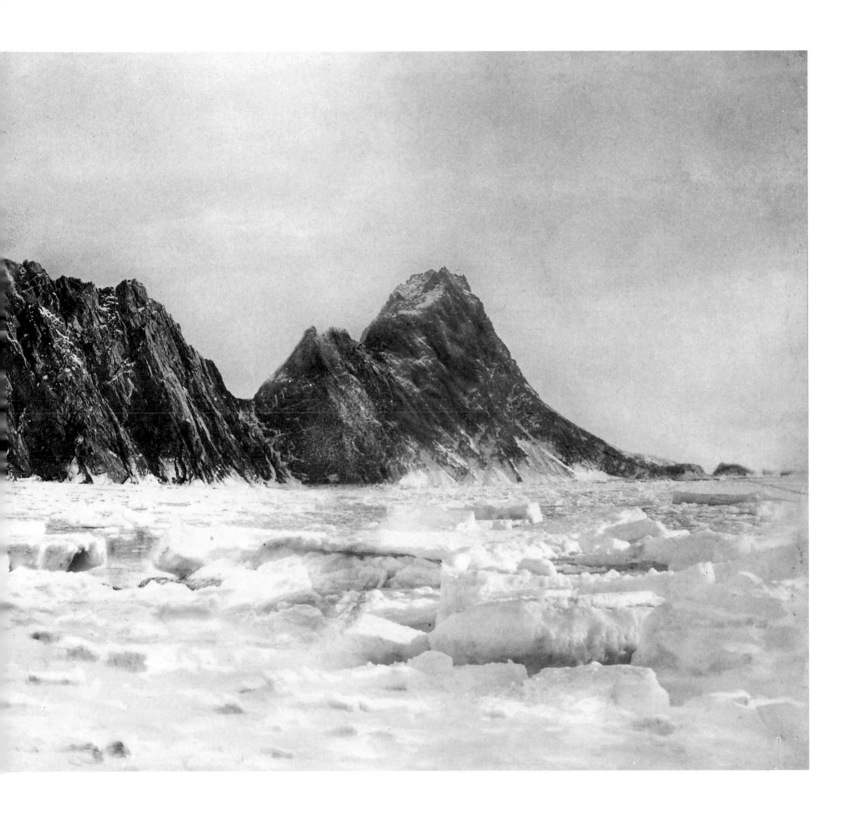

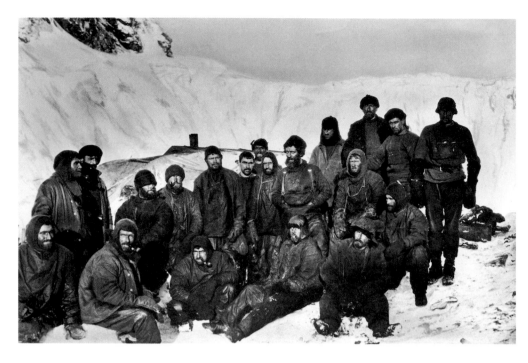

(left)

81. **The Elephant Island Party, 10 May 1916**

(See p. 229 for the names of those pictured here.)

82. **The boat shelter in which the Elephant Island Party lived for 4¹/₂ months, 1916**

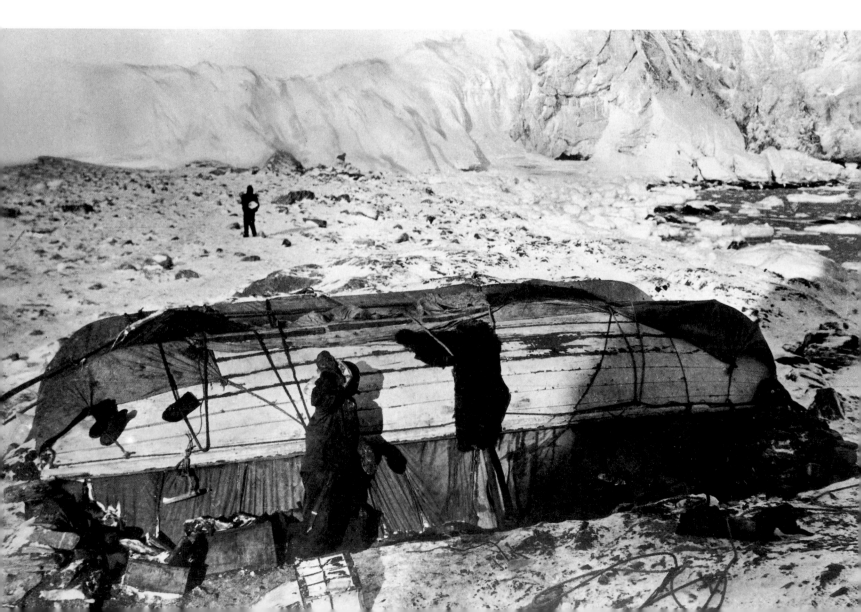

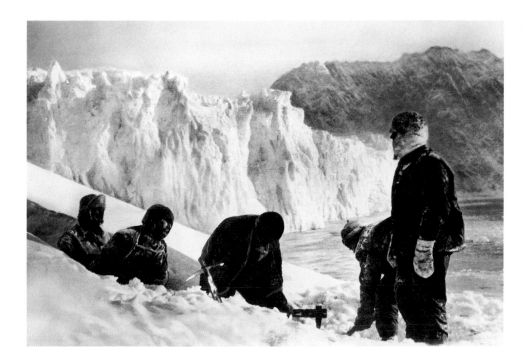

(right)

83. **The Elephant Island Party excavating an ice shelter in the glacier, April 1916**

84. **Preparing the boat for the relief voyage to South Georgia, April 1916**

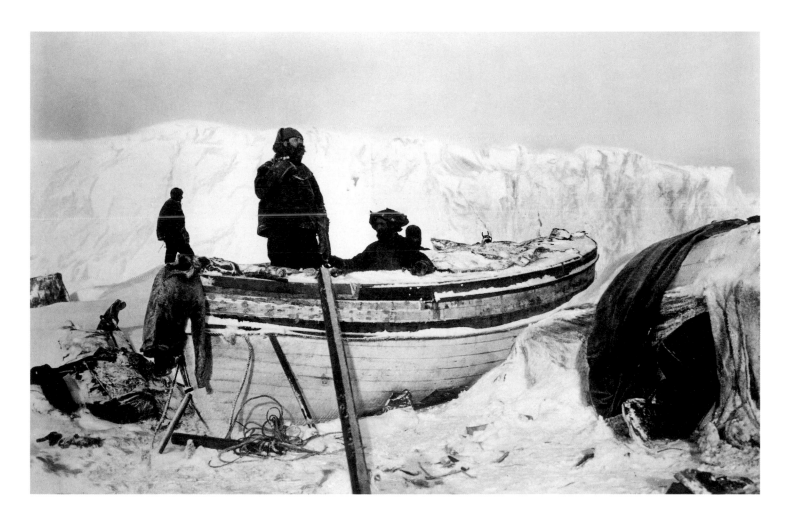

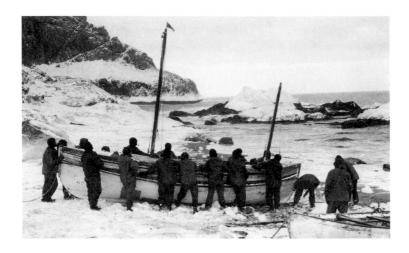

(above)

85. **Launching the *James Caird* for the relief voyage to South Georgia, 24 April 1916**

This extraordinary photograph shows the men in the *James Caird* embarking on their dramatic journey to South Georgia. They battled against the elements, several men with their heads down, pushing the boat off, legs soaked and icy cold. The nearby rocks reveal some of the dangers that lay ahead as they set off on the vast Southern Ocean. A handful of men took part in this epic journey, the remainder left behind on Elephant Island with the hope that they would soon be rescued. Hurley captured the strength and spirit of the men as they started out on their survival mission. *DHA*

86. **The *Yelcho* sighted, 30 August 1916**

Hurley altered the original negative of this image to create a slightly different scene. The *Yelcho* was photographed much closer to the shore; Hurley has erased the ship and painted in another vessel on the horizon. The smoke from the hillside on the left has also been added by hand.

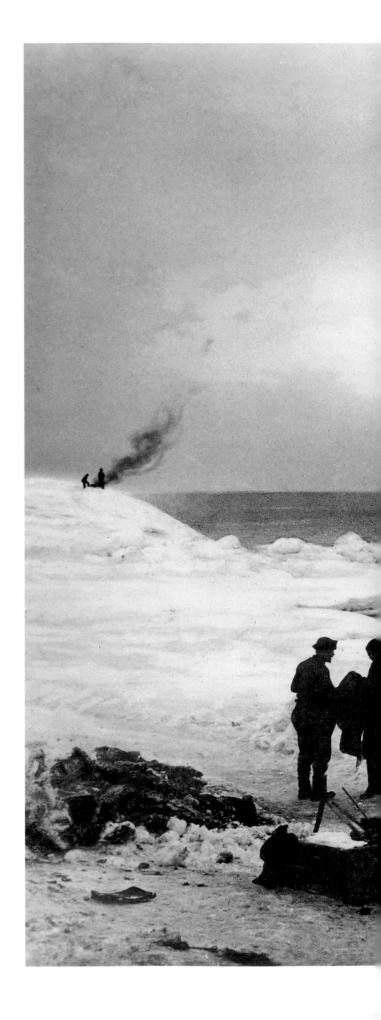

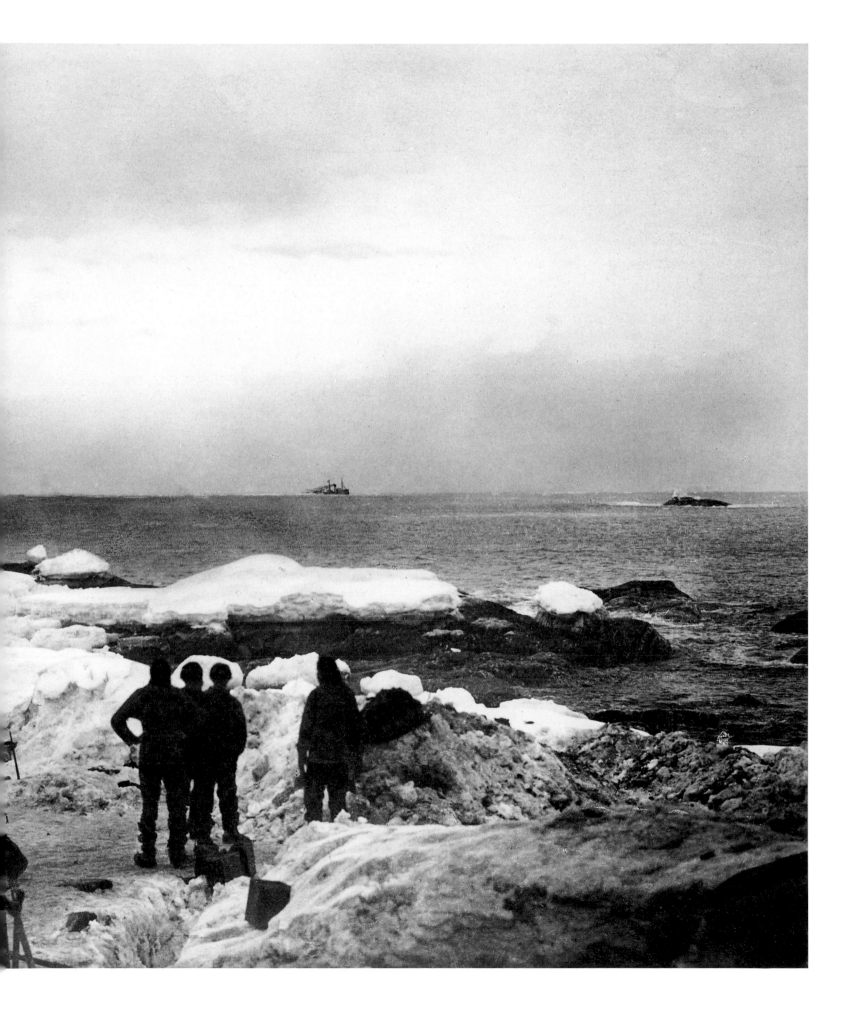

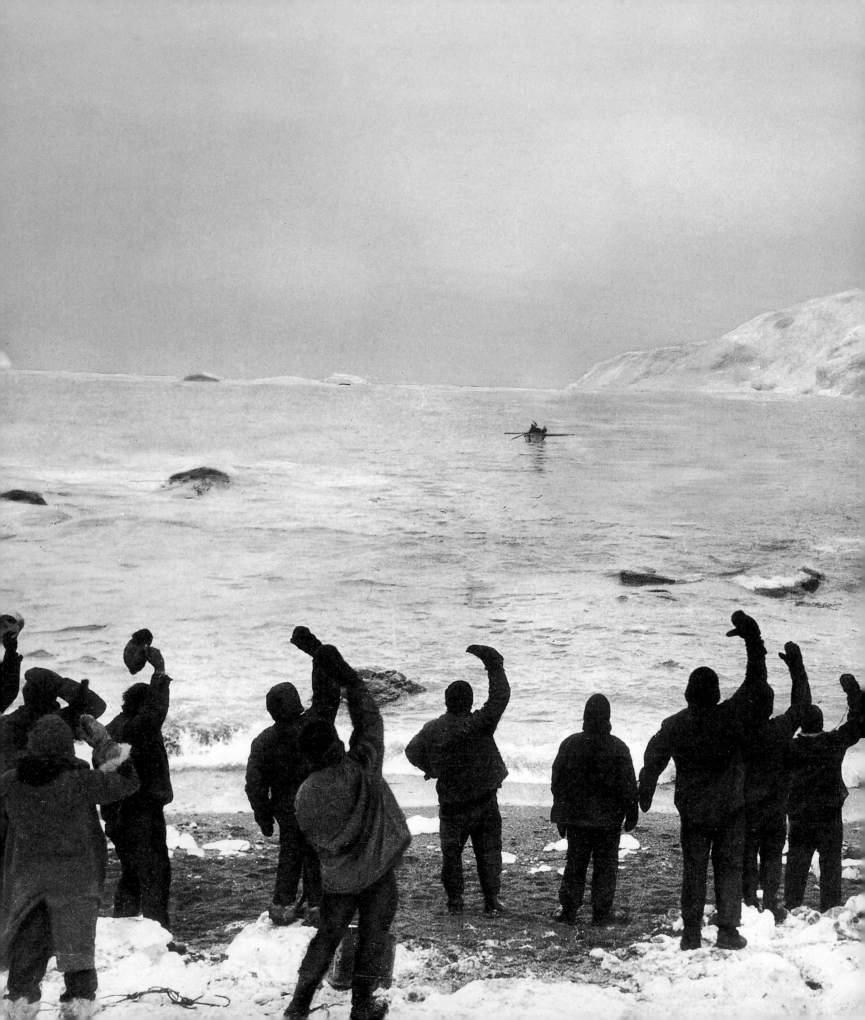

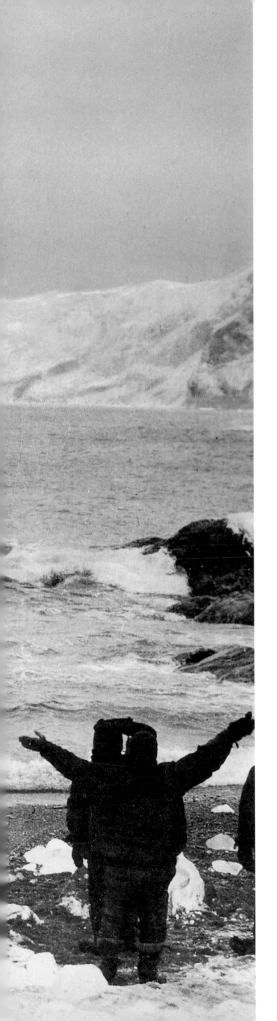

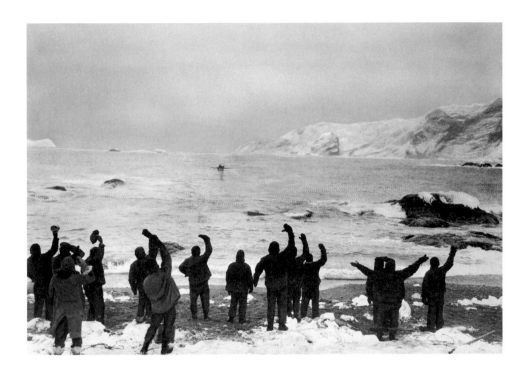

87. **Sir Ernest Shackleton arriving at Elephant Island
to take off the marooned men, 30 August 1916**

This photograph was taken at the time of the *James Caird*'s departure on 24 April.
Hurley has altered it, however, to represent the moment of rescue, with the arrival
of Shackleton on the *Yelcho*. The actual rescue was not photographed.

NON-PHOTOGRAPHIC MATERIAL

88. ERNEST SHACKLETON
(1874–1922) AND LOUIS
BERNACCHI (1876–1942), eds
***The South Polar Times.
Volume I, April to August 1902;
Volume II, April to August 1903,***
1907
London: Smith, Elder & Co.
Copy no. 156 of a limited
2-vol. edn of 250 copies

Dark blue cloth binding with
pictorial panel on front cover
showing the *Discovery* at winter
quarters, all edges gilt
283 × 228 mm (11¹/₈ × 9 in.)
RCIN 1044542 & 1044543

PROVENANCE: Probably acquired
by King Edward VII; subsequently
in the library of HMY *Britannia*

(right) Ode to a Penguin by
Fitz-Clarence (Lieutenant Barne)
from *South Polar Times*, May 1902,
vol. I, p. 29

In the preface to the *South Polar Times*, Scott wrote that 'our thoughts turned
naturally to the long dark period before us and the means by which we could lighten
its monotony' (Shackleton and Bernacchi, eds, 1907, vol. I, p. v). It was decided to
follow the example of previous polar expeditions and have a monthly newsletter, 'the
first Antarctic Journal' (ibid.). Shackleton was editor, Wilson was illustrator, and
contributions were invited from all hands, to be left in a wooden box outside
Shackleton's office. The first number appeared in April 1902, its tone a mixture of
London daily newspaper and public school magazine, with a variety of serious
scientific articles, poetry, acrostics, caricatures and silhouettes; a series of mock
heraldry named 'Arms and the Man'; and decorative illustrations of the officers'
sledging flags (Scott 1905, vol. I, pp. 362–4). The wooden box was soon so full,
especially with lighter humorous and ephemeral titbits, that Shackleton was forced to
announce a stable mate, *The Blizzard*, into which the overflow could safely go
without upsetting fragile tempers. Its first and only number appeared in May 1902,
and it then died a natural death. After Shackleton was invalided home with scurvy at
the end of the 1902–3 season, the physicist Louis Bernacchi took over as editor.
Following the end of the expedition, the *South Polar Times* was handed to Smith,
Elder & Co. for facsimile publication in a limited edition, as part of the wave of
Antarctic publishing for which the public had such an appetite.

O creature which in Southern waters roam,
To know some more about you I would wish.
Though I have seen you in your limpid home,
I don't think I can rightly call you "fish".

✢✢✢✢✢✢✢✢✢✢

To taste your body I did not decline,
From dainty skinner's fingers coming fresh,
'Twas like shoe leather steeped in turpentine,
But I should hardly like to call it "Flesh".

When asked for information of your race,
The greatest scientist is seen to scowl,
Though dread of lost repute o'erspreads his face,
He has not got the neck to call you "fowl".

✢✢✢✢✢✢✢✢✢✢

Then creature of amphibious tastes I crave,
Forgiveness if to you I may seem erring,
But hear me ere you dive beneath the wave,
I'm blowed if I will call you "good red herring".

FITZ-CLARENCE.

✢✢✢✢✢✢✢✢✢✢✢✢✢✢✢✢✢✢

THE
VOYAGE OF
THE 'DISCOVERY'

BY
CAPTAIN ROBERT F. SCOTT
C.V.O., R.N.

WITH 260 FULL-PAGE AND SMALLER ILLUSTRATIONS BY DR. E. A.
WILSON AND OTHER MEMBERS OF THE EXPEDITION.
PHOTOGRAVURE FRONTISPIECES, 18 COLOURED
PLATES IN FACSIMILE FROM DR.
WILSONS' SKETCHES, PANORAMAS
AND MAPS

IN TWO VOLUMES
VOL. II

SECOND IMPRESSION

LONDON
SMITH, ELDER, & CO., 15 WATERLOO PLACE
1905

[All rights reserved]

89. ROBERT FALCON SCOTT (1868–1912)
The Voyage of the 'Discovery', 1905
London: Smith, Elder & Co.

Dark blue cloth binding with gold medallion design on front cover showing a wreathed bust portrait of Scott, top edge gilt
246 × 182 mm (9⁵⁄₈ × 7¹⁄₈ in.)
Vol. II of 2 vols
RCIN 1092914

PROVENANCE: Probably acquired by King Edward VII

On *Discovery*'s return to New Zealand, and then to Britain, her captain and crew received heroes' welcomes, from both the public at large and, more particularly (and importantly), the scientific establishment and the Royal Navy. A new Polar Medal was instituted *(see no. 96)* and awarded to the entire ship's company and those of the two relief ships, while Scott himself was made a Commander of the Victorian Order, bestowed upon him by King Edward VII on 27 September 1904 during a visit to Balmoral. Assured of his position within the Royal Navy by a promotion to post captain, Scott found his expedition work was far from over, since the Royal Society and the Royal Geographical Society (RGS) wanted him to write the official history of the expedition. He was concerned about his literary qualifications, writing to Hugh Mill of the RGS that he was 'wholly doubtful of my capacity … I have not, like you, the pen of a ready writer' (Crane 2005, p. 316). Posterity generally does not agree with him. Leonard Huxley, the publisher's chief reader (who would later edit Scott's last diaries for publication in 1913), described Scott's ability to take in a sensation and then fix it with unerring precision as 'like wax to receive an impression and like marble to retain it' (ibid., p. 319). Scott might have doubted his abilities, but his descriptions of the Antarctic landscape did as much to form the public's perception of the new land as did the numerous photographs by Reginald Skelton and others, and the watercolours, which illustrated his history. The two-volume work was published in autumn 1905 to impressive reviews and quick sales – the first edition of 3,000 sold immediately, followed by a reprint of 1,500. The frontispiece of Scott was taken by Maull & Fox *(see p. 18)*.

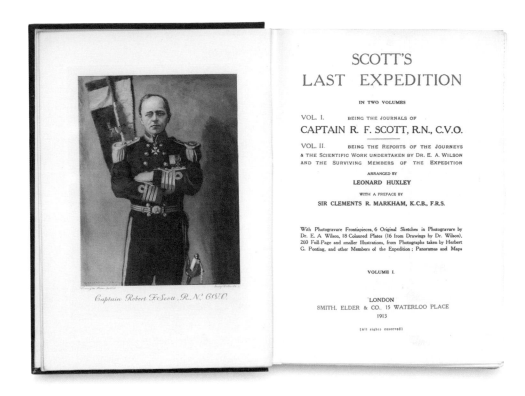

SCOTT'S
LAST EXPEDITION

IN TWO VOLUMES

VOL. I. BEING THE JOURNALS OF
CAPTAIN R. F. SCOTT, R.N., C.V.O.

VOL. II. BEING THE REPORTS OF THE JOURNEYS
& THE SCIENTIFIC WORK UNDERTAKEN BY DR. E. A. WILSON
AND THE SURVIVING MEMBERS OF THE EXPEDITION

ARRANGED BY

LEONARD HUXLEY

WITH A PREFACE BY

SIR CLEMENTS R. MARKHAM, K.C.B., F.R.S.

With Photogravure Frontispieces, 6 Original Sketches in Photogravure by
Dr. E. A Wilson, 18 Coloured Plates (16 from Drawings by Dr. Wilson),
260 Full-Page and smaller Illustrations, from Photographs taken by Herbert
G. Ponting, and other Members of the Expedition ; Panoramas and Maps

VOLUME I.

LONDON
SMITH, ELDER & CO., 15 WATERLOO PLACE
1913

[All rights reserved]

Captain Robert F. Scott, R.N., C.V.O.

90. ROBERT FALCON SCOTT
(1868–1912)
Scott's last expedition: being the journals of Captain R.F. Scott ...; arranged by Leonard Huxley, 1913
London: Smith, Elder & Co.

Dark blue cloth binding, gilt top edge
246 × 178 mm (9⅝ × 7 in.)
Vol. I of 2 vols
Inscribed on flyleaf: *Presented with humble duty to the King by his faithful & dutiful Servant & Subject Kathleen Scott 1913.*
RCIN 1124426

PROVENANCE: Presented to King George V by Lady Scott, 1913

During the winter of 1910–11, Scott was frequently to be found writing copiously in his diary, pipe in hand, as famously recorded by Ponting (no. 32). 'Once, during the winter, I asked him if he had yet started on his book. His reply was: "No fear! I'll leave that until I get home." From which I gathered that his Journal was to be used merely as notes which later would be elaborated into his official account' (Ponting 1921, p. 164). Journal keeping was second nature to naval officers, and Scott filled 12 notebooks with his daily doings, impressions and the progress of the expedition, even while sledging. After Scott's death his journals were returned to his widow, who put in train arrangements made with Scott's publishers, Smith, Elder & Co. Leonard Huxley, their chief editor, made a continuous narrative out of the 12 notebooks with their often multiple entries, and removed certain passages that were critical of expedition members. Scott's self-criticism remained, giving a portrait of a complex introspective character. Huxley also included the text of letters written to the relatives of those who died with Scott, and a facsimile of Scott's 'Message to the Public', in which Scott did his best to explain the disaster and plead for assistance for the bereaved. The first edition came out in a handsome two-volume set, complete with coloured plates, maps, sketches and photographs, and was so popular that it required five print runs between November 1913 and February 1914. Lady Scott presented this copy to the King. The Prince of Wales (later King Edward VIII) was so struck by it that he sat up late to finish it, later writing an essay on the expedition that caused especial pride to his parents and mentors. He wrote in his diary: 'It is a most fascinating book & a wonderful story of pluck in the face of ghastly hardship & suffering' (RA EDW/PRIV/DIARY/1914: 9 January). On a trip to Norway in 1914, the Prince of Wales met and lunched with Amundsen, whom he found 'most interesting' (RA QM/PRIV/CC009/1914: 2 April); and the British envoy in Norway, Mansfeldt Findlay, recorded that 'Amundsen was astonished by The Prince's accurate knowledge of the history of the recent antarctic expeditions ... I am not surprised as I noticed that The Prince appeared to know Scott's book almost by heart' (RA PS/PSO/GV/C/P/452/30).

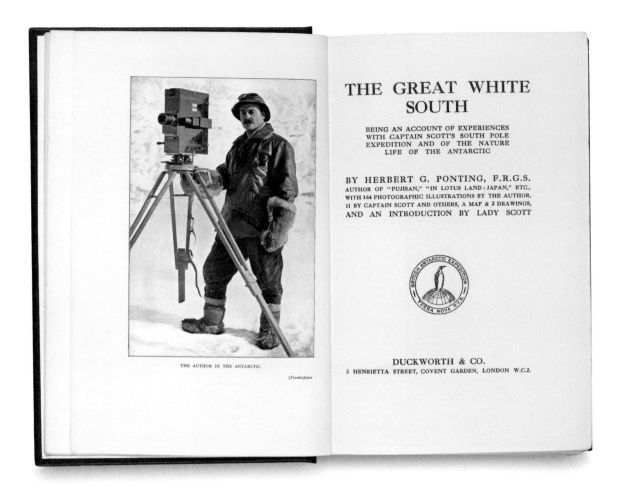

THE AUTHOR IN THE ANTARCTIC.

[*Frontispiece*

THE GREAT WHITE SOUTH

BEING AN ACCOUNT OF EXPERIENCES
WITH CAPTAIN SCOTT'S SOUTH POLE
EXPEDITION AND OF THE NATURE
LIFE OF THE ANTARCTIC

BY HERBERT G. PONTING, F.R.G.S.
AUTHOR OF "FUJISAN," "IN LOTUS LAND : JAPAN," ETC.,
WITH 164 PHOTOGRAPHIC ILLUSTRATIONS BY THE AUTHOR,
11 BY CAPTAIN SCOTT AND OTHERS, A MAP & 2 DRAWINGS,
AND AN INTRODUCTION BY LADY SCOTT

DUCKWORTH & CO.
3 HENRIETTA STREET, COVENT GARDEN, LONDON W.C.2.

91. HERBERT PONTING (1870–1935)
 i) *The Great White South*, 1921
 London: Duckworth & Co., 1st edn

Dark blue cloth binding with British Antarctic Expedition
emblem on front board
240 × 165 mm (9¹⁄₂ × 6¹⁄₂ in.)
RCIN 1124428

PROVENANCE: King George V

 ii) *The Great White South*, 1926
 London: Duckworth & Co., 3rd cheap edn, 7th imp.

Blue cloth binding with British Antarctic Expedition
emblem on front board
221 × 150 mm (8⁵⁄₈ × 5⁷⁄₈ in.)
Signed in pencil on flyleaf: *Albert*
RCIN 1166566

PROVENANCE: Prince Albert (later King George VI)

Ponting published his own account of the *Terra Nova*
expedition in 1921, lavishly illustrated with his own
photographs. His foreword stated that 'it was much to be
desired that the youth of the Nation should become conversant
with such adventures as Polar expeditions, as this would help
to stimulate "a fine and manly spirit in the rising generation"'
(Ponting 1921, p. vii). Kathleen Scott wrote an introduction
and the book went through 11 reprints in Ponting's lifetime,
proving more obviously successful than his photographs and
films. Unlike his previous book, *In Lotus-Land Japan* (1910),
which had been mostly descriptive, in *The Great White South*
Ponting discussed at length the subject of photography, the
techniques to be used and the practical problems to be
overcome when photographing in the far south. The *British
Journal of Photography* called it 'The most eloquent tribute to
his artistic and technical skill as a photographer under outdoor
conditions such as no other man has been called upon to
endure' (Arnold 1969, p. 89).

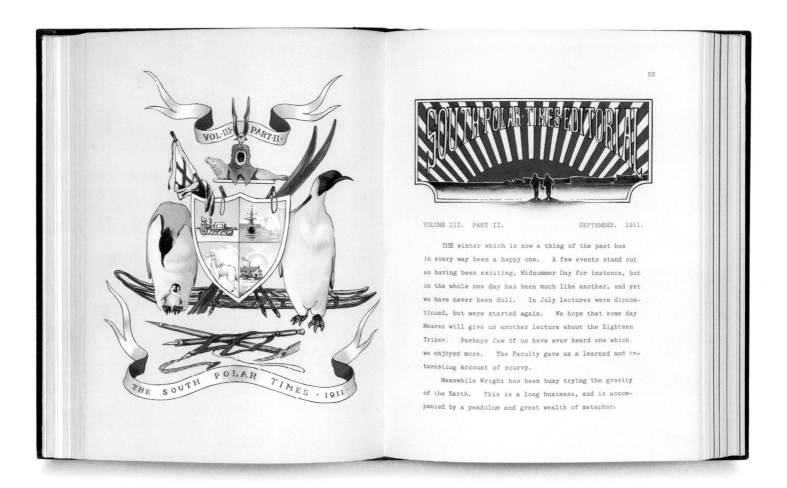

92. APSLEY CHERRY-GARRARD
(1886–1959), ed.
***The South Polar Times
Volume III, April to October
1911,* 1914**
London: Smith, Elder & Co.
Copy no. 106 of a limited edn of
350 copies

Dark blue cloth binding, with
image of the hut at Cape Evans on
front board
282 × 219 mm (11 1/8 × 8 5/8 in.)
RCIN 1102272

PROVENANCE: Acquired by
HM The Queen, October 2008

(above) Editorial for September 1911,
fol. 52

Following the success of the *South Polar Times* during the *Discovery* expedition, subsequent British Antarctic expeditions also produced their own newsletters, most notably Shackleton's *Aurora Australis.* When Scott returned to the south, the *South Polar Times* was revived, probably through the influence of Wilson, who again acted as illustrator, and 'Poor Cherry perspired over the editorial' (Scott 1913, vol I, p. 407). Apsley Cherry-Garrard was one of the youngest members of the crew, and Wilson's zoological assistant. They stuck to the old formula – serious articles on glaciology, bird life and climate change, silhouettes and sledging flags, and lighter articles such as a mock anthropological study of the invading humans written by the native rabbits, a lady's fashion article featuring Bowers's eccentric headgear, and a series of ancient chronicles depicting the expedition as ancient Egyptians. As with the previous editions, contributions were invited from all hands, and 'Among such a varied community there were some to whom writing came easily, others to whom it was a great labour: but all did their best' (Cherry-Garrard 1914, p. xiii). The first part was revealed on Midwinter's Day (22 June 1911), in a carved Venesta (an early form of plywood) packing case binding designed by Bernard Day, the car mechanic. Ponting described the scene: 'Cherry's masterpiece was then disclosed … It was a Crown Quarto volume, cleverly bound by Day with "Venesta" three-ply board, carved with the monogram S.P.T., and edged with silver-grey sealskin … many of the contributions were beautifully illustrated with water-colour sketches by Uncle Bill [Wilson] … Captain Scott read each article aloud, and there was much guessing over the authorship of the contributions' (Ponting 1921, pp. 140–41). This too was published by Smith, Elder & Co. after their return, in 1914.

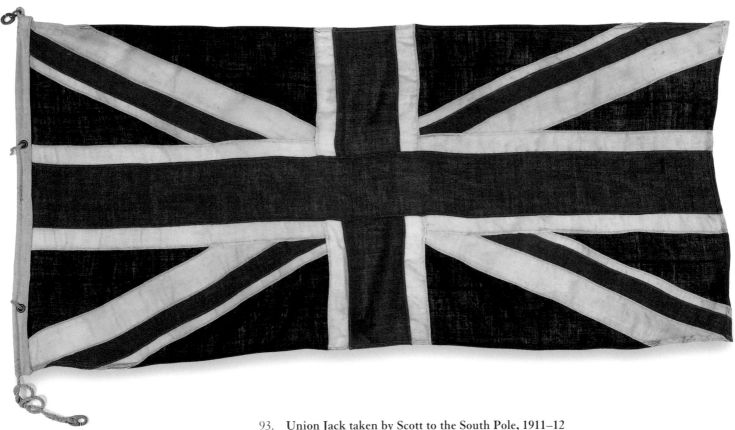

93. **Union Jack taken by Scott to the South Pole, 1911–12**
Linen, with inscribed silver plaque by Albert Barker Ltd, Silversmiths to Their
Majesties, in the form of a ribbon-hung shield, hallmarked London 1913–14
Flag 840 × 1660 mm (33 × 65⅜ in.); shield 256 × 122 mm (10⅛ × 4¾ in.);
height of shield with ribbon 355 mm (14 in.)
RCIN 38032

PROVENANCE: Presented to Scott by Queen Alexandra, 25 June 1910, and
returned by Lady Scott, 12 July 1913

Following her presentation of a Union Jack to Shackleton to take to the South Pole
in 1907, Queen Alexandra continued this very royal form of support with Scott's
expedition. King Edward VII had died on 6 May 1910, but less than six weeks later,
on 25 June 1910, the widowed queen 'Received Captain Scott & gave him a Flag to
plant at the South Pole' (RA VIC/MAIN/QAD/1910: 25 June). The Queen's flag,
made by George W. White & Co., was carried with the Polar Party to the South Pole,
despite nearly being left behind at Cape Evans. Wilson recorded that 'Here we
lunched camp [*sic*] – built a cairn – took photos, flew the Queen Mother's Union Jack
and all our own flags' (Wilson 1972, p. 232). Scott's sledging diaries, his sledging flags
(including his white ensign, no. 94, *opposite*), and Queen Alexandra's Union Jack
were recovered with his body. As recorded on the flag's silver commemorative
plaque, Queen Alexandra's flag was returned to her by Kathleen (then Lady) Scott
on 12 July 1913. 'I took Peter to see the Queen … We stayed an hour and the Queen
photographed Peter and me' (Kennet 1949, p. 124). The flag was subsequently
displayed with Shackleton's *Nimrod* flag *(see p. 24)* in the Ballroom at Queen
Alexandra's country residence, Sandringham House, Norfolk.

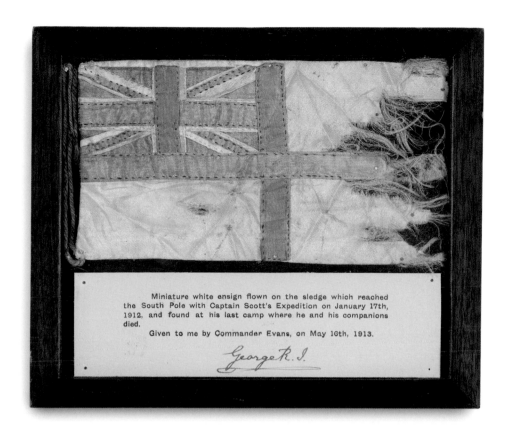

Miniature white ensign flown on the sledge which reached the South Pole with Captain Scott's Expedition on January 17th, 1912, and found at his last camp where he and his companions died.

Given to me by Commander Evans, on May 16th, 1913.

George R.I.

94. **Miniature white ensign flown on Scott's sledge on the southern journey, 1911–12**
White silk with red, white and blue silk trim, on cord, edges wind-torn, in frame with explanatory label
208 × 116 mm (8¹/₈ × 4¹/₂ in.); frame 254 × 219 mm (10 × 8⁵/₈ in.)
Printed label in frame, signed by King George V: *Miniature white ensign flown on the sledge which reached the South Pole with Captain Scott's Expedition on January 17th, 1912, and found at his last camp where he and his companions died. Given to me by Commander Evans, on May 16th, 1913. George R.I.*
RCIN 60068

PROVENANCE: Presented to King George V by Commander Edward Evans, 16 May 1913

This is one of several flags taken to the South Pole by Scott. As well as the Union Jack given to him by Queen Alexandra (no. 93, *opposite*), Scott also took a Union Jack that was left at the Pole, and his heraldic swallow-tailed sledging flag (pennant), seen hanging with others in the photograph of Scott's birthday dinner (no. 33), and again in the photographs of the five men at the Pole (nos 36, 37). These flags were another example of Clements Markham's influence; he had designed them for the officers aboard *Discovery*, following a similar practice during Franklin's Arctic expeditions. This continued aboard *Terra Nova*. This miniature white ensign which Scott carried to represent the Royal Navy, and possibly in token of his membership of the Royal Yacht Squadron, was flown on Scott's sledge on the southern journey. After its presentation to the King, it was on display for many years aboard HMY *Britannia*.

95. EDWARD WILSON (1872–1912)
i) **Within 13 miles of the South Pole, Amundsen's Flag, 16 January 1912**
Pencil on paper, with lettered mount
94 × 175 mm (3⁵/₈ × 6⁷/₈ in.); in original wooden frame
176 × 236 mm (6⁵/₈ × 9¹/₄ in.)
Label on back of frame inscribed: *Scott's Antarctic Expedition. Within 13 miles of the South Pole: Amundsen's flag, as sketched by E.A. Wilson, 16 Jan^ry 1912. This sketch was given to His Majesty, King George V in fulfilment of the artist's wish. July 1913.*
RCIN 929336

(opposite)
ii) **The South Pole, with Amundsen's flag, 18 January 1912**
Pencil on paper, with lettered mount
174 × 96 mm (6⁵/₈ × 3³/₄ in.); in original wooden frame
277 × 153 mm (6 × 10⁷/₈ in.)
Label on back of frame inscribed: *Scott's Antarctic Expedition. The South Pole, with Amundsen's flag, as sketched by E.A. Wilson, 18 January 1912. This sketch was given to His Majesty, King George V in fulfilment of the artist's wish. July 1913.*
RCIN 929337

PROVENANCE: Presented to King George V by Commander Edward Evans, July 1913

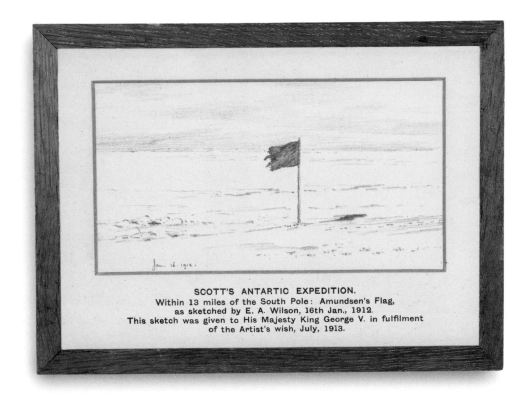

SCOTT'S ANTARTIC EXPEDITION.
Within 13 miles of the South Pole: Amundsen's Flag, as sketched by E. A. Wilson, 16th Jan., 1912.
This sketch was given to His Majesty King George V. in fulfilment of the Artist's wish, July, 1913.

Wilson's watercolours and sketches, often recorded at the risk of snow blindness, formed an important part of the expedition's scientific record. His artistic abilities had their lighter side too – the *South Polar Times* was colourfully illustrated by Wilson, sometimes in humorous style, sometimes in delicate and beautiful images for the more serious articles. His sketches of the final approach to the Pole, starkly monochrome, show the two heart-rending moments for the British team: first, when they realised that they had been forestalled by Amundsen, with 13 miles (24 km) yet to go, and then the final evidence of Norway's pre-eminence at the Pole. The sketches complemented the photographs taken by Bowers of 'Polheim' (no. 35), the Norwegians' tent, positioned about 1½ miles (2.8 km) from their estimated Pole position. Scott wrote in his diary: 'it was a black flag tied to a sledge bearer; near by the remains of a camp; sledge tracks and ski tracks going and coming and the clear trace of dogs' paws – many dogs. This told us the whole story. The Norwegians have forestalled us and are first at the Pole' (Scott 1913, vol. I, p. 543). These drawings were found with Wilson's body in November 1912.

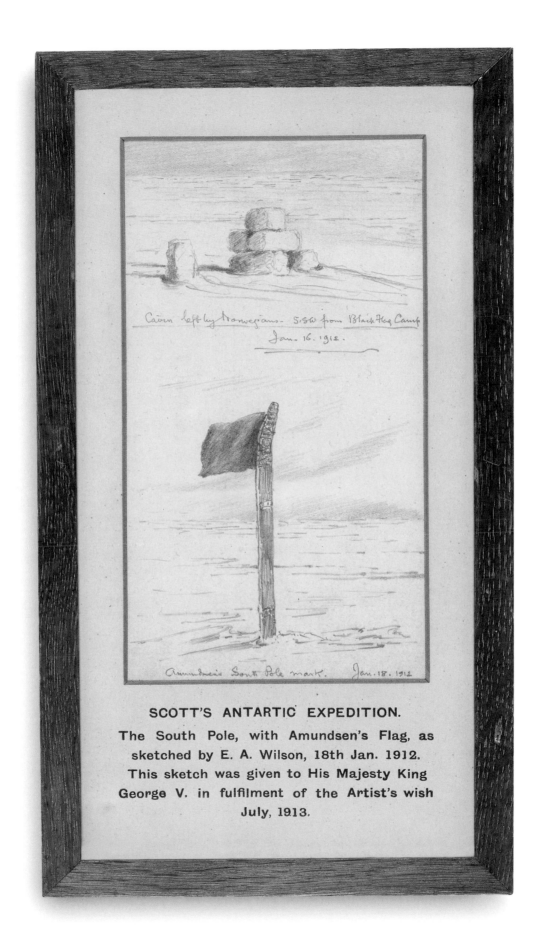

Cairn left by Norwegians - S.S.W. from Black Flag Camp
Jan. 16. 1912.

Amundsen's South Pole mark. Jan. 18. 1912.

SCOTT'S ANTARTIC EXPEDITION.

The South Pole, with Amundsen's Flag, as
sketched by E. A. Wilson, 18th Jan. 1912.
This sketch was given to His Majesty King
George V. in fulfilment of the Artist's wish
July, 1913.

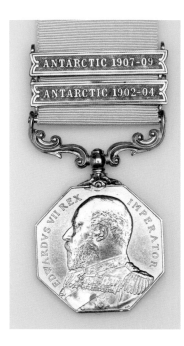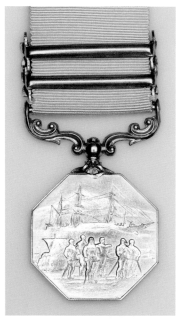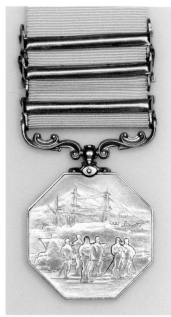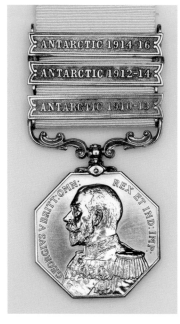

96. ERNEST GILLICK (1874–1950)
 G.W. DE SAULLES (1862–1903)
 BERTRAM MACKENNAL (1863–1931)
 Polar Medal, 1904
 (above left)
 i) King Edward VII, with two clasps: *ANTARCTIC 1902–04*;
 ANTARCTIC 1907–09
 Obverse: effigy of King Edward VII in admiral's uniform;
 legend: *EDWARDVS VII REX IMPERATOR*
 Reverse: *Discovery* with a sledging party of six in foreground,
 drawing a laden sledge with sail
 RCIN 440332

 (above right)
 ii) King George V, with three clasps: *ANTARCTIC 1910–13*;
 ANTARCTIC 1912–14; *ANTARCTIC 1914–16*
 Obverse: effigy of King George V in admiral's uniform;
 legend: *GEORGIVS V BRITT: OMN: REX ET IND: IMP:*
 Reverse: *Discovery* with a sledging party of six in foreground,
 drawing a laden sledge with sail
 RCIN 440597

 Each silver, octagonal, with white silk ribbon
 Diameter 33 mm (1¼ in.); ribbon width 33 mm (1¼ in.)

 PROVENANCE: King George VI

The Polar Medal was instituted in 1904 by King Edward VII to reward the returning Captain Scott and the crew of *Discovery*. Previous polar expeditions had been awarded various Arctic Medals (instituted by Queen Victoria in 1857), and the new Polar Medal was intended to cover exploration to both ends of the globe. All those serving with *Discovery* and with the landing party were given the silver medal with a clasp for 1902–4. The image of *Discovery* was designed by Ernest Gillick, and the obverse bust of King Edward VII by G.W. De Saulles. A bronze version without a clasp was given to those in the relief ships *Morning* and *Terra Nova*. The same medal was adopted for Shackleton's British Antarctic Expedition aboard *Nimrod* in 1907–9, where all members of the landing party were given a silver medal (if they had not already been awarded it) and dated clasp. The same medal was retained, though with King George V's effigy, by Bertram Mackennal, on the obverse, for Scott's final expedition aboard *Terra Nova* (1910–13), Mawson's aboard *Aurora* (1912–14) and Shackleton's aboard *Endurance* and *Aurora* (1914–16). King George V recorded presenting the crew of *Terra Nova* with their medals in his diary for 26 July 1913: 'At 11.30. I gave the Anartic [*sic*] medal to all the Officers & men of poor Scott's expedition, 53 in number. Lady Scott & the widows of those who lost their lives also came & I gave them the medals' (RA GV/PRIV/GVD/1913: 26 July).

The collection of decorations and medals at Windsor Castle was started by King George VI. The King made purchases to build up the collection, but the majority of pieces were presented as specimens by the Army Medal Office and the Royal Mint.

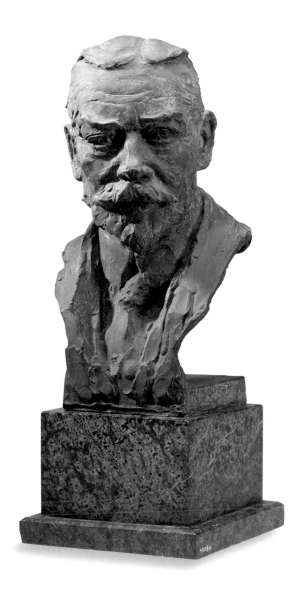

97. KATHLEEN SCOTT (1878–1947)
Bust of King George V, 1935
Bust 360 × 200 mm (14^1/$_8$ × 7^7/$_8$ in.);
plinth 125 × 184 × 187 mm (4^7/$_8$ × 7^1/$_4$ × 7^3/$_8$ in.)
RCIN 45169

PROVENANCE: Presented to Queen Mary by Kathleen Scott (Lady Kennet),
26 June 1935

Kathleen Scott, née Bruce, was the youngest of 11 children of a clergyman in Nottinghamshire. She became a student at the Slade School of Art in London in 1900, before leaving to study sculpture at the Académie Colarossi in Paris in 1902. She was a friend and admirer of Rodin and successfully exhibited alongside him several times. A constant theme in her work was motherhood. After attracting numerous suitors, in 1906 she was introduced to Robert Falcon Scott. They were married on 2 September 1908, and their son Peter was born on 14 September 1909. On the birth of her son she wrote: 'I fell for the first time gloriously, passionately, wildly in love with my husband … He became my god; the father of my son and my god. Until now he had been a probationer, a means to an end' (Kennet 1949, p. 89). Her appreciation of his 'gloriousness' (ibid., p. 121) is evident from her best-known work, her commemorative bronze statue of Scott in polar gear in Waterloo Place, London (1915; *see p. 13*). After Scott's death she became Lady Scott, having been granted the rank of a widow of a Knight Commander of the Order of the Bath. In 1922 she married Hilton Young, later Lord Kennet, but she continued her sculpting career, exhibiting regularly at the Royal Academy.

This bust of King George V is a reduction of a life-size bust which she sculpted following sittings at Compton Place, Eastbourne. The King wrote: 'Lady Hilton-Young came, I gave her sittings in morning [*sic*] & after noon for a bust she is doing of me. We walked on the parade by the sea. Lady Young had luncheon with us' (RA GV/PRIV/GVD/1935: 7 March). The original bust, which was commissioned during the King's Silver Jubilee year by the Hearts of Oak Society for their London offices, shows him head and shoulders in naval uniform, complete with medals and orders (Gwynn 1938, pp. 18–21; Sotheby's, Olympia, sale cat., 12 June 2006 (lot 274)). Kathleen had trouble getting it right: 'it is very nearly like. But just something is keeping it fierce looking, which the King is not' (Kennet 1949, p. 302). It was unveiled on 28 June 1935: 'The Queen [Queen Mary] came to the Hearts of Oak Society's building and unveiled my large bust of the King … She thanked me for the little head of the King which I had sent her two days before' (ibid., p. 305).

PUBLISHED AT THE
WINTER QUARTERS
OF THE BRITISH
ANTARCTIC EXPED
ITION, 1907, DURING
THE WINTER MON
THS OF APRIL, MAY,
JUNE, JULY, 1908.
ILLUSTRATED WITH
LITHOGRAPHS AND
ETCHINGS; BY
GEORGE MARSTON

PRINTED AT THE SIGN OF
'THE PENGUINS'; BY JOYCE
AND WILD.
LATITUDE 77°·· 32' SOUTH
LONGITUDE 166°·· 12' EAST
ANTARCTICA

TRADE MARK

98. ERNEST SHACKLETON (1874–1922), ed.
Aurora Australis 1908–09, 1908
PUBLISHED AT THE WINTER QUARTERS OF THE BRITISH
ANTARCTIC EXPEDITION, 1907, DURING THE WINTER
MONTHS OF APRIL, MAY, JUNE, JULY 1908.
ILLUSTRATED WITH LITHOGRAPHS AND ETCHINGS;
BY GEORGE MARSTON
PRINTED AT THE SIGN OF 'THE PENGUINS';
BY JOYCE AND WILD.
LATITUDE 77° 32' SOUTH
LONGITUDE 166° 12' EAST
ANTARCTICA
(Publication details have been transcribed from
the colophon of the book, reproduced above.)

Rebound in the Royal Bindery in 2008 in quarter leather
with original cowhide spine inset, Venesta packing case
boards, stamped MOC[K TU]RTLE [SOUP] inside front
board, BRITISH AN / EXPEDITIO and crate number
1723 inside back board, TION 1907 inside spine
Rebacked 273 × 210 mm (10¾ × 8¼ in.)
RCIN 1121970

PROVENANCE: Probably presented to King Edward VII
by Ernest Shackleton, 1909

(right) Title page from *Aurora Australis*

Aurora Australis was the first book to be produced entirely in
Antarctica. The idea of an expedition newsletter was not new in
polar exploration (as is demonstrated by the *South Polar Times* of
Scott's *Discovery* expedition – see no. 88), but an actual publication
had not been attempted. Shackleton returned to the Antarctic with
a printing press, paper, type and plate-making equipment, all
donated by the printing firm of Joseph Causton & Sons. Frank
Wild and Ernest Joyce took a quick course in printing before they
left England, sufficient to be able, after a couple of weeks' practice,
to produce two pages a day. The difficulties were considerable. 'A
lamp had to be placed under the type-rack to keep it warm, and a
lighted candle was put under the inking-plate, so that the ink
would keep reasonably thin in consistency' (Shackleton 1909, vol. I,
p. 217). The biologist James Murray described the cramped
conditions: 'The work had to be done … in a small room occupied
by fifteen men, all of them following their own avocations, with
whatever of noise, vibration and dirt might be incidental to them'
(Murray and Marston 1913, p. 104).

No more than 80 copies of the book were ever produced,
according to Shackleton himself in a letter to Pierpont Morgan,
25 July 1911 (Pierpont Morgan Library, New York, ARC 571.2).
The copies were bound in boards prepared by Bernard Day, from
Venesta packing cases. Surviving bound copies are often known by
the commodity advertised on the boards. This is the only known
copy with boards from crates used to transport mock turtle soup.

Shackleton begged indulgence from his readers: 'I trust that all
who have a copy will think kindly of the first attempt to print a
book and illustrate it in the depth of an Antarctic Winter'
(Shackleton 1908, fol. 5v). The book featured articles on the first
ever ascent of Mount Erebus, a comic account of the 'Trials of a
Messman', and an encounter with an Emperor penguin.
Shackleton noted in the preface that in the 'months lit only by
vagrant moon and elusive aurora; we have found in this work an
interest and a relaxation, and hope eventually it will prove the same
to our friends in the distant Northland' (Shackleton 1908, fol. 4v).

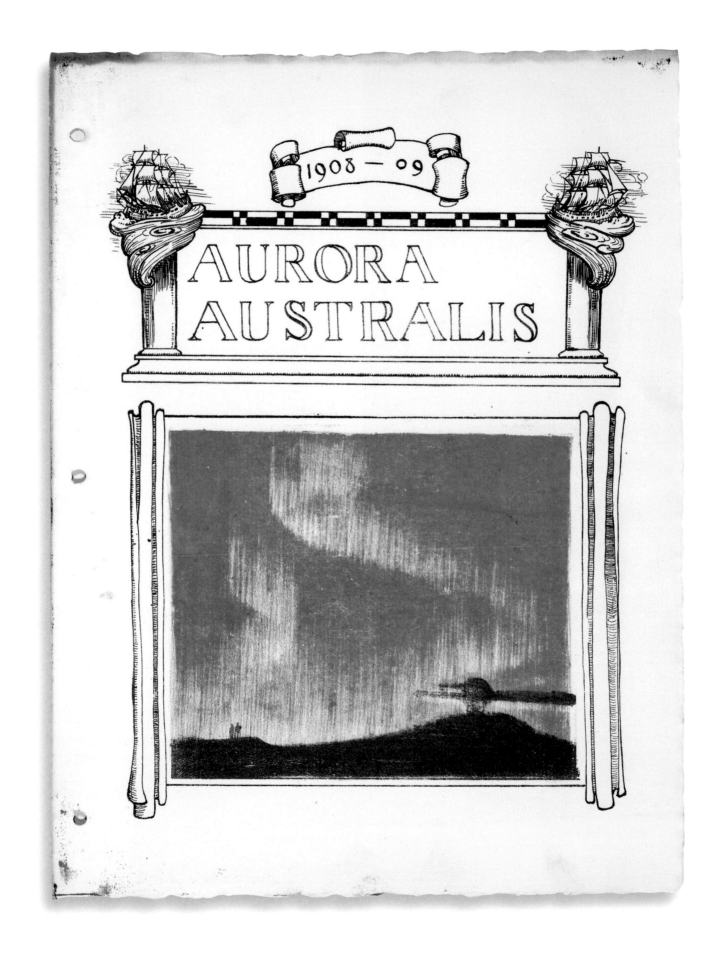

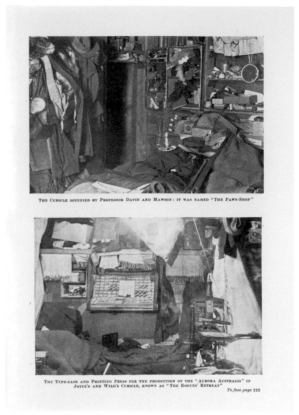

THE CUBICLE OCCUPIED BY PROFESSOR DAVID AND MAWSON; IT WAS NAMED "THE PAWN-SHOP"

THE TYPE-CASE AND PRINTING PRESS FOR THE PRODUCTION OF THE "AURORA AUSTRALIS" IN JOYCE'S AND WILD'S CUBICLE, KNOWN AS "THE ROGUES' RETREAT" *To face page 222*

99. ERNEST SHACKLETON
(1874–1922)
The Heart of the Antarctic: being the story of the British Antarctic expedition 1907–1909, 1909
London: William Heinemann

Dark blue cloth binding illustrated with image of the explorers at the Furthest South
254 × 192 mm (10 × 7½ in.)
2 vols
RCIN 1124430 & 1132903

PROVENANCE: Probably acquired by King Edward VII

(*above right*) 'The Rogues' Retreat', where the printing press and type case for the *Aurora Australis* were kept (no. 98), vol. I, plate facing p. 222

Shackleton's *Nimrod* expedition set off in 1907 to reach the South Pole. On arrival they based themselves near Scott's *Discovery* headquarters at Cape Royds. While a team under Professor T. Edgeworth David explored Victoria Land to the west and established the position of the South Magnetic Pole, Shackleton and his three companions struggled to within 97 miles (180 km) of the geographical South Pole, before turning back through lack of food. Despite the dramatic public excitement over its results, the expedition returned heavily in debt, and Shackleton also needed to make money on his own account. In New Zealand Shackleton recruited the assistance of Edward Saunders, a former reporter from the *Lyttelton Times*, who came recommended by New Zealand's Prime Minister. The work was based on Shackleton's diary and upon his own vivid recollections, and was illustrated by photographs taken by various members of the expedition. It came out in a two-volume set on 4 November 1909, decorated with the image of Shackleton at Furthest South (a direct challenge to the doubters), and was timed to coincide with Shackleton's British lecture tour. Editions in other major languages were published simultaneously and were received with overwhelmingly positive reviews (Fisher and Fisher 1957, pp. 273–4).

The Prince of Wales (later King George V) recorded in his diary how he had heard Shackleton lecture at the Royal Geographical Society: 'Mr Shackleton gave us an excellent lecture on his Antartic [*sic*] expedition … He also showed us many beautiful photographs & cinemetographs [*sic*] taken out there' (RA GV/PRIV/GVD/1909: 28 June). Shackleton was also invited to lecture at Balmoral in September 1909 (Mill 1923, pp. 164–5). The CVO, and later a knighthood awarded in the November Birthday Honours, capped a highly successful period in the ongoing struggle for the Pole.

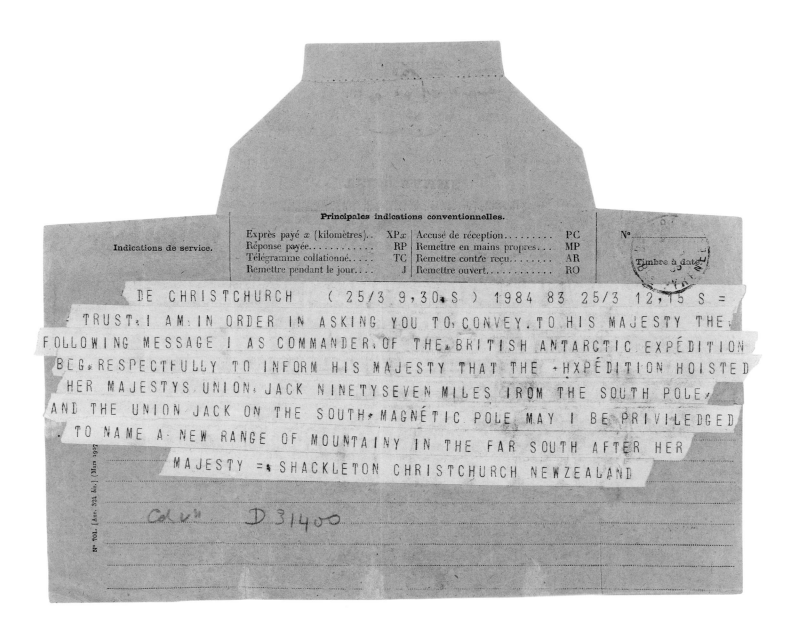

Principales indications conventionnelles.

Indications de service.	Exprès payé *x* (kilomètres)..	XP*x*	Accusé de réception.........	PC	N°...
	Réponse payée...........	RP	Remettre en mains propres...	MP	
	Télégramme collationné....	TC	Remettre contre reçu.......	AR	Timbre à date
	Remettre pendant le jour....	J	Remettre ouvert..........	RO	

DE CHRISTCHURCH (25/3 9,30,S) 1984 83 25/3 12,15 S =
= TRUST: I AM: IN ORDER IN ASKING YOU TO CONVEY TO HIS MAJESTY THE
FOLLOWING MESSAGE I AS COMMANDER OF THE BRITISH ANTARCTIC EXPÉDITION
BEG RESPECTFULLY TO INFORM HIS MAJESTY THAT THE +HXPÉDITION HOISTED
HER MAJESTYS UNION JACK NINETYSEVEN MILES IROM THE SOUTH POLE,
AND THE UNION JACK ON THE SOUTH MAGNÉTIC POLE MAY I BE PRIVILEDGED
. TO NAME A NEW RANGE OF MOUNTAINY IN THE FAR SOUTH AFTER HER
MAJESTY = SHACKLETON CHRISTCHURCH NEWZEALAND

Collⁿ D 31400

100. **Shackleton's telegram to King Edward VII, 25 March 1909**
 Telegram on paper
 133 × 242 mm (5¼ × 9½ in.)
 RA PPTO/PP/EVII/MAIN/D/31400

A telegram was sent by Shackleton to King Edward VII from Christchurch, New Zealand, announcing the achievements of the *Nimrod* expedition. The King replied in suitable terms: 'I congratulate you and your comrades most warmly on the splendid result accomplished by your Expedition, and in having succeeded in hoisting the Union Jack presented you by The Queen within 100 miles [185 km] of the South Pole. I gladly assent to the new Range of Mountains in the far South bearing the name of Queen Alexandra.'

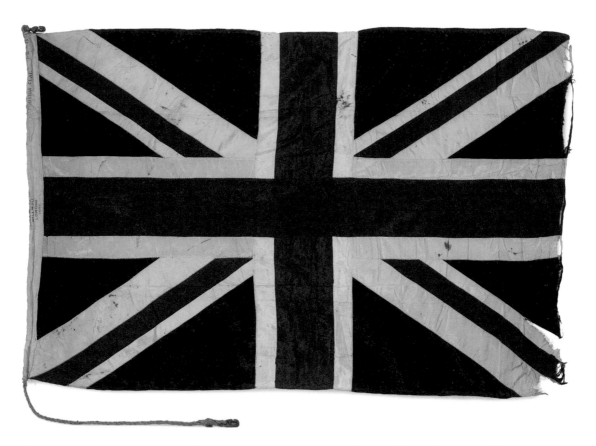

101. The Union Jack presented to Shackleton by King George V, 5 August 1914
Silk
933 × 1370 mm (36¾ × 54 in.)
RCIN 70389

PROVENANCE: Presented to Sir Ernest Shackleton by King George V, 5 August 1914, and returned to the King by Shackleton, 30 May 1917

Following a precedent set by Queen Alexandra on the *Nimrod* expedition *(see p. 24)*, King George V and Queen Alexandra gave flags to Shackleton for his Transantarctic expedition. Queen Alexandra presented hers during a visit to *Endurance* at Cowes on 16 July 1914 *(see p. 33)*. Shackleton received the King's flag *(above)* during an audience at Buckingham Palace on 5 August 1914. King George V recorded in his diary: 'Recev^d [*sic*] Sir Ernest Shackleton & took leave of him, he starts at once for his Antartic [*sic*] Expedition, I gave him a union jack' (RA GV/PRIV/GVD/1914: 5 August). The flag, made by Lane & Neeve Ltd, Millwall, London, was hoisted on *Endurance* at various notable points on the voyage: when entering the pack ice, when new land was discovered and at the expedition's Furthest South. After the sinking of *Endurance*, it was flown over the camps on the ice floes. 'I am going to hoist the King's Flag tomorrow. I think it will be a fine thing to have the flag flying here, especially as the King himself presented it to us. It'll buck the men up' (Shackleton quoted in Worsley 1931, p. 25). It remained with Frank Wild on Elephant Island while Shackleton made his desperate voyage to South Georgia. The flag then travelled to South America with the rescued crew, where it was flown again at significant moments, including aboard the rescue ship *Yelcho*; it finally accompanied Shackleton on the rescue of the Ross Sea Party. King George V received Shackleton in audience on his return, on 30 May 1917 (RA GV/PRIV/GVD/1917: 30 May), when the flag was handed back to the King. For many years it has been kept in the Royal Library, Windsor Castle.

(handwritten inscription)

Your majesty's flag, entrusted to us, as a spur to endeavour, upheld us through the scenes recorded in these pages; which my comrades and myself are graciously permitted to present to you sir.

Ernest H. Shackleton
Nov 1919.

102. ERNEST SHACKLETON (1874–1922)
South. The Story of Shackleton's Last Expedition 1914–1917, 1919
London: William Heinemann

Dark blue cloth binding with image of *Endurance*
255 × 170 mm (10 × 6⅝ in.) (closed)
Inscribed flyleaf (RCIN 1124415): *Your Majesty's flag, entrusted to us, as a spur to endeavour, upheld us through the scenes recorded in these pages; which my comrades and myself are graciously permitted to present to you Sir. Ernest H. Shackleton Nov 1919.*
Inscribed flyleaf (RCIN 1132821): *This Volume of work in the Far o/t [of the] south is handed to Her Majesty the Queen with Her gracious permission, by my comrades and myself Ernest Shackleton December 1919.*
RCIN 1124415 & 1132821

PROVENANCE: Presented to King George V and to Queen Mary, by Sir Ernest Shackleton, November and December 1919

(above right) Shackleton's presentation inscription to King George V

Shackleton's own account of how his ship was trapped and crushed in the pack ice, marooning the entire crew, is both appropriately monotonous (as drifting in the pack ice must be) and truly inspiring as a lesson on leadership. As with *The Heart of the Antarctic* (no. 99), Shackleton again had the help of Edward Saunders (Mill 1923, pp. 245 7; Fisher and Fisher 1957, pp. 507–8), though this time there were no pages of Shackleton's diary to edit; the text was worked out in a sequence of interviews and access to other fuller diaries, especially that of Frank Worsley. Shackleton was keen to join the war and thus did not have time for greater involvement, but clearly trusted Saunders to write in an appropriate manner. In such a stressful time, recalling events of such ghastly hardship, even Shackleton found it difficult to speak. The New Zealander Leonard Tripp, Shackleton's business minder and secretary, recalled: 'his whole face seemed to swell, and I could see the man was suffering. After about half an hour he turned to me and with tears in his eyes he said, "Tripp, you don't know what I've been through, and I am going through it all again, and I can't do it"' (Mill 1923, p. 245). The book was ready for publication by late 1919, and complemented the lecture tour that Shackleton was already engaged on, and Hurley's film of the expedition. It was illustrated with Hurley's dramatic photographs and sold extremely well, with its striking image of *Endurance* (no. 70) on the front cover.

103. FRANK WILD (1873–1939)
***Shackleton's Last Voyage.
The Story of the 'Quest'***, 1923
London, New York, Toronto and
Melbourne: Cassell & Co.

Illustrated blue cloth binding
241 × 175 mm (9¹/₂ × 6⁷/₈ in.)
Inscribed on flyleaf: *To His Most
Gracious Majesty King George V.
Presented with humble duty by
his loyal and devoted servant.
Frank Wild.*
RCIN 1124434

PROVENANCE: Presented to
King George V by Frank Wild

For his final voyage south, Shackleton left Britain in September 1921, aboard *Quest*, following a loose plan to circumnavigate Antarctica and fix the position of various islands: 'Programme in a nutshell: all the oceanic and sub-Antarctic islands. Two thousand miles of Antarctic outline from Enderby Land to Coats Land. Seaplane, kinema, wireless, everything up to date' (Mill 1923, p. 271). *Quest* also sailed with several old comrades aboard, including Worsley, Hussey, McIlroy and Macklin, from Shackleton's *Endurance* days, and Wild, who had been with Shackleton since the *Nimrod* expedition. On that occasion he accompanied Shackleton to Furthest South in 1909. Shackleton's voyage with *Quest* ended in South Georgia, where he died of a heart attack on 5 January 1922 and was buried at the whaling station at Grytviken (no. 104).

104. G. HUBERT WILKINS
(1888–1958) AND OTHERS
The Quest *Album*, 1921–2
Full grey goatskin quarto, with
gold tooling, four raised bands on
spine, gilt edges, grey watered silk
endpapers, guarded pages
310 × 410 mm (12¼ × 16⅛ in.)
RCIN 2582405

Containing 81 silver bromide
prints, mounted one or two per
page with handwritten black ink
captions below the prints

PROVENANCE: King George V

Album page showing
(*from left to right*):

G. Hubert Wilkins
The Cairn, 1922
Silver bromide print
152 × 110 mm (6 × 4⅜ in.)
RCIN 2582425

G. Hubert Wilkins
**Sir Ernest Shackleton's grave
under Mount Paget, 1922**
Silver bromide print
152 × 111 mm (6 × 4⅜ in.)
RCIN 2582426

After *Quest* dropped anchor in Grytviken Harbour on 4 January 1922, Shackleton retired to his cabin, promising the men that 'tomorrow we'll keep Christmas' (Fisher and Fisher 1957, p. 476). It was the last time most of his crew would see him alive. He died of a heart attack in the early hours of 5 January, and his body was embalmed before sailing for Uruguay. After a memorial service at Montevideo, Uruguay, his body was returned to Grytviken and buried in the whalers' cemetery under Mount Paget. Mrs Aaberg, the only woman on the station, laid a wreath of flowers. Hussey, representing his shipmates who had already set sail for the south, laid the bronze commemorative wreaths brought from Montevideo. On their return, *Quest*'s crew laboriously built a cairn to 'the Boss' on King Edward Point, the headland overlooking Grytviken Harbour. Macklin wrote in his diary: 'this is as "the Boss" would have had it himself, standing lonely in an island far from civilisation, surrounded by stormy tempestuous seas, & in the vicinity of one of his greatest exploits' (Fisher and Fisher 1957, p. 482).

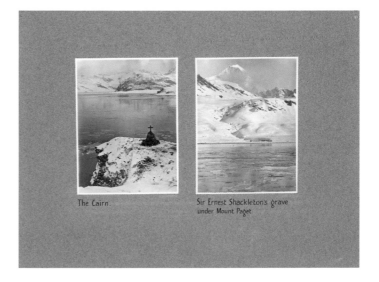

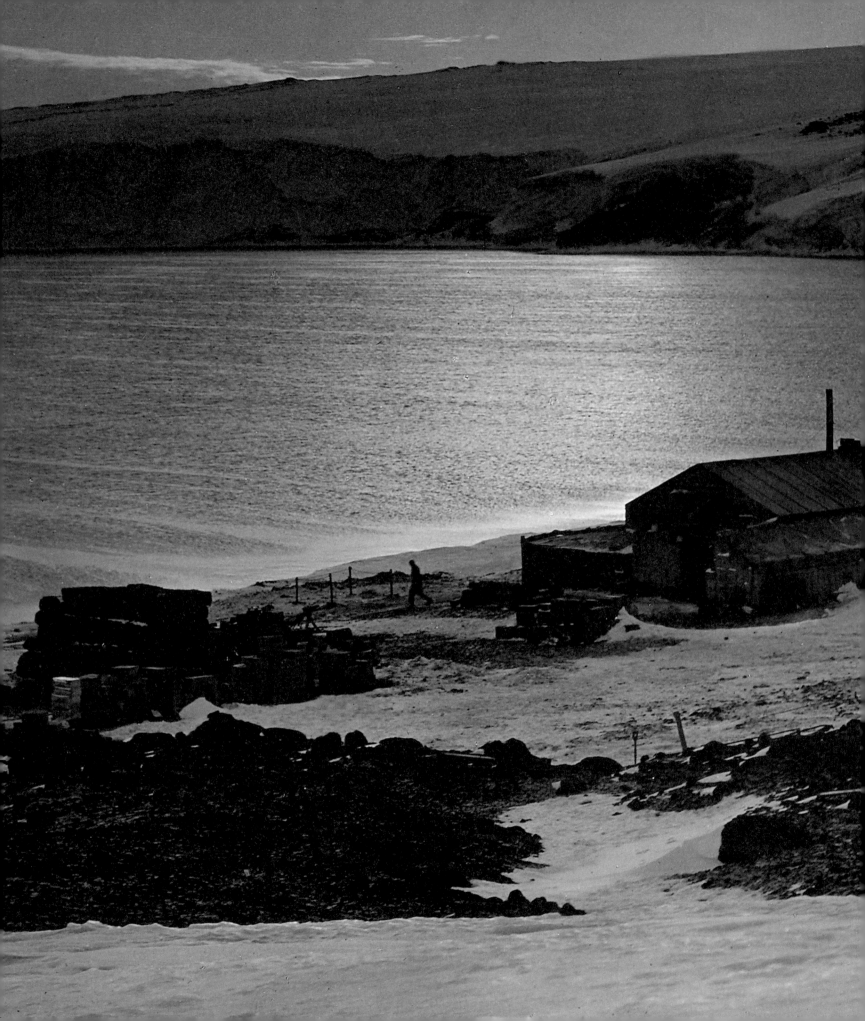

THE PHOTOGRAPHIC PROCESSES

Alan Donnithorne

THE PHOTOGRAPHS in this exhibition are of two different types: silver bromide prints and carbon prints. Hurley used only the silver process, but Ponting's images are of both types.

In both cases, the image was printed from a negative black-and-white silver image. This was made using either a glass plate or a film, manufactured with a coating of gelatin (called an 'emulsion') containing light-sensitive silver salts. The negative plate or film was exposed in the camera, then developed chemically and fixed to remove any remaining light-sensitive salts.

SILVER BROMIDE PRINTING

Although some experiments were made during the early years of photography to produce silver-based photographs by means of chemical development, it was not until around 1880 that papers prepared with a silver bromide emulsion were widely available.

Silver bromide printing uses the same chemistry as that of the negative process, but in this case the emulsion is manufactured on a special paper support. The paper is first prepared with an opaque layer of powdered baryta (barium sulphate) in gelatin. The light-sensitive layer comes next, and then a clear gelatin top layer. The baryta layer serves to isolate the image-bearing layer from any potential chemical impurities in the support paper, to give a smooth surface and to eliminate the texture of the paper fibres. The most commonly used light-sensitive substance is silver bromide, and papers prepared with this are therefore referred to as 'bromide paper' and the resulting prints as 'bromide prints'.

The printing paper is exposed for a short time to artificial light through the negative, in a photographic darkroom. The negative can be placed in contact with the printing paper, in which case the resulting print is the same size as the negative, or light can be projected through an enlarging lens, in which case the dimensions of the print may vary according to the distance between the negative and the print.

(*left*) HERBERT PONTING (1870–1935) **The hut at Cape Evans, 26 March 1911** (*detail*) (no. 4)

The newly exposed print does not have a visible image at this stage – it is called a 'latent image'. The print is immersed in a bath containing a chemical solution, the developer, which reacts with the silver bromide only where it has been altered by the light. The image begins to appear as the silver bromide salt is gradually converted to metallic silver. The development process is monitored by the operator using a 'safe lamp', which is filtered to give red light only (the paper is only sensitive to blue and green light).

When the image is dark enough, it is placed in a 'stop bath' to deactivate the developer. However, the emulsion still contains a proportion of silver bromide that was not altered by the light exposure, so this must be removed or the print would become 'fogged' when the light was switched on. The print is therefore immersed in a bath containing a solution of sodium thiosulphate ('hypo'), which dissolves the remaining unexposed silver, leaving the image clear and stable. The final wet process is to wash the print to remove all the hypo from the emulsion. The print is then dried and flattened.

A silver image is relatively stable, but it may deteriorate if not processed to remove all residual chemicals, or if it is kept together with materials that give off acidic or oxidising vapours or contain reactive sulphur compounds. These effects can be made worse if the storage environment is warm and damp.

The visible results of deterioration are fading of the highlights, tonal changes from neutral grey to a brownish colour, overall or local staining, and the formation of a slight silvery sheen on the dark areas of the image. All the photographs in the Hurley album show this last effect, which is especially noticeable at the edges, and it can also be seen in Ponting's portrait of Captain Scott (no. 3).

Toned silver bromide prints

Some printers preferred an image with warmer tones than the conventional neutral grey of a developed-out silver image. There are four main ways of altering the apparent tone of bromide prints: using coloured paper, tinting the emulsion layer with a dye, using special warm-tone development materials and processes, and by chemical toning. The only one of these processes to be found in the photographs in this exhibition is chemical toning, which was used to make ten of the Ponting images (nos 1, 8, 9, 11, 13–16, 32 and 33).

There are two types of chemical toners: metal toners use certain salts of metals such as gold, nickel or iron (which combines with, replaces or forms complex salts with the image silver); and sulphide toning, which is the type used in some of Ponting's silver prints.

In sulphide toning the print is developed and fixed as usual, then immersed in a solution that bleaches the image, and finally in a solution of sodium sulphide, which reacts with the silver to produce a compound, silver sulphide, which is a brown colour.

(right)
HERBERT PONTING
(1870–1935)
Captain Scott's last birthday dinner (aged 43), 6 June 1911 *(detail)*
Toned silver bromide print
436 × 610 mm
(17¹/₈ × 24 in.)
RCIN 2580020 (no. 33)

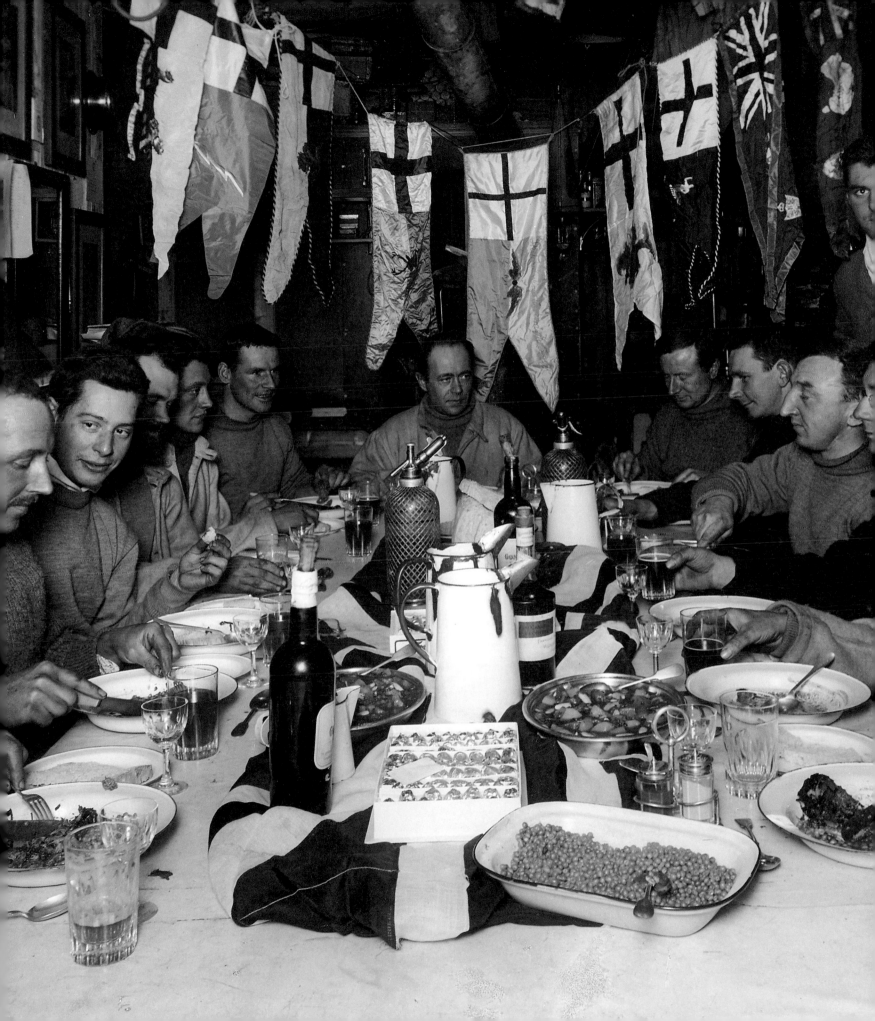

The variety of hues used for the Ponting carbon prints in the album presented to King George V. Details *(from top to bottom)* of highlight, mid-tone and dark areas, photographed at ×100 magnification.

CARBON PRINTING

Carbon printing was invented by the French chemist, engineer and photographer Alphonse Louis Poitevin (1819–82), who patented his process in 1855.

In carbon printing, the light-sensitive material is a layer of pigmented gelatin called the 'carbon tissue', which has been made light-sensitive by the addition of a solution of potassium dichromate. Ordinarily, gelatin is soluble in water, but when the sensitised gelatin is exposed to light, the dichromate salt becomes chemically active and reacts with the gelatin. This causes the gelatin to harden and become insoluble in proportion to the amount of light received. When the gelatin is exposed under a negative, the areas of varying light and dark give rise to areas of varying solubility in the gelatin.

The image is 'developed' by soaking the gelatin tissue face down in warm water, until the soluble portion of the gelatin begins to dissolve. The tissue is then squeezed, still face down, onto a second paper support, and the original paper is gently peeled away, allowing access to the soluble part. The areas of the gelatin that are still soluble are then washed away. This leaves behind the insoluble part, which now varies in thickness according to how much exposure has been received. Because the image has been transferred to the second support it is now in reversed orientation, so in order to present it the right way round it is transferred again to a third, final support. Finally, it is treated with alum to remove residual dichromate salts and further harden the gelatin, and then it is washed and dried. When viewed on a white paper backing, the thicker areas appear darker and the completely unexposed areas appear white.

The variety of image colours possible is almost limitless, as it is the colour of the pigment chosen to mix into the preparation of gelatin that determines the final colour of the print. Examination under magnification of some of the Ponting carbon prints shows that the

greenish tints are a mixture of a dark blue, such as Prussian blue, and an opaque orange brown, probably burnt sienna. The pigment used in the original experiments by Poitevin was carbon black, hence the name of the process. Although it is perfectly possible to make one's own carbon tissues from ground pigments and gelatin, in reality most practitioners are likely to have used ready-made tissues, such as those made by the Autotype Company. Provided the pigments used are light-fast and chemically stable, the resulting image is permanent.

As with bromide prints, carbon prints could also be made on coloured paper. There is one example in the King's album, in which a carbon black image layer is laid over an orange-dyed paper (no. 2; *see below*).

FURTHER READING

Baldwin, G. 1991. *Looking at Photographs*, Malibu and London
Crawford, W. 1979. *The Keepers of Light*, New York
Eaton, G.T. 1986. *Photographic Chemistry*, New York
Nadeau, L. 1994. *Encyclopedia of Printing, Photographic and Photomechanical Processes*,
 Fredericton, New Brunswick, Canada
Neblette, C.B. 1962. *Photography: Its Materials and Processes*, New York
Peres, R., ed. 2007. *The Focal Encyclopedia of Photography*, London
Sinclair, J.A., ed. 1913. *The Sinclair Handbook of Photography*, London

HERBERT PONTING
(1870–1935)
**Cirrus clouds over the Barne Glacier,
19 December, 1911** *(detail)*
434 × 588 mm
(17¹⁄₈ × 23¹⁄₈ in.)
RCIN 2580021 (no. 2)
This is an example of black-pigmented carbon tissue overlaid on orange-tinted paper. The underlying paper fibres are visible at bottom left, where the image layer has curled away from the corner.

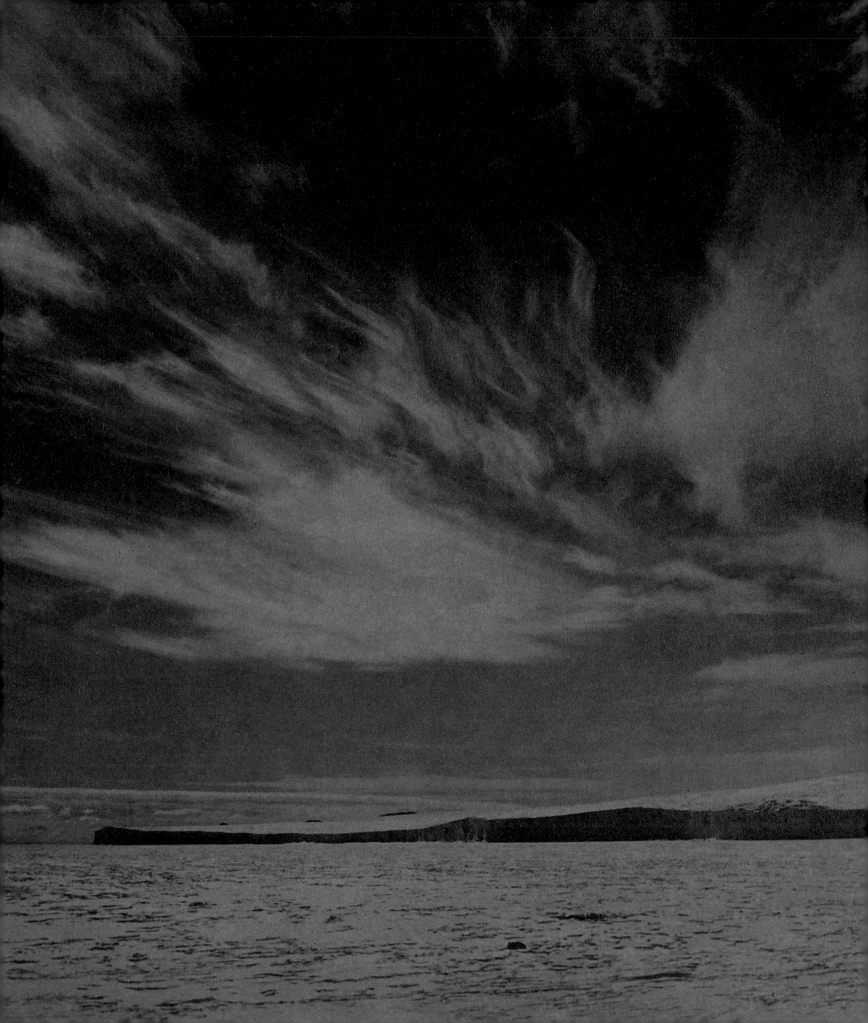

APPENDIX 1

The 1913 Fine Art Society catalogue

Cover of Ponting's exhibition catalogue published in 1913 to accompany
The British Antarctic Expedition 1910–1913 display at the Fine Art Society

NOTES

The numbered list of photographs exhibited has been transcribed. Price information
has been included, but the descriptive paragraphs that exist for most of the photographs have
been omitted. In addition, the catalogue contains seven illustrations. The copy consulted may
be found at the National Art Library, London (200.BF).

(left) HERBERT PONTING (1870–1935) **Cirrus clouds over the Barne Glacier, 19 December 1911** (no. 2)

CATALOGUE

The prices can be had on application. The copyrights of all pictures sold are reserved.

PRICES

The Pictures in this Exhibition are for sale and can be purchased in the following sizes and prices:

		£	s.	d.
29 inches	greatest length	2	2	0
23 inches	greatest length	1	11	6
18 inches	greatest length		15	0
15 inches	greatest length		10	6

Some of the photographs can be obtained in either of two sizes, and in various tints, and mounted on plate paper.

On the Way South
1. The Officers of the *Terra Nova* (1911–12)
2. Sunset in the South Pacific Ocean
3. The Crew of the *Terra Nova*
4. Albatrosses foraging at the stern of the *Terra Nova*
5. Captain Oates and Siberian Ponies
6. The *Terra Nova* in a gale
7. "Bergs and Pack Ice ahead"
8. Imprisoned in the Ice
9. Entering in the Ice Pack
10. Cinematographing in the Ice Pack
11. The *Terra Nova* Icebound in the Pack
12. Christmas Eve in the Ice Pack
13. The Afterguard sunning itself. December 28th, 1910
14. The Dogs on Deck
15. The Dogs with Mr Meares
16. "Bieleglas", one of the dogs
17. "Kesoi"
18. "Good Morning"
19. The Ice Blink
20. Face of the Great Ice Barrier and Mount Terror
21. Mount Bird
22. Penguins leaping in the Water
23. Mr D.G. Lillie
24. The Birth of an Iceberg
25. The *Terra Nova* in McMurdo Sound
26. Mr E.W. Nelson

The Arrival
27. The *Terra Nova* at the Ice-Foot, Cape Evans
28. Unloading a Motor Sledge
29. Mr Day and the Motor Sledge

30. Landing Stores from the Ship
31. Captain Scott, R.N., C.V.O.
32. Commander E.R.G.R. Evans, R.N., C.B.
33. Packing a Sledge
34. One of the Dog Teams
35. Weddell Seal about to dive
36. Farewell to *Terra Nova*

The Approach of Winter
37. Furrows of Frozen Spray
38. A Crevasse near the Edge of a Glacier
39. The Freezing of the Sea
40. Young Pancake Ice
41. Pancakes freezing into Floes
42. Seals basking on Pancake Ice
43. Weddell Seal on the beach at Cape Evans

Winter
44. The Hut at Cape Evans
45. Mr C.S. Wright at the Transit
46. Captain Scott writing his diary
47. Dr Wilson at work
48. The Ponies in the Stable
49. Captain Oates and Mr Meares in the Stable
50. Petty Officers Evans and Crean with their Ponies
51. Captain Scott's Birthday Dinner, 1911 (Officers' table)
52. The Tenements
53. Mr Ponting lecturing on Japan
54. The "Dark-room" at Winter Quarters
55. Mr Ponting developing a Plate
56. Dr G.C. Simpson, Physicist
57. Surgeon E.L. Atkinson, R.N.
58. The "Castle" Berg at Night (see No. 71)
59. Dr Wilson and Lieut. Bowers taking Observations
60. Hauling up the Fish-trap
61. The Winter Journey to Cape Crozier (June–August 1911)
62. Commander Evans observing an Occultation of Jupiter
63. Mr Meares making Dog Harness
64. Petty Officers Crean, Forde and Evans

Spring
65. Dr Wilson and the Sunshine Recorder
66. The Hut in early Spring
67. Penguin. "I don't care what becomes of me."
68. Penguin. After dinner
69. A dome Cloud on Mount Erebus (see No. 109)
70. Wind-proof clothing
71. The "Castle" Berg
72. A Huge Ice Bastion. Part of the "Castle" Berg seen in No. 71
73. Baby Weddell Seal
74. Weddell Seal with Calf

75. Weddell Seal suckling its Calf
76. Dog Teams
77. End of the Barne Glacier
78. "Volk", one of the Dogs
79. "Tresor"
80. Dog Team resting by an Iceberg
81. Pressure Ridges
82. Mount Erebus
83. The Summit of Mount Erebus
84. Scene on a Penguinry
85. Woollen Underwear
86. Penguin. "Mated."

Summer
87. Summertime, the Opening-up of the Ice
88. "Killer" Whales
89. The Cape Royds Penguinry in the Breeding Season
90 & 91. Sitting Penguins snowed-up
92. Penguin. Just about to Jump
93. Penguin. "See what a fine egg I've laid."
94. Penguin. A Heated Argument
95. The Western Geological Party
96. Midnight in the Antarctic Summer
97. The Barne Glacier
98. Cloud effect over the Barne Glacier
99 & 100. Breaking Waves at Cape Evans
101. The "Southern Party", 1911
102. Lieut. Gran Skiing
103. Mr F.E. Debenham, Geologist
104. An Approaching Blizzard
105. Cumulus Cloud rolling-up over the Barne Glacier
106. The Midnight Sun
107. Captain Oates and the Pony, "Christopher"
108. Dr Wilson and the Pony, "Nobby"
109. The Ramparts of Mount Erebus
110. The North Bay, Cape Evans
111. Mount Erebus
112. Cirrus Clouds
113. Mount Erebus seen over a waterworn Iceberg
114. An Iceberg and Mount Erebus
115. Skua Gulls
116. Mr H.G. Ponting
117. An Iceberg off Cape Royds
118. Grotto in an Iceberg
119. Exterior of the Grotto Iceberg
120. A stranded Iceberg off Cape Evans
121. A weathered Iceberg
122. Seals sleeping by an Iceberg
123. Lieut. Bowers and the Pony, "Victor"
124. Chris and the Gramophone
125. Mr Ponting and Dog Teams with his Cameras

126. "Chris"
127. "Vida"
128. Petty Officer Evans and the Pony, "Snatcher"
129. Mr T. Griffith-Taylor, Geologist
130 & 131. Sastrugi
132. Penguin and Chicks. Motherhood
133. Skua Gull returning to its Nest
134. Skua Gull Chicks
135. Mr C.H. Meares and Osman
136. "Osman." "Our Splendid Leader."
137 & 138. Petty Officer Crean and Petty Officer Lashly

On the Central Screen
139 & 140. Four of the Polar Party

The Polar Party
141. Captain Scott
142. Captain L.E.G. Oates
143. Dr E.A. Wilson
144. Lieut. H.R. Bowers
145. Petty Officer Edgar Evans

The five portraits last-named are sold separately at one guinea each, unframed, or the five in a portfolio, four guineas.

Supplementary photographs
Owing to the lack of space it has not been found possible to include in the Exhibition a selection from the Photographs made by other members of the Expedition; but generally these were of purely technical or scientific interest, and in many cases were variations of subjects already dealt with by Mr Ponting.

It has been felt, however, that a selection of the photographs taken by Dr Wilson and Lieutenant Bowers at the South Pole must be included, for they are without doubt the most tragically interesting in existence. The films from which they are made were brought back by Captain Scott, as evidence of what he had found and accomplished, to the final camp where he and his two surviving comrades died, and they lay beside the dead body of the leader for eight months before they were found. They were developed a month later in the hut at Cape Evans.

A The Polar Party and their Sledge
B Forestalled. Amundsen's Tent at the South Pole
C At the South Pole
D The Camp at the South Pole
E The Grave on the Great Ice Barrier

The five photographs, A to E, may be purchased in a portfolio, price £2 2s. 0d., or singly 10/6 each.

F In Memoriam. The Cross erected to the Polar Party, on Observation Hill, Hut Point

APPENDIX 2

Brief biographies

Adams, Jameson Boyd (1880–1962), meteorologist, *Nimrod*. Adams joined the Merchant Navy in 1893 and later the Royal Naval Reserve. He met Shackleton in 1906 when serving aboard HMS *Berwick*. He was one of the party that made the first ascent of Mount Erebus in early 1908, and was with Shackleton at his Furthest South, 1908–9. He later declined a place on *Terra Nova* and served with distinction in both world wars.

Amundsen, Roald (1872–1928), Norwegian polar explorer, member of the first party to overwinter within the Antarctic Circle aboard *Belgica*; first to sail successfully through the North-West Passage; first man to reach the South Pole, on 14 December 1911. Following his attainment of the South Pole, he succeeded in sailing the North-East Passage during an attempt to drift across the Arctic Ocean. In 1926 Amundsen flew over the North Pole with the Italian Primo Mobile. He was part of a search mission to find Mobile in the Arctic in 1928, from which he never returned.

Armytage, Bertram (1869–1910), in charge of ponies, *Nimrod*. An Australian educated in Melbourne and Cambridge, Armytage had a distinguished military career in South Africa, before joining *Nimrod* in Australia. He suffered badly from depression during the Antarctic winter of 1908, but played an important part in the geological discoveries of the following season. After *Nimrod* he applied to join the War Office but was turned down for being too old. A lack of any fixed purpose to his life brought back his depression and he committed suicide.

Atkinson, Edward (1881–1929), surgeon and parasitologist, *Terra Nova*. Born in the West Indies, but schooled in Essex, he studied medicine at St Thomas's Hospital London, from 1900 and became MRSC and LRCP in 1906. He joined the Royal Navy in 1908 and was recommended to join Scott's 1910 expedition. Atkinson assumed command after Scott's disappearance in 1912 and led the party which discovered the bodies of the Polar Party. He later served with distinction in the First World War, winning the DSO and Albert Medals. He retired from the Navy in 1928.

Bakewell, William (1888–1969), Seaman, *Endurance*. By birth an American, he posed as a Canadian in order to get aboard *Endurance*, and helped Perce Blackborrow to stow away. Despite this shaky start, Shackleton regarded him highly among his fellow seamen. After the *Endurance* expedition Bakewell served in the British Merchant Navy during the First World War. He intended to join Shackleton's *Quest* expedition, but eventually settled down to married life as a farmer in Michigan.

Barne, Michael (1877–1961), Second Lieutenant, *Discovery*. Barne gained his commission in the Royal Navy in 1898 and served aboard the *Majestic* with Scott, where he clearly impressed his commander. He undertook surveys and soundings on *Discovery* and later conducted various experiments with motor sledges in preparation for the *Terra Nova* expedition. He served in both world wars, winning the DSO.

Beardmore, Sir William (1856–1936), Scottish engineer and shipbuilder. He was a guarantor of the *Nimrod* expedition and gave his name to the Beardmore Glacier.

Bernacchi, Louis (1876–1942), physicist, *Discovery*. Educated in Tasmania, Bernacchi later gained valuable experience in magnetism at the Melbourne Observatory. He served aboard Borchgrevink's Southern Cross Expedition of 1898–1900 and conducted vital early work across a range of scientific disciplines. He was responsible for taking magnetic measurements aboard *Discovery* and became editor of the *South Polar Times* after Shackleton's departure.

Blackborrow, Perce (1894–1949), stowaway, later steward, *Endurance*. Born in Newport, South Wales, Blackborrow was only 20 when he stowed away on *Endurance*. After he was discovered he was appointed steward, assisting Charles Green to cook for the ship's company. He had to have the toes of his left foot amputated due to frostbite, an injury which prevented him joining the Royal Navy during the First World War. He served with the Merchant Navy until 1919, when he returned to Newport docks as a boatman.

Bowers, Henry 'Birdie' (1883–1912), Lieutenant, in charge of stores, *Terra Nova*. He was born in Greenock, Scotland, and had a successful early career in the Royal Naval Reserve and the Royal Indian Marine Service before being appointed officer in charge of stores aboard *Terra Nova* on the recommendation of Sir Clements Markham. He formed particular friendships with Cherry-Garrard and Wilson. A member of the Polar Party, he died with Scott on or about 29 March 1912.

Brocklehurst, Sir Philip (1887–1975), assistant geologist and surveyor, *Nimrod*. He was born in Staffordshire and educated at Eton and Cambridge, succeeding as Baronet in 1904. Brocklehurst had been promised a place in the Southern Party, but was left behind at Winter Quarters owing to badly frostbitten toes after the ascent of Erebus.

Caird, Sir James (1837–1916), Dundee jute magnate and benefactor, one of the chief sponsors of *Endurance*. The boat in which Shackleton made the rescue voyage to South Georgia was named after him. His fortune was put to many philanthropic purposes, particularly benefiting the people of Dundee. He was a life member of the British Association for the Advancement of Science and gave sizeable sums to fund scientific research. He was created a Baronet in 1913.

Campbell, Victor (1875–1956), Lieutenant, *Terra Nova*. Born in Sussex and educated at Eton, Campbell joined the Merchant Navy and then the Royal Navy in 1895. He was known as the 'Wicked Mate' aboard *Terra Nova* and was highly respected by officers and men. Scott appointed him to lead the Eastern, later Northern, Party, to explore King Edward VII Land, and later the northern peninsula, where he and his men were marooned throughout the winter of 1911–12, before sledging 200 miles (370 km) back to Cape Evans. He served with distinction in both world wars, winning a DSO and bar.

Cheetham, Alfred (1867–1918), Third Officer, *Nimrod* and *Endurance*; boatswain, *Terra Nova*. He had also served aboard *Morning*, one of *Discovery*'s relief ships. He served in the Royal Navy during the First World War, but drowned when his ship was torpedoed in 1918.

Cherry-Garrard, Apsley 'Cherry' (1886–1959), assistant zoologist, *Terra Nova*. An Oxford-educated gentleman and cousin of Scott's publisher Reginald Smith, Cherry was drawn into exploration through his acquaintance with Wilson. He acquitted himself well during the depot laying, accompanied Wilson and Bowers on the winter journey to Cape Crozier, and

was one of the Main Party, returning in the first team. He wrote *The Worst Journey in the World* (1922), and the *Geographical Journal*'s obituary for Herbert Ponting (1935).

Clark, Robert (1882–1950), biologist, *Endurance*. Born and educated in Aberdeen, Clark became a zoologist at the Scottish Oceanographical Laboratory in Edinburgh, where he was able to work on some of the specimens from the Scottish National Antarctic Expedition 1902–4. He collected a large number of zoological specimens in 1914–15, but unfortunately lost them all on the sinking of the *Endurance*. He served at sea during the First World War, and returned to Aberdeen to pursue a career in fisheries research.

Clissold, Thomas (d.1963), cook, *Terra Nova*. He was originally considered for the Main Party, partly due to his mechanical abilities, but was badly injured when he fell off an iceberg while posing for Ponting. He emigrated to New Zealand after the First World War and became a vehicle inspector.

Cook, Frederick (1867–1940), American physician and explorer. After serving aboard the *Belgica*, the first ship to winter inside the Antarctic Circle, he began a North Polar bid from Greenland in February 1908 and claimed to have reached the Pole in April. His claim was later discredited, especially since he was unable to produce any detailed navigational data.

Crean, Tom (1877–1938), Seaman, *Discovery*; Petty Officer, *Terra Nova*; Second Officer, *Endurance*. Born in Annascaul, County Kerry, Crean enlisted in the Royal Navy in 1893. He joined *Discovery* in Lyttelton in December 1901, and was promoted to Petty Officer First Class in 1904. During the *Terra Nova* expedition he was a member of the Last Returning Party on the polar journey. With Lashly, he was awarded the Albert Medal for saving the life of Lieutenant Evans. Crean joined Shackleton aboard *Endurance* in 1914, and was one of the party to make the crossing of South Georgia. He married in 1917 and later retired to Annascaul, where he kept the South Pole Inn.

David, T. Edgeworth (1858–1934), chief scientist, *Nimrod*. Born in Wales and educated at Oxford, David emigrated to Australia to become a geological surveyor in 1882. In 1891 he was appointed Professor of Geology at Sydney University. He became a Fellow of the Royal Society in 1900. In Antarctica he made the first ascent of Mount Erebus and led the party which located the South Magnetic Pole. During the First World War he became a military tunnelling expert. He was knighted in 1920.

Day, Bernard (1884–1934), motor specialist, *Nimrod* and *Terra Nova*. Day came from Beardmore's Arrol-Johnston Motor-Car Company as part of his motor-car package for Shackleton, and later served Scott in the same capacity. He was also responsible for the beautifully carved covers of the *South Polar Times*, made out of Venesta packing cases.

Debenham, Frank (1883–1965), geologist, *Terra Nova*. Born in New South Wales, Debenham majored in geology at Sydney University, where he met Edgeworth David. One of his chief contributions to the *Terra Nova* expedition was that of plane-table mapping. After the First World War he was appointed to the Royal Geographical Society's lectureship in surveying and cartography at Cambridge, and later became a tutor at Gonville and Caius College. He was largely instrumental in setting up the Scott Polar Research Institute in Cambridge in 1920, using funds from the Scott appeal and becoming its first Director.

Docker, (Frank) Dudley (1862–1944), industrialist and financier, and one of the chief sponsors of the *Endurance* expedition. One of Shackleton's three lifeboats was named after him.

Evans, Edgar 'Taff' (1876–1912), Petty Officer, *Discovery* and *Terra Nova*. Born in Rhosili, Glamorgan, Evans joined the Royal Navy in 1891, coming to Scott's notice aboard HMS *Majestic*. He was specially requested for the *Discovery* expedition, and accompanied Scott and Lashly on the journey into the Western Mountains in 1903. Joining Scott aboard *Terra Nova* in 1910, he was crucial in fitting out the ship, and later in preparing and maintaining sledges and sledging equipment for the polar journey. A member of the Polar Party, he died at the foot of the Beardmore Glacier on 17 February 1912, on the return from the Pole.

Evans, Edward (1880–1957), Lieutenant, second in command, *Terra Nova*. Evans trained on HMS *Worcester* and joined the Royal Navy in 1896. His first trip to Antarctica was aboard the *Morning*, one of *Discovery*'s relief ships, in 1902–3. He gave up plans for a Welsh Antarctic expedition in return for the position of second in command of the *Terra Nova* expedition. He nearly died of scurvy on the way back from the Polar Plateau in 1912, but was saved by Lashly and Crean. He had a distinguished naval career and was known as 'Evans of the Broke' after his heroism in the First World War. He rose to the rank of admiral (1936), and was elevated to the peerage, as Lord Mountevans, in 1945.

Ferrar, Hartley (1879–1932), geologist, *Discovery*. Born in Ireland and educated at Cambridge, Ferrar was appointed as geologist to the *Discovery* expedition, despite being inexperienced in the field. Nevertheless he achieved notable results in the Antarctic, including establishing the composition of the Royal Society Range, and the discovery of what would be named the Ferrar Glacier, a route onto the western plateau.

Forde, Robert (1875–1959), Petty Officer, *Terra Nova*. He was a member of the Shore Party during the first winter, but left aboard *Terra Nova* in 1912.

Gerov, Dimitri (1889–1932), dog driver, *Terra Nova*. Recommended to Meares in Nikolayevsk, Siberia, as an experienced dog driver, he helped Meares choose his dog teams. After the expedition he went to England and New Zealand, but eventually returned to Nikolayevsk to work in the gold mines.

Gran, Tryggve (1889–1980), Lieutenant, ski expert, *Terra Nova*. Norwegian recommended to Scott by Nansen as a ski instructor and, before Amundsen's appearance made his position awkward, a possible contender for the Polar Party. He later joined the Royal Flying Corps during the First World War and was credited with shooting down 17 German planes. He was part of the search team when Amundsen was lost in 1928.

Green, Charles (1888–1974), cook, *Endurance*. Green first went to sea as a cook in the Merchant Navy in 1909. He joined *Endurance* in Buenos Aires and (with Blackborrow) excelled at providing good meals under very difficult conditions, which helped to bolster morale.

Greenstreet, Lionel (1889–1979), First Officer, *Endurance*. The son of a Merchant Navy seaman, Greenstreet trained aboard HMS *Worcester* before passing out in 1904, and mainly served on sailing ships. He was the last man to join the *Endurance* before it left England, replacing the original first officer, who had left to join the war. He served in the Royal Engineers during the war and continued to work in the marine service afterwards. He was the last surviving member of the *Endurance* crew.

Holness, Ernest (1892–1924), second stoker, *Endurance*. Born in Hull, Holness spent his life at sea. He assisted Stephenson in keeping the fires lit to provide steam power aboard *Endurance*. He was one of four men not awarded the Polar Medal. After the war he served aboard the North Sea trawlers and died when washed overboard off the Faroe Isles.

Hooper, Frederick (1891–1955), steward, *Terra Nova*. Hooper originally joined the expedition as a steward but was transferred to the Shore Party. He was a member of the team which found Scott's body in November 1912.

How, Walter (1885–1972), Seaman, *Endurance*. An experienced sailor, and also a talented amateur artist (his drawings would illustrate Fisher and Fisher's biography of Shackleton, 1957), he was responsible with Bakewell for smuggling Blackborrow aboard *Endurance*. During the First World War he joined the Merchant Navy and was blinded in one eye after his ship was mined. He was due to accompany Shackleton on *Quest*, but withdrew at the last minute after the death of his father.

Hudson, Hubert 'Buddha' (1886–1942), Second Officer, *Endurance*. Hudson joined the Merchant Navy in 1901 and the Royal Naval Reserve in 1913. His nickname came from a practical joke in which the crew encouraged him to dress up as Buddha for a fictitious costume party on South Georgia. His stay on Elephant Island was badly affected by a severe abscess on the buttock. During the First World War he served on the Q-boats (or mystery ships). He later became a commodore in the Royal Naval Reserve before dying during a torpedo attack in 1942.

Hurley, Frank (1885–1962), Australian camera artist, *Endurance*. He also accompanied Mawson aboard *Aurora* on the Australasian Antarctic Expedition. On the *Endurance* expedition he produced some of the most striking photographs of Antarctica of the time, risking his life to save his negatives and cine-films from the sinking ship. His career after *Endurance* included acting as official war photographer in both world wars, and returning to Antarctica in 1929–31 on a joint British, Australian and New Zealand expedition known as BANZARE.

Hussey, Leonard (1891–1964), meteorologist, *Endurance*. Born in London, Hussey obtained degrees at King's College London in psychology, meteorology and anthropology. Aside from his scientific work aboard *Endurance*, his chief value was as morale booster with his banjo, which Shackleton insisted they took after the sinking of the ship. After *Endurance* Hussey joined the Royal Artillery during the war, serving in France and North Russia with Shackleton. After qualifying as a surgeon, he accompanied Shackleton on the *Quest* expedition as doctor and meteorologist. His medical career continued through the Second World War until his retirement in 1957.

James, Reginald (1891–1964), physicist, *Endurance*. Educated at London and Cambridge, James joined the expedition after a five-minute interview in which he was asked if he could sing. After the expedition he joined the Royal Engineers Sound Ranging Section and later commanded the British Army Sound Ranging School.

Joyce, Ernest (1875–1940), Seaman, *Discovery*; in charge of dogs, sledges and equipment, *Nimrod*, and co-printer of *Aurora Australis*; in charge of dogs, *Aurora*. Joyce entered the Royal Navy in 1891. He first went south aboard *Discovery* and then sold out of the Navy to join *Nimrod*. He was later recruited again by Shackleton as part of the *Aurora* shore party.

Keohane, Patrick (1879–1950), Petty Officer, *Terra Nova*. One of the First Returning Party on the polar journey, and part of the final search party for Scott in late March 1912.

Kerr, Alfred (1892–1964), second engineer, *Endurance*. Kerr spent his life in the Royal and Merchant Navies, having joined the Royal Navy straight out of school. During the war he worked on minesweepers in North Russia and later joined Shackleton's *Quest* expedition.

Koettlitz, Reginald (1861–1916), doctor and botanist, *Discovery*. He was educated in Dover and at Guy's Hospital, London. After several years of country practice he volunteered for the Jackson Harmsworth North Polar Expedition in 1894, and subsequently joined many other expeditions to Abyssinia, Somaliland and Brazil, before volunteering for *Discovery*.

Lashly, William (1867–1940), stoker, *Discovery*; chief stoker, *Terra Nova*. He accompanied Scott and Petty Officer Evans on the journey into the Western Mountains in 1903. Lashly was a member of the Last Returning Party in 1912 and, with Crean, was awarded the Albert Medal for saving the life of Lieutenant Evans. He was torpedoed in the Dardanelles during the First World War, but survived to become a customs officer in Cardiff.

Levick, (George) Murray (1877–1956), surgeon, *Terra Nova*. Levick qualified as a surgeon at St Bartholomew's Hospital London, and joined the Royal Navy in 1902. He was one of Campbell's Northern Party, took many scientifically valuable photographs and wrote the standard work on Adélie penguins. After the expedition he served during both world wars, and founded the Public Schools Exploring Society (later the British Schools Exploring Society).

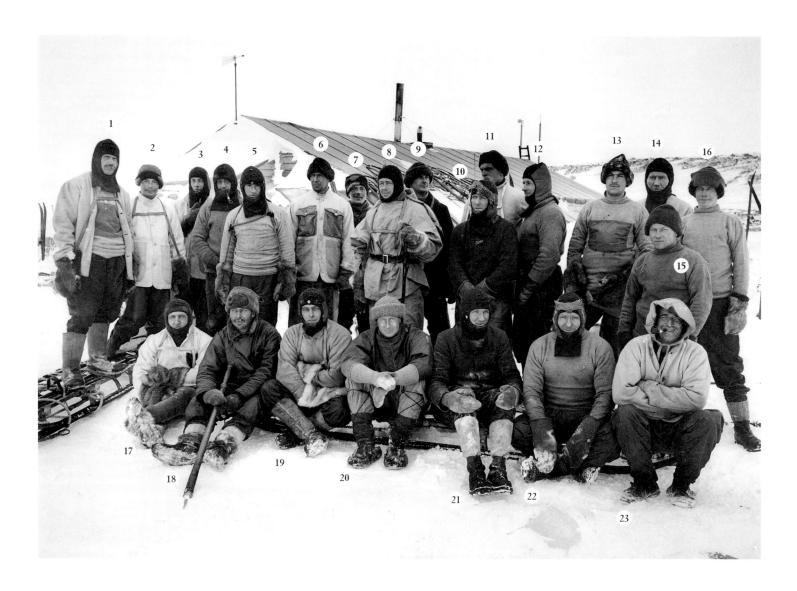

HERBERT PONTING
(1870–1935)
The Shore Party, January 1911
Silver bromide print
436 × 619 mm (17⅛ × 24⅜ in.)
RCIN 2580014 (no. 12)

1 Griffith Taylor	9 Charles Wright	17 Henry Bowers	
2 Apsley Cherry-Garrard	10 Patrick Keohane	18 Cecil Meares	
3 Bernard Day	11 Tryggve Gran	19 Frank Debenham	
4 Edward Nelson	12 William Lashly	20 Edward Wilson	
5 Edward Evans	13 Frederick Hooper	21 George Simpson	
6 Lawrence Oates	14 Robert Forde	22 Edgar Evans	
7 Edward Atkinson	15 Anton Omelchenko	23 Tom Crean	
8 Robert Falcon Scott	16 Dimitri Gerov		

Longstaff, Llewellyn (1841–1918), a Fellow of the Royal Geographical Society and a major sponsor of the *Discovery* expedition.

McCarthy, Timothy (1888–1917), Seaman, *Endurance*. Born in County Cork, of a seafaring family (his brother had been with Scott on *Terra Nova*), McCarthy was one of the youngest seamen on *Endurance*. He was chosen by Shackleton to be one of the six men who made the boat journey from Elephant Island to South Georgia. He served during the First World War as a Leading Seaman in the Royal Naval Reserve and went down with his ship when it was torpedoed in 1917.

McIlroy, James (1879–1968), surgeon, *Endurance*. Born in Ulster, and schooled near Birmingham, McIlroy took a medical degree at Birmingham University before serving as a doctor in the Middle and Far East. On his return to England in 1914, he was appointed second doctor on Shackleton's *Endurance* expedition, with Macklin. His particular non-medical forte was doing musical imitations to accompany Hussey's banjo playing, including the bagpipes. After the expedition he was badly wounded at Ypres and invalided out of the army, but later joined Shackleton's *Quest* expedition.

Mackay, Alistair (1878–1914), assistant surgeon, *Nimrod*. Educated in Edinburgh, where he later completed his medical training, Mackay also worked as a zoologist in Dundee under D'Arcy Thompson, Professor of Natural History at Dundee University. He joined the Royal Navy as a surgeon in 1903, but left to join *Nimrod* in 1907. After the expedition he continued his polar career, joining (with James Murray) the Canadian Arctic Expedition in 1913, but was lost trying to reach land after their ship had been crushed by ice north of Siberia, January 1914.

Mackintosh, Aeneas (1879–1916), Second Officer, *Nimrod*; Captain, *Aurora*. Originally of the Merchant Navy, Mackintosh was offered the post aboard *Nimrod* in 1907, but was invalided home after losing an eye while unloading the ship. His appointment to command the *Aurora* was to compensate him for his interrupted career, but tragically he was one of the men who died in the wake of setting up Shackleton's supply lines across the Barrier.

Macklin, Alexander (1889–1967), chief surgeon, *Endurance*. Born in India, Macklin became a doctor, training at Manchester University. Shortly after qualifying he joined *Endurance* as chief surgeon. His medical skills, along with those of his colleague McIlroy, were put to good use on Elephant Island. He served in the Army Medical Corps during the war, and joined Shackleton on the *Quest* expedition. He then worked in various hospitals in Aberdeen until his retirement.

McLeod, Thomas (1869–1960), Seaman, *Terra Nova* and *Endurance*. One of the most experienced sailors on the expedition, McLeod had been at sea for 27 years before *Endurance*, and had been south with Scott aboard *Terra Nova*. He later went south again with Shackleton on the *Quest* expedition, and then emigrated to Canada.

McNish, Henry 'Chippy' (1866–1930), carpenter, *Endurance*. One of the oldest in the expedition and one of the most experienced sailors, McNish was also an extremely skilled carpenter and shipwright. He was crucial in reinforcing the three lifeboats for their journey across the ice and sea to Elephant Island, and in making the *James Caird* seaworthy. His rebellion against discipline on the ice lost him the Polar Medal, which was awarded to all but four of the crew. After the expedition he served in the Merchant Navy until his retirement. He died in a nursing home in New Zealand.

Markham, Sir Clements (1830–1916), 'father' of British Antarctic exploration and Scott's chief patron. Part of the search team for Franklin's first expedition, Markham later joined the India Office, introducing the quinine-producing cinchona tree to India to treat malaria there. He was first elected to the Royal Geographical Society in 1854, and served as both Secretary and President until his retirement in 1905.

Marshall, Eric (1879–1963), surgeon and cartographer, *Nimrod*. Marshall studied at Emmanuel College and was originally intended for the Church, but entered St Bartholomew's Hospital, London, in 1899 to train as a surgeon. Despite being one of Shackleton's chief detractors on the *Nimrod* expedition, he was one of the party of four at Furthest South.

Marston, George 'Putty' (1882–1940), expedition artist, *Nimrod* and *Endurance*. Marston was recommended to Shackleton for the *Nimrod* expedition by two of Shackleton's sisters, while studying art at the Regent Street Polytechnic in London. His work appeared in both the *Aurora Australis* and in Shackleton's own book, *The Heart of the Antarctic*. He illustrated life on the pack ice and on Elephant Island during the *Endurance* expedition, and donated his oil paints to caulk the *James Caird* for the journey to South Georgia. After his return from the south, Marston taught at Bedales School, Hampshire, before being appointed to the Rural Industries Board, where he became Director in 1934.

Mawson, Douglas (1882–1958), physicist, *Nimrod*. Born in Yorkshire and educated in Sydney, Australia, Mawson became a lecturer in geology at Adelaide University, and was one of Edgeworth David's protégés. He joined Shackleton's *Nimrod* expedition and took part in the first ascent of Mount Erebus in 1908 and in the locating of the South Magnetic Pole in 1909. He led his own expedition aboard *Aurora* to Cape Denison, where his team explored 2,000 miles (3,700 km) of unknown coastline. He was knighted for his achievements in 1914.

Meares, Cecil (1877–1937), adventurer, in charge of dog teams, *Terra Nova*. Widely travelled, Meares met Ponting en route to Shanghai, and travelled to Siberia to purchase the dogs and ponies for the *Terra Nova* expedition. He became one of Oates's chief confidantes. Meares served in the Royal Flying Corps during the First World War.

Mulock, George (1882–1963), Lieutenant, *Discovery*. He was substituted for Shackleton in *Discovery*'s second season as surveyor and officer in charge of stores and deep-sea water analysis. The results of his surveys ultimately gained him the Fellowship of the Royal Geographical Society in 1908. He served in both world wars and afterwards retired to Gibraltar, where he died in 1963.

Murray, James (1865–1914), biologist, *Nimrod*. Murray trained as a sculptor, but became a self-taught international expert in natural history, particularly the microscopic world. In 1902 he was appointed assistant zoologist on Sir John Murray's survey of Scottish lochs, and was recommended to Shackleton by William Speirs Bruce, former leader of the Scottish National Antarctic Expedition. He did groundbreaking work on the freshwater lakes in Antarctica. He later joined the Canadian Arctic Expedition but was lost after the sinking of their ship in the Arctic sea ice.

Nansen, Fridtjof (1861–1930), Norwegian Arctic explorer. Nansen achieved the first crossing of Greenland in 1888–9 and proved that the North Pole was on drifting ice, not based on land. After being forestalled at both Poles by others, he turned to politics and diplomacy, becoming the first Norwegian ambassador to Great Britain. He became a close friend of Kathleen Scott.

Nelson, Edward (1883–1923), biologist, *Terra Nova*. Formerly of the Plymouth marine laboratory, he studied invertebrate zoology in the Antarctic, but was criticised by Scott for his dilettante attitudes and behaviour.

Oates, Lawrence 'Titus' (1880–1912), Captain in the Inniskilling Dragoons, in charge of ponies, *Terra Nova*. He earned the sobriquet 'No Surrender Oates' while serving during the Boer War. On the *Terra Nova* expedition Oates successfully nursed the ponies, which he considered a 'load of crocks' (Smith 2002, p. 172, quoting Oates, letter to his mother, 24–31 October 1911), as far as the foot of the Beardmore Glacier. He walked out to his death on the Barrier in order not to impede his companions on their return from the South Pole, on or about 17 March 1912.

Omelchenko, Anton (1883–1932), groom, *Terra Nova*. Omelchenko worked as a jockey in Vladivostok before being recruited to help look after the ponies on their journey south from Siberia. He served in the First World War and died in 1932 after being struck by lightning.

Orde-Lees, Thomas (1877–1958), ski expert and storekeeper, *Endurance*. Born in Aachen, Germany, Orde-Lees was educated at Marlborough, the Royal Naval School in Gosport, and later Sandhurst Military Academy, before entering the Royal Marines, in which he attained the rank of lieutenant colonel. He applied to join the *Terra Nova* expedition but was unsuccessful, but did join *Endurance* as storekeeper with responsibility for the motor sledges. He was one of the more unpopular members of the expedition, considered by some to be surly and a slacker. After the expedition he served in the Royal Flying Corps, eventually heading their Parachute Section. Later he moved to Japan, where he lived until the outbreak of the Second World War. He was evacuated to New Zealand and later died there.

Peary, Robert (1856–1920), American explorer who claimed to have been the first to reach the North Pole in April 1909, thereby rejecting the rival claims of Frederick Cook. There is still considerable controversy over Peary's claims, but his Arctic exploration achievements were many, and he was one of the generation of European explorers who studied Inuit techniques of travel and survival, and used them effectively.

Ponting, Herbert (1870–1935), camera artist, *Terra Nova*. Ponting worked previously as the official photographer to the Japanese army during the Russo-Japanese War (1904–5), and achieved professional plaudits for his book *In Lotus-Land Japan* (1910). He became interested in polar photography after meeting Meares in Russia aboard a steamer bound for Shanghai, and remained with the *Terra Nova* expedition throughout its first season. He won fame, but not fortune, with his lectures and films of Scott's expedition.

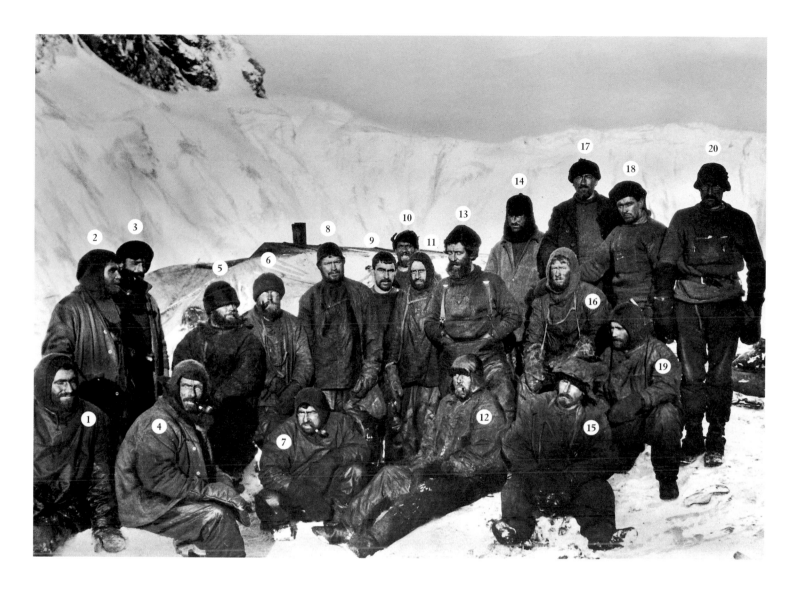

FRANK HURLEY (1885–1962)
The Elephant Island Party, 10 May 1916
Silver bromide print
134 × 203 mm (5¼ × 8 in.)
RCIN 2580121 (no. 81)

1 Charles Green

2 Lionel Greenstreet

3 James McIlroy

4 Frank Wild

5 George Marston

6 James Wordie

7 Walter How

8 Reginald James

9 Ernest Holness

10 Hubert Hudson

11 William Stephenson

12 Alfred Cheetham

13 Thomas McLeod

14 Robert Clark

15 William Bakewell

16 Leonard Hussey

17 Thomas Orde-Lees

18 Louis Rickinson

19 Alfred Kerr

20 Alexander Macklin

Priestley, Raymond (1886–1974), geologist, *Nimrod* and *Terra Nova*. Educated at Bristol University, Priestley first went south with Shackleton under Edgeworth David. He was a member of Campbell's Northern Party. His *Terra Nova* work later earned him a BA by research from Cambridge, and he won the Military Cross for signals work during the First World War. He went on to become Vice Chancellor of Melbourne and Birmingham Universities, and President of the Royal Geographical Society (1961–3), and was knighted in 1949.

Rickinson, Louis (1883–1945), chief engineer, *Endurance*. As chief engineer, Rickinson was responsible for the engines on the *Endurance*. He suffered a minor heart attack on Elephant Island, and was one of the first to move into the boat shelter, along with Hudson and Blackborrow, the other two invalids. He served in both world wars, dying in service aboard HMS *Pembroke*.

Scott, Kathleen, née Bruce (1878–1947), sculptor. She married Scott in September 1908 and bore him a son, Peter (Sir Peter Scott, bird artist and naturalist) in 1909. After Scott's death she was given the rank, style and precedence of a widow of a Knight Commander of the Order of the Bath. She refused to play the grieving widow and continued her acquaintance with some of the most powerful men of the day, including Asquith, Lloyd George and the explorer Fridtjof Nansen. In 1922 she married Hilton Young, created 1st Baron Kennet in 1935. Her best-known work is probably her full-length statue of Scott, a copy of which stands in Waterloo Place, London.

Scott, Robert Falcon (1868–1912), Captain, polar explorer, leader of *Discovery* and *Terra Nova* expeditions, MVO 1901, CVO 1904. Scott joined the Royal Navy in 1883 and became a full lieutenant in 1889 before training as a torpedo officer (1891–3). He first went south aboard *Discovery* in 1901. After Shackleton's attempt on the Pole in 1907–9, Scott returned on the *Terra Nova* with a fully equipped scientific expedition. He reached the South Pole with four companions on 17 January 1912. He died with Wilson and Bowers on the return journey, on or about 29 March 1912.

Shackleton, Emily Mary, née Dorman (1868–1936), wife of Ernest Shackleton. They met during his Merchant Navy days and married after Shackleton's return from *Discovery*. She remained a loyal wife and mother while he continued his adventuring. After his death she collaborated fully with Shackleton's friend Hugh Mill of the Royal Geographical Society in the writing of Shackleton's biography.

Shackleton, Sir Ernest (1874–1922), polar explorer, leader of *Nimrod*, *Endurance* and *Quest* expeditions, MVO 1907, CVO 1909. Shackleton was educated mainly at Dulwich College before entering the Merchant Navy in 1890. He joined *Discovery* in 1901, and was part of Scott's three-man Furthest South team. He led his own *Nimrod* expedition in 1907–9 which got to within 97 miles (180 km) of the Pole, and was showered with honours (including a knighthood) on its conclusion. He also led the *Endurance* expedition in 1914–17, which intended to cross Antarctica. *Endurance* was crushed by the ice, but Shackleton managed to save his entire crew. He died at South Georgia aboard *Quest* on his last expedition in 1922.

Simpson, George (1878–1965), meteorologist, *Terra Nova*. Educated at Manchester and Göttingen Universities, Simpson worked in the London and Indian Meteorological Offices before going south. After serving with the Indian Munitions Board during the First World War, he became Director of the London Meteorological Office (1920–38) and then Director of Kew Observatory. His groundbreaking work in the Antarctic became the basis of present-day Antarctic meteorology.

Skelton, Reginald (1872–1956), chief engineer, photographer, *Discovery*. Born in Lincolnshire, Skelton entered the Royal Navy in 1887. He did important early photographic work aboard *Discovery*. Scott wished to take him south again with *Terra Nova*, but Skelton resigned after questions of seniority arose with Lieutenant Evans. He served with distinction in the First World War, winning a DSO for his part in the Battle of Jutland. His naval career was impressive, rising eventually to Engineer-in-Chief of the Fleet in 1928. He was knighted in 1931, shortly before his retirement in 1932.

Stancomb-Wills, Janet (1853–1932), one of the chief sponsors of *Endurance*. She was the niece and adopted daughter of Lord Winterstoke, a tobacco magnate, who left her a large fortune in his will. Her gifts to Shackleton were not merely of money; she gave him and his family valuable support and advice during the expedition. She was the first female mayor of Ramsgate and gave generously to local charities, schools and other deserving causes. She was made DBE in 1918. One of Shackleton's three lifeboats was named after her.

Stephenson, William (1889–1953), stoker, *Endurance*. Born in Hull, Stephenson served as a trawlerman before joining *Endurance*. Like Holness, his active role ended with the sinking of the ship, and he was one of the four men not awarded the Polar Medal. He probably returned to Hull after the end of the expedition, dying there of cancer in 1953.

Taylor, Griffith (1880–1964), geologist, *Terra Nova*. Taylor was born in Essex, but emigrated with his family to Australia. He gained his degree from Sydney University, and came under the guidance of Edgeworth David. He obtained a BA by research from Cambridge, and led the successful Western Geological Party during Scott's expedition. He held several chairs in geography in later life, and married one of Raymond Priestley's sisters.

Vincent, John (1879–1941), boatswain, *Endurance*. Born in Birmingham, Vincent became an experienced seaman working aboard the Hull trawlers. He was physically strong and a bully, and he sided with McNish during the brief breakdown in discipline on the ice, which lost him the Polar Medal. He was one of the party who sailed to South Georgia, but his health broke down and he had to remain with McNish and McCarthy while the others made the crossing of the island. He returned to the trawlers after the expedition, and served in the Second World War, but died of pneumonia in 1941.

Wild, Ernest (1879–1918), brother of Frank, member of the shore party, *Aurora*. He played a major part in laying depots across the Barrier to the Beardmore Glacier for Shackleton's Transantarctic Party in 1915–16, and was posthumously awarded the Albert Medal for his unselfish care of two dangerously ill companions on the return journey across the ice. He died of typhoid in a military hospital in Malta.

Wild, Frank (1873–1939), Able Seaman, *Discovery*; in charge of stores, *Nimrod*; sledge master, Australasian Antarctic Expedition; second in command, *Endurance*; second in command, *Quest*. Born in Yorkshire, Wild joined the Merchant Navy in 1889, transferring to the Royal Navy in 1900. He was one of Shackleton's team at Furthest South in 1909 and led a team that opened up Queen Mary Land during Mawson's expedition in extremely difficult terrain. He was put in charge of the men left on Elephant Island and kept morale going for four difficult months in 1916. He served in Russia with the Royal Naval Volunteer Reserve during the First World War and accompanied Shackleton south on the *Quest* expedition, of which he later wrote an account. He ventured into farming in South Africa, before and after the *Quest* expedition, and died there.

Wilson, Edward (1872–1912), assistant surgeon, artist and zoologist, *Discovery*; chief of the scientific staff and zoologist, *Terra Nova*. Wilson read natural sciences at Cambridge before moving to St George's Hospital, London, to train as a doctor. After *Discovery* he worked on the government inquiry into grouse disease before going south again in 1910. He struck up a friendship with Bowers and Cherry-Garrard, and was Scott's closest confidante. He died with Scott and Bowers on the return journey from the Pole, on or about 29 March 1912.

Wordie, James (1889–1962), geologist, *Endurance*. A Cambridge academic, Wordie was recommended to Shackleton by Raymond Priestley. He had been considering an expedition to Easter Island in 1912 to expand his experience, but was appointed expedition geologist and chief of the scientific staff on *Endurance*. Wordie served with the Royal Field Artillery during the First World War, and afterwards returned to academic life in Cambridge, where he lectured in geology, participated in and later led trips to the Arctic, and eventually became Master of St John's College. He was President of the Scott Polar Research Institute, 1937–55, and was knighted in 1957.

Worsley, Frank (1872–1943), Captain, *Endurance*. New Zealand born, Worsley was a member of the Royal Naval Reserve before his appointment to *Endurance*. His navigational brilliance was fully realised in the 800-mile (1,480-km) boat journey to South Georgia to get help for the stranded men on Elephant Island. He later accompanied Shackleton south again aboard the *Quest*.

Wright, Charles (1887–1975), physicist, *Terra Nova*. A Canadian graduate from Cambridge, Wright worked particularly on 'ice problems' in the south. He was one of the First Returning Party. In the First World War he won the Military Cross and *Légion d'honneur*, and later became chief of the new Royal Naval Scientific Service. Like Griffith Taylor, he married one of Raymond Priestley's sisters.

APPENDIX 3

Major expeditions of the 'heroic age' of Antarctic exploration 1839–1922

This summary list owes much to the (more detailed) list by R.K. Headland, former archivist at the Scott Polar Research Institute, published in Piggott 2000, pp. 15–21.

DATE	LEADER	SHIP	NAME	NOTES
1839–43	James Clark Ross; Francis Crozier	*Erebus* and *Terror*		Discovered the 'Great Ice Barrier' (now known as the Ross Ice Shelf)
1897–9	Adrien de Gerlache	*Belgica*	Belgian Antarctic Expedition	1st exploring vessel to winter south of the Antarctic Circle
1898–1900	Carsten Borchgrevink	*Southern Cross*	British Antarctic Expedition	1st team to winter on land in Antarctica, at Cape Adare
1901–3	Erich von Drygalski	*Gauss*	German Deep Sea Expedition	
1901–4	Nils Nordenskjold; Carl Larsen	*Antarctic*	Swedish South Polar Expedition	
1901–4	Robert Falcon Scott	*Discovery*	British National Antarctic Expedition	1st extensive exploration of Antarctica on land. Reached Furthest South 82° 28' S, 30 December 1902
1902–4	William Speirs Bruce; Thomas Robertson	*Scotia*	Scottish National Antarctic Expedition	1st oceanographic exploration of Weddell Sea
1903–5	Jean-Baptiste Charcot	*Français*	French Antarctic Expedition	
1907–9	Ernest Shackleton	*Nimrod*	British Antarctic Expedition	Furthest South of 88° 23' S, 9 January 1909. 1st ascent of Mt Erebus. Located South Magnetic Pole, 16 January 1909
1908–10	Jean-Baptiste Charcot	*Pourquoi Pas?*	French Antarctic Expedition	
1910–12	Roald Amundsen	*Fram*	Norwegian Antarctic Expedition	1st at South Pole, 14 December 1911

DATE	LEADER	SHIP	NAME	NOTES
1910–12	Nobu Shirase	*Kainan Maru*	Japanese Antarctic Expedition	
1910–13	Robert Falcon Scott	*Terra Nova*	British Antarctic Expedition	2nd to reach South Pole, 17 January 1912. Extensive scientific programme carried out
1911–12	Wilhelm Filchner	*Deutschland*	German South Polar Expedition	
1911–14	Douglas Mawson	*Aurora*	Australasian Antarctic Expedition	Discovered and explored King George V and Queen Mary Land. Established wireless station at Macquarie Island
1913–15	Harold Power; A.C. Tulloch	*Endeavour*	Commonwealth Meteorological Expedition	
1914–16	Ernest Shackleton	*Endurance*	Imperial Transantarctic Expedition	Attempt to cross the Antarctic continent from the Weddell Sea to the Ross Sea. Ship lost in pack ice
1914–17	Aeneas Mackintosh	*Aurora*	Imperial Transantarctic Expedition	Laid supply lines from Ross Sea to Beardmore Glacier for Shackleton's Transantarctic Party
1916	Various	Various	Relief expeditions for the Imperial Transantarctic Expedition	Relief vessels from South Georgia, Montevideo and Punta Arenas attempted to reach stranded men on Elephant Island
1916–17	John King Davis	*Aurora*	Relief expedition for the Ross Sea Party of the Imperial Transantarctic Expedition	
1920–22	John Lachlan Cope	Various	British Expedition to Graham Land	
1921–2	Ernest Shackleton; Frank Wild	*Quest*	Shackleton-Rowett Antarctic Expedition	Originally intended as a circumnavigation of Antarctica; Shackleton died at South Georgia. Wild commanded a scaled-down expedition to various islands inside the Antarctic Circle

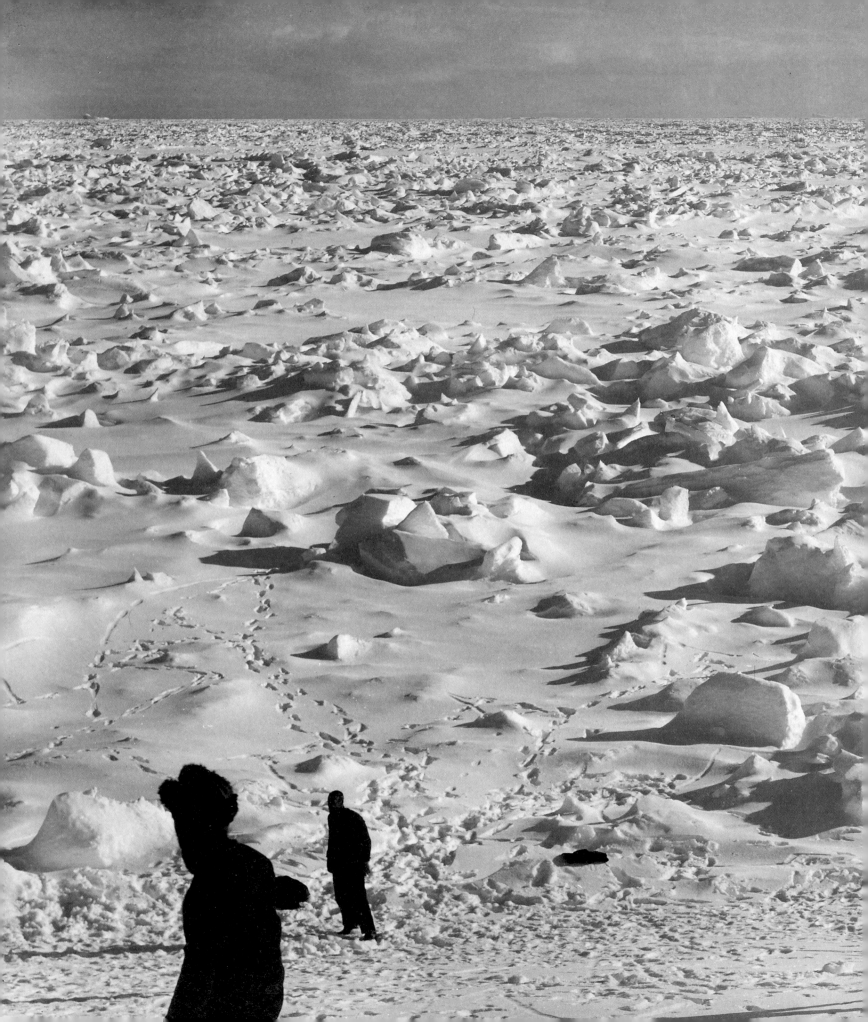

APPENDIX 4

The King's Albums

The photographs are reproduced in the order in which they appeared in the albums. The titles are adapted from those included in the albums. The dates given refer to the date the negative was exposed in the camera, rather than the date of printing, which took place after the departure from Antarctica. All dimensions are given as height × width. The photographs were removed from both albums in 2008 and are now individually mounted.

The King's Albums: *The British Antarctic Expedition 1910–1913* and *The Shackleton Expedition* (RCIN 2580000 & 2580044)

(left) FRANK HURLEY (1885–1962) **Looking south over the frozen sea, lat. 74° 10' S, long. 27° 10' W, 14 January 1915** *(detail)*

The British Antarctic Expedition 1910–1913
Photographs by H.G. Ponting, F.R.G.S.

Half-bound brown goatskin elephant folio with green cloth sides, five raised bands on spine, panelled spine with single central motif, cloth endpapers, gilt edges, guarded pages. Goatskin label stamped inside cover: *By gracious permission to his Majesty King George V. From Herbert G. Ponting.* Contained 43 photographs: 24 silver bromide prints laid down on pages, one or two per page; 19 carbon prints guarded into album. Typewritten caption labels adhered to interleaving pages. RCIN 2580000 (empty album)

PROVENANCE: From the collection of King George V. Probably presented to the King by Herbert Ponting on 12 May 1914 at Buckingham Palace (RA GV/PRIV/GVD/1914: 12 May).

The caption labels in the album (which are adapted here) were based on the titles and descriptions found in the Fine Art Society exhibition catalogue (FAS; *see pp. 220–21*). References to that catalogue are given when known. The RCIN is provided for all images in the Royal Collection, followed by the illustration number for images included in 'The photographs' section in this publication (*pp. 73–123*).

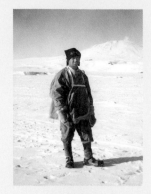

Captain Scott, RN, CVO, February 1911
Silver bromide print, 437 × 610 mm
(17¹⁄₄ × 24 in.)
FAS 1913, no. 31
RCIN 2580001 no. 3

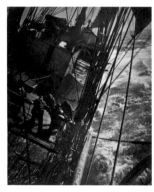

The *Terra Nova* in a gale, March 1912
Carbon print, 729 × 579 mm (28³⁄₄ × 22³⁄₄ in.)
Blindstamp, *H.G. Ponting Copyright*
FAS 1913, no. 6
RCIN 2580002 no. 19

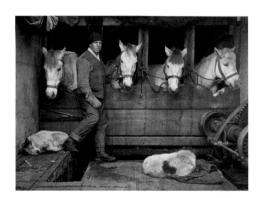

Captain Lawrence Oates and Siberian ponies on board *Terra Nova*, 1910
Carbon print, 444 × 590 mm (17¹⁄₂ × 23¹⁄₄ in.)
FAS 1913, no. 5
RCIN 2580003 no. 10

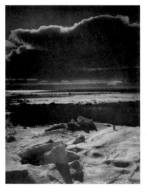

Evening in the ice pack, December 1912
Silver bromide print, 581 × 436 mm
(22⁷⁄₈ × 17¹⁄₈ in.)
RCIN 2580004

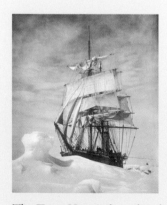

The *Terra Nova* icebound in the pack, 13 December 1910
Carbon print, 732 × 585 mm (28⁷⁄₈ × 23 in.)
FAS 1913, no. 11
RCIN 2580005 no. 17

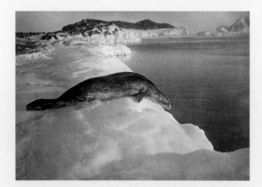

Weddell seal about to dive, Cape Evans, 15 March 1911
Carbon print, 430 × 601 mm (16⁷⁄₈ × 23⁵⁄₈ in.)
FAS 1913, no. 35
RCIN 2580006 no. 24

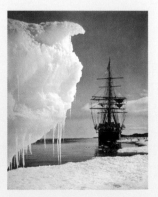

The *Terra Nova* at the ice foot, Cape Evans, 16 January 1911
Carbon print, 735 × 578 mm (29 × 22³⁄₄ in.)
Blindstamp, *H.G. Ponting Copyright*
FAS 1913, no. 27
RCIN 2580007 no. 22

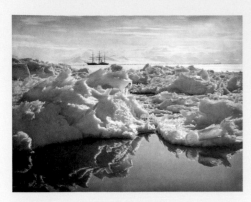

**The *Terra Nova* in McMurdo Sound,
7 January 1911**
Carbon print, 582 × 730 mm (22⁷⁄₈ × 28³⁄₄ in.)
FAS 1913, no. 25
RCIN 2580008 no. 5

The hut at Cape Evans, 26 March 1911
Carbon print, 734 × 575 mm (28⁷⁄₈ × 22⁵⁄₈ in.)
Blindstamp, *H.G. Ponting Copyright*
FAS 1913, no. 44
RCIN 2580009 no. 4

**Midnight in the Antarctic summer,
30 January 1911**
Carbon print, 530 × 745 mm (20⁷⁄₈ × 29³⁄₈ in.)
FAS 1913, no. 96
RCIN 2580010 no. 23

**The North Bay and Mount Erebus, Cape Evans,
7 March 1911**
Silver bromide print, 436 × 609 mm (17¹⁄₈ × 24 in.)
RCIN 2580011

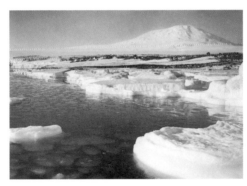

**Young pancake ice forming at West Beach,
Mount Erebus in the background, 9 March 1911**
Silver bromide print, 437 × 619 mm (17¹⁄₄ × 24³⁄₈ in.)
FAS 1913, no. 40
RCIN 2580012

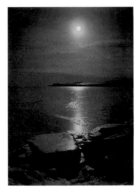

The freezing of the sea, April 1911
Carbon print, 746 × 581 mm (29³⁄₈ × 22⁷⁄₈ in.)
Blindstamp, *H.G. Ponting Copyright*
FAS 1913, no. 39
RCIN 2580013 no. 30

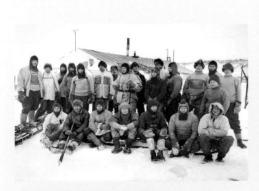

The Shore Party, January 1911
Silver bromide print, 436 × 619 mm (17¹⁄₈ × 24³⁄₈ in.)
RCIN 2580014 no. 12

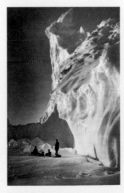

End of the Barne Glacier, 1911
Carbon print, 756 × 536 mm (29³⁄₄ × 21¹⁄₈ in.)
FAS 1913, no. 77
RCIN 2580015 no. 31

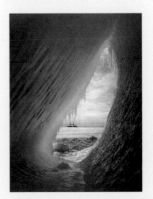

Grotto in an iceberg, 5 January 1911
Carbon print, 746 × 538 mm (29³⁄₈ × 21¹⁄₈ in.)
FAS 1913, no. 118
RCIN 2580016 no. 20

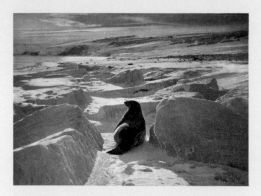

**Weddell seal on the beach at Cape Evans,
November 1911 – March 1912**
Carbon print, 444 × 602 mm (17½ × 23¾ in.)
Blindstamp, *H.G. Ponting Copyright*
FAS 1913, no. 43
RCIN 2580017 no. 25

Captain Scott writing his diary, 7 October 1911
Toned silver bromide print, 444 × 602 mm
(17½ × 23¾ in.)
FAS 1913, no. 46
RCIN 2580018 no. 32

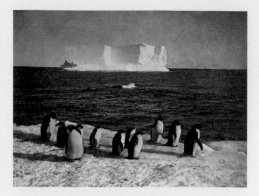

**Tabular iceberg off Cape Royds,
13 February 1911**
Carbon print, 584 × 732 mm (23 × 28⅞ in.)
Blindstamp, *H.G. Ponting Copyright*
RCIN 2580019 no. 6

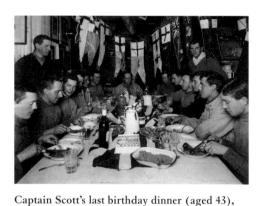

**Captain Scott's last birthday dinner (aged 43),
6 June 1911**
Toned silver bromide print, 436 × 610 mm
(17⅛ × 24 in.)
FAS 1913, no. 51
RCIN 2580020 no. 33

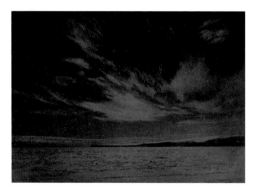

**Cirrus clouds over the Barne Glacier,
19 December 1911**
Carbon print on dyed paper, 434 × 588 mm
(17⅛ × 23⅛ in.)
FAS 1913, no. 112
RCIN 2580021 no. 2

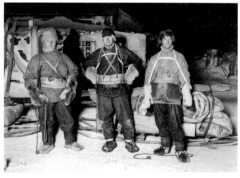

The winter journey to Cape Crozier, June 1911
Silver bromide print, 437 × 610 mm (17¼ × 24 in.)
FAS 1913, no. 61
RCIN 2580022 no. 29

**Summertime, the opening-up of the ice,
7 January 1911**
Carbon print, 575 × 740 mm (22⅝ × 29⅛ in.)
Blindstamp, *H.G. Ponting Copyright*
FAS 1913, no. 87
RCIN 2580023

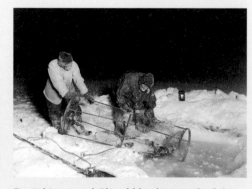

**Dr Atkinson and Clissold hauling up the fish
trap, forty degrees below zero [−40 °F/−40 °C],
28 May 1911**
Silver bromide print, 437 × 610 mm (17¼ × 24 in.)
FAS 1913, no. 60
RCIN 2580024 no. 28

The 'Stony Stare', November 1911 – March 1912
Silver bromide print, 456 × 333 mm (18 × 13⅛ in.)
RCIN 2580025 no. 27

The 'Glad Eye', November 1911 – March 1912
Silver bromide print, 457 × 335 mm (18 × 13⅛ in.)
RCIN 2580026 no. 26

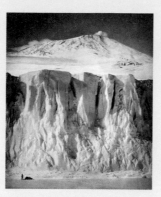

The ramparts of Mount Erebus, 1911
Carbon print, 722 × 589 mm (28½ × 23¼ in.)
FAS 1913, no. 109
RCIN 2580027 no. 18

Osman, 'our best sledge dog', 1911
Toned silver bromide print, 380 × 275 mm
(15 × 10⅞ in.)
FAS 1913, no. 136
RCIN 2580028 no. 9

Vida, 1911
Toned silver bromide print, 380 × 275 mm
(15 × 10⅞ in.)
FAS 1913, no. 127
RCIN 2580029 no. 8

Mount Erebus, 13 January 1911
Carbon print, 580 × 731 mm (22⅞ × 28¾ in.)
RCIN 2580030

**The Castle Berg, with dog sledge,
17 September 1911**
Carbon print, 532 × 750 mm (21 × 29½ in.)
FAS 1913, no. 71
RCIN 2580031 no. 7

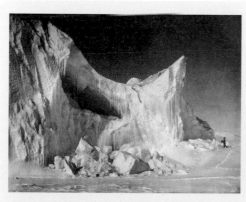

A weathered iceberg, 29 December 1911
Carbon print, 572 × 740 mm (22½ × 29⅛ in.)
Blindstamp, *H.G. Ponting Copyright*
FAS 1913, no. 121
RCIN 2580032 no. 21

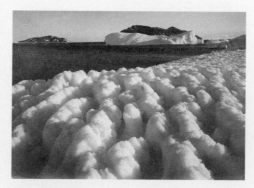

Ice furrows, March 1911
Silver bromide print, 437 × 610 mm (17¼ × 24 in.)
FAS 1913, no. 37
RCIN 2580033

Dr Edward Wilson, October 1911
Toned silver bromide print, 456 × 334 mm
(18 × 13⅛ in.)
FAS 1913, no. 143
RCIN 2580034 no. 13

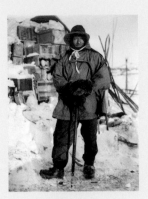

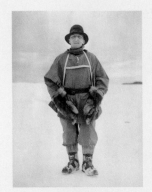

Captain Lawrence Oates, October–November 1911
Toned silver bromide print, 456 × 334 mm (18 × 13¹/₈ in.)
FAS 1913, no. 142
RCIN 2580035 no. 16

Petty Officer Edgar Evans, November 1911
Toned silver bromide print, 456 × 334 mm (18 × 13¹/₈ in.)
FAS 1913, no. 145
RCIN 2580036 no. 15

Lieutenant Henry Bowers, 11 October 1911
Toned silver bromide print, 456 × 334 mm (18 × 13¹/₈ in.)
FAS 1913, no. 144
RCIN 2580037 no. 14

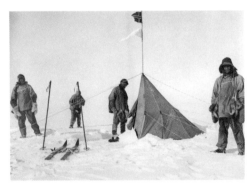

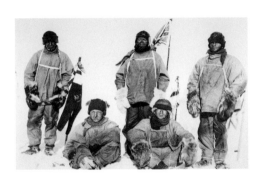

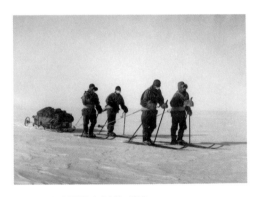

HENRY BOWERS (1883–1912)
Forestalled. Amundsen's tent at the South Pole, 18 January 1912
Silver bromide print, 275 × 380 mm (10⁷/₈ × 15 in.)
FAS 1913, no. 'B'
RCIN 2580038 no. 35

HENRY BOWERS (1883–1912)
At the South Pole, 18 January 1912
Silver bromide print, 275 × 380 mm (10⁷/₈ × 15 in.)
FAS 1913, no. 'C'
RCIN 2580039 no. 36

HENRY BOWERS (1883–1912)
The Polar Party and their sledge, 4–17 January 1912
Silver bromide print, 275 × 380 mm (10⁷/₈ × 15 in.)
FAS 1913, no. 'A'
RCIN 2580040 no. 34

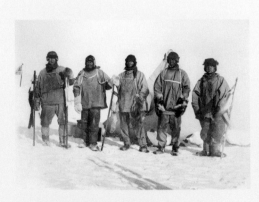

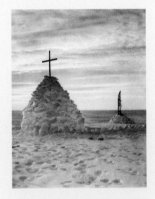

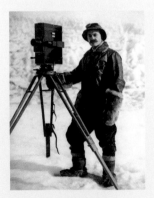

EDWARD WILSON (1872–1912)
The camp at the South Pole, 18 January 1912
Silver bromide print, 275 × 380 mm (10⁷/₈ × 15 in.)
FAS 1913, no. 'D'
RCIN 2580041 no. 37

TRYGGVE GRAN (1889–1980)
The grave on the Great Ice Barrier, 12–13 November 1912
Silver bromide print, 380 × 275 mm (15 × 10⁷/₈ in.)
FAS 1913, no. 'E'
RCIN 2580042 no. 38

Herbert Ponting, with cinematographic camera, 1911
Toned silver bromide print, 456 × 333 mm (18 × 13¹/₈ in.)
FAS 1913, no. 10 or 116
RCIN 2580043 no. 1

The Shackleton Expedition. Photographs of Scenes and Incidents in connection with the happenings to the Weddell Sea Party, 1914, 1915, 1916

Full navy blue goatskin quarto, gold tooling, five raised bands on spine, gilt edges, guarded album. With title page and page listing the officers of the expedition, handwritten in black ink. Contained 79 silver bromide prints, each dry-mounted one per page on cream card in grey window mount, with black ink captions (adapted here) on the mount.
RCIN 2580044 (empty album)

PROVENANCE: From the collection of King George V. Probably presented to the King by Sir Ernest Shackleton on 30 May 1917 at Buckingham Palace, or on 10 October 1917 at Sandringham (RA GV/PRIV/GVD/1917: 30 May and 10 October).

The RCIN is provided for all images in the Royal Collection, followed by the illustration number for images included in 'The photographs' section in this publication *(pp. 127–89)*.

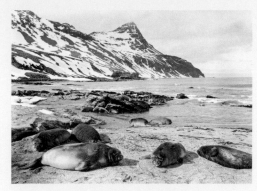

Sea elephant pups, South Georgia, 1914
Silver bromide print, 152 × 204 mm
(6 × 8 in.)
RCIN 2580045 no. 42

Young King penguin in first-year plumage, South Georgia, 1914
Silver bromide print, 152 × 204 mm
(6 × 8 in.)
RCIN 2580046 no. 49

Gentoo penguin with egg, South Georgia, 1917
Silver bromide print, 152 × 204 mm
(6 × 8 in.)
RCIN 2580047

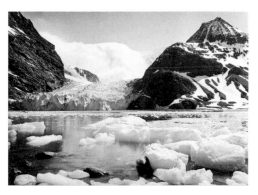

Head of Moraine Fjord, South Georgia, 24 November 1914
Silver bromide print, 153 × 205 mm
(6 × 8¹/₈ in.)
RCIN 2580048 no. 41

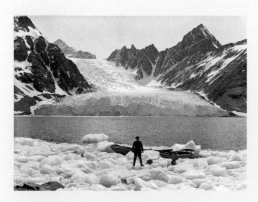

Glacier, Moraine Fjord, South Georgia, 24 November 1914
Silver bromide print, 154 × 206 mm
(6 × 8¹/₈ in.)
RCIN 2580049 no. 40

The ramparts of Mount Paget, South Georgia, 1914
Silver bromide print, 204 × 153 mm
(8 × 6 in.)
RCIN 2580050

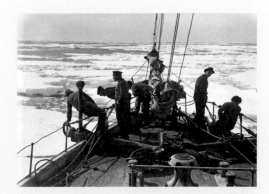

Entering the pack ice, Weddell Sea, lat. 57° 59' S, long. 22° 39' W, 9 December 1914
Silver bromide print, 153 × 205 mm
(6 × 8¹/₈ in.)
RCIN 2580051 no. 43

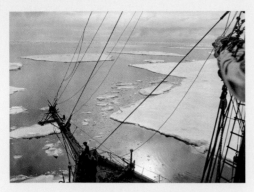

A lake among 'leads', December 1914
Silver bromide print, 150 × 202 mm
(5⅞ × 8 in.)
RCIN 2580052

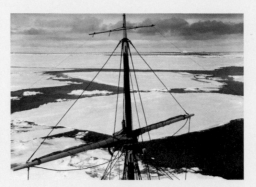

**Typical pack ice, Weddell Sea, lat. 62° 50' S,
long. 17° 21' W, December 1914**
Silver bromide print, 150 × 202 mm
(5⅞ × 8 in.)
RCIN 2580053 no. 44

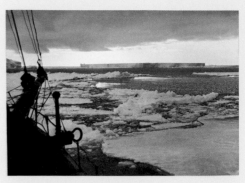

Dawn of 1915, 1 January 1915
Silver bromide print, 147 × 201 mm
(5¾ × 7⅞ in.)
RCIN 2580054 no. 46

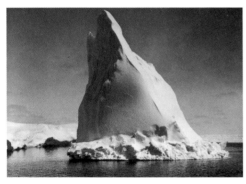

**A pinnacled glacier berg, observed in lat. 62° 41' S,
long. 17° 32' W, January 1915**
Silver bromide print, 153 × 204 mm
(6 × 8 in.)
RCIN 2580055 no. 45

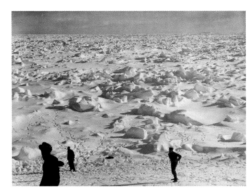

**Looking south over the frozen sea, lat. 74° 10' S,
long. 27° 10' W, 14 January 1915**
Silver bromide print, 153 × 205 mm
(6 × 8⅛ in.)
RCIN 2580056

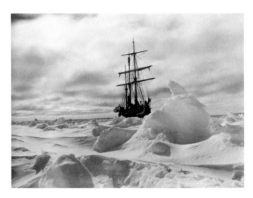

**The *Endurance* laying to awaiting the opening
up of the pack, 1 January 1915**
Silver bromide print, 154 × 204 mm
(6 × 8 in.)
RCIN 2580057 no. 48

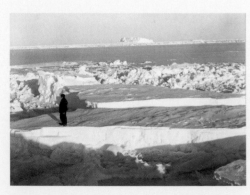

The breaking up of the pack, 5 August 1915
Silver bromide print, 151 × 205 mm
(5⅞ × 8⅛ in.)
RCIN 2580058

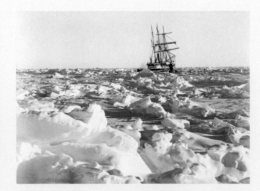

**The surroundings of the ship at the
end of winter, 1915**
Silver bromide print, 154 × 204 mm
(6 × 8 in.)
RCIN 2580059 no. 47

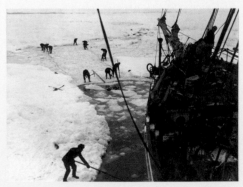

**Strenuous endeavours being made to free the
ship from frozen captivity, lat. 16° 50' S,
long. 34° 58' S, 15 February 1915**
Silver bromide print, 152 × 202 mm
(6 × 8 in.)
RCIN 2580060

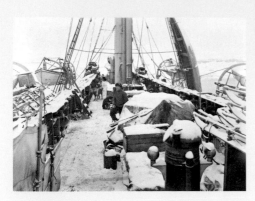

Deck of *Endurance* on the way south, 1915
Silver bromide print, 154 × 205 mm
(6 × 8¹/₈ in.)
RCIN 2580061 no. 51

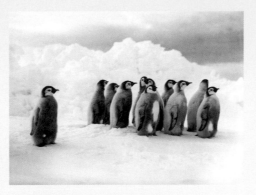

Young Emperor penguins, 1915
Silver bromide print, 154 × 205 mm
(6 × 8¹/₈ in.)
RCIN 2580062 no. 50

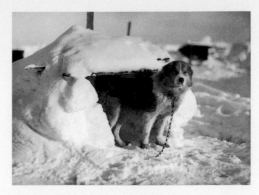

**Samson at the entrance of his dogloo,
February–March 1915**
Silver bromide print, 154 × 205 mm
(6 × 8¹/₈ in.)
RCIN 2580063 no. 54

Saint, 1915
Silver bromide print, 202 × 153 mm
(8 × 6 in.)
RCIN 2580064

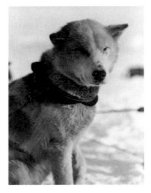

Bummer, 1915
Silver bromide print, 203 × 153 mm
(8 × 6 in.)
RCIN 2580065

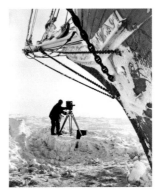

**Frank Hurley with cinematograph next to the
Endurance, 1 September 1915**
Silver bromide print, 205 × 154 mm
(8¹/₈ × 6 in.)
RCIN 2580066 no. 55

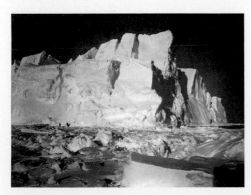

The Bastion Berg, 11 March 1915
Silver bromide print, 153 × 205 mm
(6 × 8¹/₈ in.)
RCIN 2580067

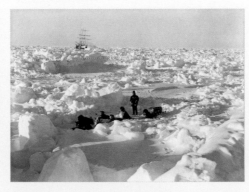

**The frozen surface of the Weddell Sea taken just
before the ship was crushed, 1915**
Silver bromide print, 153 × 204 mm
(6 × 8 in.)
RCIN 2580068

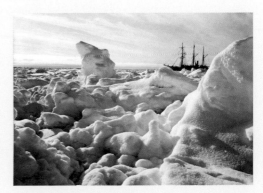

The departing sun, 1915
Silver bromide print, 153 × 204 mm
(6 × 8 in.)
RCIN 2580069 no. 52

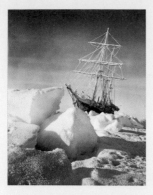

The return of the sun after 92 days, 1915
Silver bromide print, 202 × 151 mm
(8 × 5⅞ in.)
RCIN 2580070 no. 56

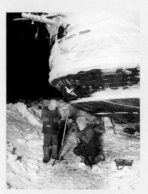

Taking occultations, June 1915
Silver bromide print, 203 × 152 mm
(8 × 6 in.)
RCIN 2580071 no. 65

Frank Hurley and Leonard Hussey on night watch, midwinter 1915
Silver bromide print, 154 × 205 mm
(6 × 8⅛ in.)
RCIN 2580072 no. 64

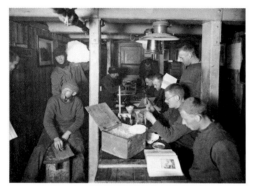

In the 'Ritz', the workroom of the ship, midwinter 1915
Silver bromide print, 153 × 203 mm
(6 × 8 in.)
RCIN 2580073 no. 68

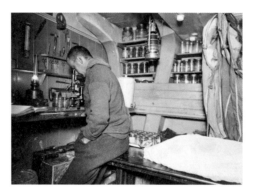

'Bob' Clark in the biological laboratory, February–March 1915
Silver bromide print, 154 × 206 mm
(6 × 8⅛ in.)
RCIN 2580074

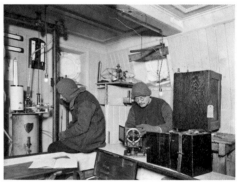

Hussey (meteorologist) and James (physicist), in the 'Rookery', midwinter 1915
Silver bromide print, 155 × 205 mm
(6⅛ × 8⅛ in.)
RCIN 2580075

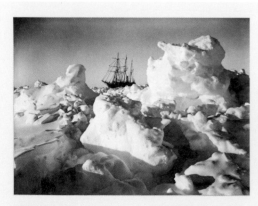

Huge blocks weighing upwards of 50 tons were thrown about in indescribable confusion, September–October 1915
Silver bromide print, 154 × 205 mm
(6 × 8⅛ in.)
RCIN 2580076 no. 57

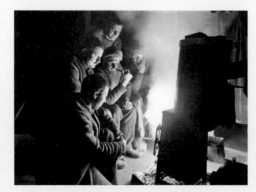

The nightwatchman spins a yarn, 1915
Silver bromide print, 155 × 204 mm
(6⅛ × 8 in.)
RCIN 2580077 no. 63

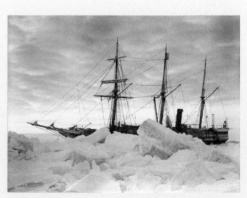

Dawn after winter, August 1915
Silver bromide print, 153 × 203 mm
(6 × 8 in.)
RCIN 2580078 no. 60

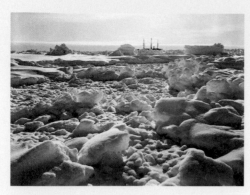

The effect of a blizzard on the floe, March 1915
Silver bromide print, 154 × 203 mm
(6 × 8 in.)
RCIN 2580079

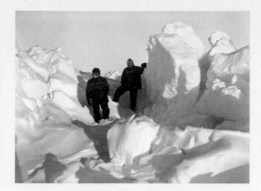

Wild and Shackleton between two pressure ridges, spring 1915
Silver bromide print, 154 × 205 mm
(6 × 8¹/₈ in.)
RCIN 2580080 no. 59

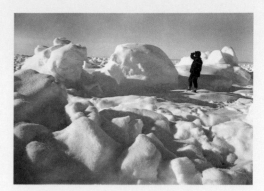

Hummocks, 1915
Silver bromide print, 153 × 206 mm
(6 × 8¹/₈ in.)
RCIN 2580081

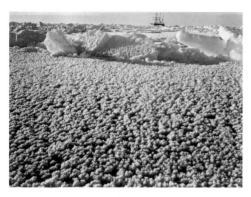

Ice flowers, spring 1915
Silver bromide print, 145 × 193 mm
(5³/₄ × 7⁵/₈ in.)
RCIN 2580082 no. 62

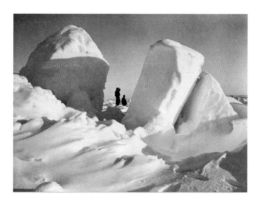

Tilted hummocks, August 1915
Silver bromide print, 153 × 204 mm
(6 × 8 in.)
RCIN 2580083

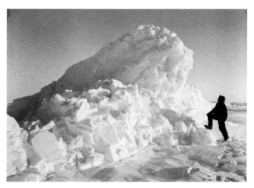

Worsley standing next to a working pressure ridge showing an immense block of over 100 tons being rafted, August 1915
Silver bromide print, 155 × 205 mm
(6¹/₈ × 8¹/₈ in.)
RCIN 2580084 no. 58

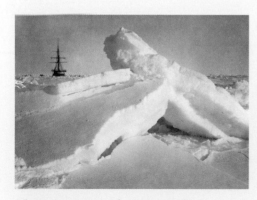

The incipient stage of a pressure ridge, September 1915
Silver bromide print, 155 × 204 mm
(6¹/₈ × 8 in.)
RCIN 2580085 no. 61

The bi-weekly ablutions of the 'Ritz', undertaken by Wordie, Cheetham and Macklin, 1915
Silver bromide print, 154 × 203 mm
(6 × 8 in.)
RCIN 2580086 no. 67

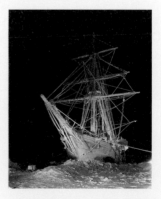

The *Endurance* in the garb of winter, June 1915
Silver bromide print, 202 × 152 mm
(8 × 6 in.)
RCIN 2580087 no. 70

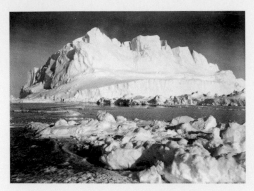

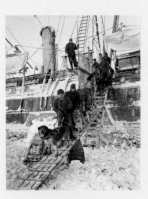

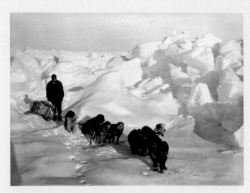

The Rampart berg which pursued the ship during her ten-month drift, 11 March 1914
Silver bromide print, 153 × 204 mm
(6 × 8 in.)
RCIN 2580088

Taking the dogs out for exercise, August 1915
Silver bromide print, 205 × 154 mm
(8¹/₈ × 6 in.)
RCIN 2580089 no. 66

Hurley with his team, August–September 1915
Silver bromide print, 153 × 203 mm
(6 × 8 in.)
RCIN 2580090 no. 53

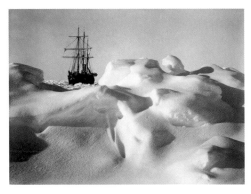

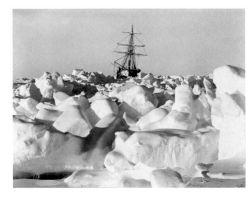

Wind-sculptured hummocks, 1915
Silver bromide print, 153 × 205 mm
(6 × 8¹/₈ in.)
RCIN 2580091 no. 69

Crab-eater seals on the floe, 1915
Silver bromide print, 154 × 204 mm
(6 × 8 in.)
RCIN 2580092

The pressure menaced us on all sides, August–September 1915
Silver bromide print, 154 × 204 mm (6 × 8 in.)
RCIN 2580093

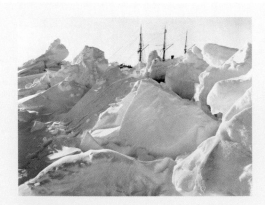

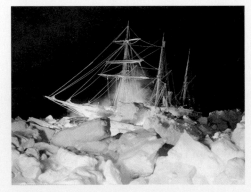

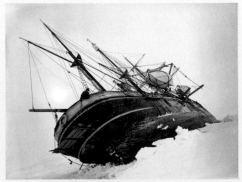

The ship was the nucleus of a pressure wave, September–October 1915
Silver bromide print, 153 × 202 mm
(6 × 8 in.)
RCIN 2580094 no. 72

During midwinter, 1915
Silver bromide print, 153 × 205 mm
(6 × 8¹/₈ in.)
RCIN 2580095 no. 71

The *Endurance* forced out of the ice by the coming together of the floes, 18 October 1915
Silver bromide print, 154 × 200 mm
(6 × 7⁷/₈ in.)
RCIN 2580096 no. 73

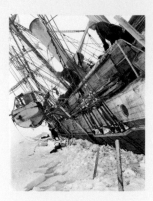

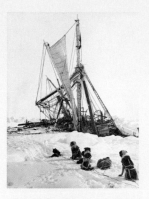

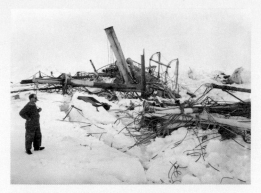

The ship was forced into this position 15 seconds after the floes came together, 18 October 1915
Silver bromide print, 205 × 154 mm (8¹/₈ × 6 in.)
RCIN 2580097 no. 74

The *Endurance* crushed between the floes, 25 October 1915
Silver bromide print, 205 × 151 mm
(8¹/₈ × 5⁷/₈ in.)
RCIN 2580098 no. 75

Wild observes the wreck, 8 November 1915
Silver bromide print, 154 × 205 mm
(6 × 8¹/₈ in.)
RCIN 2580099 no. 76

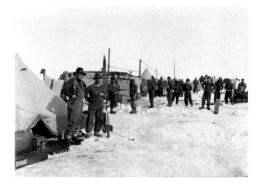

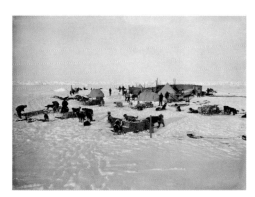

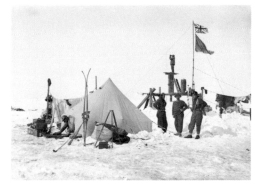

The party at Ocean Camp on the drifting sea ice: Sir Ernest Shackleton and Frank Wild on the left, 30 October 1915
Silver bromide print, 152 × 206 mm (6 × 8¹/₈ in.)
RCIN 2580100 no. 77

The drifting bivouac of the party after the ship's destruction, Ocean Camp, November 1915
Silver bromide print, 154 × 206 mm (6 × 8¹/₈ in.)
RCIN 2580101

The lookout platform at Ocean Camp, November 1915
Silver bromide print, 153 × 205 mm (6 × 8¹/₈ in.)
RCIN 2580102 no. 78

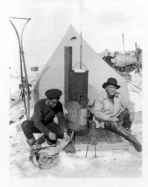

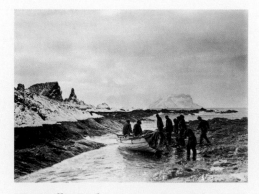

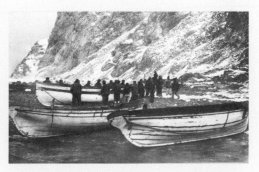

Frank Hurley and Sir Ernest Shackleton at Patience Camp, December 1915 – January 1916
Silver bromide print, 205 × 154 mm
(8¹/₈ × 6 in.)
RCIN 2580103 no. 39

The *Dudley Docker* arrives at Cape Valentine, Elephant Island, 15 April 1916
Silver bromide print, 154 × 206 mm
(6 × 8¹/₈ in.)
RCIN 2580104

Hauling up the *James Caird* at Cape Valentine, Elephant Island, 15 April 1916
Silver bromide print, 130 × 204 mm
(5¹/₈ × 8 in.)
RCIN 2580105

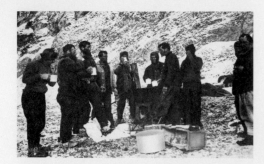

The first hot food after five days in the boats, 15 April 1916
Silver bromide print, 128 × 203 mm
(5 × 8 in.)
RCIN 2580106

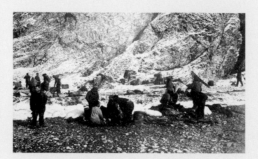

The exhausted party on the beach at Cape Valentine, Elephant Island, 15 April 1916
Silver bromide print, 123 × 207 mm
(4⅞ × 8⅛ in.)
RCIN 2580107 no. 79

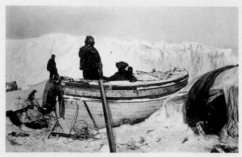

Preparing the boat for the relief voyage to South Georgia, April 1916
Silver bromide print, 132 × 205 mm
(5¼ × 8⅛ in.)
RCIN 2580108 no. 84

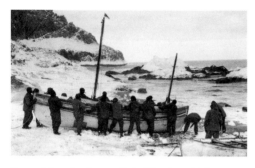

Launching the *James Caird* for the relief voyage to South Georgia, 24 April 1916
Silver bromide print, 128 × 203 mm (5 × 8 in.)
RCIN 2580109 no. 85

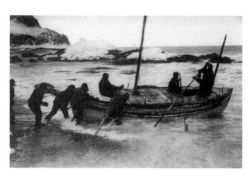

The start for South Georgia, 24 April 1916
Silver bromide print, 132 × 202 mm
(5¼ × 8 in.)
RCIN 2580110

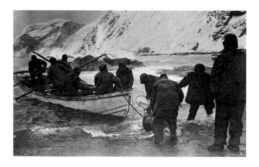

Sir Ernest Shackleton leaving in the *Stancomb-Wills*, making his way to the *James Caird*, 24 April 1916
Silver bromide print, 127 × 205 mm (5 × 8⅛ in.)
RCIN 2580111

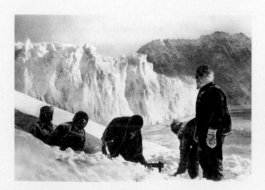

The Elephant Island Party excavating an ice shelter in the glacier, April 1916
Silver bromide print, 146 × 207 mm
(5¾ × 8⅛ in.)
RCIN 2580112 no. 83

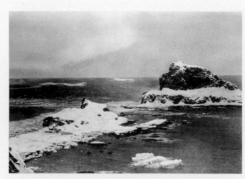

The spit, Cape Wild, where the Elephant Island Party lived for 4½ months, 1916
Silver bromide print, 141 × 204 mm
(5½ × 8 in.)
RCIN 2580113

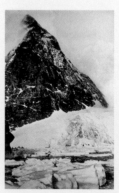

Inaccessible mountain, Cape Wild, which blocked communications from the spit to the mainland of the island, 1916
Silver bromide print, 203 × 124 mm
(8 × 4⅞ in.)
RCIN 2580114

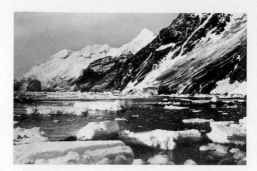

The inaccessible cliffs of Elephant Island, 1916
Silver bromide print, 134 × 206 mm
(5¼ × 8⅛ in.)
RCIN 2580115

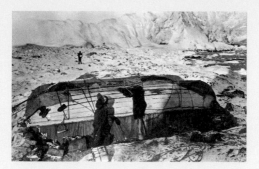

The boat shelter in which the Elephant Island Party lived for 4½ months, 1916
Silver bromide print, 133 × 203 mm
(5¼ × 8 in.)
RCIN 2580116 no. 82

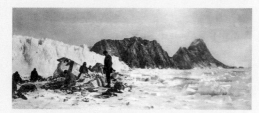

Skinning penguins, the staple diet of the party during their stay on Elephant Island, 1916
Silver bromide print, 88 × 202 mm
(3½ × 8 in.)
RCIN 2580117 no. 80

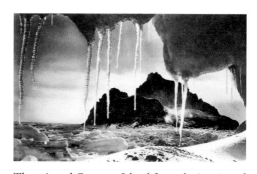

The spit and Gnomon Island from the interior of an ice grotto, 1916
Silver bromide print, 127 × 204 mm
(5 × 8 in.)
RCIN 2580118

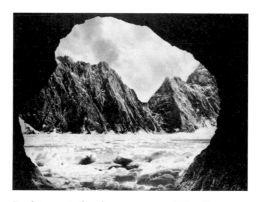

Looking out of rock cavern across West Bay, Elephant Island, 1916
Silver bromide print, 154 × 203 mm
(6 × 8 in.)
RCIN 2580119

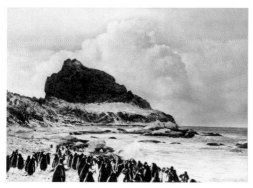

The foreshore of Spit, Gentoo penguins, Elephant Island, 1916
Silver bromide print, 152 × 205 mm
(6 × 8⅛ in.)
RCIN 2580120

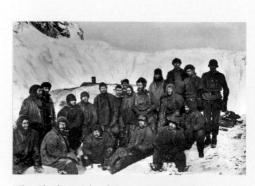

The Elephant Island Party, 10 May 1916
Silver bromide print, 134 × 203 mm
(5¼ × 8 in.)
RCIN 2580121 no. 81

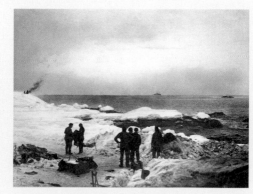

The *Yelcho* sighted, 30 August 1916
Silver bromide print, 158 × 205 mm
(6¼ × 8⅛ in.)
RCIN 2580122 no. 86

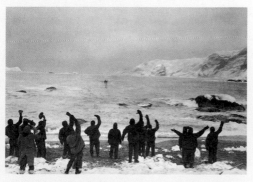

Sir Ernest Shackleton arriving at Elephant Island to take off the marooned men, 30 August 1916
(Original nitrate film shows the departure of the
James Caird, 24 April 1916)
Silver bromide print, 147 × 205 mm (5¾ × 8⅛ in.)
RCIN 2580123 no. 87

BIBLIOGRAPHY

Alexander, C. 1998. *The Endurance. Shackleton's Legendary Antarctic Expedition*, New York

Anon. 1859. *Stereoscopic Photographs of the Franklin Relics by Lieutenant Cheyne, R.N.*, London

Arnold, H.J.P. 1969. *Photographer of the World. The Biography of Herbert Ponting*, London

Baldwin, G. 1991. *Looking at Photographs*, Malibu and London

Bickel, L. 1999. *Shackleton's Forgotten Men. The Untold Tragedy of the Endurance Epic*, New York

Boddington, J. 1979. *Antarctic Photographs 1910–1916. Herbert Ponting and Frank Hurley*, New York

Bradford, W. 1873. *The Arctic Regions, illustrated with photographs taken on an Art Expedition to Greenland*, London

Browne, Lieut. W.H.J. 1850. *Ten Coloured Views taken during the Arctic Expedition of Her Majesty's Ships 'Enterprise' and 'Investigator' under the command of Captain Sir James C. Ross*, London

Cherry-Garrard, A. 1922. *The Worst Journey in the World. Antarctic 1910–13*, 2 vols, London

—— 'Obituary of Herbert Ponting', *Geographical Journal*, 85, 1935, p. 391

Christie, I., 'Ponting, Herbert George (1870–1935)', *Oxford Dictionary of National Biography*, 2004, Oxford

Cook, F. 1900. *Through the first Antarctic night, 1898–1899*, London

Crane, D. 2005. *Scott of the Antarctic. A Life of Courage and Tragedy in the Extreme South*, London

Crawford, W. 1979. *The Keepers of Light*, New York

Debenham, F. 1952. *In the Antarctic. Stories of Scott's Last Expedition*, London

Debenham Back, J., ed. 1992. *The Quiet Land. The Diaries of Frank Debenham, Member of the British Antarctic Expedition 1910–1913*, Bluntisham

Dowdeswell, J. and Lane, H. 2006. *The Antarctic Paintings of Edward Seago*, Cambridge

Eaton, G.T. 1986. *Photographic Chemistry*, New York

Evans, E.R.G.R. 1921. *South with Scott*, London and New York

Fiennes, R. 2003. *Captain Scott*, London

Fisher, M. and Fisher, J. 1957. *Shackleton*, London

Gordon, L.L. 1950. *British Battles and Medals*, Aldershot

Gwynn, S. 1938. *Homage. A book of sculptures by K. Scott (Lady Kennet)*, London

Hattersley-Smith, G., ed. 1984. *The Norwegian with Scott. Tryggve Gran's Antarctic Diary 1910–1913*, London

Hempleman-Adams, D. 1997. *Toughing it Out. The Adventures of a Polar Explorer and Mountaineer*, London

Hooker, J.D. Manuscript of a lecture by J.D. Hooker given at Swansea, 17 June 1846, J.D. Hooker Papers, Archives of the Royal Botanic Gardens, Kew

Huntford, R. 1987. *The Amundsen Photographs*, New York

—— 2000. *The Last Place on Earth. Scott and Amundsen's Race to the South Pole*, rev. edn, London

Hurley, F. 1925. *Argonauts of the South. Being a Narrative of Voyagings and Polar Seas and Adventures in the Antarctic with Sir Douglas Mawson and Sir Ernest Shackleton*, New York and London

Huxley, E. 1977 (repr. 1990). *Scott of the Antarctic*, London

Jones, M. 2003. *The Last Great Quest. Captain Scott's Antarctic Sacrifice*, Oxford

Kennet, Lady (Kathleen Scott) 1949. *Self-Portrait of an Artist*, London

Lewis-Jones, H., 'Heroism displayed. Revisiting the Franklin gallery at the Royal Naval Exhibition, 1891', *Polar Record*, 41:3, 2005, pp. 185–203

McClintock, F. 1859. *The Voyage of the 'Fox' in the Arctic Seas*, London

Markham, Sir C. 1903. *The First year's work of the National Antarctic Expedition* and *National Antarctic Expedition. Report of the Commander*, 1 vol., London

Mill, H.R. 1923. *The Life of Sir Ernest Shackleton*, London

Mörzer Bruyns, W., 'Photography in the Arctic, 1876–84. The work of W.J.A. Grant', *Polar Record*, 39:209, 2003, pp. 123–30

Murphy, S., Newton, G. and Gray, M. 2001. *South with Endurance. Shackleton's Antarctic Expedition 1914–1917. The Photographs of Frank Hurley*, London

Murray, J. and Marston, G. 1913. *Antarctic Days: sketches of the homely side of Polar life …; introduced by Sir Ernest Shackleton*, London

Nadeau, L. 1994. *Encyclopedia of Printing, Photographic and Photomechanical Processes*, Fredericton, New Brunswick, Canada

Nares, G. 1878. *Narrative of a Voyage to the Polar Sea during 1875–6 in HM Ships 'Alert' and 'Discovery'*, London

National Antarctic Expedition (1901–4) 1908. *Album of Photographs and Sketches with a Portfolio of Panoramic Views*, London

Neblette, C.B. 1962. *Photography. Its Materials and Processes*, New York

Newton, G. 1988. *Shades of Light. Photography and Australia 1839–1988*, Sydney

—— 'The perfect picture', in S. Murphy, G. Newton and M. Gray, *South with Endurance. Shackleton's Antarctic Expedition 1914–1917. The Photographs of Frank Hurley*, 2001, London

Peres, R., ed. 2007. *The Focal Encyclopedia of Photography*, London

Piggott, J., ed. 2000. *Shackleton. The Antarctic and Endurance*, London

Ponting, H. 1910. *In Lotus-Land Japan*, London

—— 1921. *The Great White South*, London

Pound, R. 1966. *Scott of the Antarctic*, London

Priestley, R. 1914. *Antarctic Adventure. Scott's Northern Party*, London

Riffenburgh, B. 2004. *Nimrod. Ernest Shackleton and the Extraordinary Story of the 1907–09 British Antarctic Expedition*, London

—— and Cruwys, L. 2004. *With Scott to the Pole. The Terra Nova Expedition 1910–1913. The Photographs of Herbert Ponting*, London

Rosove, M. 2001. *Antarctica, 1772–1922. Freestanding Publications through 1999*, Santa Monica, Calif.

Ross, J.C. 1847. *A voyage of discovery and research in the southern and Antarctic regions during the years 1839–43*, London

Ross, W. Gillies, 'The type and number of expeditions in the Franklin search', Arctic, 55:1, 2002, pp. 57–69

Savours, A., ed. 1975. *Scott's Last Voyage. Through the Antarctic Camera of Herbert Ponting*, London

—— 1992. *The Voyages of the Discovery: The Illustrated History of Scott's Ship*, London

Scott, R.F. 1905. *The Voyage of the 'Discovery'*, 2 vols, London

—— 1913. *Scott's Last expedition: being the journals of Captain R.F. Scott …; arranged by Leonard Huxley*, 2 vols, London

—— 2006. *Journals. Captain Scott's Last Expedition*, edited with an Introduction and Notes by Max Jones, Oxford

Seaver, G. 1933. *Edward Wilson of the Antarctic. Naturalist and Friend*, London

Shackleton, E.H., ed. 1908. *Aurora Australis*, Cape Royds, Antarctica

—— 1909. *The Heart of the Antarctic: being the story of the British Antarctic Expedition 1907–1909*, 2 vols, London

—— 1919. *South. The Story of Shackleton's Last Expedition 1914–1917*, London

—— and Bernacchi, L., eds, 1907. *The South Polar Times*, 2 vols, London

Sinclair, J.A., ed. 1913. *The Sinclair Handbook of Photography*, London

Smith, M. 2000. *An Unsung Hero. Tom Crean – Antarctic Survivor*, London

—— 2002. *I Am Just Going Outside. Captain Oates – Antarctic Tragedy*, Staplehurst

Solomon, S. 2001. *The Coldest March. Scott's Fatal Antarctic Expedition*, New Haven, Conn. and London

Spufford, F. 1996. *I May Be Some Time. Ice and the English Imagination*, London

Stocker, M., '"My masculine models". The sculpture of Kathleen Scott', *Apollo*, CL, September 1999, pp. 47–54

Swan, R., 'Wilkins, Sir George Hubert (1888–1958)', *Australian Dictionary of Biography*, vol. XII (16 vols), 1990, Melbourne

Thomson, J. 2003. *Elephant Island and Beyond. The Life and Diaries of Thomas Orde Lees*, Bluntisham

Tyler-Lewis, K. 2006. *The Lost Men. The Harrowing Saga of Shackleton's Ross Sea Party*, New York

Van der Merwe, P. *et al.* 2000. *South. The Race to the Pole*, London

Wharton, M. 1998. *Postcards of Antarctic Expeditions. A Catalogue: 1898–1958*, Bexhill-on-Sea

Wheeler, S. 2001. *Cherry. A Life of Apsley Cherry-Garrard*, London

Wild, F. 1923. *Shackleton's Last Voyage. The Story of the Quest*, London, New York, Toronto and Melbourne

Williams, I. 2008. *With Scott in the Antarctic. Edward Wilson: Explorer, Naturalist, Artist*, Stroud

Wilson, E. 1972. *Diary of the Terra Nova Expedition to the Antarctic 1910–1912. An Account of Scott's Last Expedition*, ed. H.G.R. King (from the original MSS in the Scott Polar Research Institute and the British Museum), London

Worsley, F. 1931. *Endurance. An Epic of Polar Adventure*, London

Wright, J. *et al.* 2001. *South with Endurance. Shackleton's Antarctic Expedition 1914–1917. The Photographs of Frank Hurley*, London

Young, L. 1995. *A Great Task of Happiness. The Life of Kathleen Scott*, London

EXHIBITION CATALOGUES

'Discovery' Antarctic Exhibition, 1904, Bruton Galleries, London

The British Antarctic Expedition 1910–1913. Exhibition of the Photographic Pictures of Mr. Herbert G. Ponting, FRGS, 1913, Fine Art Society, London

SALE CATALOGUES

Christie's, London, 27 September 2006, *Exploration and Travel with the Polar Sale*

Christie's, London, 25 September 2008, *Exploration and Travel*

INDEX

ACKNOWLEDGEMENTS

The permission of HM The Queen to reproduce items in the Royal Collection and to consult documents in the Royal Archives is gratefully acknowledged. The permission of HRH The Duke of Edinburgh to reproduce items in his collection is also gratefully acknowledged.

Many people have assisted in this project, but particular thanks must be offered to David Hempleman-Adams, who has given generously of his time and knowledge, based on first-hand experience in Antarctica.

Special thanks must also be given to Heather Lane and Lucy Martin (Scott Polar Research Institute) and to Richard Kossow for their advice and time.

The following have also provided valuable assistance: Naomi Boneham (Scott Polar Research Institute), Natalie Cadenhead (Canterbury Museum), Andrea Clark (British Library), Daniella Dangoor, John Falconer (British Library), Isobel Gillan, Ashley Givens (Victoria and Albert Museum), Louise Johncox, Jenny Knight, Antonia Leak (Arts University College, Bournemouth), Huw Lewis-Jones (Scott Polar Research Institute), Martin Lubikowski, David Marshall, Brian Owen, Vicki Robinson, Poppy Singer, Pierre Spake, Alison Thomas, Debbie Wayment, Nicky Webster, Anthony Wright (Canterbury Museum), Annabel Wylie.

Within the Royal Household: Hayley Andrew, Alex Barbour, Angeline Barker, Irene Campden, Stephen Chapman, Beth Clackett, Elizabeth Clark, Pamela Clark, Jacky Colliss Harvey, Julie Crocker, Allison Derrett, Anne Griffiths, Kate Heard, Lisa Heighway, Laura Hobbs, Kathryn Jones, Roderick Lane, Karen Lawson, Sabrina Mackenzie, Jonathan Marsden, Simon Metcalf, Theresa-Mary Morton, Alessandro Nasini, David Oakey, Shruti Patel, Stephen Patterson, Jane Roberts, Michael Sefi, Susan Shaw, Philip Sidney, Paul Stonell, Stephen Weber, David Westwood, Bridget Wright, Eva Zielinska-Millar.